The Media of Photography

Edited by Diarmuid Costello and Dominic McIver Lopes

Registered Office
John Wiley & Sons Ltd. The Atrium, Southern Gate, Chichester, West Sussex, PO19 8SQ, United Kingdom
Editorial Offices
350 Main Street, Malden, MA 02148-5020, USA
9600 Garsington Road, Oxford, OX4 2DQ, UK
The Atrium, Southern Gate, Chichester, West Sussex, PO19 8SQ, UK

For details of our global editorial offices, for customer services, and for information about how to apply for permission to reuse the copyright material in this book, please see our website at www.wiley.com/wiley-blackwell.

The right of Diarmuid Costello and Dominic McIver Lopes to be identified as the authors of the editorial material in this work has been asserted in accordance with the Copyright, Designs and Patents Act 1988.

Library of Congress Cataloging-in-Publication Data

The media of photography / edited by Diarmuid Costello and Dominic McIver Lopes.
 pages cm
 ISBN 978-1-118-26901-5 (pbk.)
 1. Photography–Philosophy. I. Costello, Diarmuid, editor of compilation. II. Lopes, Dominic, editor of compilation.
 TR183.M43 2012
 770.1–dc23
 2011050262

Contents

THE MEDIA OF PHOTOGRAPHY

Diarmuid Costello and Dominic McIver Lopes, Editors

Introduction

Photography has matured as a visual art medium to such an extent that exhibitions of contemporary photography have become a staple of the exhibition programs of museums and galleries. Over the last decade, institutions as diverse in their remits and collections as the Metropolitan Museum and the Tate Gallery mounted their first shows of work by living photographers, and for the first time in their histories, many museums and galleries have appointed dedicated curators of photography. These episodes reflect larger cultural trends: no longer confined to specialist galleries, distribution networks, theoretical discourses, or educational programs, photography has won mainstream institutional recognition. But why should such cultural shifts interest philosophers, even philosophers of art?

Two events in particular occasion this volume on the philosophy of photography. Gradually, though marked by some standout moments, recent decades have seen a blurring of the boundaries that some philosophers took to demarcate photographic technology and photographic practices on the one hand from other representational and artistic technologies and practices on the other hand. The task of demarcation has been part of the history of photography since its early days: for example, Barbara Savedoff's discussion of photography's "struggle to define itself against painting" takes up issues that can be found in the writings of pioneering photographers like Joseph Nicéphore Niépce, Louis-Jacques-Mandé Daguerre, and Henry Fox Talbot.[1] The struggle to define photography against painting culminated in a photographic version of the medium-specificity doctrine, which directed that each art be defined in terms of those features that are both "unique and irreducible" to it.[2] The bellwether question

was: what is special about photography? Perhaps the most developed response from within the photographic artworld was John Szarkowski's list of five "characteristics and problems ... inherent in the medium" in his introduction to the catalogue for the 1966 exhibition The Photographer's Eye at MoMA, where he was Director of Photography.[3] Theorists and historians of photography have tended instead to take as their starting point a small cluster of theoretical concepts and categories, including C. S. Peirce's notion of indexical signs, Walter Benjamin's "aura," and Roland Barthes's "punctum" and "studium."[4]

Yet, nowadays, outside philosophy, the question of what distinguishes photography no longer sounds so urgent. The once tight family of representational imaging has grown from painting, printing, and photography to include scores of imaging technologies, many designed for scientific purposes, that take the edge off comparisons between photography and painting. Meanwhile, the boundary between photographic and nonphotographic art has blurred, as the camera has found a home in a wide range of art practices from painting and theater through sculptural installation to conceptual art. The camera has become one more means at artists' disposal; it is no longer just for photographers. And the camera has also become one more tool at photographers' disposal, as the practice of photographic art has grown to include elaborate mis-en-scène before the shutter is tripped and extensive editing afterward. The boundary between what is photographic and what is nonphotographic in these art practices has also blurred.

Overlapping this gradual blurring is a second event, of which nobody is unaware, namely, the invention of digital photography. In its early years,

many argued that digitalization moves photography closer to painting.[5] The thought is usually that digital photography is so open to "post-production" editing that we cannot invest it with the kind of epistemic authority that was widely credited to analog photography and that gave analog photography its distinctive aesthetic powers. Others take a contrary line, namely, that "a digital image ... differs as profoundly from a traditional photograph as does a photograph from a painting."[6] Unlike analog photographs and paintings, digital images can be copied and distributed without loss, and mode of distribution impacts possibilities for appreciation, as websites like Flickr illustrate.

The purpose of this issue is not to revive the older question by asking what is special about photography now, in light of these events, nor is it to retell recent history in any detail. Rather, contributors to the issue were invited to consider sundry questions about the materials and tools—or media—of photography from a variety of perspectives. The articles that follow frequently address these questions in relation to classic arguments in the philosophy of photography. Since these arguments were profoundly shaped by the struggle to define photography against painting, critiquing or modifying them implicitly nudges us toward an understanding of photography that takes the measure of recent events.

At the core of the classic arguments in the philosophy of photography is the belief, expressed in a variety of ways, that photography is special because it is at bottom an automatic recording mechanism that ensures that what one sees in a photograph is causally determined by the photographed scene, rather than intentionally determined by the photographer.[7]

In one form or another, this idea lies behind all attempts to distinguish photography from painting. Formalized in different ways in influential articles by Roger Scruton and Kendall Walton, it is already present in the work of André Bazin and Stanley Cavell.

Bazin looked to photography to underwrite a theory of cinematic "realism."[8] According to Bazin, film is essentially a mechanical recording process that reproduces what it records (sometimes without even depicting it). Its significance is largely psychological, insofar as images produced by recording feed a deep-seated need for "identity substitutes" (hence the use of photographs for remembering the dead). Worries have been raised about Bazin's understanding of identification, but they need not detain us, for what is more important here is Bazin's insistence that how we respond to photographs relies heavily on folk conceptions of how they are produced.[9]

Cavell inherits Bazin's emphasis on photography as an automatic recording process, though he neither believes that photographs reproduce what they record nor, therefore, that they can serve as substitutes for it. Whereas Bazin sees photography as expressing a wish to overcome time (by creating substitutes for the dead), Cavell sees it as expressing a wish to escape the limits of human finitude, so as to experience the world free from the vagaries of subjectivity. What photography does is unprecedented in the history of representational art: it circumvents subjectivity "by removing the human agent from the task of representation."[10] As Bazin put it, "for the first time, between the originating object and its reproduction there intervenes only the instrumentality of a nonliving agent. For the first time an image of the world is formed automatically, without the creative intervention of man."[11] This thought is the leitmotif of subsequent theories of photography in analytic philosophy.

Cast as an opposition between causality and intentionality, it drives Scruton's doubts about whether photography can be a genuine art.[12] According to Scruton, it is impossible to have an aesthetic interest in a photograph as a photograph—that is, as something made by strictly photographic means. Such an interest, he assumes, must center on the thought that is expressed by the artist, but images made by strictly photographic means are pure causal traces of their subjects and not expressions of artistic intentions. Paintings stand in contrast to photographs: we cannot understand how a painting represents without ascribing intentional states to its maker. As this already makes plain, Scruton's argument implies a strong conception of medium-specificity, defining photography by what is unique to it. It also implies that photographs are fictionally incompetent—there are no photographic fictions because things that do not exist have no causal traces. Finally, Scruton concludes that we cannot take an aesthetic interest in a photograph as the expression of a thought in that photographs are nothing but "surrogates" for the aesthetic interest we might take in what they show.

More influential than Scruton's paper is Kendall Walton's "Transparent Pictures."[13] The part of this paper that has provoked the most heated debate is the claim that photographs are "transparent."[14] This entails, for example, that when you look at a photograph of a relative whose death preceded your birth, you literally (but indirectly) see something you could not have seen in any other way. You see your dead relative through the photograph. Recognizing that this would not be accepted lightly, Walton provides two necessary conditions for any experience to count as "seeing through." The content of the experience must be naturally rather than intentionally counterfactually dependent on what is seen, and it must preserve "real similarity" relations—ones that occasion the same sort of discriminatory errors as those we are prone to make when seeing the world with the naked eye. Paintings fail to satisfy the first condition, and mechanically generated descriptions fail to satisfy the second.

Like Scruton's, this argument deploys a distinction between mechanical and intentional causation to demarcate photographs from nonmechanically generated images, such as paintings. Whatever the controversy about photographic transparency, the underlying claim that photographic depiction is independent of the intentions of the photographer has been largely accepted. So although Walton regards transparency as the source of the epistemic authority of photographs in documentary, forensic, and personal settings, many of his critics continue to locate this authority in their mechanical origins.

In a departure from the emphasis on what is special about photographs, Patrick Maynard stresses what is special about photography.[15] It is, according to Maynard, a family of technologies for amplifying human powers, notably the powers of depiction and detection. By addressing these both individually and in interaction, Maynard's work holds out the prospect for a philosophy of photography that does equal justice to its epistemic, aesthetic, and scientific functions. In one respect, this strategy can be seen as a return to the classic work of photography's pioneers, who viewed photography as a means of doing various things, chiefly marking surfaces with light for a variety of purposes. The strategy is broader than that of analyzing the "is a photograph of" relation, since many surfaces marked with light are neither pictures nor, if pictures, pictures of anything.

Arguably, though, much reflection on photography, up to and including the work of Scruton and Walton, has been premised on something like the snapshot (or some other relatively automatically recorded image). How the selection of the snapshot as a paradigm case has shaped the philosophy of photography merits scrutiny, especially when the selection is made to bear the weight of discussions of the definition of photography, its ontology, its aesthetics, its art status, its malleability to artistic intention, its relationship to drawing and painting, and its epistemic capabilities. While snapshot-oriented or automatic conceptions of photography have succeeded in founding a new subdiscipline of aesthetics and in reaching important insights, notably into the epistemic privilege of photography vis-à-vis other forms of depiction, it is not obvious that every photographic medium or every use of a photographic medium comfortably fits existing philosophical conceptions of photography.

The first two articles in this issue wrangle with this conception as it was harnessed in Scruton's attack on the possibility of a genuine art of photography. The attack opens up on several fronts whose lines have been understood somewhat differently by different commentators, but there is consensus on the main argument.[16] Ideal photographs are not representations, but no work is a representational artwork unless it is possible to take an aesthetic interest in it as a representation, so no ideal photograph is a representational artwork. Assuming that no ideal photograph is an artwork unless it is a representational artwork, it follows that no ideal photographs are works of art—nonideal photographs are works of art only because they are made using the techniques of painting or some other representational art. What is so stirring in this argument is not so much the provocation of its conclusion, but rather the implicit invitation to consider the nature of photography in relation to artistic representation and the nature of our aesthetic interest in representational art.

Peter Alward responds in "Transparent Representation: Photography and the Art of Casting" that some ideal photographs are representations. Scruton thinks that photographs are not representations because they simply record the appearance of photographed scenes. Alward grants that photographs record the appearance of photographed scenes but proposes that photographs represent "by casting"—that is, by choosing from among a collection of preexisting objects. Scruton

acknowledges that photographers make such choices, but he downplays their significance, and Alward argues that this is a mistake. Indeed, some recent art photography has thematized casting by making it obvious that the photographer has arranged, with careful intention, the scene to be photographed. For example, Jeff Wall stations actors in the scenarios he photographs, and Thomas Demand photographs life-size paper models of scenes from newspaper photographs.

Alward sees no good reason to deny that ideal photography includes representation by casting; in "Fiction, Nonfiction, and Deceptive Photographic Representation," Paloma Atencia-Linares sees no good reason to deny that certain manipulations that take place after the shutter is released count as part of the photographic process. As noted above, the claim that photographs simply record the appearance of photographed scenes implies that they cannot represent nonexistent items. Atencia-Linares argues that there are images of nonexistent objects that are made using strictly photographic means. Ideal photography, properly understood, is fictionally competent in Scruton's sense. Even so, Atencia-Linares adds that what makes a representation a fiction is not that it represents a nonexistent item, but rather the attitude that its viewers are to take to it. The article closes with some observations about the difference between fiction and deception, a topic on the agenda since the rise of digital photography.

Whether or not it is a work of art, a photograph is often something that we appreciate—for its beauty, for its ability to surprise and provoke, for its looking like what we wish to remember. Philosophers say that a photographic work is the item that has the properties for which we appreciate it.[17] Suppose someone asked whether the photographic work is the pattern of light refracted onto a light-sensitive surface or the developed film or a digital image file or a print or a screen display. The answer would be that the work is the item that we appreciate. At a first pass, that would seem to be a print or some other two-dimensional display of an image, but there might be reasons to think that this is not quite the right result. Suppose you take a photograph and have several prints made as gifts for friends. Then maybe what is appreciated is an image type which has several instances, namely, the prints. The prints might be objects of appreciation in their own right, but appreciating print quality and photographic quality can differ. The lab might get the credit for one and the photographer for the other. The standard view is that works of art that have multiples (for example, most songs, stories, plays, and dances) are types with concrete instances.[18] If the standard view applies to photography, then photographic works are image types whose instances are prints, transparencies, projections, or image displays on-screen. It is the image type so instanced that is beautiful, insightful, or nostalgic.

In "Photographic Art: An Ontology Fit to Print," Christy Mag Uidhir resists applying the standard view to photography. The crux of his case is Maynard's conception of photography as a family of technologies that overlaps the family of technologies for printing. For example, photographic technology is used in printing text (like this issue) and for making silicon computer chips.[19] Mag Uidhir argues that photographs are prints akin to etchings, lithographs, and the like. Moreover, a work of print making is just the print, not an image type. Therefore, photographic works are also prints, not image types. Of course, prints from the same film are similar to each other, just as lithographs pulled from the same stone are similar to each other, but the similarity relation is all that is needed to acknowledge this fact and situate it within our practices of photographic appreciation.

John Zeimbekis's "Digital Pictures, Sampling, and Vagueness" defends the application of the standard view to photographs through a careful—and surprising—examination of digital photographs. To begin with, Zeimbekis carefully avoids what may be called the fallacy of the file, which is to infer that since digital photographs are encoded in digital files, they are those files. Files are not images; they must be turned into images. Zeimbekis accordingly takes digital photographs to be pixilated images.[20] Nelson Goodman thought that pixilated imaging is notational because pixels are discrete and they are not ordered along a dense continuum.[21] He also thought that only notational systems are "allographic" and that two images in an allographic system may belong to the same image type. By this reasoning, digital photographs are image types (not so analogue photographs). Zeimbekis argues to the contrary, that digital photography is not notational because pixels are discrete samples of a densely ordered continuum. Yet sampling is sufficient to

make a system allographic. So digital images are image types but they are not notational. Moreover, analogue photographs may involve sampling so that they are also allographic and belong to image types.

Tracking a trend in analytic aesthetics that investigates artistic agency as a focus of the appreciation of works of art, five essays in this issue put the agential capabilities of the media of photography at center stage. An overemphasis on the mechanical–causal origins of photographs risks occluding the various forms of agency that photographic artists express and that suitably sensitive spectators pick up, though some (particularly Scruton's critics) have insisted on style as an indicator of the photographer's creative agency.[22] Dawn Wilson's and Richard Shusterman's contributions show that photographic agency may be found in previously unexplored domains. What they have in common is an attention to the performative dimensions of taking photographs.

In "Facing the Camera," Wilson considers the photographic self-portrait. Rejecting suggestions that some of these self-portraits challenge the automatism and autonomy of the photographic process, she argues that these expressions of agency work by harnessing photography's automatism. Automatism functions in general as a condition of photographic agency, not its antithesis. Self-portraiture is well suited to bring this out: because the photographer serves as both artistic agent and subject matter, self-portraits perspicuously thematize the role of the artists and their relation to their medium. Seeing this means taking seriously a perspective onto the photographic process—the photographer's perspective—that standard accounts bracket out. The upshot of Wilson's article is that we need to weigh far more than automatism as we take the measure of these works as art.

More attention also needs to be given to how people pose for portraits. Extending his work on "somaesthetics," Shusterman's goal in "Photography as Performative Process" is to direct attention from end products to the activity of achieving them, through a look at photographic portraits (as opposed to self-portraits). Shusterman highlights the sitter's self-presentation, the photographer's setup, and the interaction that is required between the two, within a process that includes not only taking photographs, but also setting up the scene itself and anything that bears

on the communicative interaction between photographer and subject. This process is mediated by fine-grained bodily actions and somatic and social skills—notably the kind of sympathetic attunement and creative self-presentation that getting the best from this situation requires of photographer and sitter alike. All these contribute to an exchange that is participatory and interactive, that serves to dramatize whatever takes place within it, and that has both an aesthetic and ethical dimension.

In "Artwork and Document in the Photography of Louise Lawler," Sherri Irvin asks what distinguishes a photographic document from a photographic artwork when the two need not be visually discriminable. The question is more pressing for photography than it is for painting or sculpture, given the prevalence of nonartistic uses of photography, especially for documentation. To focus the issues, Irvin compares the practice of Louise Lawler, who makes photographic artworks that document other people's artworks in situ, with that of Larry Qualls, who makes photographs that document other people's artworks but that are not works of art in their own right. To explain why the former but not the latter is an art practice, she employs a cluster theory of art, canvassing a range of possible conditions for being art, none of which are individually necessary but various combinations of which may be jointly sufficient.

Bence Nanay's "The Macro and the Micro" uses Andreas Gursky's large-scale, richly detailed prints to draw attention to an overlooked feature of pictorial aesthetics. Philosophers have debated whether the aesthetic appreciation of pictures requires alternating attention between design features of the picture surface and what is depicted in it, or whether we have a "twofold" experience that simultaneously represents a picture's designed surface and what is depicted. Nanay advocates a more nuanced model of pictorial appreciation than this dichotomy admits. Fully appreciating Gursky's photographs requires attending to their intense detail at the microscopic level, to the simple, abstract compositions at the macroscopic level, and to the relation between them. Simultaneous awareness of both the macrostructure and the microstructure of a Gursky is an awareness of what is depicted at two different levels of detail, where fine detail is seen as aggregating to the macrostructure. However, it is impossible to simultaneously experience the detailed surface

features of the photograph and what it depicts at the macro level. In consequence, an experience of a Gursky is both twofold and alternating.

Through close attention to a late series of still lifes by Lee Friedlander, Diarmuid Costello takes issue with the thesis that photographic representation is mind-independent. He argues that the artistic features of images are those that are relevantly mind-dependent in their production. He sets this up through a surprising analogy between Walton's version of the mind-independence thesis and Martin Heidegger's antisubjectivism. Where Heidegger conceives of authentic art as an "assisted self-disclosure of nature," the mind-independence thesis echoes the recurring trope that in photography, nature "depicts itself." If this analogy holds, then photography, as understood by analytic philosophers, might promise the kind of "decisive confrontation with technology" that Heidegger sought from authentic art. However, Costello argues that whether this promise pans out depends on the degree to which photographic artworks, like artworks in general, exhibit a distinctive kind of artistic character. So photography stages a decisive confrontation with technology only to the extent that it is, contra both Walton and Heidegger, mind-dependent.

The nature of photography and its media has been a theme of photographic art since its inception, but that theme has also been taken up in other arts, often with illuminating results. Many philosophers have come to photography through movies, and the role of photographs either as documents or parts of works of conceptual art is well known.[23] Two articles bring in comics and music.

The article by Richard Beaudoin and Andrew Kania is a collaboration between a composer and a philosopher who together consider the score of a composition by Beaudoin directly inspired by an 1835 photograph by Talbot. Beaudoin and Kania ask whether the score might be a musical photograph. Answering this question requires an analysis of what distinguishes photographs from other kinds of representations, but also a look at what distinguishes Beaudoin's score from a standard score, a recording, a spectrograph, and a transcription of a performance. The authors conclude that "Beaudoin's compositional process generates a new kind of musical object" that warrants extending the idea of photography into the realm of music.

According to Roy Cook in "Drawings of Photographs in Comics," some conventions of drawing photographs in comics challenge the conception of photography as objective on account of its mind-independence. Cook observes that in comics, photographs are standardly drawn in a more realistic style than is used elsewhere. This suggests that photographs have or are regarded as having objective purport of one kind or another. Yet Cook rejects this hypothesis since it conflicts with the more compelling principle that, as a rule, comic fictions accurately depict fictional objects and states of affairs. Instead, he proposes an alternative hypothesis, that the apparent realism of drawings of photographs in comics is a stylistic device that serves to distinguish how fictional characters would appear in the actual world from how they appear in the world of the fiction.

The philosophy of photography has characteristically linked the aesthetic and artistic features of photographs to their epistemic features. The linkage is pivotal to Scruton's attack on the possibility of an art of photography, which assumes that photographs simply record the appearance of photographed scenes. Yet photography's alleged aesthetic liability has been taken to be an epistemic virtue, and Savedoff argues that the epistemic advantage of photographs has been the main factor in their aesthetic appeal. In her view, photographs "'document' an unfamiliar world that is at the same time our world, transformed."[24] The dialectic linking matters of epistemology and aesthetics is not mandatory, however. Photographic art practices like those of Wall and Demand do not always seek to document a familiar world transformed, and many photographs are made without concern for their aesthetic impact; so it may be wise to set aside questions of aesthetics while getting an independent fix on the epistemology of photography.

Scott Walden's "Photography and Knowledge" addresses a recent proposal by Jonathan Cohen and Aaron Meskin.[25] Cohen and Meskin have two aims. The first is to provide an analysis of the epistemic advantage that can accrue to an image, recognizing that some photographs do not have that advantage, yet some drawings have it. The second is to explain how we come to recognize when an image of one kind or another has the advantage in question. Walden objects to what Cohen and Meskin have to say on both scores and then offers an account of the epistemic advantage of

photographs as grounded in their mechanical origins, which secures their objectivity—that is, their independence of the image maker's cognition. This is not, of course, a new idea, but Walden works out the details in a way that sidesteps problems with earlier formulations.

A time-traveling Albrecht Dürer landing in the first decade of this century would be surprised not only by the magic of photography but by the vast panoply of imaging technologies, from flow charts and axonometric engineering drawings to scanning electron micrographs. In "Depiction, Detection, and the Epistemic Value of Photography," Laura Perini follows Maynard in distinguishing the depictive function of images from their detective function, which is subserved by their carrying information about states of affairs, perhaps without depicting those states of affairs. Perini presents three case studies from biological science to illustrate some tactics for extracting data from images in aid of detection, without reliance on depiction. She concludes that photography is indeed a special case wherein detection is served by depiction.

The blurring of the boundaries of photography through recent changes in technology and in the use of that technology in photographic art, in the arts more generally, and outside the arts altogether is a golden opportunity to revisit, whether to discard or to fortify, some widespread assumptions about photography. Achieving a better understanding of the media of photography matters, as photography makes high-quality images more "takeable"—never mind reproducible—now than in any previous age. The thirteen essays that make up this issue pause to reexamine some classic philosophical thinking about photography and to initiate some new lines of thought.[26]

DIARMUID COSTELLO
Department of Philosophy
University of Warwick
Coventry CV4 7AL, UK

INTERNET: d.costello@warwick.ac.uk

DOMINIC MCIVER LOPES
Department of Philosophy
University of British Columbia
Vancouver, BC V6T 1Z4, Canada

INTERNET: dom.lopes@ubc.ca

1. Barbara Savedoff, *Transforming Images: How Photography Complicates the Picture* (Cornell University Press, 2000), p. 185.

2. Clement Greenberg, "Modernist Painting," in *The Collected Essays and Criticism*, vol. 4 (University of Chicago Press, 1993), p. 86.

3. John Szarkowski, *The Photographer's Eye* (New York: Museum of Modern Art, 1966).

4. For example, C. S. Peirce, "The Icon, Index, and Symbol," in *The Collected Papers of Charles Sanders Peirce*, vol. 2, ed. Charles Hawthorne and Paul Weiss (Harvard University Press, 1932); Walter Benjamin, "A Small History of Photography," in *Walter Benjamin: Selected Writings*, vol. 2, ed. Howard Eiland, Michael Jennings, and Gary Smith (Harvard University Press, 1999), and "The Work of Art in the Age of Its Technical Reproducibility," in *Walter Benjamin: Selected Writings*, vol. 4 (Harvard University Press, 2003); and Roland Barthes, *Camera Lucida*, trans. Richard Howard (London: Fontana, 1984). See *Photography Theory*, ed. James Elkins (London: Routledge, 2007) for an overview.

5. For example, Savedoff, *Transforming Images*, pp. 185–186.

6. William J. Mitchell, *The Reconfigured Eye: Visual Truth in the Post-Photographic Era* (MIT Press, 1994), p. 4.

7. See Diarmuid Costello and Dawn M. Phillips, "Automatism, Causality and Realism: Foundational Problems in the Philosophy of Photography," *Philosophy Compass* 4 (2009): 1–21.

8. André Bazin, "The Ontology of the Photographic Image," in *What Is Cinema?* vol. 1, trans. Hugh Gray (University of California Press, 1967), pp. 9–16.

9. For example, Noël Carroll, *Philosophical Problems of Classical Film Theory* (Princeton University Press, 1988), pp. 93–171.

10. Stanley Cavell, *The World Viewed: Reflections on the Ontology of Film*, Enlarged ed. (Harvard University Press, 1979), p. 23.

11. Bazin, "The Ontology of the Photographic Image," p. 13.

12. Roger Scruton, "Photography and Representation," *Critical Inquiry* 7 (1981): 577–603.

13. Kendall Walton, "Transparent Pictures: On the Nature of Photographic Realism," *Critical Inquiry* 11 (1984): 246–277.

14. For example, Gregory Currie, *Image and Mind: Film, Philosophy and Cognitive Science* (Cambridge University Press, 1995).

15. Patrick Maynard, *The Engine of Visualization: Thinking Through Photography* (Cornell University Press, 2000).

16. For example, Dominic McIver Lopes, "The Aesthetics of Photographic Transparency," *Mind* 112 (2003): 432–448; and Berys Gaut, *A Philosophy of Cinematic Art* (Cambridge University Press, 2010), pp. 21–50.

17. See David Davies, *Art as Performance* (Oxford: Blackwell, 2004), pp. 16–24.

18. Classic expositions are Richard Wollheim, *Art and Its Objects*, 2nd ed. (Cambridge University Press, 1980) and Jerrold Levinson, "What Is a Musical Work?" *Journal of Philosophy* 77 (1980): 5–28.

19. Maynard, *The Engine of Visualization*, pp. 57–58.

20. Not all digital images are pixilated: vector drawings are not. A systematic treatment is Dominic McIver Lopes, *A Philosophy of Computer Art* (London: Routledge, 2009), pp. 1–19.

21. Nelson Goodman, *Languages of Art*, 2nd ed. (Indianapolis: Hackett, 1976), pp. 127–175.

22. For example, Nigel Warburton, "Individual Style in Photographic Art," *The British Journal of Aesthetics* 36 (1996): 389–397.

23. For example, Scruton, "Photography and Representation," and Gaut, *A Philosophy of Cinematic Art*.

24. Savedoff, *Transforming Images*, p. 128.

25. Jonathan Cohen and Aaron Meskin, "On the Epistemic Value of Photographs," *The Journal of Aesthetics and Art Criticism* 62 (2004): 197–210.

26. We are grateful to Susan Feagin for her sound guidance in bringing this issue to press, to the *Journal*'s editorial board for helpful suggestions, and to the authors who have contributed their ideas and energy to this project.

PETER ALWARD

Transparent Representation: Photography
and the Art of Casting

Roger Scruton, in his essay "Photography and Representation," notoriously argued that photography is not a representational art form.[1] Not only did he argue that one cannot have a genuine aesthetic interest in the representational natures, broadly understood, of photographs, but he also argued that in a narrower and more important sense, photographs are not even representations at all. Although in much of the literature on this issue, the former claim has been contested, the latter claim has been largely ignored.[2] And on the few occasions it is addressed, it is simply conceded that photographs are not, in Scruton's sense, representations.[3]

In my view, however, contra Scruton's critics, if photographs are not representations, then one cannot have a genuine aesthetic interest in their representational natures (however broadly construed). As a result, any attempt to defend an aesthetic interest in the representational natures of photographs that ignores or concedes Scruton's claim vis-à-vis their status as representations is doomed to failure. Nevertheless, contra Scruton, photographs are (or can be) representations in his sense. Hence, the status of photography as a representational art form is secure.

This article consists of four parts. First, I offer a reconstruction of Scruton's argument. Second, I present a number of responses to Scruton's argument that ignore or concede the claim that photographs are not representations and explain why they are inadequate. Third, I argue contra Scruton that photographs are representations. And finally, I consider a number of potential responses to my argument.

I. THE ARGUMENT

Strictly speaking, the target of Scruton's argument is not photography per se, but rather what he calls "ideal photography."[4] Ideal photography is characterized by a nonintentional causal relationship between the photograph and the photographic subject, a relationship that entails both that the subject exists and is (or was) as it appears in the photograph. A photograph departs from this ideal when it is the product of an attempt "to pollute the ideal of [the] craft with the aims and methods of painting."[5] This includes such things as altering the photographic plate—"[the photographer] can proceed to paint things out or in, to touch up, alter or *pasticher* as he pleases"—photo-montage, and, presumably, photoshopped images.[6]

Scruton can be fruitfully understood to be offering two distinct arguments for the conclusion that photography is not a representational art form: the master "representation" argument and the subsidiary "style" or "detail" argument.[7] I will consider each in turn. Scruton's master argument relies on two distinct and independent premises, each of which requires some comment:

(M1) Ideal photographs are not representations.

(M2) If ideal photographs are not representations, there cannot be a genuine aesthetic interest in their representational natures.

(C) There cannot be a genuine aesthetic interest in the representational natures of ideal photographs.

One might, of course, think that the conclusion of the master argument more or less trivially

follows from (M1). After all, if photographs are not representations, then they do not have any representational natures for there to be any kind of interest in. In order to understand (M2) to make a substantive claim, as I think we must, a distinction will have to be drawn between a broader and narrower sense of representation. This will be taken up in more detail below.

Let us consider, first, (M1). A picture is a representation, in Scruton's sense, just in case it stands in a certain sort of intentional relation to a subject. In particular, it has to express a thought about the subject—"a thought embodied in perceptual form"—and thereby offer an interpretation of reality, rather than a "presentation of how something looked."[8] Moreover, pictures that are representations are fictionally competent: the represented subject need not exist, and even if it does, it need not appear as represented by the picture. Scruton takes paintings to be the paradigmatic examples of pictorial representations.

Scruton argues, however, that ideal photographs are not representations in this sense. Because an ideal photograph stands in a causal, rather than an intentional, relation to the photographic subject, it is not fictionally competent: the subject must exist and be as it appears in the photograph (at least at the time the photograph was taken). And even if the photographer intends to express a thought about the subject, "it is neither necessary nor even possible that the photographer's intention should enter as a serious factor in determining how the picture is seen."[9] There are, of course, cases in which we might be tempted to characterize a photograph as a work of fiction, as when someone "take[s] a photograph of a draped nude and call[s] it *Venus*."[10] But such cases involve photographs of representations—photographs of subjects that independently represent various things—rather than photographic representations per se. As Scruton puts it, "the representational act, the act which embodies the representational thought, is completed before the photograph is ever taken."[11]

Let us turn now to (M2). Scruton offers three distinct reasons that one might have for an aesthetic interest in a picture. First, one might have an interest in the formal properties of the picture, appreciating it merely as a pattern of lines and colors. Second, one might have an interest in the subject of the picture and, hence, an interest in the picture in a derivative sense as means of perceiving or otherwise accessing the properties of the subject. And finally, one might have an interest in the picture qua picture: an interest in the representational nature of the picture, but for its own sake and not for the sake of the represented subject. And not only does Scruton claim that the latter interest "forms the core of the aesthetic experience of pictorial art," but he also claims it is required of representational art: "[only] if there is such a thing as aesthetic interest which has representation as its object can there be representational art."[12] Note: having a representational nature does not presuppose that a picture is a representation in Scruton's narrow sense; it only requires that there be a pictorial subject—something the picture is a picture of.

Now Scruton's thesis that one can have an aesthetic interest in a picture qua picture only if it is a representation rests on the assumption that a properly aesthetic appreciation of something is indifferent to truth. Just as the existence of Odysseus and occurrence of the events described in the *Odyssey* are irrelevant to an aesthetic appreciation of it as a literary work, a correspondence between a picture and the world is irrelevant to an aesthetic appreciation of the picture.[13] Instead (of truth), what is of aesthetic interest is the thought expressed by the picture and how that thought is embodied in pictorial form—how by depicting a feature of the pictorial subject in a certain way, a thought about that subject is expressed.[14] Since ideal photographs and other nonrepresentational pictures do not express thoughts—offering instead of an interpretation of reality merely a presentation of it—one cannot have an aesthetic interest in their representational natures, but rather only in their subjects (and formal properties).

Although not the central topic of this article, it is worth saying a few words about Scruton's subsidiary detail or style argument at this point.[15] Like the master argument, it can be formulated, as follows, in terms of two premises and a conclusion:

(S1) If the representational natures of ideal photographs were of aesthetic interest, then ideal photographers would have (sufficient) control over detail (to have a photographic style).

(S2) Ideal photographers lack (sufficient) control over detail (for photographic style).

(C) The representational natures of ideal photographs are not of aesthetic interest.

There are a couple of comments worth making at this point. First, by "detail," Scruton means the observable features of a picture. And second, the counterfactual formulation of (S1) should be noted.[16] Since, according to Scruton, ideal photographs are not representations, the material condition,

If the representational natures of ideal photographs *are* of aesthetic interest, then ideal photographers *do* have (sufficient) control over detail,

is, again in Scruton's view, trivially true. The counterfactual claim is, nevertheless, substantive.

II. THE REPLIES

Most commentators on Scruton's paper have focused on the detail or style argument.[17] In particular, while apparently conceding (S1), these commentators have typically taken issue with (S2), arguing that photographers do have significant amounts of control over the observable features of their photographs. The kind of control they exercise can be subdivided into three categories: they can control a photograph's surface and formal properties; they can influence—via focal length, exposure, and the like—which features of the photographic subject appear most clearly in the photograph; and they can exercise choice, not merely over the photographic subject and the point of view from which it is photographed, but also over which of the numerous images they record to print and display. Note: this latter form of choice will play an important role in what follows.

Scruton's basic line on such suggestions is that they either yield insufficient control for there to be any kind of photographic style or involve a departure from the photographic ideal to a form of painting bound by "largely unnecessary constraints."[18] It is, however, a difficult matter to adjudicate this particular dispute without an account of how much control of detail is sufficient for photographic style and how various kinds of control facilitate it, as well as an account of what sort of techniques, deployed to what degree, result in the abandonment of photography in favor of (unnecessarily constrained) painting. But, as Lopes argues, even if the proposed techniques, individually or in unison, yield adequate control of detail without abandoning the photographic ideal, this does not suffice to establish that there can be a genuine aesthetic interest in the representational natures of ideal photographs.[19] After all, that photographers exercise sufficient control over their images for them to have a photographic style is compatible with Scruton's thesis that one can have a genuine aesthetic interest only in the formal features of a photograph or the photographic subject rather than the photograph's representational nature.

Lopes, in my view rightly, focuses his critical attention on Scruton's master argument. But, as I shall argue, he erroneously concedes Scruton's (M1)—that ideal photographs are not representations—while rejecting (M2), claiming instead that one can have an aesthetic interest in photographs qua photographs even though they are not representations.[20] In this section, I argue, contra Lopes, that Scruton's (M2) is accurate or, more modestly, at least that Lopes has not shown otherwise. And in the next section, I argue, contra Scruton and Lopes, that ideal photographs can be representations. It is worth noting that Lopes assumes photographic transparency—that by means of looking at a photograph, one literally sees the photographic subject.[21] More precisely, seeing a photographic subject through a photograph is a kind of indirect seeing, akin to mirror seeing, which is, of course, distinct in important ways from direct or face-to-face seeing; nevertheless, both seeing through and face-to-face seeing are species of generic seeing. Photographic transparency is a somewhat stronger thesis than Scruton's claim of a nonintentional causal (and resemblance) relation between photographs and their subjects, although Scruton does at times flirt with the stronger claim: "[in] some sense, looking at a photograph is a substitute for looking at the thing itself."[22] For present purposes, I simply concede that photographs are transparent in this sense.

Now Lopes argues that since photographs are transparent, a proper interest in seeing a photograph as a photograph is "necessarily identical to" an interest in seeing the photographic subject through the photograph. As a result, all that is required to reject Scruton's (M2) is to show that one can have an aesthetic interest in seeing an object through a photograph that cannot be satisfied by seeing the same object face-to-face.[23] To this end, Lopes draws five distinctions between seeing through and face-to-face seeing: photographs capture their objects fixed at moments of time;

seeing through (normally) occurs in the absence of the seen object; seeing through alters the context that the object is normally seen to inhabit; an object seen through a photograph is always in front of a camera that may alter or affect its properties; and seeing through a photograph, unlike face-to-face seeing, is twofold in the sense that one's experience consists both of seeing the photographic subject and seeing the photograph.[24] And Lopes argues that photographic seeing through can have two sorts of aesthetic properties in virtue of possessing these features. First, it promotes visual clarity—enabling viewers to see features of objects difficult to discern face-to-face. And second, it can yield revelatory, transformative, and defamiliarizing seeing by showing properties objects could not be seen to have face-to-face. [25]

Before addressing what I take to be the central difficulty of Lopes's argument, there are a couple of concerns worth mentioning about the manner in which he draws the distinction between seeing through and seeing face-to-face. First, certain photographic techniques, such as pinhole photography, involve exposures as long as eight hours or more. As a result, contra Lopes, such photographs at least do not capture objects fixed at moments in time, but rather only record those features which endure through long periods of time; hence, they promote no greater visual clarity than can be achieved face-to-face. And second, just as an object seen through a photograph is always in front of a camera that can affect its properties, an object seen face-to-face is always in front of a person, which too can affect its properties. Consider, for example, seeing the look on someone's face when he or she realizes who you are.[26] As a result, face-to-face seeing can sometimes yield revelatory, transformative, and defamiliarizing seeing in more or less the same sense as seeing through can.

The central difficulty with Lopes's argument is that it fails to establish that one can (properly) have an aesthetic interest in a photograph as a photograph that is not wholly derivative upon an aesthetic interest in the photographic subject. Lopes does, of course, explicitly deny this: "[this] is not an interest limited to the scene itself; it is an interest in the scene as it is seen through the photograph."[27] But in my view, this is due to his erroneous identification of having an aesthetic interest in the photographic subject with having an aesthetic interest in seeing the photographic sub-

ject face-to-face. Even if Lopes is right that one could have an aesthetic interest in seeing an object through a photograph that could not be satisfied by seeing it face-to-face, this is compatible with an aesthetic interest in both kinds of seeing being wholly derivative of an aesthetic interest in the seen object.

What is important to note is that our primary interests—aesthetic or otherwise—are not in objects per se, but in the properties that they have at various times and under certain conditions. Despite the incumbent metaphysical baggage, one might aptly formulate the point using the idiom of appearances: an object is of aesthetic interest only because certain of its appearances are. Some properties or appearances can be discerned only by using particular techniques at particular times and places; others can be discerned using a variety of techniques in a wide range of spatiotemporal contexts. Lopes's central claim is, at bottom, that certain properties of objects can be discerned only by means of photographic seeing through. But, as noted above, the same is true of other techniques: just as an instantaneous look on the face of someone posing for a camera can be discerned only via photographic seeing through, the look on someone's face when he or she recognizes who I am can be discerned only via face-to-face seeing. Moreover—and this is the key point—there is a distinction between having an aesthetic interest in photographic seeing through—or any technique of property discernment—for its own sake and having an interest in it as a means—or even the only means—of discerning the properties of an object in which one has an aesthetic interest. In order to undermine Scruton's (M2), Lopes would have to establish the former; but, in fact, he has established only the latter. The reason we have an interest in an object as seen through a photograph (when we do)—which is not simply an interest in the object per se and cannot be satisfied by experiencing it in some other way—is because that is the only means of discerning the properties of the object in which we are (primarily) interested.

III. THE CASTING DIRECTOR

Rather than attacking (M2), my strategy here is to grant it and attack (M1) instead by arguing that photographs are (or can be) representations in Scruton's sense. Lopes has argued that this

requires rejecting the transparency thesis: "[deny-ing] the conclusion of the core argument, that pho-tographs do not represent, means denying that photographs are transparent."[28] In my view, how-ever, Lopes is simply wrong on this point; repre-sentation is, in fact, compatible with transparency. As a result, although I am officially neutral about photographic seeing through, I simply concede it for present purposes and argue that photographs nevertheless can be representations.

A background presupposition of the argument on offer here is a distinction between what might be called the pictorial object and the pictorial sub-ject, that is, what a picture is of and what it is about.[29] The object of a picture is something that plays the requisite kind of causal role in its pro-duction. The object of a photograph is whoever or whatever the camera was pointed at and focused on when the picture was taken. And the object of a painting is the model the artist used when he or she produced it. The subject of a picture, in contrast, is the entity that the picture represents or expresses a thought (or thoughts) about; as such, it is a function or product of what the picture means or how it is correctly interpreted, rather than the causal process by which it was produced. There are, of course, various accounts of interpretation. Intentionalists of various kinds, for example, take the meaning—and hence the subject—of an art-work to be the product of the artist's (actual or hypothetical) intentions.[30] Anti-intentionalists, in contrast, take it to be wholly a function of features of the art object itself and features of the (gen-eral and specific) art-historical context in which it was produced.[31] And constructivists take it to be generated by the process of interpretation itself.[32] But whatever the correct account of interpreta-tion, there seems to be no reason to suppose that, in general, the pictorial object and the pictorial subject have to coincide.

Nevertheless, Scruton's argument seems to pre-suppose that photographs either lack pictorial subjects or the photographic subject and the pho-tographic object must coincide. Although he does not explicitly address the point, Scruton's reason-ing presumably goes something as follows: first, unlike paintings, photographs necessarily have ob-jects; and second, again unlike paintings, pho-tographs—or perhaps better, what observers see in photographs—are necessarily caused by and re-semble their objects. Moreover, if, as Lopes would have it, photographs are transparent, then when one looks at a photograph, one literally sees its object. The challenge, then, is to show how, given these (putative) facts about photographic objects, photographs can both have subjects and photo-graphic subjects and objects can diverge.

To meet this challenge, a distinction needs to be drawn between two methods of producing repre-sentations: creating and casting. Creation involves making something new by means of combining or modifying various kinds of raw materials. Repre-sentations produced in this way include paintings as well as various forms of traditional sculpture. What is important about such representations is that, within the constraints set by the medium and artistic ability, their features are fully within the artist's control. As a result, how the subject is rep-resented is largely within her control as well. And it is the corresponding lack of control over the ap-pearance of photographs—and, hence, over how the photographic subject is represented—I take it, that leads Scruton to deny the existence of pho-tographic subjects or identify them with photo-graphic objects.

But this is to overlook the possibility of rep-resentation by casting. Rather than making some-thing new, casting involves choosing from among a collection of preexisting objects. Examples of what I have in mind include such things as (unmodified) found art and low-budget set design, but I want to focus here on casting actors for movie and theatri-cal roles. The casting director chooses from among various groups of actors, not all of whom need have applied for the job, a number of individuals to portray the characters in a play or movie. Now, of course, theatrical and cinematic representation involves such things as makeup, costume, and act-ing, in addition to being cast in a role. Neverthe-less, there could be a pure art of casting wherein a person comes to represent a character by the cast-ing director's fiat alone. What is important, how-ever, is that given a large (and diverse) enough collection of actors to choose among, the cast-ing director can have as much control over how the character (or subject) is represented as does a painter or sculptor. Moreover, not only is casting fictionally competent—actors are often cast in the roles of fictional characters—but even when the subject is a real person, she can be represented as being other than she in fact is simply by cast-ing an actor whose properties differ from those of the subject. As a result, there is no reason to resist the suggestion that casting can be representational

and, hence, that one's casting choices can embody thoughts about the subjects thereby represented.

What I want to argue here is that photographs can become representations in Scruton's sense via a process of representational casting. Photographic artists normally record large numbers of images from which they choose a small subset to print and display. As a result, they are capable of exerting a high degree of control over the appearance of the photographs that they use to represent various photographic subjects. Just as "a particular way of painting [a pictorial subject's] gesture...[can be] revelatory of the subject's character," choosing a photograph whose object makes a certain gesture can be revelatory of the photographic subject's character (where, as above, the photographic subject is discerned or fixed via a process of interpretation).[33] And since, given this degree of control over the appearance of displayed photographs, there is no reason to deny that photographs are fictionally competent or capable of representing their subjects other than they in fact are, they can be representations in Scruton's sense. In fact, photography can be fruitfully understood as an art of representational casting.

IV. TRANSPARENT REPRESENTATION

Scruton's response to the kind of maneuver on offer here is to claim that in the kinds of cases that I have in mind, it is not the photograph that represents the subject, but rather the photographic object: "Of course I may take a photograph of a draped nude and call it *Venus*, but insofar as this can be understood as an exercise in fiction, it should not be thought of as a photographic representation of Venus but rather as a photograph of a representation of Venus."[34] Scruton's idea is that the object acquires its status as a representation before the photograph is taken—either because of the intentions or, more broadly, the intentional states of the photographer or because the object was independently a representation, a prop or an actor in a stage play, for example.

There are, however, a couple of reasons to balk at Scruton's argument. First, by parity of reasoning, this would entail that paintings that are produced using models are pictures of representations rather than pictorial representations proper, a result that Scruton would not find very congenial. After all, there is little reason to believe that a painter's representational thoughts about her model differ significantly from—or occur later than—a photographer's similar thoughts about the object of his photographs. And to any attempt to distinguish between model-based painting and photography by appeal to the putatively greater degree of control painters have over the appearances of their pictures, I reiterate that given a large and diverse enough collection of images to choose from, photographers have a similar degree of control over the appearances of the pictures they display. Second, there is no reason to suppose that, in general, photographers perform their representational acts prior to taking their photographs. In particular, the decisions both to use members of a collection of images as part of a photographic exhibition and how to so use them can be and often are made well after the photographs have been taken.

Scruton does explicitly consider the latter objection: "suppose [the photographer] were to take a photograph of a drunken tramp and label it *Silenus*."[35] But he rejects it on the basis of an analogy he draws between performing a photographic representational act subsequent to taking the photograph and performing a representational act while gesturing at the same photographic object. Scruton acknowledges that by means of some such gesture, one might turn the object into a representation, but he denies that the gesturing finger could itself be a representation: "[to] accept that conclusion is to fail to distinguish between what is accidental and what is essential in the expression of a representational thought."[36] And the reason that the gesture is inessential is that it is merely one of many devices of ostension: "[the] act of ostension might on some other occasion be accomplished by a camera (or a frame, or a mirror, or any other device which isolates what it shows)."[37] Similarly, the camera, in the case at hand, is merely a device of ostension, and hence a photograph taken with it is not a representation in its own right.

There are a number of reasons to balk at Scruton's argument here, however. First, rather than being based on hypothetical—or, as Scruton would have it, "dubious"—examples, the suggestion that photographers can perform their representational acts only after the photographs that they exhibit have been taken is grounded in genuine

photographic practice. Consider, for example, appropriation artists, such as Sherrie Levine and Richard Prince, whose (often controversial) exhibitions consist of photographs originally taken by other people.[38] Second, the analogy Scruton draws between a camera and a gesturing finger is dubious. Cameras, unlike fingers, are not devices of ostension—they are used to record images of objects, not to point at them. One might with equal justification claim that paintbrushes are devices of ostension used to point at painters' models. And third, even if cameras are sometimes devices of ostension, in the kinds of cases under consideration, the camera was not used to gesture at and confer representational status upon photographic objects; instead, any representational acts occurred only after the photographs were taken. As a result, rather than taking photographs to play an inessential role in the expression of representational thought by other objects—as records of the acts by means of which the latter object acquired their representational status—they are better characterized as representations in their own right, distinct from their objects. Moreover, their status as representations is independent of that of their objects: they can be representations even if their objects are not.

At this point, however, someone might rejoin that this latter possibility is incompatible with photographic transparency. If photographs are transparent, then to see photographs (as photographs) is to see their objects. As a result, insofar as one's experience leads one to grasp a representational thought, it is the photographic object that embodies or expresses this thought; hence, the object must be a representation if the photograph (qua photograph) is. Of course, this does not rule out grasping a representational thought while experiencing the photograph formally—as a pattern of lines and colors—which would not, of course, require that the photographic object be a representation. But insofar as our interest is in whether photographs qua photographs are representations, no such maneuver will prove satisfactory.

There are a number of strategies of which the advocate of transparent representation can avail herself here. First, even if transparency entails that the photographic object is a representation if the photograph is, the representational status of the photograph is in an important sense primary. The object is a representation because the pho-

tograph is, but not vice versa: the photograph is not a representation because it is of a representation. Moreover, the photographic object is properly experienced as a representation only when seen through the representing photograph; if seen face-to-face or through a different, nonrepresenting photograph, the object would not (normally) be properly so experienced.

Second, as Lopes notes, the experience of photographs as photographs involves a kind of dual vision in the sense that the observer sees both the photographic object and the photograph itself: "[photographic] seeing through is always simultaneous with plain vanilla seeing of a photograph."[39] As a result, as long as one of the two objects of sight—the photograph or the photographic object—is a representation, an experience of the photograph as a photograph can lead an observer to grasp a representational thought. Hence, there is still no reason to believe that photographs can be representations only if their objects are.

Moreover, third, seeing, like believing, is an intentional activity. To use a familiar fictional example, Lois Lane could believe that a photograph is of Superman without believing that the photographic object—Clark Kent—is Superman, at least not when seeing him face-to-face or through other photographs wearing glasses and a business suit. Similarly, when seeing a photograph as a representation—which, in my view, is one way of seeing it as a photograph—an observer can see the photograph as standing in some kind of aboutness relation to the photographic subject without seeing the photographic object standing in a corresponding identity relation to the subject. Let me elaborate. In the case of theatrical representation, seeing an actor (or prop) as a character (or the inanimate analogue thereof) involves imagining of the actor that she *is*, in what might be called the sense of theatrical identification, the character. Consider now the case of pictorial representation. It would, of course, be a mistake to imagine of the picture that it is, in any sense, the pictorial subject. Rather, what one imagines is that the picture is of the subject, that is, that the actual subject of the picture is the pictorial object. But what I want to emphasize is that this does not require imagining of the actual photographic object that it is, in some sense, identical to the photographic subject. Suppose, for example, that I was the object or model of a photograph whose

subject was Samwise Gamgee. To see this photograph as a representation would require imagining that the photographic object is Sam Gamgee; but this would not require imagining that I was Gamgee.[40] Of course, nothing prevents an observer from seeing the photographic object through a representational photograph (assuming, again, that photographs are, in fact, transparent). But this would be to fail to see the photograph as a representation—akin to seeing the goings-on onstage as the actions of actors rather than of the characters they portray—even if, I would argue, that in so doing, he imagined of the photographic object that it was the subject.

V. MISSING THE POINT?

One final worry: Scruton might rejoin here that I have missed the central point of his discussion. After all, what I have shown, at most, is that photographs can be used as representations in a relational sense, which he acknowledges: "I may use a photograph of Lenin as a representation of him, in the way that I might have used a clenched fist or a potato or a photograph of Hitler."[41] But what Scruton means to establish is that, unlike photographs, paintings are intrinsic representations: "[that] is why representation can be thought of as an intrinsic property of a painting and not just a property of some process of which the painting forms a part."[42] Just as a sentence of a language has a meaning that can be understood independently of its use in particular contexts of utterance, a painting has a meaning that "can be understood in isolation from the special circumstances of its creation."[43]

There are a couple of comments that I wish to make in response to this potential maneuver. First, even if Scruton is right that photographs are not intrinsic representations, they can still be representations per se—vehicles of representational thought. Even though the thought expressed cannot (normally) be grasped by investigating a photograph's intrinsic properties alone, it can often be easily grasped by considering such extrinsic features as the artist's statement, her body of work, and the art-historical context in which she exhibited it. Moreover, arguably, it is a work's context-dependent meaning that is of primary aesthetic interest anyhow; after all, to continue the analogy with language, the intrinsic

or context-independent meaning of a sentence is not what is of primary communicative interest, but rather the context-dependent thought expressed by it.

And second, how a painting represents its subject may be an intrinsic matter, but whether it represents—in the sense of having a pictorial subject at all—and what it represents are relational matters.[44] After all, not only can (what is seen in) a painting equally well resemble multiple entities, as Scruton emphasizes a painting need not even resemble its subject very closely at all. Hence, to discern what, if anything, a painting represents, one will have to look to extrinsic features like the artist's statement. Scruton might, of course, retreat to the view that the sense in which paintings are representations but in which photographs are not is that paintings can be in Walton's sense p-depictions without depicting$_q$ anything—that, for example, a painting can be a man-depiction without there being a particular man, actual or fictional, that it depicts.[45] But not only does this run counter to the tenor of Scruton's whole discussion—it is, after all, supposedly in part the fact that paintings can represent their subjects other than they in fact are that renders them vehicles of representational thought—but also, as long as we do not simply identify the photographic subject with the photographic object, there is no reason to think the same is not true of photographs.

PETER ALWARD
Department of Philosophy
University of Lethbridge
Lethbridge, Alberta, Canada T1K 3M4

INTERNET: peter.alward@uleth.ca

1. Roger Scruton, "Photography and Representation," *Critical Inquiry* 7 (1981): 577–603.

2. On the former claim, see, for example, Nigel Warburton, "Individual Style in Photographic Art," *The British Journal of Aesthetics* 36 (1996): 389–397; Berys Gaut, "Cinematic Art," *The Journal of Aesthetics and Art Criticism* 60 (2002): 299–312; and Dominic McIver Lopes, "The Aesthetics of Photographic Transparency," *Mind* 112 (2003): 433–448. For an exception to the latter claim's being ignored, see Gregory Currie, *Image and Mind: Film, Philosophy, and Cognitive Science* (Cambridge University Press, 1995).

3. Lopes, "The Aesthetics of Photographic Transparency," p. 441.

4. Scruton, "Photography and Representation," p. 578.

5. Scruton, "Photography and Representation," p. 578.

6. Scruton, "Photography and Representation," p. 593.

7. Although reminiscent of the distinction Lopes, in "The Aesthetics of Photographic Transparency," draws between the "object" and "style" arguments, my reconstruction is importantly different from Lopes's. In particular, according to Lopes, "The Aesthetics of Photographic Transparency," p. 435, the two arguments "build upon" a core argument. In my view, in contrast, Lopes's core and object arguments actually together make up Scruton's master argument. It is worth noting that David Davies, in his "Scruton on the Inscrutability of Photographs," *The British Journal of Aesthetics* 49 (2009): 341–355, resists this whole approach to reconstructing Scruton's argument.

8. Scruton, "Photography and Representation," pp. 581, 588.

9. Scruton, "Photography and Representation," p. 588.

10. Scruton, "Photography and Representation," p. 588.

11. Scruton, "Photography and Representation," p. 588.

12. Scruton, "Photography and Representation," pp. 586, 585.

13. Scruton, "Photography and Representation," p. 585.

14. Scruton, "Photography and Representation," p. 586.

15. Scruton, "Photography and Representation," pp. 592ff.

16. Scruton, "Photography and Representation," p. 592.

17. R. A. Sharpe, *Contemporary Aesthetics* (Brighton: Harvester, 1983); Robert Wicks, "Photography as a Representational Art," *The British Journal of Aesthetics* 29 (1989): 1–9; William King, "Scruton and the Reasons for Looking at Photographs," *The British Journal of Aesthetics* 32 (1992): 258–265; Warburton, "Individual Style in Photographic Art"; and Gaut, "Cinematic Art."

18. Scruton, "Photography and Representation," p. 594.

19. Lopes, "The Aesthetics of Photographic Transparency," pp. 437–438.

20. It is worth emphasizing that Lopes denies that transparent pictures represent only in Scruton's narrow sense.

21. Lopes, "The Aesthetics of Photographic Transparency," p. 438ff.

22. Scruton, "Photography and Representation," p. 588.

23. Lopes, "The Aesthetics of Photographic Transparency," p. 440.

24. Lopes, "The Aesthetics of Photographic Transparency," pp. 442–443.

25. Lopes, "The Aesthetics of Photographic Transparency," p. 444–445.

26. I have in mind here a case in which a disguised wronged party who has been secretly plotting revenge reveals herself to her victimizer once her schemes have been successful.

27. Lopes, "The Aesthetics of Photographic Transparency," p. 445.

28. Lopes, "The Aesthetics of Photographic Transparency," p. 441.

29. A similar distinction can be found in Patrick Maynard, *The Engine of Visualization* (Cornell University Press, 1997) and Dawn Phillips, "Photography and Causation: Responding to Scruton's Scepticism," *The British Journal of Aesthetics* 49 (2009): 327–340.

30. See, for example, Jerrold Levinson, "Intention in Interpretation and Literature," in *The Pleasures of Aesthetics: Philosophical Essays* (Cornell University Press, 1996), pp. 175–213.

31. See, for example, Monroe C. Beardsley, "Intentions and Interpretations: A Fallacy Revived," in *The Aesthetic Point of View: Selected Essays*, ed. M. J. Wreen and D. M. Callen (Cornell University Press, 1982), pp. 188–207.

32. See Robert Stecker, "The Constructivist's Dilemma," *The Journal of Aesthetics and Art Criticism* 55 (1997): 43–52 for a nice discussion of views of this kind.

33. Scruton, "Photography and Representation," p. 586.

34. Scruton, "Photography and Representation," p. 588.

35. Scruton, "Photography and Representation," p. 589.

36. Scruton, "Photography and Representation," p. 589.

37. Scruton, "Photography and Representation," p. 589.

38. Levine's exhibition, After Walker Evans, which consisted of rephotographed Walker Evans photographs, is a well-known example.

39. Lopes, "The Aesthetics of Photographic Transparency," p. 443.

40. Kendall L. Walton, "Transparent Pictures: On the Nature of Photographic Realism," *Critical Inquiry* 11 (1984): 246–277, at p. 254, argues that when one indirectly sees the photographic object through a photograph, it is fictional that she sees the object directly, in the sense that she imagines *de se* so doing. Supposing Walton to be correct on the general point, the view on offer here is that while appreciating photographic fiction might require imagining *de se* seeing the photographic subject directly, this need not consist in imagining *de se* seeing the photographic object directly while imagining *de re* of the photographic object that it is the subject.

41. Scruton, "Photography and Representation," p. 597.

42. Scruton, "Photography and Representation," p. 590.

43. Scruton, "Photography and Representation," p. 597.

44. And it is worth noting that Scruton acknowledges ("Photography and Representation," p. 580) that there is an interplay between what is represented and how it is experienced.

45. Kendall L. Walton, "Are Representations Symbols?" *The Monist* 58 (1974): 236–254.

Fiction, Nonfiction, and Deceptive Photographic Representation

The relation between the photographic image and reality has arguably been the major concern of the vast bulk of the literature on photography (philosophical or otherwise) since the invention of the medium. This is understandable given that the very nature of photography has frequently been conceived of as "never less than the registering of an emanation, a material vestige of its subject."[1] This intimate link between the image and "the real" has undoubtedly influenced the function photographs perform in our societies: as snapshots, photographs are records, accurate public memories of our family and social life; as legal or journalistic documents, they are reliable evidence of an event, playing the part of a public eye. However, more than a century and a half after the advent of photography, the functions, uses, and possibilities of the medium have diversified, and sometimes, *pace* the recommendations of the modernists, the search for realism or its exploitation has been completely abandoned. These nonrealistic uses of photography have been well documented and studied by art historians and scholars from other disciplines.[2] But they have received scarce attention from philosophers, many of whom still demonstrate a degree of skepticism about the possibility of nonrealistic photographs in general and fictional ones in particular.

In this article, I explore some issues regarding the fictional capacity of photographs and their classification as fiction or nonfiction. In particular, I address the debate on the purported "fictional incompetence" of photography, whether photographs can or cannot represent ficta. In this debate, I side with theorists who defend the view that photographs can indeed represent fictive entities or ficta, but I offer an alternative argument: I claim that photographs can indeed represent ficta *by photographic means*, something that most theorists have denied. Then I consider some possible objections to my view and try to offer responses. Finally, I question whether representing fictive entities or events is all that is needed for a photograph to be fictional. In this context, I suggest what I take to be the correct way to classify deceptive photographs.

I. THE DEBATE ON THE FICTIONAL INCOMPETENCE OF PHOTOGRAPHY

Photographs are frequently characterized in the philosophical literature as natural images. Photographs, like shadows and fossils, bear a causal relation to their content: what is seen in photographs depends causally, and counterfactually, on the object that was in front of the camera at the moment of the shot. Moreover, the content of a photograph is not essentially dependent on the photographer's intentions. Paintings and drawings are different in this regard, for what we see in a painting is entirely dependent on the mind of the painter. Photographs, unlike paintings, are therefore visual traces of the objects that were in front of the lens when the photograph was shot.[3]

From this characterization of photography, some theorists have concluded that the photographic content is constrained by the particular real object that gave rise to the image, and consequently, they claim, photography is fictionally incompetent. Here are two paradigmatic defenses of this view, which I will call the "fictional incompetence of photography" (FIP):

The relation between a photograph and its subject is a causal relation.... The photograph lacks that quality of "intentional existence," which is characteristic of painting. The ideal photograph, therefore, is incapable of representing anything unreal.[4]

With regard to the choice of subject matter, the photographer (unlike the painter, sculptor or poet) is limited to a particular real or existing object or state of affairs. It is usually said, as a consequence, that traditional photography is "fictionally incompetent," that is, it is a medium necessarily *incapable of representing a fictional character or state of affairs*.[5]

This view has been rejected by various authors. One line of defense has been to argue that there are modes of representation available to photography other than the physical portrayal of its source.[6] According to Gregory Currie, for instance, photographs characteristically represent a certain subject or event by registering the presence of the subject or event, the source, that once stood before the lens. This way of representing, Currie maintains, is the only one that is specifically photographic. Yet this does not prevent photographs from representing fictional events or entities by other means. It is possible, for instance, that a photograph of a real subject (the source of the photo) is *used* to represent another. So while photographs cannot represent fictions by source, *by origin*, or by strictly photographic means, Currie maintains, they certainly can do so *by use*.[7] Noël Carroll makes a similar argument with respect to cinematic works, claiming that there are various modes of representation in films. The shots of a photographic film will always physically portray the concrete particulars that caused the image, but this is by no means the only possible use of shots, nor is it necessarily the essential and most important one. The photographic shot also "*depicts* a member of a class describable by a general term." So a photograph of, say, Clark Gable also represents *a man*, and this second mode, in a relevant context, "opens up another possibility of cinematic representation" that is what Carroll calls the "nominal portrayal": "the nominal portrayal occurs when a shot represents a particular person, object or event different than its photographic provenance, due to its context as a result of factors like commentary, titles, an ongoing story or editing."[8] According to Carroll and Currie, then, a photograph or a cinematic shot that

physically portrays Charlie Chaplin, a real person, by source can also (nominally) represent Charlot, a fictional character, by use.

Certainly, Currie and Carroll agree, subjects differ in suitability when it comes to representation, even *by use*. As Carroll puts it, "it is hard to imagine how . . . a clean medium shot of Lenin [can] depict an ice cream soda."[9] However, there are certain effective ways of reducing what Currie calls "representational dissonance," that is, methods by which the viewer's attention can be directed away from the subject represented by source while making the object represented by use more salient. Given the right conditions, then, Carroll and Currie contend, photographs can represent fictional entities.

Now, although these arguments might be right and eventually convince us that the representation of fictional objects is indeed a possibility open to photography, it is not clear that they respond effectively to the challenge raised by those who endorse FIP.

If FIP were simply a question of whether or not photographs can represent fictional entities or events *simpliciter*, these arguments would surely be enough to appease the skeptic. However, advocates of FIP do not deny that photographs can *be used to* represent fictions in a sense similar to that suggested by Currie and Carroll:

Of course I may take a photograph of a draped nude and call it *Venus*, but insofar as this can be understood as an exercise in fiction, *it should not be thought of as a photographic representation of Venus but rather as the photograph of a representation of Venus*. In other words, the process of fictional representation occurs not in the photograph but in the subject: it is the *subject* which represents *Venus*; the photograph does no more than disseminate its visual character to other eyes.[10]

The charge against photography raised by FIP's advocates seems to be stronger: what they deny photography is the capacity to represent fictions *by photographic means*, that is, through the relevant causal relation of a source (a particular object) with the camera lens or the photosensitive surface. In this sense, Currie and Carroll's proposal does not offer a solution. In fact, even Currie agrees with FIP advocates that photographs cannot represent fictions by strictly photographic means.[11]

II. PHOTOGRAPHIC MEANS

Certainly, the charge that advocates of FIP raise against photography holds true in one trivial sense: no one, not even realists about fictional characters, would maintain that fictional entities reflect or emit light. So it is obviously true that there cannot be photographs of ficta in their limited way, for ficta cannot causally interact with a photosensitive material. Less obvious, however, is that their description exhausts all the possible photographic means by which photographs can represent ficta.

Now, in order to see what other photographic means there are available, we need to review our conception of the photographic process.

Standard philosophical accounts of photography have generally provided an oversimplified view of the photographic practice. By overemphasizing the distinctive capacity of photographs to record the pro-filmic scene without presupposing intentionality, theorists have often failed to account for how this record becomes an actual visual image. An alternative and perhaps more comprehensive account of photographic practice would need to account for the process between the moment light is impressed on the photosensitive material and the moment when the viewer experiences the photograph.

Developing such an account in detail is beyond the scope of this article. However, drawing partially on the work of Dawn Phillips, I aim to say enough about the photographic process to justify the claim that there is an alternative, broader conception of photographic means that allows for the photographic representation of ficta.[12]

Producing a photograph is a complex process that normally requires more than the exposure of photosensitive material to a particular scene reflecting light. Certainly, this event, which Phillips calls the "photographic event," is crucial: it is at this stage that the pattern of light is registered.[13] However, this by no means exhausts the whole process. In fact, as Phillips correctly indicates, at this point there is *not yet a visual image*; the impression of the pattern of light is still *latent*, that is, a further exposure to light or to another light-reflecting scene will change the current pattern or ultimately fog or saturate the photosensitive surface. The photosensitive material has to go through further processes to (1) turn the recorded information into one or many *patent* or actually visible images—let us call this "transduction"—and (2) fix or preserve the pattern created by the impression of light—let us call this "storing."[14] It is only when all these processes are completed that we can speak of the existence of a photograph. Phillips calls our attention to a couple of things worthy of note. First, the various processes taking place in the production of the photograph may vary a great deal. Consequently, the information recorded might result in a final photographic image whose appearance turns out to be very different from the appearance of the pro-filmic scene or object. Second, the fact that all processes involved in the production of a photograph can be mechanically or automatically performed does not mean that this is always the case. And we do not have reasons, in principle, to believe that if those actions are performed nonmechanically, the process ceases to be photographic.[15]

Now it seems to me that when authors talk about photographic means, they assume that the first stage of the photographic process is the only one that deserves to be called *strictly* photographic, since it is presumably at this stage that the relevant causal relation of a source (a particular object) with the camera lens or the photosensitive surface is instantiated. But why should we think this? FIP theorists have not given us any reason as to why this first stage, conceived of as they do, should set the boundaries of our conception of photographic means. As a matter of fact, one could argue that, if the description of the photographic process I developed above is correct, up to the first stage of the process there is not yet a visual image. So a relevant question, I think, is to ask why we should exclude, for instance, what happens in the darkroom as photographic means. After all, it is there (or then) that in many instances the latent image becomes the visual image we can appropriately call a photograph. Moreover, a great many of the processes taking place in the darkroom can be said to be specific to photography or strictly photographic.

Certainly not all actions performed in the darkroom exploit strictly *photo*graphic techniques, where *photo*graphic techniques means any action consisting solely in the exploitation, manipulation, or control of the incidence of light onto, and its interaction with, photosensitive material. Scratching or physically drawing on the film's surface, for instance, may not be strictly *photo*graphic processes, for they exploit means different from the

manipulation of light and its properties in order to create an image or parts of an image.[16] However, "drawing with light" using, say, a flashlight or a "light pencil" is indeed a *photo*graphic process.[17] Likewise, physically cropping some parts of an image with scissors may not count as a *photo*graphic technique, but using a template to selectively mask the relevant parts of the image will surely count.[18] Other methods that employ strictly *photo*graphic techniques could be selective over- and underexposure, combining negatives, burning or blurring parts of the image, manipulation of contrast, and the use of filters, various types of photosensitive papers, and developing liquids to vary the quality of the image. It seems to me perfectly reasonable to consider these techniques as photographic means, for after all, what they exploit is not any contingent aspect of photography, but its very essence: the action of light on photosensitive material. In view of this, we may want to consider an alternative notion of photographic means, which could be the following:

Photographic means: any action or technique performed or taking place during the production of an image, including the stages of transduction and storing, that consists solely in the exploitation, manipulation, or control of the incidence of light onto, and its interaction with, a photosensitive material.

Notice that I am not talking about digital manipulation, which, arguably, in some cases may not be considered strictly photographic because (1) it may be a case of postproduction and (2) it may alter the image by technical means different from the projection and recording of light. Yet, this is not the case with analog photography, where there is a long-standing tradition of editing and working on prints and negatives using strictly photographic methods while the photographic image is being produced.[19]

Now these photographic techniques mentioned above, which require a high degree of skill and knowledge about the photographic process, can be used either to make corrections for purposes of composition or for other creative (or deceptive) purposes such as representing ficta. Figure 1 is a photographic image that represents a hybrid creature, a *cat-woman*, we can call it, or the transformation of the photographer, Wanda Wultz, into a feline. The cat-woman, or Wanda Wultz's feline alter ego, clearly does not exist. Can we not say that

this photograph represents a fictional entity by photographic means? I think we can. After all, the cat-woman that we can see in the picture was created by using multiple-exposure techniques; that is, either by combining two negatives, one showing the face of a cat and the other the face of a woman, to produce one single image, or by exposing one single negative twice.[20]

If this is sound and there can be certain actions performed during the production of a photograph, other than those considered by FIP, that can count as strictly photographic, then we have an alternative way in which photographs can be said to represent fictional entities by photographic means.

III. OBJECTIONS AND ANSWERS

The skeptic might accept that the cat-woman image is fictionally competent. However, she may deny that it is a photograph, claiming instead that it should be classified as another pictorial type closer to, if not completely analogous with, painting or drawing. Scruton himself suggests this when he says that if a photographer proceeds "to paint things out or in, alter, or *pasticher* as he pleases . . . the photographer has now become a painter."[21]

The argument will then be the following: photographs are fictionally incompetent (FIP) and *Io Gatto* is fictionally competent, so *Io Gatto* is not a photograph. But this argument clearly begs the question. Photographs, the argument assumes, are fictionally incompetent and, if a picture is fictionally competent, then it is not a photograph. The conclusion is only true if we assume that FIP is true. Without any further reason for why we should take images such as *Io Gatto* as nonphotographic, this objection is not acceptable.

But, are there further reasons to think *Io Gatto* is indeed a photograph? I think there are. Let me briefly mention two.

The cat-woman image is consistent with the main claims traditionally made about the nature of photography. First, it is still a trace of the objects that produced it; it registers the presence of its sources.[22] Moreover, being aware of this fact is important for understanding the image. Even those in sympathy with the thesis that photographs are transparent can accept that one can still literally see the cat and the woman through the photograph.[23] Second, in order to produce the picture, the photographer was constrained by a particular real or existing object or state of affairs in a way

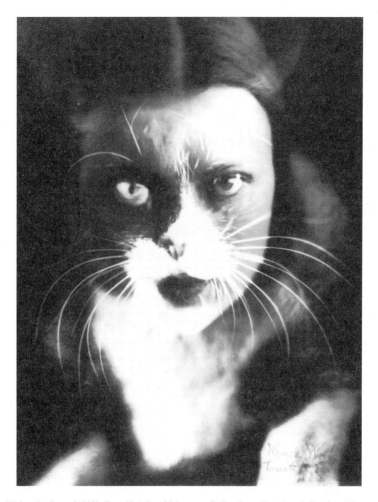

FIGURE 1. Wanda Wultz, *Io Gatto* (1932). Fratelli Alinari Museum Collections–Zannier Collection, Florence.

that a painter would never have been. Indeed, the composition of the image depends crucially on the amount of light the different parts of the scene reflect onto the photosensitive surface. It is the task of the skilled photographer to control this element in order to obtain the desired image. Third, the fact that certain photographs, such as this one, presuppose intentionality, or belief-mediated counterfactual dependence, is consistent with the view that photographs and paintings differ substantially in that the former but not the latter can represent objects or events in the absence of intentionality or without mediation of the artist's beliefs.[24]

The second reason is that *Io Gatto* is interesting precisely because it is a photographic image and not a painting. A painting of a similar crea-ture would certainly not surprise the spectator, but the fact that it is a photograph arguably does. Barbara Savedoff explains this phenomenon nicely.[25] As experienced spectators, she claims, we concede certain epistemic authority to photographs, and this prompts us to identify the objects that were once in front of the camera.[26] But when confronted with photographs such as that of our cat-woman, we feel a certain tension: although we identify the objects that caused the image, we see them presented in uncanny ways. This tension has a positive effect and makes our appreciation of photographs representing ficta different from our appreciation of paintings with similar content. If this is so, evaluating *Io Gatto* as a painting would be to miss the whole point of the picture.

The skeptic will perhaps now concede that the picture is a photograph, but she may still insist that, strictly speaking, it does not depict a cat-woman photographically; rather, it depicts two objects: a woman's face and a cat.[27]

This, I take it, is no more than a sophisticated version of the former objection, for it suggests the following argument. Photographs can only represent their sources photographically; *Io Gatto* is a photograph; but there is no cat-woman causally related to the image; rather, a particular woman and a particular cat are the sources of the image; therefore, *Io Gatto* photographically represents only a particular woman and a particular cat. Again, this argument is question begging. It assumes that the only way photographs are able to represent is by source, by being causally related to the object they are of. And, if the picture represents any other object that was not the picture's source, then such representation cannot be photographic. In other words, the argument is true only if FIP is true, but this is precisely what is being questioned.

Now, it might be correct to say that photographs have a distinctive way of representing objects that other pictures lack: unlike other pictures, there is a sense in which photographs always represent what they are of.[28] However, this does not mean that this is the only way by which photographs can depict their objects, or that other ways of representing available to photography are necessarily not photographic.[29]

Understanding *Io Gatto* may require that we identify the woman's face and the cat as the sources, but also, and crucially, it requires us to see one, single, whole creature in the picture that we can easily identify as a cat-woman.[30] Now, in order for us to identify or see a cat-woman in the picture, we do not need a label or a convention that tells us what the picture depicts, as is the case in the Chaplin picture representing Charlot. Rather, in the case of *Io Gatto*, we need only to look at the image to naturally generate an interpretation of a single object whose visual properties or shapes can easily be associated with a creature that we may be led to call a cat-woman. Such properties, moreover, can be seen in the picture due to the manipulation of some specifically photographic techniques.[31]

Champions of FIP might still want to leave the particular case of *Io Gatto* aside and take issue with the general framework that I used to characterize the photographic process and that allowed me to extend the notion of photographic means. They may argue, for instance, that while it might be the case that some photographs are produced nonautomatically following the processes described above, such photographs move away from the essence of photography or from the ideal photograph, which is really what they are concerned with.[32] A similar and perhaps more sophisticated version of this objection claims that the process I described above, where the photographic event is just one stage of a more complex process, is only a historical contingency and so does not capture the essential elements of photography. After all, there could be photographic images produced in a different way, where the second and third steps described above (transduction and storing), for instance, worked differently or were not present. Hence, one could object that what I take to be genuine photographic means are not so because they are not essential to photography.[33]

In answer to the first worry, a reasonable response would be, I think, to ask why we should accept that nonautomatically produced photography is less essential than its automatic counterpart, and also why achieving automatism should be a desirable goal of photography.[34] Without such an explanation, the objection is ad hoc. As for the second version of the objection, even if the objector were right and the process described above were only a historical contingency, this would not cancel the existence of a distinctive photographic process that necessarily requires these steps to produce a photographic image. Moreover, my claim is not that these purported extra steps are themselves essential to photography, but that, when they are present, they are still part of the production of the image and, more importantly, that some actions performed therein exploit something that is indeed essential to photography, namely, the incidence of light onto, and its interaction with, photosensitive material.

As a last resort, advocates of FIP may try to claim that their position is stronger than I take it to be. Thus, the relevant causal relation of a source with the lens or the photosensitive surface that they take to define photographic means would involve the exposure of a single continuous photosensitive surface by a bundle of light from a single spatiotemporally connected scene.[35] If this were so, the case of *Io Gatto* would not count as a

FIGURE 2. Jerry Uelsmann, *Untitled, 1982* (1982).

representation of a fictional character by photographic means.

A preliminary reaction to this revised version of FIP would be to ask again what the motivation for such a restrictive account is. To my knowledge, there is currently no theory of photography that defends a view such as that stated above, and without a proper justification for this limiting notion of photographic means, it seems to be nothing more than a defensive move to safeguard FIP. Moreover, the view does not seem to sit well with the way we classify and appreciate photographs. I already mentioned the case of *Io Gatto*, but the objector should also explain why other images obtained using techniques such as multiple-exposure and combination printing, such as Eliot Elisofon's *Duchamp Descending a Staircase* (1952) or Jerry

Uelsmann's *Untitled, 1982* (Figure 2), should not be considered strictly photographic when both the techniques and the resulting images are part and parcel of the history of photography and its practice.[36] It is also worth noting that although this restrictive conception of photographic means seems tailored to rule out cases such as *Io Gatto* as an example of fictional representation by photographic means, it is not clear that it will exclude other cases obtained by using techniques such as long exposure. Take, for instance, Gjon Mili's photograph of Picasso drawing a centaur.[37] One could argue that this picture depicts both Picasso and a centaur (a fictional entity), and that both representations qualify as photographic; they would certainly be photographic representations in my sense, but the proposed revised version of FIP will not rule out

this possibility either. After all, the centaur that can be seen in the photograph was produced by a long exposure of a single continuous photosensitive surface by a bundle of light—radiating from a light pencil—from a single spatiotemporally connected scene—Picasso's studio.

It might well be that the objector has good reasons to revise both our appreciative and classificatory practices, but in the absence of any further justification, one should prefer a more open conception of photographic means, one that is in accordance with the way we appreciate and classify photographs. I believe that I have provided this alternative conception.

IV. FROM BEING FICTIONALLY COMPETENT TO BEING FICTIONAL

So far I have argued that there is an alternative conception of photographic means that allows us to say, against FIP, that photography is indeed fictionally competent. Currie and Carroll showed us how photography can represent fictive entities by use; and, if my arguments are sound, it can also do so by photographic means. Notice that once our conception of photographic means is expanded, we can also see how photography can depict not only ficta, but also fictive events by photographic means; fictive events, moreover, that do not necessarily contain fictive entities.

Consider the infamous photograph in Figure 4, which represents an event that never occurred, at least not as depicted. It is therefore a fictive time slice.[38] The actual scene to have once taken place before the camera included the presence of P. J. Goebbels (second from the right in Figure 3).

Could this photograph have been made by strictly photographic means? Yes, I think it could. The photographer could have subtly blocked the light selectively over the figure of Goebbels in a first exposure and subsequently projected other sections of the negative over the underexposed part of the photosensitive surface in order to fill the deleted areas, all this before developing or making the image patent on the photosensitive paper. If this is right, then photographs can indeed represent not only ficta, but also fictive events by photographic means.

Now, could we conclude that since certain photographs represent fictive entities or events, they are fictional works or instances of fictional, as opposed to documentary, photography? I do not

think so. Nothing that I have said here shows this, nor does it explain how a photograph becomes fictional. Up to this point, I have argued that photographs can represent ficta and fictive events. But, contrary to what I suspect may be in some readers' minds, representing ficta and fictive events does not make a photograph fictional—no more so, at least, than reference to fictional characters make a text or a sentence fictional.

Here it is useful to remember the distinction that is commonly made between the representational dimension of a work and its functional or genre dimension.[39] Very schematically, the representational dimension (which can be referential or otherwise) tells us what the content of the work is, what it is that the work represents. The genre dimension, which is logically independent from the representational, in turn, informs us about the kind of work it is (under which category it falls) and the function it performs. It is this dimension that indicates to the audience members the relevant attitude that they are supposed to take toward the work's (representational) content. It is the genre dimension and not the representational dimension that determines whether a work is fictional or nonfictional. According to the orthodox approach to this matter, a work is fictional if it requires the audience to make-believe or imagine that which is represented, regardless of whether it is a fictional or real entity or event, while nonfictional or documentary works ask the audience to believe the content of the work, again, regardless of its being fictional or real.[40]

If this distinction applies to works of literature and films, there does not seem to be any reason, in principle, to think that it should not be valid for depictive works in general and photographic works in particular. If this is right, then not all photographs that represent ficta or fictive events are necessarily instances of fictional photography. Likewise, not all photographs that represent real entities are necessarily documentaries. In order for them to be either fictional or nonfictional, we need them to have a relevant function that indicates to the audience the pertinent attitude they should take toward the work's representational content.

Take, for instance, the case of a still photograph of the making of a film in which one of the (fictional) characters is entirely computer generated and projected holographically in three dimensions on the pro-filmic scene. The

FIGURE 3. *Adolf Hitler with Leni Riefenstahl and Joseph Goebbels* (1937). Süddeutsche Zeitung Photo Archive.

FIGURE 4. *Image Forgery: Adolf Hitler with Leni Riefenstahl* (1937). Süddeutsche Zeitung Photo Archive.

photograph is aimed as evidence of the shooting process, and what we see in it is, say, part of the original set where the film was shot and the holographic figure projected on-site. This photograph presumably depicts a fictional character (although not strictly by photographic means), and yet, since its function is to make us believe something about the shooting process, it is not an instance of fictional photography.

More controversial perhaps are the cases of deceptive photography, such as the Hitler-without-Goebbels image (Figure 4). As I have said, this image represents a fictive or nonveridical event, something that never happened as such, and yet, its function is to make the audience believe the (fictive) representational content. That is, it is asking us to believe that Goebbels was not present at that precise moment in time. The same will be

true of other photographs that represent fictive entities either by use or by photographic means, such as in the following examples: (1) a photograph that I take while climbing the Himalayas of a real person wearing a furry, bulky outfit on a snowy, windy day, which I subsequently manage to sell to a magazine as proof of the existence of the abominable snowman; (2) a photograph of the Loch Ness Monster, supposing this photograph had been made, as I think it could have been, by photographic means.

Again, as in the case of the Hitler-without-Goebbels photograph, the function of these two images is to make the audience believe that what is represented, namely, the fictive entity, was in a particular place at a particular moment. Hence, given their function, it is reasonable to say that these photographs are nonfictional even if they depict fictive entities or events.[41] If this is right, these would be other examples of photographs that represent ficta and, yet, are nonfictional.

It can be claimed, however, that nonfictional or documentary photographic works should only be those that really represent what they claim to represent: if we are told that a photograph depicts a subject or an event, it has to be that exact event or subject that caused the photograph. Hence, deceptive photographic works should not be classified as nonfictional; rather, they fit more comfortably into the category of fiction.

A proper response to this objection will require advancing a definition of documentary works that I cannot provide here. However, let me try to sketch some reasons I hope can help to make my position plausible.

One reason is that characterizing photographic nonfictional or documentary works in the way suggested conflates the ontological question, "what are photographic nonfictional or documentary works?" with the epistemic question, "how successful are they in conveying the truth?" The problem with this is that it does not allow for there being defective documentary works, since only those that are good can be called "documentary," but the history of documentary photography is replete with cases of deception.

Another reason is that the fact that deceitful photography raises criticisms only makes sense if we acknowledge that its function is to make us believe something about the work's representational content. Being deceitful or false is not typically an appropriate criticism of fictional works.[42] If we are

informed that, say, the photograph *Dr. Duanus' Famous Magic Act* is part of Duane Michals's series of fictional photography, it would certainly be misguided to criticize it just because it is not true that there is a man emerging from the top hat.[43]

By contrast, to say of a nonfictional work that it is false or deceitful is indeed a criticism. That is because the documentary genre sets those expectations. Notice that what sets the relevant expectations is not the fact that the work is photographic. It is true that we concede epistemic authority to photographs, but as experienced spectators, we also know that photographs can be put to various uses. We do not evaluate the photographic manipulation of the Hitler-without-Goebbels image as a defect just because it is a photograph and therefore it should be accurate. There is nothing in the medium that dictates what its correct use should be. The medium is normatively neutral. Rather, we find the photograph defective because it invites us to believe what is depicted, because we recognize it as nonfictional. If this same photograph were presented as fictional, our assessment of it would be very different; the manipulation might not be considered a defect.

Let me now briefly summarize what I have claimed in this article. I first addressed the discussion on the capacity of photographs to represent ficta. Against FIP theorists, I argued that if we take a more comprehensive view of the nature of photography and a broader notion of photographic means, then there is no reason to deny that photographs can represent ficta by photographic means. After addressing possible objections to my position, I argued that representing fictive entities does not make a photograph an instance of fictional photography. The categories of fiction and nonfiction or documentary, as they have been traditionally theorized, are not defined by the type of representational content of the image. Rather, they indicate the attitude the audience has to take toward that representational content. Finally, I suggested that deceptive photography is better understood as nonfictional photography, however defective.[44]

PALOMA ATENCIA-LINARES
Department of Philosophy
University College London
London WC1E 6BT United Kingdom

INTERNET: p.atencia-linares@ucl.ac.uk

1. Susan Sontag, *On Photography* (New York: Delta, 1978), p. 15.

2. For two representative works, see Nancy Armstrong, *Fiction in the Age of Photography: The Legacy of British Realism* (MIT Press, 1998); and Daniel A. Novak, *Realism, Photography and Nineteenth-Century Fiction* (Cambridge University Press, 2008).

3. For characterizations of photography along these lines, see Gregory Currie, *Image and Mind: Film, Philosophy and Cognitive Science* (Cambridge University Press, 1995); his "Pictures of King Arthur: Photography and the Power of Narrative," in *Photography and Philosophy: Essays on the Pencil of Nature*, ed. Scott Walden (Oxford: Blackwell, 2008); and his "Visible Traces: Documentary and the Contents of Photographs," *The Journal of Aesthetics and Art Criticism* 57 (1999): 285–297. See also Kendall L. Walton, "Transparent Pictures: On the Nature of Photographic Realism," *Critical Inquiry* 11 (1984): 246–277; and Scott Walden, "Objectivity in Photography," *The British Journal of Aesthetics* 45 (2005): 258–272.

4. Roger Scruton, "Photography and Representation," *Critical Inquiry* 7 (1981): 577–603, at p. 588. The underlying idea behind Scruton's claim that photography is fictionally incompetent is that photographs do not *represent* but *present* their content. This view has been challenged by many authors. See, for instance, Gregory Currie, *Image and Mind*; Noël Carroll, "Concerning Uniqueness Claims for Photographic and Cinematographic Representation," in his *Theorizing the Moving Image* (Cambridge University Press, 1996), pp. 37–48; Dominic Lopes, "The Aesthetics of Photographic Transparency," *Mind* 112 (2003): 433–448; and David Davies, "How Photographs 'Signify': Cartier-Bresson's 'Reply' to Scruton," in *Photography and Philosophy*, pp. 167–186, among others. In this article, I ignore this debate and assume that Scruton's critics have succeeded in proving that photographs are indeed representational. I do not think that I am unfairly weakening Scruton's argument. After all, if I understand him correctly, his claim that photographs are fictionally incompetent is an argument to support his claim that photographs are not representational.

5. Jonathan Friday, "Digital Imaging, Photographic Representation and Aesthetics," *Ends and Means* 1 (1977): 7–11, at p. 9. For a similar view, see Robert Hopkins, *Picture, Image and Experience* (Cambridge University Press, 1998), p. 74.

6. An alternative argument is that because there are clearly fictional films that are photographic in nature, photography cannot be fictionally incompetent. To see why this argument does not work against FIP, see Dan Cavedon-Taylor, "In Defence of Fictional Incompetence," *Ratio* 23 (2010): 141–150.

7. Currie, "Photographs of King Arthur," pp. 265–283.

8. Carroll, *Theorizing the Moving Image*, p. 240.

9. Carroll, *Theorizing the Moving Image*, p. 241.

10. Scruton, "Photography and Representation," p. 588. Emphasis added.

11. Still there would be disagreement between Currie and Scruton. Scruton maintains that if photographs cannot represent fictions, it is ultimately because they are not representations but *presentations*. Currie denies this. For him, photographs are indeed representations.

12. Dawn Phillips, "Photography and Causation: Responding to Scruton's Scepticism," *The British Journal of Aesthetics* 49 (2009): 327–340, esp. pp. 336–340.

13. As Phillips correctly points out, the photographic event amounts to *the recording* of the light image, but is not yet *a record* of such an image. See Phillips, "Photography and Causation," p. 337.

14. I am grateful to the editors of this special issue for suggesting these labels.

15. For a response to the view that nonautomatically produced photographs move away from the real essence of photography, see Section III below.

16. However, these techniques are part of the practice of photography.

17. The technique of drawing with a flashlight can be used even during the first stage of the photographic process.

18. Notice that these two processes may lead to exactly the same image, but one of them would count as strictly photographic while the other would not.

19. I do not mean to deny that certain procedures used to manipulate the projection and reflection of light within digital photography are also strictly photographic in the sense explained above. Some techniques such as multiple exposure, long exposure, and under- and overexposure are (sometimes) available in digital cameras, and these techniques only depend on the manipulation of light; moreover, they affect the image while it is still being produced, so there will be no reason, in principle, to deny that these are also, strictly speaking, photographic processes. However, the questions of whether digital photography belongs to the same ontological kind as analog photography or whether or not reflections on analog photography can be extended to digital photography remain open to debate. I am inclined to say that they are not two different ontological kinds and that the reflection on analog photography is by and large susceptible to being extended, at least in some important respects, to cases of digital photography, but I do not try to argue for this here. I do not need to commit to this view for the purpose of this article. For convenience, I leave this discussion aside and focus just on the case of analog photography.

20. Neither multiple exposure nor the other techniques mentioned above are rare in the history of photography. As a matter of fact, many of these techniques were frequently used when digital editing software was not available, sometimes for creative purposes and, at other times, especially in the case of combination printing, for practical purposes, such as to compensate for the slowness of the film's emulsion. Actually, the case of Wanda Wultz's *Io Gatto* is a relatively simple one; in the nineteenth century, Pictorialist photographers such as Henry Peach Robinson and Oscar G. Rejlander produced images combining up to thirty negatives. More recently, photographers such as Jerry Uelsmann still work with nondigital technologies to create dream-like images that require employing up to a dozen enlargers, great control, and selective use of illumination (both in the studio and outdoors), and a mastery of combination printing, as well as various other darkroom techniques (see Figure 2).

21. Scruton, "Photography and Representation," p. 156.

22. It may even be claimed that in some sense, the image represents, or even depicts, the relevant cat and the relevant woman, the artist, Wanda Wultz.

23. Walton himself endorses this view in "Transparent Pictures," esp. pp. 266–267.

24. Photographs such as *Io Gatto* would be at odds with, or would be a counterexample to, any view that holds that photographic content is *always* independent of the

photographer's beliefs or intentionality, but it will be consistent with theories only committed to the view that photographic content, unlike pictorial content, *can be* independent of the photographer's intentions.

25. Barbara Savedoff, "Documentary Authority and the Art of Photography," in *Photography and Philosophy*, pp. 111–138.

26. She uses the term 'documentary authority.' For reasons that will become clear in what follows, I prefer to call it 'epistemic authority.'

27. I thank a member of the audience at the 2010 British Society of Aesthetics annual meeting for this comment.

28. This does not mean, however, that they necessarily *depict* the object they are of. A photograph can be of a particular train in virtue of its having appropriately caused the photographic image. However, it might not depict it if, for instance, all that we can see in the image is a blurred trail due to, say, a long exposure shot.

29. Compare Currie, "Photographs of King Arthur," pp. 269–273.

30. At least if the image is not meant to be deceptive but, say, playful, mysterious, or ingenious.

31. How it is that this photograph or any other picture depicts its object is a question that ultimately needs a theory of depiction. I do not aim to offer one here. I use the idea of natural generativity in the spirit of Flint Schier, *Deeper into Pictures: An Essay on Pictorial Representation* (Cambridge University Press, 1986). However, I do not mean to commit myself in this article to this particular theory of depiction.

32. See Scruton, "Photography and Representation."

33. I am grateful to Robert Hopkins and the editors of this special issue for making me think about this problem.

34. For arguments against ideas of this ilk, see Carroll, "Concerning Uniqueness Claims."

35. I am grateful to the editors of this special issue for pushing me to think about this objection. John Zeimbekis raised a similar concern.

36. Elisofon's picture can be seen here: http://db.tt/3maS0t7.

37. See the image here: http://db.tt/6jC6uBs.

38. Or, at the very least, a nonveridical representation.

39. Peter Lamarque and Stein Haugom Olsen, *Truth, Fiction and Literature* (Oxford University Press, 1994), pp. 223–252.

40. Although not all nonfictional works are necessarily documentaries, for the purpose of this article, I use 'nonfiction' and 'documentary' interchangeably. Furthermore, one need not endorse the view that it is the engagement in make-believe that distinguishes fiction from nonfiction. This has been the traditional approach, but one may support another account of such a distinction while respecting the difference between the referential and genre dimensions. One such view, for instance, is proposed by Stacie Friend in "Imagining Fact and Fiction," in *New Waves in Aesthetics*, ed. Kathleen Stock and Katherine Thomson-Jones (New York: Palgrave Macmillan, 2008), pp. 150–169.

41. I do not intend to say that an intention to make the audience believe certain content is a sufficient criterion for a work to be nonfiction. I cannot provide here a proper definition of nonfictional or documentary works. I am just relying on a very simplified version of the orthodox views regarding the difference between fiction and nonfiction and suggesting reasons why we should consider certain photographs as nonfictional rather than fictional.

42. Some fictional works, such as historical novels, also require the audience to believe part of its contents. However, it seems to me that in nonfictional works, unlike in fictional ones, the intention to get the audience to take the content presented as accurate or true to the facts is a standard feature or default position.

43. The picture can be seen here: http://bit.ly/kdeHrO.

44. I thank Noël Carroll, Robert Hopkins, Pepe Isla, Michael G. F. Martin, Mario Santos-Sousa, Maarten Steenhagen, David Teira, John Zeimbekis, an anonymous referee, and the editors Dominic Lopes and Diarmuid Costello for their challenging questions, comments, and very useful suggestions. I am also grateful to the audiences at the Logos Workshop on Fiction in Barcelona, the University of Murcia, the 2010 meeting of the British Society of Aesthetics, and the UCL Graduate Philosophy Conference for providing useful comments. Special thanks to Jerry Uelsmann and Maggie Taylor for generously letting me use Uelsmann's photograph *Untitled, 1982*. Special thanks also to Dan Cavedon-Taylor for making me think about this topic, to Stacie Friend for extensive discussions on earlier versions of the article, and to the AHRC and the British Society of Aesthetics, whose studentships made possible this research.

CHRISTY MAG UIDHIR

Photographic Art: An Ontology Fit to Print

A common, indeed standard, art-ontological position is that repeatable artworks are abstract objects with multiple concrete instances.[1] Since artworks in the medium of photography are widely thought to be repeatable works, it seems reasonable to identify them with abstract objects. I argue, however, that identifying photographic artworks with abstracta mistakenly ignores photography's printmaking genealogy, specifically its ontological inheritance. The products of printmaking media (*prints*) must be construed in a manner consistent with basic print ontology. Since the most plausible ontology of prints is nominalist, photographic artworks should be construed not as abstracta but as individual and distinct concreta. So if photography ought to inherit basic print ontology, then insofar as photographic artworks are photographs, the correct ontology of photographic art is also nominalist—it treats photographic artworks as individual and distinct concrete artworks.[2]

I. PHOTOGRAPHIC ART AND PHOTOGRAPHY ON THE REPEATABILITY MODEL

I take the standard model of repeatable work ontology, broadly construed, to be as follows: for a work to be a repeatable work, that work must be a multiply instantiable abstract object. More precisely, that work must be an abstract object (that is, a nonphysical type, individual, or particular necessarily lacking spatial, if not also temporal, location) that, in principle at least, has multiple instances (copies, tokens, embodiments), each of which is a concrete object (that is, a physical object necessarily possessing spatiotemporal location).[3] So described, the repeatable work model ought to be sufficiently narrow to support the substantive philosophical discussion to come but also

sufficiently broad to capture a variety of disparate, robust art-ontological views about the nature of repeatable artworks, of which photographic art is at least standardly assumed to be a part.

Given the repeatable work model, if photographic artworks are standardly repeatable, then photographic artworks are standardly multiply instantiable art-abstracta.[4] For example, if Sean Scully's *Deptford Blue Door* (1999) names a work of photographic art, then *Deptford Blue Door* names an art-abstractum for which there can be, and in fact are, multiple (full, proper, authentic, Scully-sanctioned or editioned) concrete instances. It follows that the physical object displayed in the art gallery, archived in the wealthy collector's flat file, or tacked to the wall of Scully's studio is not itself the artwork *Deptford Blue Door*, but merely a concrete instance of that photographic artwork. Moreover, the destruction of one of these instances does not itself constitute the destruction of *Deptford Blue Door*—vandalizing the concrete instance on display in Galeria Bernd Klüser can no more damage or destroy *Deptford Blue Door* than can dog-earing the book sitting on my shelf damage the literary work *Moby Dick*. The destruction of an instance of *Deptford Blue Door* fails to constitute a metaphysical loss with respect to *Deptford Blue Door*, the photographic artwork.[5]

While this model nicely conforms to general intuitions about repeatable works imported from other repeatable work domains, it fails to tell us exactly why we should think that the standard repeatable work ontology is a good model for photographic art. What exactly about the nature of photographic art makes the model suitable for photography? One obvious source of support is what I call the *inheritance principle for*

photographic art, which I take to be as follows: if *being a photographic artwork* entails *being a photograph*, then photographic artworks should be of the same ontic kind as photographs. Of course, this claims only that the general ontological model for photographs, whatever it is, also applies to photographic artworks. So, should one accept the standard repeatable work ontology for photographic art and also endorse the inheritance principle for photographic art, one must also accept standard repeatable work ontology for photographs. The principal question then becomes whether photographic ontology can plausibly be viewed in terms of the standard model for repeatable works—photographic art's ontological inheritance depends on the answer.

Obviously, anyone endorsing the inheritance principle for photographic art alongside the repeatable work model for photographs should unsurprisingly arrive at the repeatable work model for photographic artworks. After all, if photographic artworks are photographs, then if photographic prints are not themselves photographs but merely instances of photographs, then photographic prints are not themselves photographic artworks. For instance, if the object hanging on the gallery wall is a photographic print of Robert Mapplethorpe's *Tulips* (1979), then that object is not a photographic artwork—it is not even a photograph—but merely a non-art instance of the photograph that *Tulips* names, and it is this photograph and not its instances that is the photographic artwork.

Moreover, once we suppose that the standard repeatable work model is correct, it unsurprisingly follows that the principal ontological debate becomes one between various competing views of abstracta and their corresponding existence, identity, and individuation conditions. While some customizations may look more promising than others, anyone embracing repeatable work ontology for photographs would find that the standard model for *Tulips* at least has the same general structure as the standard model for *Moby Dick*, *The Wasteland*, and the *Eroica*, and so they would find photographic works to be no stranger sort of object than literary or musical works (that is, novels, poems, symphonies, and so on—and photographs). Any further ontological debate involves competing robust models united in their assumption that repeatability tracks multiply instantiable abstracta. For example, while Saul

Bellow's *Herzog*, Sergei Rachmaninoff's Piano Concerto No. 2, Akira Kurosawa's *Ran*, and Marilyn Minter's *Prism* may be radically divergent objects at the level of their particulars, insofar as novels, concertos, films, and photographs are repeatable works as standardly conceived, all belong to the same general ontic kind.

The above should provide a rough yet informative characterization both of the standard ontological terrain with respect to repeatable works as well as the scope and limits of photographic ontology taken to be contained therein. In the next section, I provide an alternative ontological model for photography also derived from an ontological inheritance principle, not between photographic art and photography, but instead between photography and printmaking.

II. PRINTMAKING AND PHOTOGRAPHY ON THE RELEVANT SIMILARITY MODEL

The standard repeatable work model for photography derives the bulk of its prima facie plausibility from an implicit and illicit ontological bootstrapping. Construing photographs according to the standard repeatable work model makes sense only in a selectively backward direction—first endorsing the inheritance principle for photographic *art* and then working backward from photographic art to photography. There is, however, another starting point from which we can proceed in a forward rather than backward fashion. I propose another inheritance principle, according to which photography ought to inherit basic print ontology.

Basic print ontology, I claim, is nominalist—the works of printmaking (that is, the products of printmaking forms, processes, or techniques) are concrete, individual, and distinct prints. So, given that photography is a form of printmaking, no less so than other printmaking forms (for example, intaglio, lithography, relief printing, aquatint, silkscreen, sugar lift, gum printing, and the like), *being a photograph entails being a print*. Just as a lithograph is the print product for lithography, a photograph is the print product for photography (that is, the print product of photographic processes). From this, it follows that photography ought to inherit basic print ontology, and so photographic ontology is nominalist—works of photography are concrete, individual, and distinct photographs. If being a photographic artwork entails being a photograph, then photographic art

should inherit photographic ontology, and so the ontology of photographic artworks is also nominalist—works of photographic art are concrete, individual, and distinct photographic artworks.

To be a print is to be the individual and distinct concrete product of a printmaking process (typically operating over a template and onto a support). Furthermore, prints are characterized according to and have their character largely determined by the processes of which they are the products (for example, a lithograph is the print product of the printmaking process known as lithography, a screen print is the print product of the printmaking process known as screen printing, and so on). Most importantly, being a print itself entails neither being a copy nor being a reproduction. That is, prints are individual, distinct works, and this fact nevertheless remains consistent across the vast majority of printmaking processes, save the varieties of monotyping, being capable of producing multiple (what I call) *relevantly similar prints*.

Much of my project depends on my ability to capture intuitions about the putative repeatability of photography without having to construe photographs as multiply instantiable abstracta. To this end, I employ the following notion of relevant similarity: two prints are relevantly similar to each other if and only if they share all constitutive appreciable properties in common in virtue of sharing a causal history. Prints share a causal history if and only if they are printed from the same template (for example, a particular etched copper plate), by the same process (for example, intaglio), onto the same support (for example, paper).[6] Note that the relevant similarity relation is not a stand-in for the tokening-the-same-type relation. Viewing it as such misses the point. While standard repeatable work ontology posits types as abstract objects, of which concrete objects can be tokens, appeal to relevant similarity models the repeatable aspects of printmaking without entailing a corresponding increase in the number of objects posited. To be sure, one may continue to posit abstracta, of which concrete prints may be instances; however, positing such abstracta is not implied by the basic print ontology itself. Insofar as basic printmaking ontology is concerned, there need be no such thing as an abstract object.

In order to move forward toward photographic artworks, we can simply appeal to yet another equally evident inheritance principle, namely, one

between prints and photographs. According to the inheritance principle for photography, if being a photograph entails being a print, then photography should simply inherit the basic print ontology. From this, we can extend basic print ontology to photography.

A print is the individual and distinct concrete product of a printmaking process to which other individual and distinct concrete products of that printmaking process may be relevantly similar. Of course, not all printmaking processes produce multiple relevantly similar prints—some simply cannot, while others by design do not. For instance, in monotyping, the pressure required to transfer the image from the template onto the support destroys the image on the template, so that to be the product of such a process (a monotype) is to be a print to which no other print can be relevantly similar. Other processes, though capable at least in principle of producing multiple relevantly similar prints, are designed to produce multiple *unique* prints. For instance, in monoprinting, the ink is manipulated in each successive printing from the same (unaltered) template so as to produce a unique edition of prints (an edition of unique prints). To be the product of such a process (a monoprint) is to be a print to which (ceteris paribus) no other print, even those within that unique edition, is relevantly similar. Repeatability in printmaking seems to require printmaking processes that are able, if not also designed, to yield multiple relevantly similar prints.

Given the inheritance principle for photography, it follows that a photograph is the individual and distinct concrete print product of a photographic process (that is, the printmaking process of photography) to which other individual and distinct concrete print products of that printmaking process may be relevantly similar. Of course, not all photographic processes produce multiple relevantly similar photographs—some simply cannot, others by design do not. For instance, daguerreotyping allows for no direct transfer of the photographic image onto another light-sensitive medium—to be the product of such a process (a daguerreotype) is to be a photograph to which no other photograph can be relevantly similar. Other photographic processes, though capable at least in principle of producing multiple relevantly similar photographs, are designed to produce multiple *unique* photographs. For example, while instant cameras are designed to produce unique

photographs, the photographic processes they employ are capable at least in principle of producing multiple relevantly similar photographs (that is, typically involving film negatives that, while quite difficult to isolate and effectively extract, with or without destroying the photographic print, could nevertheless in principle be used to produce multiple relevantly similar photographs). To be the product of such a photographic process (a Polaroid) is to be a photograph to which (ceteris paribus) no other photograph is relevantly similar—though there could in principle be such photographs. Repeatability in photography seems to require photographic processes that are able, if not also designed, to yield multiple relevantly similar photographic prints. So, if the consequence of extending basic print ontology to photography is that to be a photograph *just is* to be a photographic print, then it follows that capturing repeatability for photography, just as for printmaking, does not require positing some further object (that is, some abstractum), but instead requires nothing more than relevant similarity.[7]

III. AN INCONSISTENT SET AND THE PLAUSIBLE DENIABILITY OPTION

Consider the following set of claims:

Repeatable work model of photographic art: photographic artworks are multiply instantiable art-abstracta, whose instances are concreta.

Inheritance principle for photographic art: photographic art inherits basic photographic ontology: being a photographic artwork entails being a photograph, so photographic artworks belong to the same ontic kind as photographs.

Inheritance principle for photography: photography inherits basic print ontology: being a photograph entails being a print, so photographs belong to the same ontic kind as prints.

Basic print ontology: a print is the individual and distinct concrete product of a printmaking process to which other individual and distinct concrete products of that printmaking process may be relevantly similar.

Each of the above claims, when considered alone, appears prima facie plausible; however, when taken together, they form an inconsistent set from which only contradiction and absurdity can emerge.

To help illustrate this, assume that there could be some object that is a photographic artwork (that is, a photograph that satisfies the conditions for being art, whatever those may be). From the above, it then follows that there could be some object that is (1) both an abstract object and a concrete object, (2) both a print and not a print, (3) both a photograph and not a photograph, and (4) both a photographic artwork and not a photographic artwork. Obviously, there could be no such object. So, from the assumption that there could be photographic artworks, it follows that there could not be photographic artworks. Clearly the above set of claims is an inconsistent set, and so any view endorsing all of its member claims is ipso facto incoherent.

Given the above, our principal focus ought to be on determining which of the member claims we must abandon so as to resolve the inconsistency. My own position is that any minimally adequate analysis of the notion of *photographic art* must be consistent with the relatively uncontroversial content contained in basic print ontology and the inheritance principle for both photography and photographic art. That is, I take the truth of basic print ontology along with that of both inheritance principles to be prima facie evident, so the only sensible thing to do is to reject the repeatable work model for photographic art. However, what matters for present purposes is that any competing view endorsing the repeatable work model for photographic art must find a plausible way to deny basic print ontology, the inheritance principle for photography, or the inheritance principle for photographic art.

In denying basic print ontology, one might accept both inheritance principles but claim that what provides the correct account of basic print ontology is not my relevant similarity model, but rather the standard repeatable work model, thereby rejecting the nominalist construal of photographic ontology all the way up. On this move, the principal problem lies not with construing photographic artworks as abstracta according to the standard repeatable work model, but instead with the nominalist construal of the ontology of printmaking according to my relevant similarity model. So, by denying the latter, we preserve the former in a manner that is consistent with both inheritance principles.

The trouble with this is that the standard repeatable work model for both photography and

photographic art implicitly entails basic print ontology as I have described it. The work required of photographic prints (that is, qua instances full, proper, or authentic) in the repeatable work model of photographs and photographic artworks can only be done if the ontological model for photographic prints supports a nominalist construal. So, if the standard repeatable work model for photographic art makes sense only insofar as it implies that photographic prints are concrete objects, then rejecting the nominalist construal of basic print ontology means rejecting the standard repeatable work model for photographic art (only to replace it with some model best described as wholly sui generis). For the standard repeatable work ontology to be even prima facie plausible for photographic art, basic print ontology must be nominalist. Insofar as preserving the repeatable work model for photographic art is concerned, denying basic print ontology is no better than unconditionally endorsing basic print ontology. Of course, this all assumes that it is possible to deny basic print ontology without a direct and wholesale indictment of the standard practices and conventions governing the world of printmaking.

Should one wisely agree that any account of printmaking ontology must remain nominalist, one could nevertheless deny the inheritance principle for photography. That is, one might simply reject the claim that photography is a subspecies of printmaking so as to deny that photographs are prints. This would allow one to claim that there is no ontological inheritance from printmaking to photography, and that preserves the repeatable work model for photographic art by halting the nominalist move upward toward photographic art at the printmaking level.

Denying the inheritance principle for photography also threatens to indict the entirety of photographic practice and convention—the cost of preserving the repeatable work model for photography is radical revisionism. Anyone denying the inheritance principle for photography must somehow find a coherent way to predicate photographic conventions and practices on something other than photography's printmaking genealogy. They must also construct a rather daunting sort of error theory that explains how the vast majority of the relevant folk (that is, artists, photographers, printmakers, buyers, brokers, insurers, collectors, museum curators, gallery owners, and so on) have all been the unwitting victims of a massive refer-

ence failure of such unprecedented scale and altogether devastating impact, not only for substantial parts of the worlds of art and printmaking, but also for the world of photography as a whole.

In order to minimize conflict with the photography and printmaking worlds, one might instead choose to deny the inheritance principle for photographic art. That is, one could argue that art-ontological concerns need not piggyback upon those of more mundane or ordinary things, and we need not suppose that photographic art must have the bulk, let alone the entirety, of its ontological inheritance determined at the level of the ordinary photograph. On this view, our expectations ought to be that the most plausible ontology of photographic artworks may not, all things considered, simply carry over from ordinary photographic ontology. So, even though we might perhaps pretheoretically regard the inheritance principle for photographic art as true, we certainly should not continue to hold it in such high esteem. If, after endorsing basic print ontology and the inheritance principle for photography, a tension remains, then our art-theoretic concerns demand that we sacrifice the inheritance principle for photographic art so as to preserve the repeatable work model for photographic art. Sometimes doing our best to preserve our art-ontological commitments requires that at certain joints the artworld sharply break with the world of non-art.

As a consequence, absent endorsing a wholesale eliminativist position with respect to photographic art, denying the inheritance principle for photographic art seems to require revising the notion of *photographic artwork*. That is, in order to coherently deny the inheritance principle for photographic art, one must revise the notion of photographic art, such that an object's being a photographic artwork no longer entails that object's being a photograph (that is, that for an object to be a photographic artwork that object need no longer be a photograph at all, let alone a photograph that satisfies the conditions for being an artwork, whatever those may be). To help illustrate this, consider the following analysis of the notion of photographic art: for an object to be a photographic artwork is for that object (1) to satisfy the conditions for being an artwork (whatever those may be), (2) to be a multiply instantiable abstract object, and (3) to bear certain salient relations to photographs (for example, requiring its instances to be photographs themselves or, more

weakly, requiring its instances to at least share certain salient features in common with photographs, though such instances need not themselves be photographs).

On such a view, the ontology of photographic art must be largely, if not exclusively, informed, shaped, determined, and constrained by art-theoretic considerations rather than photographic ones. Given the largely, if not exclusively, mundane and ordinary non-art considerations motivating the ontology of photographs, the ontology of photographic art cannot simply be a matter of an ontological inheritance from mundane, ordinary non-art photographs precisely because photographic artworks are ontically distinct from mundane, ordinary non-art works of photography. Just as we need not suppose that Gerrit Rietveld's *Red and Blue Chair* (1917) is an object of the same ontic sort as a mundane, ordinary non-art chair, we likewise need not regard Andres Serrano's photographic artwork *Heaven and Hell* (1984) as the same ontic sort as the mundane, ordinary non-art photographs of Uncle Joe's skiing holiday.[8] Just as many take De Stijl or Bauhaus design and manufacture to be substantively distinct from their ordinary craft kin, perhaps we also ought to expect their respective products to reflect that distinction *ontically*. So, if the inheritance principle for photographic art must be false for the repeatable work model for photographic art to be plausibly preserved, then we ought to deny the inheritance principle for photographic art.

The problem should be obvious. Any claim entailing the denial of the inheritance principle for photographic art can be coherent, intuitive, plausible, and substantive only insofar it entails a notion of photographic art that is itself coherent, intuitive, plausible, and substantive (at least *ceteris paribus* more so than the prima facie evident notion of photographic art entailed by the inheritance principle for photographic art). Moreover, denying the inheritance principle for photographic art, though consistent with there being photographs that instance photographic artworks, nevertheless entails that objects in the extension of *photograph* cannot be in the extension of *photographic artwork* (and vice versa)—if photographs are concreta and photographic artworks are abstracta, then there can be no photograph that is itself a photographic artwork. A rather strange result of this is that being a photograph and being photographic art must be mutually exclusive

properties even though what it is to be a photographic artwork has to do with what it is to be a photograph (presumably being a photographic artwork does not entail being a photograph but rather being photograph-like). That means explaining how photographs and photographic artworks are similar enough to ground a coherent, intuitive, plausible, and substantive notion of photographic art and yet are different enough to be ontically distinct (and rather acutely so at that). Without such an explanation, invoking some sort of art-ontological privilege in defense of the repeatable work model for photographic art is virulently ad hoc.

Notice that even if one were able to find a coherent way to preserve the repeatable work model for photographic art while withholding as to the rest, this would still require neutrality with respect to the ontology of photography and printmaking. Any account of photographic art can be informative and productive only given a well-specified account of photography and printmaking capable of settling the relevant issues for photographic art and its various relata. This requires a well-specified ontology for photography and printmaking, according to which the salient features of concrete (causal, physical) works of photography can be shared with abstract (noncausal, nonphysical) works of art to any degree, let alone to the degree minimally sufficient for responsibly and meaningfully referring to photographic artworks as photographic in the first place.

Preserving the repeatable work model for photographic art appears to require some level of purchase in at least one of following three wildly implausible, if not evidently false, claims: (1) there are no (can be no) photographic artworks, (2) prints are not (cannot be) concrete objects, or (3) photographs are not (cannot be) prints. So, barring a compelling argument as to why we ought to think photographic artworks (photographic art) and photographs (photography) are sufficiently dissimilar to ground the radical distinction in ontic kind, adopting the standard repeatable work model for the ontology of photographic artworks appears to be nothing short of an abject failure. Just consider the implausibility of the very same move applied to the art products of other printmaking processes such as lithography. For instance, being a lithographic artwork (for example, Bruce Nauman's *No* (1981), Claes Oldenburg's *Shuttlecock on a High Wire* (1995),

and Kiki Smith's *Litter* (1999)) entails being a lithograph that satisfies the conditions for being art. To claim either that lithographic artworks are not lithographs or that even though lithographs may be artworks, no such lithograph may be a lithographic artwork just seems patently absurd—so too for photography, photograph, and photographic artwork.

The only plausible model for the ontology of photographic art is the only plausible model for the ontology of photography and is the only plausible model for the ontology of printmaking. That model is the nominalist relevant similarity model, according to which photographic artworks, photographs, and prints are concrete objects to which other concrete objects may be relevantly similar. Ultimately, the reason that the standard repeatable work model cannot but fail is that the putative repeatability of photographic art is, upon closer inspection, nothing but the relevant similarity relation between prints.[9]

IV. RELEVANT SIMILARITY AND MAKING SENSE OF "PHOTOGRAPH"

One of the primary motivations for adopting the standard repeatable work model is that construing putatively repeatable works as abstracta better jibes with how we talk about such works—unless they are so construed, we could not plausibly hope to fully and coherently capture the substantive semantic, linguistic, conventional, and practical distinctions at play. For example, when you and I both claim to have heard Beethoven's Ninth Symphony, read *Moby Dick,* or seen Mapplethorpe's *Tulips,* we are not claiming to share a relation to the same physical object. Rather, we are both claiming to have accessed the same work in virtue of having stood in some relation or other to one of that work's proper instances. Most importantly, the instance in your case need not be the very same instance in my case; that is, we are not claiming to have heard the very same performance (Tuesday's), to have visually scanned the very same book (the library's), or to have looked at the very same photographic print (the Whitney's). The standard view then is that any nominalist account, which does without abstracta, fails to capture the putative repeatability of certain sorts of works without radical semantic revision accompanied by a rather hefty error theory. In what follows, I suggest a few ways in

which my relevant similarity model can address such issues, trusting these few to be sufficiently indicative of a more general program from which any such semantic worry could be satisfactorily diffused.

Presumably, most speakers (at least of English) employ the word 'photograph' in a variety of ways, some more precise than others. That said, while I do think that the nonprofessional laity use 'photograph' to pick out the photographic film in some cases, the photographic print in other cases, and the photographic image in yet other cases, I also think that any perceived semantic imprecision or reference confusion can be dispelled rather quickly by applying certain basic clarifications.[10] For example, consider the following utterances:

(A1) I have several photographs of Gina, all of which are different.

(A2) I have several photographs of Gina, all of which are the same.

I take 'having a photograph' standardly equivalent to 'having a photographic print,' and as such, the less precise 'I have several photographs of Gina' typically ought to lie somewhere between the following more precise readings of (A1) and (A2):

(A1*) I have several photographic prints, each of which features a photographic image of Gina distinct from that featured by any other of those photographic prints.

(A2*) I have several photographic prints, each of which features the same photographic image of Gina indistinct from that featured by any other of those photographic prints.

By contrast, consider the following utterances:

(B1) I took several photographs of George, all of which are different.

(B2) I took several photographs of George, all of which are the same.

I assume here that 'taking a photograph' standardly indicates performing a certain relevant action (for example, tripping a camera's shutter release) initiating a certain relevant process (for example, photochemical, photoelectrical) over a certain relevant base (for example, film, plate, file), onto which some (latent or visible) image

is thereby produced (or encoded) and from which further certain relevant products may subsequently be developed or processed (for example, negatives, prints, slides, and so on). Given this, (B1) and (B2) (in an appropriately broad and narrow fashion, respectively) can be more precisely read as the following:

(B1*) I performed either several relevant actions (varying angle, light, focus, and so on) or the same relevant action several times over either the same subject (for example, George standing still) or a varying subject (for example, George doing cartwheels) such that each of the several resultant photographic films featured a photographic image of George distinct from that featured by any other.

(B2*) I performed the same relevant action several times over the same subject such that each of the several resultant photographic films featured a photographic image of George indistinct from that featured by any other.

With the above albeit brief and rudimentary analysis, we can diffuse potential problems with what at first blush may appear to be some challenging sorts of cases. For example, consider the following utterances:

(C1) I discovered that the glass negatives, for which I paid twenty dollars at a yard sale last week, are in fact early Ansel Adams photographs worth in excess of a million dollars.

(C2) On Tuesday, I dropped off my vacation photographs at the drugstore, so I should pick them up on Friday.

Presumably, the speaker in (C1) is neither asserting some nuanced view about negatives as a subspecies of photograph nor expressing delight that the otherwise worthless glass negatives somehow magically transformed themselves into fantastically expensive photographs. Instead, I take the more precise reading to be:

(C1*) I discovered that the glass negatives, for which I paid twenty dollars at a yard sale last week, are in fact the result of Ansel Adams having, early in his career, performed certain relevant actions (that is, having "taken some photographs," of which those glass negatives are the results).

Similarly, I assume that the speaker in (C2) does not take herself to be simply swapping photographs for photographs (for example, "On Tuesday, I dropped off my blazer at the dry cleaners, so I should pick it up on Friday"). Rather, the more precise reading clearly ought to be seen as:

(C2*) On Tuesday, I dropped off the photographic film featuring photographic images from my vacation (that is, the photographic results of having at that time performed certain relevant actions), so I should pick up the photographic prints (that is, the photographs printed from that photographic film) on Friday.

What matters most for my purposes here is that none of the above cases requires construing as abstracta any of the prima facie plausible candidates for what 'photograph' purports to pick out. Of course, one might still reply that we simply must appeal to abstracta in order to capture a coherent and substantive notion of repeatability. The true test of my view then is to show how it can capture the putative repeatability of photographic works in a manner consistent with, if not supportive of, the various conventions and practices surrounding photographs and photographic artworks, all without recourse to identifying those works with multiply instantiable abstract objects.

Recall that my view accounts for the putative repeatability of photographs in terms of the relevant similarity relation between photographic prints. That is, the principal motivation for thinking of photographic works as standardly repeatable works is best captured by the notion of relevant similarity—photographic works are standardly repeatable works because photographic processes standardly yield multiple relevantly similar photographs. For example, consider the following utterances:

(D1) I have that same photograph on my wall at home.

(D2) I have that same photograph but in matte finish and 5″ × 8″ size.

(E1) I have ten photos in my wallet, and they are all the same.

(E2) I have ten photos in my wallet, and they are all different.

(F1) I have three photographic artworks by Diane Arbus, and they are all the same.

(F2) I have three photographic artworks by Richard Prince, and they are all different.

By employing the relevant similarity relation, we get the following:

(D1*) That photograph is relevantly similar to the photograph I have on my wall at home.

(D2*) I have a photograph relevantly similar to that photograph except for its finish and size.

(E1*) I have ten photographs in my wallet, and they are all relevantly similar to one another.

(E2*) I have ten photographs in my wallet, and none are relevantly similar to any of the others.[11]

(F1*) I have three individual and distinct photographic artworks by Diane Arbus (for example, *Child Crying, New Jersey* (1967) 18/75, *Child Crying, New Jersey* (1967) 39/75, and *Child Crying, New Jersey* (1967) 22/75), each of which is an individual and distinct photographic artwork and each of which is relevantly similar to one another (at least when considered locally—considered globally, they are quite likely relevantly similar to many more photographic artworks, such as others in the edition).

(F2*) I have three individual and distinct photographic artworks by Richard Prince (for example, *Upstate* (1995) 3/5, *The Girl Next Door* (1999) 9/26, and *Cowboys and Girlfriends* (1992) 2/3 AP), none of which is relevantly similar to the others (though each may be relevantly similar to photographic artworks other than those two, for example, *Upstate* (1995) 2/5, *The Girl Next Door* (1999) 25/26, *Cowboys and Girlfriends* (1992) 4/26, and so forth).[12]

Again, not only does making sense of the way in which we talk about photographs and photographic artworks at no point require identifying any of the relevant objects with abstracta, but in addition a coherent understanding of the conventions and practices surrounding photographic artworks seems in fact to be hard to achieve as long as they are taken to be abstracta. The lesson is that forcing the standard ontological model for repeatable artworks onto photographic art may successfully capture photographic art qua *repeatable* but only by failing to capture photographic art qua *photograph*.

V. CONCLUSION

Standard repeatable work ontology fails to provide an acceptable model for the ontology of pho-tographic artworks precisely because standard repeatable work ontology fails to be an acceptable model for basic print ontology. Any minimally adequate ontology of photographic artworks must be built from the bottom up, and in doing so, entail the following:

A print is an individual and distinct concrete object to which other individual and distinct concrete objects (that is, other prints) may be relevantly similar.

Photographs are individual and distinct prints to which other individual and distinct prints (that is, other photographs) may be relevantly similar.

Ceteris paribus, for any pair of relevantly similar prints, one is a photograph if and only if the other is a photograph.

Photographic artworks are individual and distinct concrete photographs to which other individual and distinct photographs (that is, photographic artworks) may be relevantly similar.

Ceteris paribus, for any pair of relevantly similar photographs, one is a photographic artwork if and only if the other is a photographic artwork.

Photographic artworks, photographs, and prints are all in a sense standardly repeatable works because photographic artworks, photographs, and prints are all standardly works to which other photographic artworks, photographs, and prints may be relevantly similar (that is, printmaking processes standardly yield multiple relevantly similar prints). As a result, the standard ontological model for repeatable works cannot help but fail when imported into photographic art because the operative notion of repeatability in that standard model (that is, multiple instantiability) is not the operative notion of repeatability in basic print ontology (that is, relevant similarity). If photographic art has an essentially printmaking genealogy whose ontological inheritance is relevant similarity, then any account of photographic art that leaves out its print lineage simply fails to be an account of *photographic* art.[13]

CHRISTY MAG UIDHIR
Department of Philosophy
University of Houston
Houston, Texas 77204

INTERNET: cmaguidhir@gmail.com

1. I thank Marcus Rossberg, Roy T. Cook, P. D. Magnus, Dominic McIver Lopes, and Diarmuid Costello for their helpful suggestions and criticisms.

2. For those unfamiliar with the various philosophical issues surrounding both art ontology and photography, see Stephen Davies, "Ontology of Art," and Nigel Warburton, "Photography," in *The Oxford Handbook of Aesthetics*, ed. Jerrold Levinson (Oxford University Press, 2003), pp. 155–180 and 614–626.

3. For an excellent discussion of the issues, see David Davies, "Multiple Instances and Multiple 'Instances,'" *The British Journal of Aesthetics* 50 (2010): 411–426.

4. For those explicitly endorsing the standard repeatability of photographic artworks, see Jerrold Levinson, "The Work of Visual Art," in his *The Pleasures of Aesthetics* (Cornell University Press, 1996); and Guy Rohrbaugh, "Artworks as Historical Individuals," *European Journal of Philosophy* 11 (2003): 177–205. Levinson presumably adopts the more traditional indicated-type model of repeatable works that he elsewhere defends in *Music, Art, and Metaphysics* (Cornell University Press, 1990); Rohrbaugh, however, advocates what he calls a "historical-individual" model. Note that while Rohrbaugh takes his historical-individual model to be an alternative to the standard repeatable work (type-token) model, his account, at least for my purposes here, is nevertheless one according to which photographs are objects sufficiently similar to abstracta of the standard sort posited by that standard model. On Rohrbaugh's view, photographs are neither pure abstracta nor concreta but instead "real" objects that admit multiple embodiments (for example, photographic prints) and exist in both space and time, but only in a manner wholly dependent upon the spatial and temporal properties of their embodiments, from which they are themselves distinct. The objections I give against the repeatable work model of photographic ontology hold mutatis mutandis against the historical-individual model.

5. Against the backdrop of standard repeatable work ontology for photographic artworks, consider acts of vandalism directed at Andres Serrano's *Piss Christ* (1987), a photographic artwork of which there are ten editioned photographic prints (two of which have already been vandalized beyond repair, one as recently as April 2011). For instance, in 1997, John Haywood entered the National Gallery of Art in Melbourne, where he removed a *Piss Christ* print from the gallery wall and proceeded to kick it several times before being apprehended by security. If Haywood sincerely believed that *Piss Christ* was the sort of thing that could be kicked, then he suffered from a deep metaphysical confusion and so could not help but be a metaphysically harmless sort of vandal whose best efforts could amount to nothing more than registering protest by destructive (and needlessly criminal) proxy.

6. I take the phrase 'constitutive appreciable properties' as a broad, theory-neutral stand-in for roughly those relevant descriptive physical (internal) features of the print (for example, color, shape, size) as well as those relevant descriptive nonphysical (relational) features (for example, aesthetic, semantic, representational features) supervening on (in part determined by) those relevant descriptive physical (internal) features of the print. For more on relevant similarity between prints, see my article "Unlimited

Additions to Limited Editions," *Contemporary Aesthetics* 7 (2009).

7. While this view is consistent with photographic slides and digital prints being photographs, it appears to preclude both slide projections and digital screen images from themselves being photographs. That is, though projections and digital images on a screen clearly involve photographic images, neither are prints and so neither can be photographs (especially if construed as events rather than physical objects). So, for example, when a friend sets up her slide projector or computer in order to show me her vacation photographs, I take it that I am shown no actual photographs (that is, photographic prints), but instead am shown a series of projected or displayed photographic images, specifically those relevantly similar to those featured in my friend's vacation photographs. To be sure, those hesitant to endorse the above have other recourses to which they may appeal, such as bifurcating photography along support, template, or process lines (for example, print versus projection, film versus digital file, photochemical versus photoelectrical), adopting a pluralistic ontology (for example, prints as concreta and projections as either events or concreta ontically distinct from prints), or simply abstracting up to a level of concrete particulars under which both concrete objects and events can be subsumed. Whether such moves can be plausibly and productively made is a question best answered elsewhere. Thanks to Dominic McIver Lopes for suggesting this.

8. One could also just straightforwardly claim that *Red and Blue Chair* is not itself a chair but just has a chair as a proper part, and so analogously claim that photographic artworks are not photographs. That is, though photographic artworks may have photographs as proper parts, photographic artworks are not themselves photographs.

9. One might alternatively claim that the candidates for photographic artworks are either *editions* or *portfolios*. However, current art practice finds that galleries routinely break up portfolios in order to sell the constituent photographs, thereby presenting a problem for modeling portfolios as anything other than spatially dislocated objects. So too it is for positing editions as photographic artworks. Editions in other printmaking media are almost never seen as being artworks themselves, and even when the edition is itself taken to be an artwork, its print constituents nevertheless remain individual, distinct artworks.

10. In the examples that follow, I assume that further facts about the various conversational rules, conventions, contexts, and cues in play would serve to clear up any ambiguities.

11. Presumably, at no point were the photographs in fact relevantly similar to one another (for example, before a trip through the washing machine).

12. Note that my view allows for relevant similarity to apply differently to photographs *simpliciter* than to photographic art (for example, with respect to certain agential relations such as the sanctioning or editioning of prints). For more on such distinctions, see my "Unlimited Additions to Limited Editions."

13. On my account, John Haywood's assumed attempt to vandalize Andres Serrano's *Piss Christ* (1987) was *not* an art-ontologically harmless sort of activity resulting from a deep metaphysical confusion. Rather, Haywood's attempt

to destroy that particular photographic print on display at the National Gallery was in fact (at least *de re* if not *de dicto*) an attempt to destroy an individual, distinct photographic artwork (for example, *Piss Christ* (1989) 1/6). Of course, the severity of such destruction for the artworld (as well as for Haywood's evaluation of his own destructive efforts) may be mitigated to the extent that there still remain either photographic artworks relevantly similar to the one targeted for destruction (for example, *Piss Christ* (1989) 2/6) or at least the photographic film from which any such relevantly similar photographic artwork must be produced.

JOHN ZEIMBEKIS

Digital Pictures, Sampling, and Vagueness: The Ontology of Digital Pictures

Digital pictures appear to challenge Nelson Goodman's theory that pictures are autographic, that is, that two pictures cannot be type identical representations. If the challenge turns out to be successful, it should be possible for digital pictures to be phenomenal replicas of one another, and digital pictures may be defined as types. Any defense of the value of certain tokens over others (if applicable to such pictures) would have to restrict itself to pointing out differences in the historical properties of distinct tokens, since each copy would token exactly the same representational properties. Pictures would thus be split into two categories, autographic and allographic.[1]

Yet, granting digital pictures allographic status would have an unexpected consequence. It sounds reasonable to hold that digital pictures are allographic, whereas agentive or film-based pictures are autographic. But if digital pictures are replicable (and knowably so), picture replication will no longer be a "logically and mathematically grounded impossibility," to borrow Goodman's phrase.[2] In that case, the lack of technologies for replicating agentive and film-based pictures could be contingent and defeasible; so on what grounds would we maintain that such pictures are nonreplicable, or autographic? As Gregory Currie has pointed out, the fact that we think of paintings as singular does not mean that they are singular.[3] It may turn out that all pictures form a single, allographic representational kind, in a way we could not imagine was possible before recent digital imaging technology was developed.

This article argues both that digital pictures are allographic types and that what makes them allographic also makes agentive and film-based

pictures replicable. Showing that digital pictures are types is less straightforward than at first appears because digital imaging technology does not convert pictures into notations. Instead, it manipulates analog quantities by using sampling processes that can suffice to keep pictures type identical. But this complication has a positive spin-off: if digital pictures can be types without being notational characters, then other pictures, which are not notations either, can also be types for the same reasons. The article is organized as follows. I begin by describing an "atomistic" intuition about digital pictures (Section I), which initially suggests that they are notational. On closer examination (Section II), it turns out that the identity of digital pictures runs into problems of vagueness that make them violate Goodman's criteria for notational systems. This brings us before a dilemma: either, contrary to intuition, two digital pictures cannot be type identical, or the theory that notationality is required for allography is false. In Section III, I defend the second horn of the dilemma: notationality is not necessary for allography because sampling can also provide sufficient conditions for pictures to be type identical. Briefly, digital display devices are designed to instantiate only limited ranges of objective properties (light intensities, sizes, and shapes). Those ranges succeed in keeping differences in objective magnitudes below sensory discrimination thresholds (and do so in a way which preserves transitivity). In other words, they define objective conditions sufficient for pictures to be phenomenally type identical. In the conclusion, I explain why the principles that make digital pictures allographic also make agentive and film-based pictures replicable.

I. AN ALLOGRAPHIC ACCOUNT OF DIGITAL PICTURES

Close-up perceptions of pixels cause a roughly atomistic intuition about digital pictures. The gist of the intuition is that digital pictures are made up of small identical building blocks that impose a lower limit on how such pictures can differ from one another. In turn, this suggests that digital pictures may avoid the problems of vagueness that afflict the individuation of other pictures, problems that emerge from the continuous ordering of shapes, colors, and sizes, the essential properties of pictures. If this is true, digital pictures should be allographic. In this section, I construct an allographic account of digital pictures along these lines. The account would apply to pictures comprising pixels made with liquid crystal materials and responding to voltages from programs that determine the intensity of visible wavelengths transmitted through those materials.

Some preliminary issues have to be cleared first. For digital pictures to be allographic, they would have to be type identical in respect of their shape, color, and size properties. But they would not have to be identical in respect of their *objective* shapes, colors, and sizes. First, even if the pixels in two liquid crystal display devices differed minutely in size (in nanometers, or even micrometers), this would not make any difference if the pictures were designed to be perceived by the human visual system. Second, for whatever discrimination system two pictures are designed, there are likely to be infinitesimal differences in the light intensities, the objective sizes, and the objective shapes they token that the discrimination system cannot capture. So apart from objective identity being unnecessary, it is out of reach. If digital pictures are allographic, it will be because they are capable of being type identical in respect of determinable, epistemically defined colors, shapes, and sizes, which are more coarse grained than their determinate, objective counterparts. Identity under epistemic types includes not only phenomenal identity, but also identity under more fine-grained forms of measurement than perception (all the way down to those used by microtechnology and nanotechnology) and identity in respect of more coarse-grained types than perception (such as the eight colors generated by 3-bit pixel displays). I focus mainly on phenomenal (perceptual) identity, but the article's conclusions also apply to other epistemic forms of identity. Finally, for brevity, I almost always use 'objective' ('objective colors,' 'objective sizes') to refer to *determinable* objective types, as long as they are more fine grained than phenomenal types.

The atomistic intuition suggests that digital pictures may be able to preserve type identity because their shapes, colors, and sizes are discretely ordered, unlike those of non-digital pictures. For example, a digital display cannot generate pictures or subiconic parts with lengths between the lengths two pixels and three pixels.[4] This applies across the range of sizes; it is not a local trait specific to the part of the ordering that contains the types two pixels and three pixels, but applies generally to n pixels and n + 1 pixels. Since there are no further types between two such types, the sizes that aggregates of pixels can token are not densely ordered. Moreover, it seems that any sizes generated by the display will be discretely ordered.[5] The fact that sizes corresponding to fractions of pixels, like 1.2 pixels or 1.5 pixels, do not figure in the display's scheme of sizes means that there are separations between the size-types that the display can generate; the presence of such separations between types amounts to discreteness (noncontinuity) of the types.

Similar points apply to the shapes generated by pixel displays. Those shapes are aggregates of pixels, so any digitally generated shape can be analyzed into identical component shapes. All of the shapes that a pixel display can generate are analyzable into values on a Cartesian coordinate system comprising only a finite number of positive integer values, corresponding to the number of pixels on the screen. Thus, the display can generate only a finite number of shape types; and since density would imply an infinite number of types, the display's scheme of shapes cannot be densely ordered. Once again, in addition to being nondense, the types are discretely ordered: the values of the coordinate system that express shapes are integers, so there are no further shapes between them (expressible by fractions). Although there are such shapes, the *display* cannot instantiate them.

Colors generated by digitally manipulated displays do not seem to be densely ordered either. Whether or not the human visual system can tell apart the adjacent color options of a display application, the number of colors that the application can instantiate is finite because it corresponds to a number of binary-code possibilities. For example,

in the color system called Truecolor, each pixel has three 8-bit subpixels, each of which emits a different visible wavelength with an intensity from a range of 256 values. This yields 256^3 objective colors (colors defined as wavelength intensities) for the pixel. A dense ordering would comprise an infinite number of types; since the device cannot instantiate an infinite number of colors, its colors are not densely ordered.

Does this mean that the color types digital pictures can instantiate are also discretely ordered? (Non-density does not automatically imply either discreteness or disjointness; see note 5.) Here, the allographic scenario could hold that just as we have carved up the continuous property spaces of objective sizes and shapes into discrete packages, we could do the same with continuously ordered wavelength intensities by using, for example, a sufficiently fine-grained process of sampling. In particular, an allographic argument could be constructed along the following lines. In coarse-grained, digitally controlled color displays, like 3-bit color, which generates only six chromatic colors, the colors are obviously discrete since such displays cannot generate color continua. The missing colors are regions of the objective color space, dropped from the program's scheme and thus keeping its few colors disjoint. In more fine-grained devices, the same principle applies, but with the following—phenomenally striking, but objectively trivial—difference: the application's objective color types are so fine grained that differences between adjacent types are below sensory discrimination thresholds. Discontinuities in the scheme are phenomenally invisible, but they are nevertheless there objectively, making the wavelength intensities objectively discrete, just as they did (but visibly) in the coarse-grained system.

The range of possible shapes, colors, and sizes that the digitally manipulated display can generate can be seen as the set of its syntactic types. Those types are ordered in the way just seen, that is, digital pictures are made up of shapes, colors, and sizes that are not densely ordered. The allographic scenario has also argued that digital shapes, colors, and sizes are discrete. This is important, because although non-density is necessary for a scheme to be notational, it is not sufficient, and discreteness would go much of the remaining way toward showing that digital pictures are allographic. It would prevent types from having common members, en-

suring Goodman's notational requirement of disjointness. Moreover, the way the disjointness requirement is discharged means that the types are finitely differentiated: if the system generates a picture with the size n pixels, that picture's size will be measurably and knowably distinct from the next size, n + 1 pixels (something that would not be the case if the system could also generate sizes for all fractions of pixels). The same applies to colors, if the argument about discretely measured wavelengths is correct. To conclude: according to the allographic scenario, the essential properties of digital pictures are taken from sets of disjoint and finitely differentiated shapes, colors, and sizes.

We have now made the most of the "building-block" or atomistic intuition about digital pictures, but we have still not shown that digital pictures are notational. Disjointness and non-finite differentiation of types (characters) are necessary for a property space (here, a scheme of characters) to be notational, but they are not jointly sufficient. Central to notationality are the concept of character and the relation Goodman calls character-indifference. Like type identity, character-indifference is meant to be transitive, and characters themselves are meant to include all token representations that preserve that transitivity: "a character in a notation is a most-comprehensive class of character-indifferent inscriptions; that is, a class of marks such that every two are character-indifferent and such that no mark outside the class is character-indifferent with every member of it."[6] Somewhat worryingly, the allographic scenario does not explain how the extent of its "atoms" can be accounted for without running into problems of continuity and vagueness that would defeat transitivity. What surface can a pixel have when it tokens what we are calling the size 1 pixel? Which wavelength intensities can a pixel emit when it instantiates one of the numerically defined 256^3 objectively defined colors? Note that no similar question arises for classic examples of notational schemes, such as words and numbers, because the size and color of an inscription are not issues when it comes to recognizing what word-type it belongs to; the same word can be drawn in the sand or scribbled in the margins of a book. But the question does emerge when we are dealing with the qualitative identity of pictures because changes in size and color are changes to the qualitative identity of a picture. Questions about the limits of types like 1 pixel and the intensity

triplet (Red 100, Green 100, Blue 100) will be hard to answer because objective sizes, shapes, and colors are continuously ordered, so any groupings of them based on practical discrimination methods (such as those used in industry) will admit some degree of vagueness, preventing an all-inclusive account of characters in a way "such that no mark outside the class is character-indifferent with every member of it."

II. AN AUTOGRAPHIC ACCOUNT OF DIGITAL PICTURES

Alongside the allographic account just sketched, we can also construct an autographic scenario for digital pictures. To be allographic, pictures produced by digitally manipulated pixel displays would have to preserve some form of type identity in respect of colors, shapes, and sizes. What prevents type identity for *non*-digital pictures, such as analog photographs and paintings, is that color, shape, and size types are continuously ordered, making their limits vague and undecidable, a point Goodman captures by saying that those types are not finitely differentiated. According to the autographic account, the type identity of digital pictures can be challenged on the same grounds.

Finite differentiation is the ordering of types in a property space (such as a color space for colors or an axis for lengths) in a way that makes it possible in principle to establish type membership unambiguously. To the extent that the limits of types in an ordering are vague, membership cannot be established. The allographic account had two replies to this challenge. First, it pointed out that the digital display cannot generate pictures with sizes and shapes that differ by fractions of pixels; there is no size n + ½ pixels whose appurtenance to either n pixels or n + 1 pixels could be undecidable. Second, it pointed out that the colors, shapes, and sizes of digital pictures cannot be densely ordered because density implies an infinite number of types, while digitally generated sizes, shapes, and colors are finitely numbered.

This is true, but it does not get us off the hook where finite differentiation of types is concerned. Density is one way of defeating finite differentiation, but there are others that we have not excluded yet. Types can be non-finitely differentiated even when they are finite in number.[7] Consider is a heap and is not a heap, or bald and non-bald as they divide up the domain of heads:

there are only two types, yet there are heads whose membership cannot be decided. So non-density (the absence of further types between the two types) does not prevent the non-finite differentiation of the two types, according to Goodman's definition: "for every two characters K and K' and every mark m that does not actually belong to both, determination either that m does not belong to K or that m does not belong to K' is theoretically possible."[8]

Undecidability of type membership can also emerge at the limits of a *single* type. Even when we do not add a type adjacent to bald in the form of the predicate negation non-bald, there are still heads whose appurtenance to bald cannot be decided. In that case, we cannot define the type all-inclusively ("most-comprehensively" in Goodman's words). For example, we would feel secure in holding that any quantity of sand greater than one billion grains is a heap. All greater numbers of grains will then be type identical in respect of is a heap. But our certainty comes from the fact that we have kept all borderline cases at a safe distance from the type. So some quantities below one billion grains will also be identical to all the type's members in the same respect, but we have excluded them from the type. On the other hand, if we try to build up is a heap to include all such cases, we will run into "borderline borderline cases," or higher-order vagueness: the fact that the undecidable cases cannot be demarcated from the decidable ones.[9] In other words, we can do no more than define a *subset* of the all-inclusive type.

An autographic account of digital pictures can exploit both of these forms of vagueness to show that the types in respect of which digital pictures would have to be identical cannot qualify as notational characters. Consider a classic case of non-finite differentiation in which we cannot decide which of two adjacent types a particular instantiates. In the color scheme of the Truecolor system, the light-intensity values (Red 0, Green 0, Blue 127) and (Red 0, Green 0, Blue 131) are phenomenally discriminable: if we place them side by side, we see a faint line of color stepping between them. So pixels tokening those intensities have phenomenally different colors. But pixels lit at the intermediate intensity (0, 0, 130) are indiscriminable both from pixels instantiating (0, 0, 127) and from pixels instantiating (0, 0, 131). Even when two regions uniformly colored with

Blue 127 and Blue 130 respectively are placed side by side (without any other background color in between), we still cannot see any color stepping between them; the same applies to Blue 130 and Blue 131. Therefore, we cannot exclude that the pixels lit at (0, 0, 130) token both colors, and this defeats the finite differentiation of the color types in respect of which pictures would have to be identical.

As Goodman pointed out, there is no type identity without finite differentiation. We can now no longer say that even the *in*discriminable Blue 127 and Blue 130 are the same color: sameness of color would be transitive, which the similarity relation between Blue 127 and Blue 130 apparently is not.[10] To complete the comparison with classic examples of vagueness: not all colors will fall unambiguously under the discretely ordered numerical triplets, any more than the fact that numbers of hairs are discretely ordered in integers means that there is no vagueness about baldness.

Can we not avoid such cumulations of objective differences simply by maintaining the same numerical luminance values? Yes. But this misses the point of the non-transitivity argument. Its point is that since non-transitive series can be constructed, the indiscriminability of two digital pictures, *even* when they instantiate the same numerically expressed intensity values, does not guarantee their type identity in the first place. Keeping the same numerical value was supposed to ensure identity *because* it ensured indiscriminability. If it did not, we would not have thought of arguing that digital pictures are allographic in the first place. But now that that entailment is broken, maintaining the same numerical values ensures only indiscriminability, minus the identity. Since digital pictures do not preserve type identity in respect of color even when they are identical under the most determinate digital color-types (the numerically expressed triplets), digital pictures are not notational. This is exactly what Goodman was getting at when he argued that non-finite differentiation is necessary for character-indifference and notationality:

Now the essential feature of a character in a notation is that its members may be freely exchanged for one another without any syntactical effect.... And a true copy of a true copy of...a true copy of an inscription *x* must always be a true copy of *x*. For if the relation of being a true copy is not thus transitive, the basic purpose of a notation is defeated. Requisite separation among characters...will be lost unless identity is preserved in any chain of true copies.[11]

Yet, although this argument against the notationality of digital pictures is fundamentally correct, it still has a theoretical flavor that makes it inconclusive. For suppose that we accept the general point about indiscriminability not guaranteeing type identity. Then, even if two colors *were* type identical, all we could know about them perceptually would be that they are indiscriminable. We would not know that they are identical (since we have rejected the thesis that indiscriminability implies identity), but nevertheless they *would* be identical. Well, how do we know that when we maintain the same numerically expressed intensity values we are not in this kind of case—a case in which the colors are not just indiscriminable, but also type identical?

Before we hear the autographist's reply to this rejoinder, let us step back to take a synoptic view of it and try to weigh our options. The numerically expressed types, like (Red 0, Green 0, Blue 130), are groupings of light intensities. The autographist is going to argue that those groupings do not define the types in respect of which pictures have to be identical to have the same color. Before the autographist even gets started along such lines, we may begin to wonder why it is so important for bona fide types to be defined when we are at levels of discrimination so far below perception. Surely—the doubt goes—such fine-grained physical manipulation of light intensities *can* get it right where producing perceptual identity is concerned. This skepticism is legitimate. The reason why we are following the autographist into this area is that we have so far granted that unless digital pictures are *notational*, they will not be allographic. But if the requirements for notationality begin to look too exacting to allow digital pictures to be allographic, then we may have to try devising a form of allography that can sidestep the criteria for notationality. This is a radical enough step to warrant a close look into the autographist's argument: we need to be sure that the autographist is right (that digital pictures are not notational) to decide whether we really have to embark on the quest of showing that digital pictures can be allographic *without* being notational.

With this wider picture in mind, let us hear the details of the autographic rejoinder to the allo-

graphic scenario, which shows that digital pictures are not notational. Numerically expressed types like (0, 0, 130) in Truecolor, or simply Blue 130, are groupings of objective light intensities. When any of those intensities is instantiated by pixels and perceived, it causes a kind of color experience, Φ. The color Φ corresponds to (can be caused by) a band of indiscriminable intensities. That band is wider than Blue 130, since Blue 129, for example, also causes Φ. On the other hand, a larger aggregate of numerical values, like Blue 127–131, not only includes all of Φ, but also goes beyond it, since it includes intensities that cause a color *discriminable* from Φ. (Remember that if we place a group of pixels lit at [0, 0, 127] side by side with a group of pixels lit at [0, 0, 131], without any space between them, we *do* see a faint line of color stepping between the two groups.) The reason why aggregates of the numerically expressed groupings of light intensities do not coincide exactly with phenomenal colors such as Φ is that colors correspond to vaguely defined bands of intensities. Intensities are densely ordered, so they defeat finite differentiation of the limits of any types that attempt to group them.

As such, a light intensity triplet like (0, 0, 130) has some of the virtues that Goodman expects of notational characters, but it does not have all of them. First, all of the members in the grouping are type identical in respect of their ability to cause Φ-experiences: we have to go outside $(0, 0, 130)$, for instance as far as $(0, 0, 137)$, to have a different color experience. Second, all the member intensities within a group are transitively identical in that respect: we cannot construct non-transitive series by using only intensities from within $(0, 0, 130)$. But despite these virtues, the groupings will not qualify as the types we need for type identity in respect of color, because they fail to define "most-comprehensive classes" of objective conditions for color appearances:

A character in a notation is a most-comprehensive class of character-indifferent inscriptions; that is, a class of marks such that every two are character-indifferent and such that no mark outside the class is character-indifferent with every member of it. In short, a character in a notation is an abstraction class of character-indifference among inscriptions.[12]

More specifically, although any two light intensities grouped by a numerical value like Blue 130 are

type indifferent in respect of the ability to cause Φ, there are intensities outside the group (in Blue 129, for example) such that they are type indifferent with every member inside it in the same respect. So such groups (Blue 130) are not "most-comprehensive." Next, for composites of several numerical values, there are two possibilities. One is that the composite is not a most-comprehensive either (this applies to Blue 127–130). The other is that it extends so far that it violates transitivity in respect of Φ (this applies to Blue 127–131). Notational characters do not violate transitivity, so in that case, too, we are not dealing with a notational character. Therefore, the wavelength intensity groupings represented by the numerical triplets do not, either alone or together, *define or coincide with the types in respect of which pictures have to be identical to have the same color.*

We should concede that the autographist is right on the issue of notationality. However, the issue of the *notationality* of digital pictures aside, the door to *type identity* is still left ajar for the allographist. She can concede that the light intensity groupings do not coincide with the types in respect of which pictures have to be identical, because if they are *narrower* than those types, then maintaining the same numerical triplets *will* make the pictures type identical in respect of color. It seems the only way the autographist can resist this conclusion is to repeat that pictures cannot be allographic (capable of being type identical) without being notational. But this time, the autographist's argument is void of substance because the point of notationality in the first place was supposed to be to preserve the type identity of pictures.

III. WHY DIGITAL PICTURES ARE ALLOGRAPHIC

Let us return to the skeptical question sketched earlier: how can the fine-grained measurement and manipulation of physical quantities (such as color measured in wavelength intensities) far below perceptual thresholds fail to pin down the parameters required for the much more coarse-grained, perceptual form of identity that we are looking for? The reply is that such technology does *not* fail to pin down the physical conditions required for perceptual identity or for other epistemically defined forms of identity (such as those described at the start of Section I). We are right to imagine that by physically manipulating quan-

tities at a subphenomenal level, we can get below perceptual discrimination thresholds and engineer objects whose objective differences remain well below anything perception could detect, thus making them perceptually identical.

The key to exploiting the intuition is that, in order for digitally manipulated display applications to be able to instantiate type identical colors, shapes, and sizes, we do not need to previously define those types, and we do not need the display applications to encode those types. All we need to be able to do is define objective properties that are *sufficient* to preserve the more coarse-grained epistemic forms of type identity, such as phenomenal identity. Accordingly, display applications only have to be able to encode information about those sufficient objective conditions. This is feasible because it does not encounter insoluble obstacles from vagueness, unlike the definition and encoding of objective information about the full extent of the types (the most-comprehensive types) under which the pictures have to be identical.

Showing that this project is feasible requires showing that we can isolate, encode, and preserve across different devices sets of objective conditions sufficient for the identity of digital pictures. Before we begin to deal with those tasks, a preliminary issue must be dealt with, albeit in a frustratingly brief way. Our objective is to preserve type identity in respect of colors, shapes, and sizes; so will non-transitivity not crop up again, as soon as we try to show that digital technologies and their display applications can ensure such forms of type identity for pictures? The reply depends on one's convictions concerning the identity of qualia. If one is a skeptic about the identity of qualia, like Armstrong, then one has to abandon the hope that two digital pictures can be phenomenally identical (but on the same grounds, non-transitivity, one should also deny all other forms of epistemic identity for digital pictures).[13] On the other hand, what is arguably the main school of thought regarding the definition of qualia or appearance types, represented by Goodman (in *The Structure of Appearance*), Austen Clark, and perhaps Jackson and Pinkerton, holds that the non-transitivity argument does not prevent us from defining phenomenal identity: we just have to define it on criteria stricter than perceptual indiscriminability.[14] Since, as we have seen, the numerically expressed illumination values for pixels are more fine grained than phenomenal colors, they

may cut finely enough to define phenomenal identity. If they do not do so in Truecolor, then perhaps they do in more advanced systems, whether existing (like 30-bit color) or possible, which distinguish several times more wavelength intensities. Finally, wondering just how far we need to go below indiscriminability to reach phenomenal identity, we may begin to suspect that this approach is on the wrong track: where exactly are we to stop, since we now can no longer use the evident criterion of perceptual indiscriminability itself? These suspicions have given rise to approaches that reinstate indiscriminability as a sufficient criterion for phenomenal identity, though on different and conflicting grounds each time.[15] If we adopted one of those approaches, we could no longer accept the arguments presented by the autographist in Section II. In that case, the allographist could simply argue that digital pictures are phenomenally identical whenever they are indiscriminable.

In what follows, the concept of type identity used is compatible both with the Goodman-Clark position, and with the position that indiscriminability amounts to type identity. The difference is that on the Goodman-Clark position, perhaps no existing digital device carves up light intensities finely enough to set up phenomenally identical colors. (Or perhaps such a system does already exist; there is no way of telling from those theories what counts as phenomenal identity once indiscriminability is dropped as the criterion.) On the alternative account, which equates indiscriminability with phenomenal identity, such devices are already in use. They came into use when the color scheme called "Truecolor" was applied, by using video cards, display devices, and operating systems that allowed pixels to instantiate colors that are objectively different but phenomenally indiscriminable.

Now we can return to the main subject of this section: showing that it is possible to isolate, encode, and preserve across different devices sets of objective conditions sufficient for the identity of digital pictures in respect of color, shape, and size. Suppose that our objective is to produce a given phenomenal color Φ by using a liquid crystal display. We do not have to define the full, exactly delimited band of wavelength intensities that can cause Φ. We have only to define a narrow region of that band, since the pixels' instantiating *any* intensity in the band will suffice to cause Φ. So we do not have to solve the intractable

problems of vagueness and non-transitivity that would emerge if we tried to define an all-inclusive group of intensities for Φ, including the borderline cases. Accordingly, the display application's numerically represented triplets of intensities (for red, green, and blue) do not have to carve up the continuous space of wavelength intensities along the same joints as perceptual discrimination does when it discriminates those intensities as Φ or non-Φ. The job of the triplet (0, 0, 130) is only to encode information about *any* objective properties sufficient to cause Φ. This means that it will not define *necessary* objective conditions for causing that color, since the same color could equally be caused by another intensity not included in the group represented by (0, 0, 130).

The required properties—not only wavelength intensities for colors, but also sizes and shapes of pixels—can only be known and defined by using subphenomenal means of discrimination. Suppose that objective wavelength intensities F and G are indiscriminable, so that they cause the same color experience Φ. Their indiscriminability means that they differ by objective magnitudes that are too small to pass sensory discrimination thresholds. Therefore, any intensity between and excluding F and G will be indiscriminable from both of them (it will differ less, in the objective ordering, from either F or G than they differ from one another), so the group of intensities between and excluding F and G will be transitively identical in respect of causing Φ. If all we had to go on was perception, we could not define such a set: carving out a region of intensities between two *in*discriminable intensities requires *sub*phenomenal discrimination.[16]

What we have so far described could equally well apply to the intensities represented by a *series* of several numerically represented triplets: remember that in Truecolor, such triplets come in indiscriminable series so that, for example, the groupings Blue 127–130 are all indiscriminable. Why does the Truecolor scheme fit several groupings into a space where all the light intensities are indiscriminable? Because that way, the color scheme allows the application to cause perceptions of color continua. For this, the display has to be illuminated in such a way that neighboring pixels are indiscriminable and more distant pixels discriminable, but without there being any visible color stepping. This is achieved by gradually cumulating subphenomenal objective differences in intensity: over a small region of the screen, the

objective differences remain below sensory discrimination thresholds, but over a larger region they are cumulated to pass those thresholds.[17] If the application could not carve up intensities more finely than perception can, it would not be capable of causing this appearance of continuity.

Different transitive groupings of intensities have to be kept disjoint from each other; otherwise, the subphenomenal discrimination system used could not keep them apart (for instance, there would be intensities that for the discrimination system equally belonged to Blue 127 and Blue 128.) Leaving objective differences out of an ordering (of signal intensities, wavelengths, voltages, or spatial magnitudes) is essential to digital signal processing. For example, the discretely ordered binary values (0, 1) in binary code correspond to two disjoint domains of voltages. A range of the continuous ordering of voltages is dropped (0.8 V to 2 V), so that voltages between 0 V and 0.8 V represent 0 and those between 2 V and 5 V represent 1.[18] Wavelength intensities instantiated by pixels are similarly disjoint. In fact, the process of sampling at intervals, which digitally encodes continuous magnitudes by means of discrete values, *has* to leave out intensities in order to carve up the continuous ordering into groupings; unless each sample-value is disjoint from the next, the result will still be continuity.[19] But, from the perspective adopted here, sampling can also *afford* to leave out intensities, since its job is only to ensure *sufficient* objective conditions for causing a color experience. It can do this without running into the problem of vagueness, which it would do if we tried to use it to define all-inclusive sets for color identity.

The sizes of pixels can be defined on a comparable basis in order to preserve identity. Sizes taken from a proper subset of a set of sizes that human visual perception cannot discriminate will preserve transitivity on the same principles as those described for colors. Again, this requires subphenomenal discrimination that can differentiate among phenomenally identical sizes sufficiently to be able to define a disjoint subset of other indiscriminable sizes between them. Once such a subset is defined by subphenomenal means, all objective sizes within the subset (even ambiguous members of the subset) will be perceptually indiscriminable.[20] By using microtechnology, which applies metrology standards, pixels can be made to instantiate only sizes and shapes from within

such a transitive grouping. The result is that we cannot construct series of digital pictures whose objective differences cumulate beyond the magnitudes defined in the transitive regions.

In respect of their size and shape properties, pixels thus constitute cases of "indiscriminability from the same sample": new devices are not made by copying existing devices, but from data about objective (though determinable) sizes and shapes that they have to instantiate.[21] So it is not that differences of micrometers, or even nanometers, *cannot* be cumulated sufficiently to pass visual discrimination thresholds; it is just that they *are* not cumulated because of the way display devices are made. This is strictly analogous to the way in which we can make copies of non-digital pictures by starting each time from the original, instead of making copies from copies, to prevent the cumulation of differences. However, there is also a crucial difference between making copies from the original by using perceptual discrimination and making them with the industrial technology that produces computer displays. Only the latter can carve out subphenomenal regions of the objective property spaces of colors, shapes, and sizes that preserve transitivity. The result is that no two members of the group of copies can differ phenomenally. But in reproductions made without using subphenomenal means, even when all the reproductions are made from the same copy, two copies *can* differ phenomenally. (Copies *b* and *c* can both be indiscriminable from original *a*, but still differ perceptibly from each other: the difference between *a* and *b*, and that between *a* and *c*, are cumulated when *b* and *c* are compared.)

Thus, the transitive groupings of light intensities, which preserve type identity for digital pictures, bear an ambiguous relation to Goodman's criteria for notation. (1) They meet a disjointness condition: they include only intensities that are kept disjoint (by subphenomenal means) from all other intensities. (2) Members of the groupings may be freely exchanged for one another. (3) Identity within the group is transitive. (4) However, the transitive groupings do not meet a final condition. They are not all-inclusive; there are particulars outside the subset that are type identical with every member of it in respect of causing the same phenomenal color or size. Because they do not meet this condition, the groupings do not count as characters in a notational system. If we tried to satisfy this last condition, we would run into

trouble and spoil everything: we would meet sizes whose appurtenance is ambiguous, thus losing (1), and as a consequence of this, we would also lose (2) and (3).

The key point about the transitive groupings of light intensities, shapes, and sizes that preserve type identity for digital pictures is that they keep the differences in real magnitudes, which inevitably occur, well below some epistemically defined discrimination threshold. Accumulation of such differences is prevented by defining narrow ranges of objective properties and staying within those ranges to preserve the interchangeability of the magnitudes, and their transitive identity, *with respect to some epistemically defined need*. That need is defined by the discrimination system for which the picture is designed to function. In the absence of any such epistemic criterion, no form of type identity can be defined, because we would have no criterion on the basis of which to know which magnitudes to include in the transitive sets.

IV. CONCLUSION

The main conclusion of this article is that digital pictures, while they are not tokens of notational representational systems, are nevertheless allographic, because they can be type identical in respect of maximally determinate appearances (but also under other epistemic types). In other words, two digital pictures can be phenomenally identical in respect of color, shape, and size. For the reasons pointed out toward the start of Section III, this identity is not reducible to indiscriminability (construed as a similarity relation weaker than identity).

Even though the allographist has turned out to be right in holding that digital pictures are *types*, this account of digital pictures is very different from the one from which the allographist started out. Our initial atomistic intuition suggested that digital pictures are made up of properties from discrete orderings. But digital pictures are made up of shapes, colors, and sizes no less than other pictures; these are continuously ordered properties, and they still prevent digital pictures from being notational. Instead, what allows digital pictures to be type identical is that engineers manipulating analog properties have found ways to circumvent (not defeat) the problem of continuity by keeping variations in analog properties within noncumulable subphenomenal limits.

The technology that allows digital pictures to be allographic is not primarily the digital technology of binary-code representations, but the microtechnology and metrology that keeps differences in magnitudes within subphenomenal ranges. The role of binary-code representations is indirect: it allows the required subphenomenal information to be consistent and to be stored long enough for the picture to be reproduced. Subphenomenal discrimination, to a large extent, but especially consistency and storage, were not available when we could only reproduce pictures manually. Magnifying glasses could give us a degree of subphenomenal information, but neither consistency nor storage capacity. Without these, visual information, which is perception-dependent and short-lived, could not be preserved consistently until we got to act on the prospective copy, so phenomenal identity would be lost.

The conclusion that digital pictures are allographic because they can be type identical has repercussions for the concept of autography itself. It means that pictures are not *necessarily* autographic. If some pictures can be types, what is the difference between those that can and those that cannot? A distinction that would have been useful here to the autographist is that some pictures are notational, and only those pictures are allographic. But we have seen that digital pictures are not notational, so we cannot defend autography by using that criterion. On the other hand, what allows digital pictures to be types is not so much their dependence on binary-code representations as it is the technology that manipulates subphenomenal quantities. This, jointly with the fact that autography is not necessary for pictures, suggests that by using the same principles (defining transitive subphenomenal sets of sufficient objective conditions), it is possible to make type-identical paintings and analog photographs. In that case, we should preserve the distinction between notational and nonnotational representations, but abandon the distinction between autographic and allographic representations.

JOHN ZEIMBEKIS
Institut Jean Nicod, Paris
Department of Philosophy
University of Grenoble
Grenoble, France 38040

INTERNET: john.zeimbekis@upmf-grenoble.fr

1. Thanks to Dominic Lopes and Diarmuid Costello for comments, and to Denis Vernant, Olivier Massin, and Alexandra Athanasiou for discussions of related issues.

2. Nelson Goodman, *Languages of Art* (Indianapolis: Bobbs-Merrill, 1968), p. 136. In the relevant passage, Goodman in fact argues against the possibility of *knowing* that two objects are type identical ("character-indifferent").

3. Gregory Currie, *An Ontology of Art* (New York: St. Martin's Press, 1989), p. 87.

4. I adopt the convention of underlining types, but have made an exception for triplets of intensity values for colors (000, 000, 000) in order not to deform the text too much.

5. Non-density does not automatically imply either discreteness or disjointness. See Goodman, *Languages of Art*, p. 136n6, on discreteness and p. 137 on disjointness and finite differentiation.

6. Goodman, *Languages of Art*, p. 132.

7. "Finite differentiation neither implies nor is implied by a finite number of characters" (Goodman, *Languages of Art*, p. 136).

8. Goodman, *Languages of Art*, pp. 135–136.

9. Rosanna Keefe, *Theories of Vagueness* (Cambridge University Press, 2000), p. 112.

10. Similar arguments have been made in other contexts; for example, David Armstrong, *A Materialist Theory of the Mind* (London: Routledge, 1968), p. 218; Crispin Wright, "On the Coherence of Vague Predicates," *Synthese* 30 (1975): 325–365.

11. Goodman, *Languages of Art*, pp. 131–132.

12. Goodman, *Languages of Art*, pp. 131–132.

13. Armstrong, *A Materialist Theory of the Mind*, p. 218.

14. Nelson Goodman, *The Structure of Appearance* (Boston: Reidel, 1977), especially p. 210; Austen Clark, "The Particulate Instantiation of Homogeneous Pink," *Synthese* 80 (1989): 277–304, esp. p. 283; Frank Jackson and R. J. Pinkerton, "On an Argument Against Sensory Items," *Mind* 82 (1973): 269–272, esp. p. 270. What the relations are between Goodman's two works is an interesting issue that cannot be explored here; suffice it to say that I do not think that there is a contradiction between the early work's definition of qualia and the later work's insistence on autography for pictures.

15. Delia Graff Fara, "Phenomenal Continua and the Sorites," *Mind* 110 (2001): 905–935; Robert Schroer, "Matching Sensible Qualities: A Skeleton in the Closet for Representationalism," *Philosophical Studies* 107 (2002): 259–273; John Zeimbekis, "Phenomenal and Objective Size," *Noûs* 43 (2009): 346–362.

16. Since intensities are densely ordered, we cannot sharply define the limits of the region between and excluding F and G (there is no "last" intensity before G). Thus, by excluding F and G, we in fact exclude a zone of intensities; all we have to know is that a given intensity (for example, toward the middle of the region) is *not F*, and this is feasible for subphenomenal systems of measurement.

17. For a full explanation of how color continua can be generated artificially, see Clark, "The Particulate Instantiation of Homogeneous Pink."

18. Anand Kumar, *Fundamentals of Digital Circuits* (Delhi: Prentice-Hall India, 2006), p. 3.

19. It is conceivable that instead of disjoint groupings of intensities, sampling produces disjoint maximally determinate intensities. But this will not be feasible if intensities can differ infinitesimally, in ways that practical measurement methods cannot capture with perfect accuracy. In that case, each sample will be a tiny zone in reality, not a point or line.

20. Ambiguous intensities at the limits of the grouping can be included in it because the ambiguity that would matter (that which concerns appurtenance to the set *of which* the grouping is a proper subset) has already been pushed beyond the limits of the group.

21. The concept is from John McDowell, *Mind and World* (Harvard University Press, 1996), p. 171.

DAWN M. WILSON

Facing the Camera: Self-portraits of Photographers as Artists

Self-portrait photography presents an elucidatory range of cases for investigating the relationship between automatism and artistic agency in photography—a relationship that is seen as a problem in the philosophy of art. I discuss self-portraits by photographers who examine and portray their own identities as artists working in the medium of photography. I argue that the automatism inherent in the production of a photograph has made it possible for artists to extend the tradition of self-portraiture in a way that is radically different from previous visual arts.

In Section I, I explain why self-portraiture offers a way to address the apparent conflict between automatism and agency that is debated in the philosophy of art. In Section II, I explain why mirrors play an important function in the production of a traditional self-portrait. In Sections III and IV, I discuss how photographers may create self-portraits with and without the use of mirrors to show how photography offers unique and important new forms of self-portraiture.

I. AUTOMATISM, AGENCY, AND REPRESENTATIONAL ART

In the philosophy of art, discussions of photography recurrently feature versions of the idea that automatism stands in competition or conflict with artistic agency. "Automatism" is the notion that a photograph is the product of a nonconscious, natural, or mechanical process. This being so, it is supposed that a photograph is not primarily the product of an agent's conscious control, and it is inferred that an artistic agent can have only a limited or inhibited responsibility for the salient features of a photograph. The idea that scope for artistic intentionality is diminished by automatism

has been a basis for treating photographs as inferior to other art forms and remains a hurdle for evaluations of photography in the philosophy of art.

Art history can demonstrate that many artists have made advantages of automatism in photography to create works of art that feature chance, accident, abstraction, repetition, found objects, and effects of nonconscious control. Philosophers who acknowledge the significance of such works as art may nonetheless remain concerned that automatism presents a barrier to creating works that require manifest conscious intent: in particular, representational art. A picture is representational, it is argued, only if it displays the conscious control of the artistic agent in a way that guides the viewer's interpretation of the depicted subject.[1] The impetus to account for representational art explains why apparent conflict between agency and automatism is central to discussions of photography in the philosophy of art.

Various approaches might be taken to address this area of philosophical concern. One approach might aim to revise the requirements for representation, perhaps to recognize a lower threshold of artistic intent. An alternative could be to relegate the presupposition that representation is of paramount importance, as might happen if we were willing to judge photography on a par with sonic art rather than visual art. The most direct response would set out to refute automatism in order to make room for agency. My approach is not a direct response in any of these ways; in particular, I am not offering an argument against automatism. Instead, I aim to expand and reconfigure the philosophical debate by championing a perspective that has been insufficiently addressed. It is usual for photography to be investigated and characterized from the perspective of a perceiver

confronting a peculiar kind of visual object. In this vein, philosophers have debated whether a photograph is "transparent," whether it is a "spatially agnostic informant," and whether it provides perceptual access to objects and facts.[2] Theories of this kind often assume that photographs have distinctive and interesting properties because they are "mind-independent" images and are primarily the product of automatism rather than agency. To expand the field of inquiry, I make a compelling case for realizing that an account of photography should seek to accommodate, rather than exclude, the perspective of agents where they are involved in the production process. Thus, we would not just be interested in finding out "why the experience of viewing a photograph is different from viewing a painting"; we would also be interested in finding out "why the experience of posing for a photograph is different from posing for a painting"—just as one example.

Someone who believes that automatism in the production of photographs precludes artistic agency might seek to rule out my approach by arguing that the perspective of the creative agent cannot be treated as relevant; however, in my view, this prejudges the point at issue. The notion that automatism conflicts with agency retains intractable plausibility precisely because the concept of a photograph has been primarily theorized from the perspective of a viewer while "bracketing" and excluding the role of the photographer as epiphenomenal or conceptually irrelevant. When photographs are analyzed from the perspective of a viewer, a concession is commonly granted that any given photograph could have been produced without intentional agency: perhaps, it is said, the camera could have been triggered by accident, yet the photograph would still look exactly the same. This concession of a hypothetical possibility is too often rapidly converted into the idea that intentional agency can be "bracketed" from further consideration without loss. In fact, an artwork and its hypothetical "accidental" counterpart should not be considered interchangeable solely because they (could) appear the same from the perspective of a viewer: from the perspective of the photographer, there is a definite difference that cannot be ignored without loss. If philosophical investigations were primarily, or just equally, to incorporate the perspective of agents where these are in fact involved in the creation of photographs, the apparent conflict between agency and automatism

would not arise or become entrenched. My task is to show how giving credence to the perspective of photographers and their artistic activity is a substantive contribution to the philosophical debate.

To achieve this, in what follows, I investigate the tradition of representational self-portraits in the visual arts: the kind of self-portrait, roughly speaking, where we see a genuine likeness of the face or whole figure of the artist.[3] Self-portraiture is uniquely important for my purposes because in this art form, an artist self-consciously and self-critically explores her relationship with the medium in which she portrays herself. This is particularly true of self-portraits in which the artist portrays herself as an artist, though an artist may choose to portray entirely different aspects of her identity.[4] The self-portraits that interest me here are works that self-reflexively depict distinctive qualities of the artist, the medium, and the relationship between the two. In photographic artworks of this kind, automatism and artistic agency are explored and presented in ways that are open to philosophical scrutiny.

For example, in Edward Steichen's *Self-portrait* (1901), the artist has depicted himself in the traditional stance of a self-portrait painter, holding a brush and palette (Figure 1).

FIGURE 1. Edward Steichen, *Self-portrait* (1901). Gum bichromate print, image size: 21 × 15.9 cm (8 1/4 × 6 1/4 in.), mount size: 24.4 × 19.2 cm (9 5/8 × 7 9/16 in.), The J. Paul Getty Museum, Los Angeles.

Through his pose, Steichen is commenting that his artistry as a photographer involves no less skill than a painter, and through the softened chiaroscuro rendering of this self-portrait, he is also commenting on the distinctive artistic potential of his photographic medium: creative effects that are characteristic of the gum-bichromate printing process. During printing, the coated surface of the photograph is wet and malleable, and in many of his early works, Steichen achieved his creative effects by working on the surface with a paintbrush, leaving discernible brushstrokes. Steichen has produced a photograph that asserts itself as having a status equal to a self-portrait painting—both in terms of his own artistry and the artistic potential of the medium in which he works. However, this manifesto for pictorialism will not remove entrenched philosophical doubts about the problem of automatism in photography. Rather, this work is vulnerable to the objection that the photographer has relied on a painter's methods to exert appreciable conscious control over the appearance of his self-portrait.[5] Thus, it does nothing to dispel the skeptical idea that photography can only succeed as art when it aspires to the condition of painting. Despite his aim, Steichen, it could be argued, has failed to create a self-portrait as a photographer, though he may have created a self-portrait as a painter. I disagree and will return to this example after further discussion. Understanding the importance of the artist's perspective will make it possible to recognize how Steichen's self-portrait is a distinctively photographic artwork.

Many examples of self-portraiture in photography repay philosophical investigation either in specific respects or because they raise general questions. Addressing these examples has the potential to alter our conception of photography, but also our conception of self-portraiture. A passport photograph from an automated photobooth is, usually, simply considered to be a document rather than a self-portrait, yet artists such as Andy Warhol have created self-portraits from these machines. I consider in what sense these and other examples are traditional self-portraits and argue that the art form is extended rather than restricted by the automatism inherent in photography.

II. MIRRORS IN SELF-PORTRAITURE

Before examining photography, I note some significant points about the history of self-portraiture. Over many centuries, artists have successfully created self-portraits that display genuine likenesses of their own appearances even though it is not possible for an artist to directly see her own face. To achieve this, an artist must work from an intermediary visual image of her face, such as the image displayed on a reflective surface such as still water, glass, or polished metal. For several centuries, artists employed mirrors as an invaluable instrument for the art of self-portraiture. A flat mirror is a static, two-dimensional surface that displays, by reflection, a nonstatic, three-dimensional image. Alternatively, a concave mirror may produce, by projection, a nonstatic, two-dimensional image, displayed on a surface such as a wall.[6] Johannes Gumpp's *Self-portrait* of 1646 depicts the process of self-portraiture with a flat mirror, but in doing so it illustrates some of the intriguing challenges facing an artist who undertakes a work of self-portraiture as traditionally conceived (Figure 2).[7]

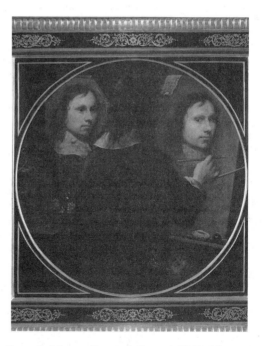

FIGURE 2. Johannes Gumpp, *Self-portrait* (1646). Oil on canvas. Galleria degli Uffizi, Florence © 2011 Photo SCALA, Florence, courtesy of the Ministero Beni e Att. Culturali.

Gumpp depicts himself as an artist standing in front of a flat mirror, painting his self-portrait on a canvas. The face of the artist is not directly visible, as we see him only from behind, but we judge from the fact that he is depicted as looking into the mirror that we are, on the left, seeing his genuine appearance and, on the right, seeing a self-portrait of his appearance.[8] Within the depicted scene the presence of a true likeness, displayed by the mirror image, guarantees that the self-portrait we can see is a good likeness of the face that we do not see. This is because, even though we cannot directly compare his face with the self-portrait, we can compare the self-portrait with the mirror image.[9] The depicted artist is using a mirror precisely because it is impossible for him to see his own face, but it is also impossible for the artist to see his own back, so we must assume that Gumpp's portrayal of his own figure from behind is an imaginary invention—unless, improbably, he worked from an additional mirror image that is not featured in the depicted arrangement.[10]

Matters are more complicated if we recall that a mirror image is three-dimensional and nonstatic. Gumpp is compelled to depict the mirror image by an image that is two-dimensional and static, with the result that his picture of the mirror image has the same visual properties as his picture of the painted image. To help to differentiate the two, he has carefully depicted a beveled frame on the mirror. Although the picture initially seems to present a familiar or plausible event, we need to appreciate that it presents an important fiction. The scene this depicts involves the fantastical possibility that a three-dimensional mirror image might be "frozen" as a static, two-dimensional image to serve as a totally accurate likeness of the artist's face. This fantasy has a long association with photography through the idea that a photograph is a kind of mirror image miraculously "arrested" and preserved.[11]

Mirrors occupy a symbolic and semi-mythical status in the history of the representational arts, as objects that can perfectly replicate appearances or create virtual doubles of real objects.[12] My interest is specifically to consider the function of mirrors in the production of self-portraits as the basis for talking about photography and photographs. To consider what is at stake in Gumpp's painting, imagine what would change if the static, two-dimensional image on the left did not depict

a mirror image, but another painted picture. Suddenly we would no longer have a guarantee within the depicted scene that the image on the left is a genuine likeness of the face that we cannot see. Equally, we could no longer be confident that the image on the right is a genuine self-portrait. Instead, all we would know is that the image on the right is a close likeness of the image on the left. Perhaps the artist is simply creating the reproduction of a portrait for a client.[13] A mirror image is radically different in kind from a painted image, and Gumpp's picture reveals what is at stake in this important difference.

An artist who portrays a person usually wants to actually see the features of that person, rather than work from a picture of those features. Although self-portraiture faces the unique obstacle already described, the same principle applies. It would be surprising if Gumpp were creating his self-portrait by copying from a portrait of himself by another artist.[14] In self-portraiture, an artist seeks to have the same kind of access to her own face as she has to the face of any other person whom she might choose to portray; this is why mirrors are invaluable: it is not possible to see my own face directly, but I can see my own face in a mirror.[15] An artist who uses a mirror as an intermediary visual image of her face is not working from a picture. A mirror may be positioned expressly for the purpose of displaying the artist's face, but this does not mean that the mirror displays a pictorial representation of the artist's face. A fortiori, the mirror image on its own is not a portrait or self-portrait.

I have noted that, because an artist cannot see her own face, mirrors are important in self-portraiture: a mirror makes it possible for the artist to create a likeness of her own appearance without recourse to a picture of her own face. In Section III, I examine the distinctive effects that artists have achieved by using mirrors in self-portrait photography.

III. SELF-PORTRAIT PHOTOGRAPHS WITH MIRRORS

Like Gumpp's painting, Ilse Bing's photograph *Self-portrait with Leica* (1931) depicts a complex three-way arrangement so that Bing can situate her self-portrait within a depiction of the production of that self-portrait (Figure 3).

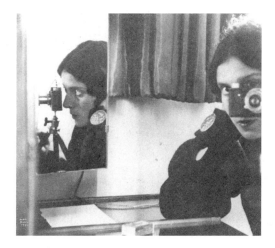

FIGURE 3. Ilse Bing, *Self-portrait with Leica* (1931). Gelatin silver print, 11 × 14 in. © Estate of Ilse Bing.

Like Gumpp's painting, this photograph has an intriguing structure. The photograph presents two images of Bing: on the left, we see a reflection of her profile in a mirror; on the right, we see her frontal self-portrait. It is usual for portraits to show a person's head either in profile or in a frontal position, but this self-portrait shows both alternatives simultaneously. In both cases we see a Leica camera in front of her face, though her face remains clearly visible. The image on the left strikes us immediately as mirror image, but it takes longer to notice that the image on the right is also a mirror image as the main mirror is not immediately obvious. A beveled edge of the main mirror, running down the left-hand side, makes it possible to grasp the full complexity of the arrangement. Bing has depicted the presence of two mirrors in this picture.[16] Like Gumpp's depiction of himself at work, Bing has created a photograph that portrays her own appearance and at the same time depicts her in the process of creating that photograph. However, whereas Gumpp's painting contained the imagined depiction of his figure from behind, everything depicted here has a double guarantee that it is a true likeness: first because everything we see in the picture is reflected in a mirror, second because the image we see is the product of a camera recording reflected light from the mirror.

To appreciate this point, we should note that the elements depicted in this arrangement play different roles. The small mirror is depicted to show Bing in the act of taking a photograph, using a shutter release cable; the Leica camera is depicted to show the photographic means of production of the image; and, thanks to its beveled edge, the main mirror is also carefully depicted. The inclusion of the mirror edge in the photograph entitles us to judge that most of what we see (except only the edge of the mirror) was reflected in the mirror surface.[17] We see this technique in many examples of self-portraits in painting as well as photography, but when it occurs in photography, the effect is particularly significant: under these conditions, we are in a position to judge that the camera has recorded its own reflection. In the case of Bing's self-portrait, we see both the face of the artist and the "face" of the camera: it is a double self-portrait. Our sense that the camera has produced a true likeness of its own appearance serves as a guarantee that the face of the artist is also a true likeness.

To consider the significance of this idea, imagine a different version of Bing's photograph. This time there is no evidence of the edge of a main mirror. We see only the small mirror image on the left and Bing with her camera on the right. Now, we have no signal to provide reassurance that the camera we see has recorded its own reflection. Instead, we could equally well imagine that the photograph was produced by a second camera— one that is not itself depicted in the photograph. Using a second camera, Bing would be able to portray herself as an artist using a Leica, but the Leica would not have created a photograph of itself. In a genuine example, when Gillian Wearing created a self-portrait in the guise of Diane Arbus, *Me as Arbus* (2008), the work is a double disguise: the face we see is not Wearing's own, and the camera we see is not the one used to create the photograph. By comparison, Diane Arbus's *Self-portrait with Mirror* (1945) makes it evident that the camera we see has recorded its own reflection by clearly including the edge of the mirror.

It is significant that although Bing portrays herself as a photographer creating a self-portrait, she is not taking a photograph with her left eye pressed to the viewfinder of her camera: rather, her right eye is clearly in view and her left eye also appears to the side of the viewfinder, above the "eye" of her camera. A photographer using the "Leica A" camera would be able to frame a photograph with right eye closed and left eye against the viewfinder. Bing is not looking at her own image through the camera, but rather gazing directly at the mirror in

front of her, having secured the camera position on a tripod. Arbus adopts a more direct version of this pose by appearing at the side of her camera, with face and body fully in view, displaying her pregnant figure. Like a painter creating a traditional self-portrait, each artist works with the mirror as an intermediary visual image to have conscious control over the way her appearance is depicted in the self-portrait. Bing has carefully adjusted her pose in the mirror to ensure that her own face is not obscured by the camera, and Arbus stands forward with the camera only half in view. This makes it clear to the viewer that the artist's conscious agency is depicted as the controlling influence in these self-portraits, rather than the camera mechanism.

Like the Steichen example, these photographs assert that the photograph is the product of artistic agency, but we must recognize that this is not sufficient to alleviate the philosopher's concern about automatism inherent in the production process. Later artworks, which also feature arrangements of the artist, camera, and mirror, reverse the impression given by the examples considered so far. Photography from the 1960s is marked by its departure from portrayals of the artist's agency and instead often presents photographs as the product of a mechanically automatized process.

One example, by John Hilliard, *Camera Recording Its Own Condition: (7 Apertures, 10 Speeds, 2 Mirrors)* (1971), explores the phenomenon of a camera repeatedly recording its own reflection in a mirror (see Figure 4). Another example, by William Anastasi, *Nine Polaroid Portraits of a Mirror* (1967), explores the phenomenon of a mirror repeatedly recording its reflection in a camera. In each case, the relationship between mirror and camera is exhibited as an automatic sequence of reflection, recording, and repetition, systematically arranged in a grid.

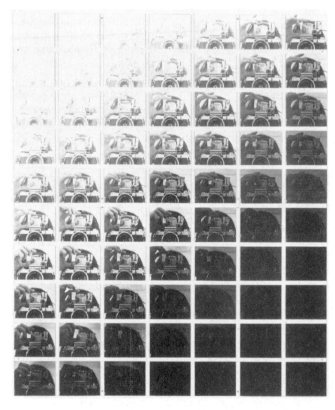

Figure 4. John Hilliard, *Camera Recording Its Own Condition (7 Apertures, 10 Speeds, 2 Mirrors)* (1971). B/w photographs on card, mounted on Perspex, 86 × 72 in. Collection of Tate Gallery, London. © John Hilliard.

In both examples the photographer is at least partially visible, but the works are not presented as ordinary self-portraits of the artist, and the titles instead indicate that the subjects of the work are, respectively, the camera and the mirror. Whereas Bing used a small mirror to show the artist controlling the camera, the small mirror in Hilliard's work is positioned to show the control settings on the camera itself. Anastasi, like Bing, initially makes his face visible around the side of the camera, but the accumulation of photographs in the sequence increasingly obscures his presence.[18] These artists have created the impression that the artist is present merely to assist the camera, rather than the other way round, as if the artist serves only as a shutter release mechanism in an otherwise automatic task.

Many philosophers have argued that photography is relevantly the product of artistic agency because the photographer is responsible for adjusting the camera settings, positioning the camera, and choosing the moment of exposure. A deeper philosophical concern is that even if the photographer is responsible for determining these variables, still the image is not handmade by the artist, but rather merely "selected" from a matrix of possibilities that could be automatically generated by the mechanism.[19] The grid format employed by Hilliard and Anastasi reinforces this anxiety and highlights the perceived gap between photography and handmade media such as painting or drawing. Unlike paintings, these images, we are invited to acknowledge, were principally generated by camera technology. The photographer makes selections or arrangements, but in these works that self-reflexively explore the production of photographs, automatism seems to overshadow agency. Nevertheless, the striking format of these works leaves us in no doubt that the viewer's interpretation of the depicted subject is guided by the conscious control of the artistic agent. In this respect, these conceptual works are not a departure from authored art.

The artworks discussed in this section stand in the framework of traditional self-portraiture, where an artist faces a mirror and creates a portrait of her own appearance.[20] I have focused on works that use mirrors to self-reflexively interrogate the means of producing a photographic self-portrait. The resultant photographs show the face of the camera, as well as or instead of the face of the artist.[21] I have shown that within this format, some photographers have created works that assert the primacy of the artist's agency. Other photographers have used the format to emphasize the automatism of photography. The philosophical problem of agency and automatism in representational art cannot be straightforwardly settled by appeal to these examples. Indeed, given the diverse ways that artists have critically examined the relationship between automatism and agency, art is a mirror for the problems raised in philosophical inquiry.

To investigate the relation between agency and automatism in photography, I propose to move away from the territory of traditional self-portraiture, which is overshadowed by the paradigm of painting. In the next section, I argue that automatism makes it possible for photography to offer an entirely new form of self-portraiture, a kind of artwork impossible in painting. These examples reveal a different understanding of the relationship between automatism and artistic agency.

IV. SELF-PORTRAITS WITHOUT MIRRORS

Nan Goldin included many self-portraits in her published collection titled *I'll Be Your Mirror*. *Self-portrait Battered in Hotel, Berlin* (1984) is a photograph using mirrors, taken in the self-reflexive style previously described. Goldin holds her camera at chest height, leaving her injured face clearly in view. To the right of the image we see the beveled edge of the main mirror, and the faces of Goldin and her camera are reflected a second time in a side mirror. Soon afterward, she produced a different photograph showing the extent of her recovery, *One Month after Being Battered* (1984). This time no mirror is involved. Goldin gazes directly ahead, face to face with her camera.

In contrast with Goldin's earlier image, the later photograph provides no signs, in content or title, to inform the viewer that it is a self-portrait. Unlike the other examples that I have considered, it is not a self-reflexive portrait of the artist at work, and the camera does not appear in view. We might consider it simply to stand in the tradition of head-and-shoulders self-portrait paintings, by Van Gogh and others, which contain no signs of painting equipment and do not depict the artist posing as an artist. However, although

the format may initially seem familiar, this ex-
ample illustrates a significantly different kind of
self-portrait. I have claimed that, historically, an
artist who seeks to represent a likeness of her
own face or figure requires an intermediary visual
image, such as a mirror image. Many examples
of self-portraiture in photography lie within this
tradition, but the arrival of photography did not
merely offer a new way to create traditional self-
portraits: it also made possible an entirely new
kind of self-portrait. With photography, for the
first time an artist is able to create a self-portrait
without looking at an intermediary visual image.
As the Goldin example shows us, an artist may cre-
ate a self-portrait by facing the camera and taking
a photograph.[22]

In her earlier self-portrait, Goldin is self-
consciously examining her appearance in the mir-
ror and using that intermediary image to pose
herself and compose her photograph. Sitting in
front of the camera, Goldin poses for the later
self-portrait without looking at an image of her
own appearance.[23] Though she has conscious con-
trol over the position, settings, and timing of the
camera exposure, the crucial recording stage of
the photographic process is a causal phenomenon
that produces visual effects outside her conscious
control.[24] Unlike any artist in the history of
painting, Goldin will be able to make surprising
discoveries about her appearance by looking at
her self-portrait.

Although Goldin's later self-portrait was not
created with a mirror, it stylistically resembles that
tradition of head-and-shoulders self-portraiture:
Goldin looks purposefully into the camera just
as she might otherwise meet her own gaze in the
mirror. The appearance that she presents to her-
self in this photograph is one that she could have
created by traditional methods of self-portraiture,
which is not to ignore that the viewer's response
is different when the image is a photograph rather
than a painting. For one thing, a painting from
a mirror often displays right–left reversal. Van
Gogh's *Self-portrait with Bandaged Ear* (1889)
portrays the artist with his right ear bandaged,
although in fact his left ear was injured.[25] The
same reversal occurs in Goldin's hotel mirror self-
portrait. By comparison, in Goldin's self-portrait
without a mirror, the large bruise around her
left eye is not a reversed image. In this photo-
graph we see Goldin portrayed as another artist

might portray her from direct observation, not as
she would portray herself by looking at her own
reflection.[26]

The examples considered so far have taken a
step beyond traditional self-portraiture, but still
do not sufficiently illustrate how radically pho-
tography expands the art form. What remains to
be considered is how automatism in photogra-
phy makes it possible to create a uniquely dif-
ferent kind of self-portrait. Far removed from the
gum-bichromate process favored by Steichen, the
camera technology favored by Andy Warhol in-
volved a high degree of machine automatism: Po-
laroid cameras and photobooths both offer an au-
tomated developing and printing process that is
designed to deliver a final product without fur-
ther intervention by the photographer. Warhol
produced a wide range of self-portrait images,
including photographs taken with a mirror and
photographs gazing into the camera lens similar
to ones already discussed.[27] Despite the casual
and experimental style, they are otherwise simi-
lar to traditional frontal self-portraits, but in *Self-
portrait (Eyes Closed)* (1979) he created a differ-
ent kind of image. With his eyes closed, Warhol
presents his face to the Polaroid camera and sub-
mits to its gaze without looking back. This example
shows that photography releases artists from de-
pendence on the mirror image in more than one
sense: an artist may choose not to look at a mirror
image while creating the photograph, but, more
importantly, an artist may create a self-portrait
that portrays a genuine likeness of her face that
it would be impossible for her to view even with
a mirror.[28] Photography gives the artist access to
otherwise inaccessible and unexpected features of
her own appearance in new and creatively signifi-
cant ways.[29]

The idea that photographs enable an artist to
portray herself in ways that are otherwise impos-
sible is a specific instance of a much wider no-
tion: photography provides ways of viewing the
world that are otherwise unavailable to human vi-
sion. However, as this is only possible insofar as
the production does not depend on the conscious
awareness of human agents, it allows doubts about
the status of photography as art to resurface. My
claim is that, with the automatism of photogra-
phy, an artist is able to create self-portraits that
would be impossible in traditional visual media.[30]
Whereas the appearance of a painting is governed

by how the artist sees or imagines her model and sees the work that she is creating, the visual appearance of a photograph does not depend on the conscious eye-to-hand control of a human agent. But for this reason Warhol's Polaroid is open to an objection that would reverberate against all works of self-portrait photography. The objection is that these photographs are not an extension to the category of self-portraiture because, simply put, they are not works of self-portraiture at all: they do not to a sufficient degree manifest the intentional agency of the artist portrayed. Certainly, the photographs feature a particular person and present a visual likeness that is interesting or revealing, but the artist who features in the picture has not consciously controlled the production of the image; rather, the appearance of the picture is the nonconscious product of the camera mechanism. As far as the viewer is concerned, this photograph could have arisen accidentally or could have been produced entirely independent of Warhol's conscious control.

The whole point of my present argument has been to show that an objection of this kind lacks credibility once we consider artworks like the ones already discussed. These self-reflexive self-portraits compel us to recognize that there is a significant difference between types of photograph according to all the relevant circumstances of their production, rather than simply facts about the degree of automatism in the technological apparatus. I have proposed that the perspective of the artist must be included as part of our concept of photography and photographs. This is not a matter of calculating to what extent the photographer personally handled the material or intervened at stages of the process. Instead, it is a matter of understanding that what the artist takes herself to be doing makes a manifest difference. An artist might take a Polaroid snapshot of her face as a simple record for the purpose of painting a self-portrait.[31] Alternatively, she might take a Polaroid snapshot of her face as a self-portrait. She sits in a photobooth one day to get a passport photograph and another day to create a self-portrait. The difference cannot be settled by appeal to how much conscious control is exerted over the camera settings, as this may be exactly the same in both counterpart cases. Rather, to appreciate the difference is to recognize that one of the defining conditions of a self-portrait is settled by whether

and how the artist is posing for a self-portrait. We see this in Figure 5, when, like Warhol, Gavin Turk faces the camera with his eyes closed for *Portrait of something that i will never really see* (1997).

FIGURE 5. Gavin Turk, *Portrait of something that i will never really see* (1997). C-Type print. 90 × 90 cm. Original in color. © Gavin Turk.

The title makes clear that this is a self-portrait conceived by Turk even though in fact the camera was operated by his collaborator Anthony Oliver. Posing for a self-portrait, which requires a distinctive form of self-scrutiny, is a different activity than posing for a portrait, or for a snapshot picture. A self-portrait requires not just self-examination, but a presentation of the self to itself. The automatism inherent in photography makes it possible to pose for self-portraits in radically new ways, and, crucially, even if the apparatus is an entirely automatic mechanism, this does not inhibit the artist's agency to pose in a way that creatively defines the image as a self-portrait. Instead, automatism is what makes it possible for an artist to have this distinctive form of creative self-awareness.

Francesca Woodman's *Self-portrait at 13* (1972) is a self-reflexive work that dissects the unique demands of posing for a photographic self-portrait (see Figure 6). The photographer depicts herself in the process of producing the self-portrait: a shutter release cable emerges in front of the lens and stretches diagonally across the frame into her hand, obscuring a corner of the scene. The strange, umbilical appearance of the foreshortened cable

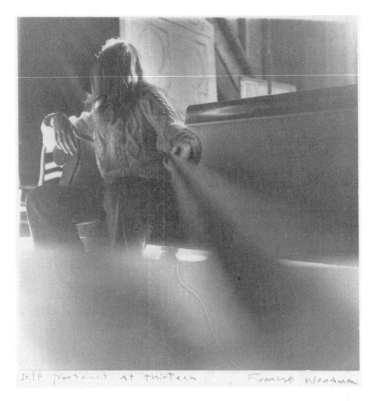

FIGURE 6. Francesca Woodman, *Self-Portrait at 13* (1972). Paper size 10 × 8 in. Boulder, Colorado. Estate ID/Filename: E.1. Courtesy of George and Betty Woodman.

reminds us that cameras can produce unanticipated optical effects, leading to distinctive features that we would be unlikely to see in a painting. The face of the subject is also obscured, this time because she has pointedly turned her face away from the camera and over her shoulder, leaving the camera to record the back of her head—a view that, like Gumpp, she is not able to see unaided.

Posing for a self-portrait in such an unusual way throws into question one of our basic assumptions about self-portraiture: the idea that by taking herself as her own subject, the artist is willing to subject herself to scrutiny. Instead, Woodman deliberately adopts a pose that disturbs these expectations: she presents the authorial control typical of a portrait artist and at the same time the uncooperative posture of a subject who is reluctant to be portrayed. She performs herself as a controlling artist and as an uncontrollable subject. The subject who refuses to be portrayed is also the artist who seeks to secure a portrayal. In a painting, no tension of this kind could be successfully sustained because a self-portrait cannot be created unless the subject (artist) carries out the task of painting what she sees. But Woodman's photography shows that an unresolved tension can be genuinely established: the camera mechanism will enable an artist to portray her subject, even when the artist (subject) is not granted the view of the subject that she intends to portray. Without automatism, Woodman would not be able to create this dual performance, and without her dual performance, this work would not be self-portraiture.

With the key importance of photographer's perspective in mind, it is time to reconfigure the philosophical attitude toward automatism and agency that casts doubt over Steichen's *Self-portrait*. Doubt might arise, I suggested earlier, because although this work evidently displays sufficient artistic intentionality to count as a self-portrait, it achieves this principally through painterly methods rather than by photographic methods. Certainly Steichen presented himself in the typical pose associated with a painter's self-portrait, a

pose that carries the preconception that he is viewing his appearance in a mirror. But I have argued that the difference between the pose of a painter and the pose of a photographer can be radically different in self-portraiture. Assume for the sake of argument, but also because it seems plausible, that Steichen is posing for this self-portrait without a mirror. Although his props symbolically indicate that he is posing as a painter, it is far more important that he is in fact posing, or presenting himself, for his self-portrait as only a photographer can do—facing the camera in full awareness that he is harnessing the automatism of the photographic process. The artistic intentionality that seemed evident and compelling at the outset has not altered, and thus we should be in no doubt that this self-portrait is a representational work by an artistic agent, but we should also see in the work the distinctive intentionality of a photographic artist.[32]

DAWN M. WILSON
Department of Humanities
Philosophy, University of Hull
Hull, HU6 7RX, United Kingdom

INTERNET: dawn.wilson@hull.ac.uk

1. The *locus classicus* for this argument is Roger Scruton, "Photography and Representation," *Critical Inquiry* 7 (1981): 577–603.

2. For an overview of these topics in current philosophical debate, see Diarmuid Costello and Dawn M. Phillips, "Automatism, Causality and Realism: Foundational Problems in the Philosophy of Photography," *Philosophy Compass* 4 (2009): 1–21.

3. Not every picture of a person is a portrait; a painter who depicts the likeness of a studio model may produce a picture of a dancer, rather than a portrait of that model. A portrait is a study of some particular person that intentionally portrays the personal qualities of that individual.

4. Self-portraits in the latter category include the portrayal of family identity, sexual identity, national identity, ethnic identity, and more.

5. Scruton's argument anticipates examples of this kind. He objects that representational works are not truly photographic artworks in cases where they are merely "the result of the attempt by photographers to pollute the ideal of their craft with the aims and methods of painting" ("Photography and Representation," p. 578).

6. This phenomenon is discussed in detail by David Hockney, *Secret Knowledge: Rediscovering the Lost Techniques of the Old Masters* (London: Thames and Hudson, 2006). He offers no examples of self-portraiture using this technique, and the arrangement required would be highly impractical.

7. I say "as traditionally conceived" because the technology was not available for earlier artists to work with a mirror of this size. Albrecht Dürer, working at the turn of the fifteenth century, would have used a relatively small hand-held mirror. See Cynthia Freeland, *Portraits and Persons* (Oxford University Press, 2010) p. 170; however, artists did not begin to depict themselves with their tools until the 1550s (p. 171).

8. The face on the right is both a depiction of a self-portrait and, we assume, a real self-portrait.

9. Norman Rockwell's *Triple Self-portrait* (1960) playfully employs this strategy to invite the viewer to judge how far the artist has departed from his appearance in the mirror when painting his self-portrait.

10. Martine Franck created a portrait photograph that in certain respects parallels the Gumpp painting: *Henri Cartier-Bresson Drawing His Self-portrait, Paris, France* (1992). We see Cartier-Bresson from behind, with his face reflected in a mirror, drawing a self-portrait.

11. In 1859, Oliver Wendell Holmes welcomed the invention of "the mirror with a memory": the photograph can make "a sheet of paper reflect images like a mirror and hold them as a picture" in "The Stereoscope and the Stereograph," *Atlantic Monthly* 3 (1859): 738–748, reprinted in *Photography: Essays and Images*, ed. Beaumont Newhall (New York: Museum of Modern Art, 1980), pp. 53–62.

12. The myth of Narcissus is a primary reference point in art-historical discussions of works that depict mirrors, particularly self-portraits. See, for example, Carol Armstrong, "Reflections on the Mirror: Painting, Photography and the Self-portraits of Edward Degas," *Representations* 22 (1988): 108–141.

13. This scenario is plausible for a second, alternative version of the same work titled *Self-portrait with Mirror and Easel*, Johannes Gumpp (1646). The alternative version, in an extended, rectangular format (128 × 90 cm), was until recently held in the Schloss Schönburg Gallery in Pockling, Germany, but is now in the hands of an anonymous owner. In the rectangular version, the face in the mirror and face on the canvas have a near identical appearance, reinforcing the notion that the painted image is a direct match for the mirror image. By comparison, in the circular version, held in the Uffizi Gallery, Florence, the faces differ in appearance. Most notably, the mirror image is depicted showing the artist meeting his own gaze by staring directly ahead in the mirror, whereas the face on the canvas is shown with eyes peering to one side, as he would appear when looking sideways in the mirror.

14. Surprising but not impossible: Paul Cézanne's *Self Portrait* (1880–1881) is based on, though not an exact copy of, August Renoir's *Portrait of Cézanne* (1880).

15. There is, of course, a significant range of examples by artists from Paul Cézanne to Chuck Close who use photographs rather than a mirror as the basis for painting a self-portrait. As my focus is self-portrait photographs, rather than paintings, I leave these cases to one side; however, I return to the issue briefly in the final section.

16. A print of the same work in the MoMa collection is titled *Self-portrait with Mirrors*.

17. Artists achieve this in numerous different ways. In *Self-portrait* (c. 1944), Man Ray reveals the existence of a mirror by photographing himself touching the reflective surface.

18. Rather than showing the edge of the mirror in view, Anastasi confirms the existence of a mirror by the device of pinning a photograph to its surface.

19. John Baldessari examines this conception of photography in the series *Choosing Green Beans* (1972).

20. I have also indicated that some works, such as Wearing's *Me as Arbus*, subvert this familiar format to produce disorientating effects. Jeff Wall's *Picture for Women* (1979) contains multiple cues to suggest that the photograph portrays the artist and his camera reflected in a mirror, yet closer examination reveals a deeply ambiguous structure that, according to David Campany, might not include a mirror at all. See David Campany, "A Theoretical Diagram in an Empty Classroom: Jeff Wall's *Picture for Women*," *Oxford Art Journal* 30 (2007): 7–25.

21. I have therefore not discussed a further range of interesting examples where an artist creates a self-portrait by photographing a mirror, but without making the camera visible. See, for example, Bill Brandt, *Self-portrait with Mirror* (1966); Nan Goldin, *Self-portrait in the Blue Bathroom* (1991).

22. Using a separate technique, numerous photographers have created self-portraits by photographing their own shadows. Notable examples include André Kertesz, *Shadow Self-portrait* (1927); Ansel Adams, *Self-portrait, Monument Valley, Utah* (1958); and Lee Friedlander, *New York City* (1966). These abstract silhouettes do not have sufficient visual resemblance to include them in the present discussion of representational art, though many are self-reflexive insofar as they show the shadow of the camera as well as the artist.

23. A photographer creating a self-portrait of this kind might decide to create a pose using a reflective surface—for example, by setting up a mirror behind the camera. More ingeniously, a mirror can be used to see the LCD display on the back of a digital camera while taking a self-portrait. However, the simple case is all that matters here.

24. For a full characterization of this distinctive causal process, see Dawn M. Phillips, "Fixing the Image: Rethinking the 'Mind-independence' of Photographs," *Postgraduate Journal of Aesthetics* 6 (2009): 1–22.

25. I am grateful to Susie Phillips for this example.

26. To achieve the same effect, painters might employ a double arrangement of mirrors to reverse the reversal. It is possible for a photographer to deliberately create—or equally to hide—a mirror effect by printing a negative in reverse. See Campany, "A Theoretical Diagram in an Empty Classroom," pp. 22–23.

27. For example, Andy Warhol, *Self-portrait with Polaroid Camera* (1979); Andy Warhol, *Grimace* (1979).

28. The earliest known self-portrait photograph is an example of this kind. Hippolyte Bayard, a pioneer of photographic technology, posed with his eyes closed for *Self-portrait as a Drowned Man* (1840).

29. Artists experimenting with x-rays and scanning technology offer an interesting extension of this point, but the focus of this discussion is limited to portrayals of visual likenesses.

30. It is possible to draw a close connection with a different "blind" process of self-portraiture, where an artist makes a cast of her face or body by taking a mold of her features. This comparison has links to André Bazin's idea of a photograph as a "mold" akin to a death mask, "The Ontology of the Photographic Image," in his *What Is Cinema?* vol. 1 (University of California Press, 1971), pp. 9–16, and it merits further discussion. However, for present purposes, I am concerned with the detailed visual likeness that is characteristic of two-dimensional photographs rather than the abstract form that is characteristic of three-dimensional cast sculptures.

31. According to Stephen Peterson, the photobooth images Warhol created between 1963 and 1966 were not originally exhibited as self-portraits in their own right, but used as the basis for silkscreen works. See Stephen Peterson, "Review: I Am a Camera," *Art Journal* 60 (2001): 110–112.

32. I am grateful for written comments received from Diarmuid Costello, Jason Gaiger, Margaret Iversen, Katrina Mitcheson, Olivier Tonneau, and Jonathan Wilson. I am indebted to St. Anne's College, Oxford, for appointing me to a Post-doctoral Research Fellowship in 2010–2011.

RICHARD SHUSTERMAN

Photography as Performative Process

I

Photography pervades our lives. Its multiple and wide-ranging roles make it not only ubiquitous but also immensely diverse. There are photo IDs, all sorts and styles of advertising images, documentary shots of news and sports events, criminal "wanted" posters, scientific photographs to serve either as heuristics in the process of discovery or as evidentiary tools for proof and teaching, portrait shots of individuals, families, or other groups (including school or conference pictures), candidly intimate photos reserved for someone special, personal travel photos (now typically in digital form and shared with friends through some Internet network), and then there is art photography, which is what concerns me here and which constitutes a diversely mixed genre in itself.

A distinctively modern art (one not to be found in Hegel's famous nineteenth-century classificatory rankings), photography's association with newness is not merely temporal, but indeed reflects a tendency toward continuing innovation. Its original photochemical film technique engendered new forms such as movies and videos, but it also led to the new varieties of digital photography that dispense with the photochemistry of film and instead use sensors that convert light into electrical charges that are then digitally analyzed and converted back into images. Photography's artistic uses display continuing innovation, such as the distinctive trend that began in the late 1970s of creating very large-scale photographs expressly meant for posting on the gallery wall and typically "summoning a confrontational experience on the part of the spectator that sharply contrasts with the habitual processes of appropriation and projection whereby photographic images are normally received and consumed."[1]

Heterogeneity and novelty are familiar themes in theorizing photography. Faced with its intractable diversity (that he described as an "unclassifiable" "disorder"), Roland Barthes wondered whether photography had an essence but then argued that its "essence . . . can only be (if it exists at all) the New of which it has been the advent."[2] Walter Benjamin even more influentially characterized photography in terms of its transformational novelty. Besides generating the further novelty of cinema, photography's powers of mechanical reproduction "transformed the entire nature of art" by shifting art from its original essentially ritualistic use (with its auratic cult value of the authentic original) to an "absolute emphasis on its exhibition value" instead. Moreover, its automatic mechanism of capturing attractive, accurate pictorial images likewise removed the traditional need for skilled artistic hands to create them: "For the first time in the process of pictorial reproduction, photography freed the hand of the most important artistic functions which henceforth devolved only upon the eye looking into a lens."[3]

Given such heterogeneous and innovative tendencies, I dare not presume that there must be a distinct and permanent essence of photography whose identity it is my duty as theorist to define. If there is such an essence, I hope this article will shed light on it, but my purpose here is rather to highlight a dimension of photographic art that has been largely neglected but that can constitute the locus of real aesthetic experience and value. This dimension concerns the performative process of making a photograph of a human subject and the sorts of artistic performances and aesthetic experiences that this process involves.[4] These performances and experiences have a clearly somatic aspect that I initially failed to recognize despite my

interest in developing a somaesthetic perspective on art.[5] There is likewise a salient dramatic dimension to the photographic performative process that also escaped me, despite my having advanced a general theory of art as dramatization.[6] The import of these somatic and dramatic aspects of photography only recently became evident to me through collaborations with photographic artists and curators interested in somaesthetics.[7] I then realized that photography's dimension of somatic, dramatic, performative process (and its potential for enhanced artistic use and aesthetic experience) is occluded by our one-sided concentration on the photograph itself (a static object), with which we tend to identify photographic art.

I argue, however, that an important distinction can be made between photography and the photograph.[8] Although the photograph (whether in hard-copy print or in digital display) is surely the standard end product of photography and conventionally recognized as the goal and work of photographic art, there is more to photography than the photograph. To appreciate this distinction and see that the photograph and its aesthetic perception are only part of a larger complex of elements that constitutes photography as an activity and as an art, we first need to examine these other elements, which include the photographer, the target that he photographs, the photographic equipment, and the spatiotemporal context or scene in which the target is posed and photographed. In reducing photography to the photograph, we diminish its aesthetic scope and power by limiting the elements that can manifest artistic value and provide aesthetic experience. Moreover, as the essential meaning of the photograph (at least in philosophical discussions) often gets reduced to the object photographed, so reducing the aesthetics of photography to the photograph risks reducing it to the aesthetics of an object (that is, the real-world referent) actually outside the photograph, hence allegedly beyond photography, and this would leave the aesthetic value of photography gravely in question.[9]

Given the diversity of photographic art, I limit my analysis to photographic art that takes a knowing, voluntary individual human subject as its photographic target. By that I mean a human subject who is both aware that she is being photographed and is also willing to be. In articulating key elements of the artistic photographic process, I suggest how some of them can display significant aspects of artistic creativity and aesthetic experience. These can be manifested not only in the photographer's mise-en-scène of himself, his camera, and his subject within the photographic context and process, but also in the photographed subject's posing, self-presentation, or self-styling before the camera within the mise-en-scène of the photographic situation and in critical communication with the photographer. Indeed, if communicative expression in artistic creation contributes significantly to the value of aesthetic experience, then the communicative interaction between photographer and subject in the process of setting up and taking the shot could provide a rich source for such experiential value.

Why have these aesthetic aspects of photography as process been neglected? It is not enough to posit our one-sided preoccupation with the photograph as the sole explanation of this neglect, because that preoccupation may itself be partly the result of other reasons that discourage attention to photography as performative process. I therefore devote a brief concluding section to discussing those other reasons.

II

In its simplest form, the photographic situation treated here involves a photographer, a human subject who knowingly and willingly serves as the photographic target, the camera (with its necessary accessory photographic equipment), and the scene or context in which the photography session takes place.[10] What I wish to highlight as the photographic process of performance is essentially what goes on in the process of setting up, preparing, and taking the photographic shots in a photography session. Although the technique of film photography involves the further process of developing the film to produce a negative (or positive) image, this procedure does not involve the artistic process and interaction between photographer and subject whose neglected aesthetic potential I explore in this article.[11] For the same reason, although art photography also includes the subsequent critical process of selecting which shots are worth exhibiting and what the best ways to mount or show them are, I do not discuss that process here but instead focus on the aesthetic experience of photography before the existence of the photograph that is its product.

i. Taking a photographic shot, like any action we perform, always involves some bodily action. At the bare minimum one must use a body part to activate the camera's shutter release, usually by an action involving one's fingers. But there are obviously further somatic skills, like properly steadying the camera in one's hands to ensure a clear shot and also being able to maneuver effectively one's photographic equipment along with one's own bodily position, posture, and balance so that one can best aim the camera to get the desired optical image. Taking a picture is a bodily act that requires a certain effort and competence of somatic self-use, despite the advertising myth that photographic technology is so magically simple that even a child or dumb brute can produce an excellent photo. This need for somatic skill despite photography's mechanical magic is comically thematized in Buster Keaton's *The Cameraman* (Edward Sedgwick, 1928), where the hero clumsily struggles with his photographic equipment, knocking out windows and doors with his tripod, while his pet monkey manages to load and aim the camera with considerably less clumsiness and more success, producing some excellent footage of fighting in New York's Chinatown.

In real life, I have witnessed many comic instances of the photographer's need for somatic control and awareness, such as friends losing their balance and falling off a curb or into a pool as they backed up to get a better shot, eyes locked on the optical image in the camera, hands tightly grasping the camera itself. Some people like photography but dislike taking pictures because of its somatic constraints; they prefer having their hands unencumbered and their gaze free to survey the horizon rather than narrowly fixed on a small aperture or screen held in their hands. There are good evolutionary reasons why one would instinctively want to have one's hands free for action and one's gaze free to survey the horizon and thus more readily able to identify friends, prey, and predators at a distance. Though many people, on the contrary, love to use cameras and feel empowered by wielding them, it is obvious that handling, looking through a camera, and taking a good shot involve sensorimotor skills that need to be learned. Some people need considerable practice to master the control of breathing and steadiness of hands to keep the camera firmly fixed to take a clear picture, and some never master it.

Because we typically associate somatic effort with large and strenuous movements, we are apt to ignore the sort of somaesthetic skills of fine-motor control that are involved in mastering the art of operating a camera, even in everyday snapshots. Moreover, in certain kinds of art photography, the photographer's somatic efforts can be much more demanding.

Besides the somatic skill of controlling one's camera, posture, and balance, there is also the photographer's skill in winning the confidence of the person photographed. This is important for making the subject feel more comfortable and cooperative rather than guarded and ill at ease, thus rendering her more suitable for photography's dominant dual aims of not only portraying the real, but also producing aesthetic objects and experiences, even from people who in real life are painfully unattractive. Susan Sontag thus praises Diane Arbus's frontal photographs of "freaks and pariahs" for capturing "subjects . . . one would not expect to surrender themselves so amiably and generously to the camera. . . . To get these people to pose, the photographer has had to gain their confidence," and this requires social skills that also have a somaesthetic dimension.[12] For instance, the photographer's body language must not be threatening; it must be friendly, even in a way intimate, but not intrusive. Her somatic style needs to display a quality of keen attentiveness and interest regarding the person photographed (even if that attention and interest are merely transitory and professional and thus not really genuine in a substantively ethical sense). This quality of attention and interest, somaesthetically projected by the photographer and perceived by the subject (often only implicitly by both parties), will be displayed in posture, gesture, and facial expression.[13]

The photographer's expression of sympathetic, attentive interest is not simply necessary for putting a subject at ease, but further aids as a stimulus in engaging the subject's own attentive interest and heightened focus on the photographic situation or event. It is as if the photographer's quality of attention and presence infects the photographed subject as well, thus raising her quality of presence that can then be captured in the resulting photograph, a presence that transfigures even ordinary faces into beautifully expressive ones. The masterful Richard Avedon describes this process of contagion where the subjects come to him "to be photographed as they would go to a doctor

or a fortune teller—to find out how they are" and in the hope of feeling better through the transfigurative experience of self-exposure before a charismatic observer:

I have to engage them. Otherwise there's nothing to photograph. The concentration has to come from me and involve them. Sometimes the force of it grows so strong that sounds in the studio go unheard. Time stops. We share a brief, intense intimacy. But ... when the sitting is over ... there's nothing left except the photograph ... the photograph and a kind of embarrassment.[14]

This experience of deeply felt and focused communicative expression structured through the mise-en-scène of the photographic process is a form of aesthetic experience whose transfiguring intensity can indeed leave its participants embarrassed once the drama of the shooting is over and they return to their everyday selves and routine.

Of course, photography that seeks veracity and drama by catching its subject up close yet totally unaware involves an altogether different sort of photographic skill. Its secrecy generally includes a dimension of somatic virtuosity in order to keep the camera (or at least its use) concealed. Think, for example, of how Walker Evans secretly took his close-up, frontal shots of New York subway passengers, "with the lens of his camera peering between two buttons of his topcoat," so that he could catch them unaware that they were being considered as photographic objects and thus capture a look free from any posing, posturing, or self-consciousness. Some prefer such candid shots; others find them ethically suspect. But there is little doubt that people display a different demeanor when they know they are being photographed, and often there is something awkward, artificial, or false about it.[15]

ii. Overcoming the awkwardness of posing also requires from the photographic subject a certain talent or effort, no matter how skillful the photographer is at making his subject feel natural and uninhibited in exposing herself to the camera. Barthes poignantly confesses his own complex problems as a posing subject. On the one hand, as soon as he knows that he is "observed by the lens," Barthes feels the need to reconstitute himself "in the process of posing. ... I instantaneously make another body for myself, I transform myself in advance into an image."[16] On the other hand,

Barthes knows his image will ultimately be controlled by the photographer and the photographic equipment, so there is the added anxiety of having no real control of the self that will emerge from his creative posing, "the anguish" of not knowing whether one will be reborn as an "antipathetic individual" or "a good sort"; and this anxiety exacerbates the discomfort or awkwardness of posing.[17]

A further difficulty is how to organize oneself somatically in the pose to achieve the look one wants to convey. It is not easy to control one's facial and postural expression, especially when one cannot use a mirror but must instead rely only on proprioception. Barthes provides a wonderful description of this effort to strike the right pose: "I don't know how to work on my skin from within. I decide to 'let drift' over my lips and eyes a faint smile which I mean to be indefinable, in which I might suggest, along with the qualities of my nature, my amused consciousness of the whole photographic ritual."[18] For Barthes, there are two essential and discomforting paradoxes in the act of photographic posing or self-presentation. First is the desire for the photographic image to "coincide with my ('profound') self," while knowing that "'myself' never coincides with my image"; the "Photograph is the advent of myself as other."[19] Second, the posing subject is made into an object, not only in the actual photographic print but in the very process of objectifying oneself before the camera, by representing or reshaping oneself through one's pose. Such a process, Barthes confesses, makes him "invariably suffer from a sensation of inauthenticity, sometimes of imposture."[20] "I am neither subject nor object but a subject who feels he is becoming an object."[21] Such feelings make it difficult to achieve an attractive pose.

The subject who poses for a photograph therefore has an important aesthetic role to perform: to escape these feelings of inauthenticity and render her pose less awkward, forced, and false or, to put it positively, to render herself more photographically attractive by being more vitally or authentically present. Though Barthes himself lacked this skill, he recognized it in his mother, a skill in posing through which "she 'let' herself be photographed" in a free and natural way that would suggest her "essential identity," even when the different photographs did not fully capture it: "she triumphed over this ideal of placing herself in front of the lens (an inevitable action) with *discretion* (but without a touch of the tense theatricalism of humility or

sulkiness).... She did not trouble with her image, as I do with mine: she did not *suppose* herself."[22]

Knowing the camera's power to make a permanent and widely reproducible image, the person at whom the camera is directed instinctively recomposes his image, transforms his expression or posture, and typically arrests his movement in order to strike an effective pose. He stylizes himself, even if only minimally and barely self-consciously, for the camera. Barthes laments this posing effect as a betrayal of personal identity, as the objectifying of a subject, as the transformation of an indefinable essence of lived, inner identity into a frozen external image that traps and stifles his felt flow of subjectivity. But the problem here (as Barthes almost seems to recognize) may be that he takes himself or his identity too seriously and essentially. With a more creative, fluid attitude, one can see the camera's invitation to pose as an opportunity to create a new look, a new posture, a new element in the construction of the self whose identity is not a fixed essence but an ongoing project whose continuous construction can either reinforce habitual modes of being or creatively seek new ones. In some forms of art photography, the subject can be creatively spurred to creative self-fashioning, to experiment with different poses, costumes, expressions, attitudes; and the special situation of an art photography session provides a circumscribed, protected stage to try out such experiments and then resume one's habitual modes of being and self-presentation if one prefers them (or requires them) for dealing with the needs of everyday life.

For purposes of analysis, I have separately articulated the somaesthetic skills and aesthetic experience of photographer and subject. But as the discussion of Arbus and Avedon has already suggested, the somatic comportment and aesthetic experience of photographer and subject (though obviously distinguishable and often very different) cannot be completely separated because what is involved is an essentially communicative, participatory process, an interactive dance of pose and gestures, even if the subject's movement is confined to positioning of the head and facial expressions. In cases where there is excellently empathetic communication, subject and photographer can inspire each other toward creative improvisations in the mise-en-scène and realization of the shot, and they can thus enjoy a powerfully shared aesthetic experience of creativity, a pleasurable harmony of understanding, even a sense of intimate collaborative expression. I suspect that there are implicit hints or diminished analogues of such feelings in the participatory pleasures of snapshots in everyday popular photographic art. In the hurried, pressured flow of life and its hectic activities in which individuals are bent on achieving their own ends and meeting their duties, one pauses and poses for a photographic moment while one's companion (in tourism, in partying, in business or family affairs) also pauses and concentrates her attention on making the best of this shared moment by taking a snapshot that both she and the posing subject (or subjects) can enjoy. The performative process of photography provides a heightened, framed moment of enjoying something together and underlying that sharing by an intentionally collaborative creative act that witnesses it.

iii. The camera is the essential element in the photographic situation that turns the encounter between photographer and the voluntary subject into a scene of posing that so often renders the subject ill at ease despite her willingness to be photographed. This is not merely the feeling of wanting to project a certain look to the public, to be seen by others in a specific way that may not be precisely the way one actually is or feels at that moment. Such a desire is present in many kinds of social situations where we perform the role playing of self-presentation in everyday life without feeling especially self-conscious. But the camera thematizes this self-presentation, making it explicit by focusing on framing a particular moment of such self-presentation and fixing it in a permanent image that objectifies and defines the self in terms of that experiential moment, an image that can be indefinitely reproduced and circulated as a representation of what the self really is.

The camera thus creates a particular pressure of posing not only because it typically requires the subject to arrest her movement (or at least control it) to ensure that her image is captured clearly but also because it raises the stakes of one's self-presentation by harboring the threat of permanently representing the self as an object in ways that the self as subject may not want to be represented or defined. Though experience itself is elusively evanescent and significantly subjective, the photograph has the powers of durability, fixity, and objectivity that belong to real physical things.

These powers constitute one reason why the experiential process of photography is obscured by the photograph as object. In thus framing a real moment and giving it permanence, public representation, and wide-ranging reproducibility and circulation, the camera intensifies or magnifies that moment; it dramatizes it in precisely the way in which I argue that all art dramatizes things by putting them in an intensifying frame and thus giving them a sense of heightened reality or vividness.[23]

iv. The performative process of having a subject pose for the camera always involves posing that subject in some setting—a situational or environmental background that, if successful, can enhance the interest and quality of the photographic act and resulting photograph. Important situations (such as a wedding or a funeral) can give special meaning and gravitas to a work of photography and provide a characteristic background with relevant props imbued with situational meaning. If the posing subject can be likened to an actor, then determining the background can be likened to stage setting. If the photography studio offers only a limited range of situations and backgrounds, then it compensates by providing better control of the settings it does provide (for example, by regulating conditions of light and temperature and preventing excessive noise, crowds, or other factors that would interfere with producing a desired image of the subject). Here again, in the choice and regulation of situations or backgrounds, there is considerable room for aesthetic mise-en-scène—an artistic dramatization that intensifies experience through formal framing or stage setting well before the photographer decides to release the mechanism that produces the photograph.

III

Besides our preoccupation with the photograph as object, other factors contribute to obscuring the aesthetic significance of photography as performative process. First, the automatic mechanism involved in making a photograph—the fact that pressing the release of the camera shutter requires no special skill or thought and that the camera mechanism automatically does all the rest to produce a realistic photograph—diminishes the sense of photography as a performance achievement.[24] Thus, Susan Sontag speaks of "the effortlessness of picture-taking, which must be the sole activity resulting in accredited works of art in which a single movement, a touch of the finger, produces a complete work."[25] The instantaneous act of shutter release likewise suggests that there is no sustained duration of effort involved as one would expect in a performative process.[26] These reasons, however, neglect the complex performative process that occurs *before* the shutter release and the camera's ensuing mechanism of producing the photographic image. But that prior process—involving the mise-en-scène performative activity of the photographer and the posing subject—is necessary for achieving the desired optical image in the camera lens that one then seeks to fix in the photographic image.

The fact that this performative process is ontologically complex and difficult to demarcate in its experiential dimensions provides further reasons for its neglect. The process is complex in that it involves the action and thought of both the photographer and the subject; it is difficult to define not only because it involves the elusive experiential flow of these two subjectivities but also because its physical actions of positioning and posing are typically performed without a formal script or scenario that defines the mise-en-scène, clearly demarcating its essential components and structure.[27] Moreover, as an experiential event, the performance is transient and cannot strictly speaking be perfectly repeated, if we admit that the subject's expression and state of consciousness (if not also the photographer's posture and feelings) will always change in some way, even if only through the recognition that one is repeating the mise-en-scène of a prior shooting. Though the photograph documents in some way the performative process through which it is engendered, it only documents a particular moment in that process and does so from a particular angle and in terms of its visual qualities. But the performative process itself includes also other sensory, semantic, and affective qualities that have aesthetic import and whose resources for aesthetic experience in photography should not be ignored.

Still another likely reason for such neglect is that the photographer and the subject—who are the best (and often the only) candidates for observing and appreciating the performative process—may be too absorbed in performing the process to pay proper attention to its aesthetic qualities and potential. Because our powers of

consciousness are limited, the efficacy of actions is often harmed if we also pay distinct reflexive attention to the precise feelings that we have or the qualities that we experience in performing those actions. So it is understandable for photographer and subject to execute the performative process without thematizing its actions and qualities in explicit, reflective consciousness, even if they implicitly feel them and use them to guide and inspire their performance.

If such "parsimony of consciousness" is a psychological commonplace, it has an analogue or a corollary in the familiar notion of aesthetic distance—namely, that a certain psychological distance or detachment from an object or event aids the appreciation of its aesthetic features. When one is in the performative moment, one is by definition very close to it; when one is looking at a photograph, one is by definition distanced from the real moment taken by the photograph, a moment that has already passed or died. "Aesthetic distance seems built into the very experience of looking at photographs," writes Sontag.[28] For such reasons, she and Barthes link photography very closely with death. "All photographs are *momento mori*," Sontag claims: "To take a photograph is to participate in another person's (or thing's) mortality.... Precisely by slicing out this moment and freezing it, all photographs testify to time's relentless melt."[29] For Barthes, because the photograph presents "the absolute past of the pose," it constitutes "an image which produces Death while trying to preserve life."[30]

The history of photography's theoretical reception provides two other reasons for neglect of its art of performative process. From the outset, photography was seen as an analogue and rival to the art of painting. If Baudelaire described "the photographic industry [as] the refuge of every would-be painter, every painter too ill-endowed or too lazy to complete his studies," and thus "art's most mortal enemy," others defended photography for liberating painting from the duty of mimetic exactness that the photograph could more easily and better provide instead.[31] As painting is grouped with the nontemporal, nonperformative arts, whose end product is a flat object portraying a two-dimensional image and is immediately grasped without unfolding in time, so photography (through association with painting) came to be identified entirely with its two-dimensional end product or photograph as object

while its performative, temporal dimension was neglected.

We should recall, however, that photography's early history had strong links to theater as well as to painting. Daguerre, an influential photography pioneer in Paris, "was running a panorama theater animated by light shows and movements in the Place du Château" when he began his photographic work, while Baudelaire condemned photography for "committing a double sacrilege and insulting at one and the same time the divine art of painting and the noble art of the actor."[32] To dismiss photography's performative, dramatizing process as not really belonging to photography per se but instead pertaining merely to theater is not only wrong historically—it errs conceptually in presuming that photographic art exists in a pure form, unmarked by other arts that helped engender it.

Walter Benjamin's influential views on photography, as formulated in his most famous and oft-cited essay "The Work of Art in the Age of Mechanical Reproduction," can generate a further line of reasoning for theory's ignoring the aesthetics of photography's performative process while focusing on the photograph as the sole site for photography's aesthetic experience. Benjamin (whom Sontag describes as "photography's most original and important critic") argued that photography's epoch-making transformation of art through mechanical reproduction involved changing art's essential nature from cult value to exhibition value.[33] If art originally emerged from "magic" and religious ritual "with ceremonial objects destined to serve in a cult" whose transcendent quality imbued artworks with an elevated sense of "aura" and "unique existence," then photography (as "the first truly revolutionary means of reproduction") "emancipates the work of art from its parasitical dependence on ritual" and "the unique value of the 'authentic' work" that has its role in ritual or cultic use, for "to ask for the [one] authentic print makes no sense."[34]

Art's essential nature, Benjamin claims, was therefore transformed from emphasizing "cult value" (where the work could serve effectively even when hidden from view but recognized as being kept in its hallowed place) to instead emphasizing "the exhibition value of a work," because the work's "fitness for exhibition increased" through photography's new powers of "mechanical reproduction."[35] What gets widely exhibited

through such mechanical reproduction is the photographic print (or now, ever increasingly, the digital photographic image). So if art has essentially lost its function as ritual (which is a performative process), but instead is constituted by an "absolute emphasis on exhibition value," then one might argue that the art of photography should be identified with the photograph (where exhibition value is manifest), while its performative, experiential process (rarely exhibited and, in its inner experiential dimensions, difficult to exhibit) should be conversely dismissed as irrelevant or anachronistic.[36]

Despite the apparent force of this argument, there remains a distinctive ritualistic element in photography. Many ritual events (weddings, graduations, baptisms, conference meetings, award ceremonies, and so on) expressly include the taking of posed pictures that serve not simply to recall the event in future times, but also to mark out and heighten the current moment as one worth savoring in present experience by putting that moment in a formal frame or mise-en-scène that dramatizes its qualitative presence and meaning. Though serving as the relentless motor of exhibition value, photography still displays a ritual dimension of performative, dramatizing process. Is it mere coincidence that contemporary cultures still strongly shaped by rich aesthetic traditions of ritual (such as Japan's) display an especially strong tendency to perform the process of taking photographs with a dedication and style suggestive of ritual performance?

Moreover, a closer look at Benjamin's views on photography reveals that he indeed recognized the photograph's power to maintain art's auratic "cult value," for instance, in "the cult of remembrance of loved ones, absent or dead."[37] In an earlier, less familiar essay explicitly devoted to photography, he insists on this "magical value" and "auratic appearance," affirming that the portrait subjects of "early photography" indeed "had an aura about them."[38] But this was destroyed when photography was "invaded on all sides by businessmen" who, "more concerned with eventual saleability than with understanding," pandered to "changing lights of fashion" and reduced the experienced time and absorption of posing toward the momentary "snapshot." Benjamin also praises early photography for the way it required its subjects "to live inside rather than outside the moment" of the photographic shoot: "During the long duration of these shots they grew as it were into the picture and in this way presented an extreme opposite to the figures on a snapshot." And this absorption of the subject, Benjamin further suggests, had a counterpart in the photographer's absorption and his ability to make his subjects feel comfortably "at home," for example, by deploying the camera with "discrete reserve." If Benjamin gives the impression that such early photography provided a profound, sustained experience of performative process, then this kind of experience could still be available today if one only took the time, care, and effort to develop this dimension of photographic art.

I close this article by cautioning against two possible misunderstandings. In arguing that there is more to photography than the photograph and that photography can be aesthetically appreciated as performative process, I do not mean to neglect or diminish the undeniable aesthetic importance of photographs. Photography is a mixed art serving multiple ends, and its diverse values are best appreciated in a framework of pragmatic pluralism. Second, I do not believe that photography is unique among the arts in offering an aesthetic experience not only of its standard artistic end product but also of its creative process. Portrait painting provides a very clear analogue of the sort of collaborative performative process that I have described in photography, and, in fact, it seems in some ways somatically far more demanding on both subject and artist, which may be why some artists now prefer to paint from photographs of their subjects. To highlight a neglected aspect of the art of photography is not to erect that aspect into the distinctive, defining essence of that art, if it indeed has one.[39]

RICHARD SHUSTERMAN
College of Arts and Letters
Florida Atlantic University
Boca Raton, Florida 33431

INTERNET: shuster1@fau.edu

1. Jean-François Chevrier, "The Adventures of the Picture Form in the History of Photography," trans. Michael Gilson, in *The Last Picture Show: Artists Using Photography, 1960–1982* (Minneapolis: Walker Art Center), exhibition catalogue curated by Douglas Fogle, pp. 113–127, at p. 116. Michael Fried cites and develops Chevrier's insight in *Why Photography Matters as Art as Never Before* (Yale University Press, 2008). Susan Sontag claims that earlier

"the book has been the most influential way of arranging (and usually miniaturizing) photographs," in her influential *On Photography* (New York: Farrar, Straus and Giroux, 1977), p. 4.

2. Roland Barthes, *Camera Lucida: Reflections on Photography*, trans. Richard Howard (New York: Hill and Wang, 1981), p. 4. Later, however, when Barthes focuses his discussion of photography on the photograph, he describes its "very essence" in terms of reference to the past. "What I intentionalize in a photograph is neither Art nor Communication, it is reference.... The name of Photography's *noeme* would therefore be 'That has been'" (pp. 76–77). As an "emanation of *past reality*," he continues, "the Photograph . . . is *without future* (this is its pathos, its melancholy)" (pp. 88, 90). Barthes's paradoxical identification of photography's essence with both future and past might be mitigated by insisting on a distinction between photography and the photograph. In this article, I will argue for this distinction but primarily for reasons other than this paradox of Barthes.

3. Walter Benjamin, "The Work of Art in the Age of Mechanical Reproduction," in *Illuminations*, trans. Harry Zohn (New York: Schocken, 1969), pp. 227, 225, 219.

4. David Davies, *Art as Performance* (Oxford: Blackwell, 2004), has argued for the far more extreme claim that artworks in general (not just in photography) are not the physical objects with which they are commonly identified but rather the actual performances of artists that create such objects and that to appreciate those objects properly always requires relating them to the actual performance that (according to this theory) is the work. I do not subscribe to this radically revisionist ontological and aesthetic theory that departs too much from our established (and far more complex) conceptual scheme to be convincing. In arguing for the artistic dimension and aesthetic value of the (dramatic, somatic) performative process of photography, I am not urging that this process deprive the photograph of its artwork status by usurping its role as the standard end product of photography. Nor am I arguing that the photograph must be evaluated in terms of the performance that engenders it: process and product can be judged separately and with different evaluative verdicts. My modest position is rather that photography is a complex art that offers various objects for aesthetic appreciation (such as photographs and photographic performance processes or events) and that these objects are differently individuated for our purposes of aesthetic appreciation. Our individuation of the performative process of a photo session would diverge sharply from the way we identify a particular photographic image or a photographic print that results from a particular moment or part of that performative process.

5. For an introductory outline of the somaesthetic project, see Richard Shusterman, "Somaesthetics: A Disciplinary Proposal," *The Journal of Aesthetics and Art Criticism* 57 (1999): 299–313; for the most comprehensive discussion, see my *Body Consciousness: A Philosophy of Mindfulness and Somaesthetics* (Cambridge University Press, 2008). For discussions relating somaesthetics to the arts, see, for example, Martin Jay, "Somaesthetics and Democracy: Dewey and Contemporary Body Art," *Journal of Aesthetic Education* 36 (2002): 55–68; Peter Arnold, "Somaesthetics, Education, and the Art of Dance," *Journal of Aesthetic Education* 39 (2005): 48–64; Eric Mullis, "Performative Somaes-

thetics: Principles and Scope," *Journal of Aesthetic Education* 40 (2006): 104–117; and the articles of the special issue devoted to somaesthetics in *Action, Criticism, and Theory for Music Education* 9 (2010). The article there by Fred Maus is especially illuminating. See also the somaesthetic anthology *Penser en corps: soma-esthétique, art et philosophie*, ed. Barbara Formis (Paris: L'harmattan, 2009). For a full bibliography of work on somaesthetics by authors other than me, see http://www.fau.edu/humanitieschair/Somaesthetics_Bibliography_Others.php.

6. See Richard Shusterman, "Art as Dramatization," *The Journal of Aesthetics and Art Criticism* 59 (2001): 361–372.

7. Since June 2010, I have been working with the Parisian artist Yann Toma on a series of photographic works in the genre he calls "Radiant Flux," in which he tries to capture and visually represent (with lights and camera) the invisible aura of the person posing for him, an aura he conceives and perceives as a temporally changing energetic force emanating from the person's body. He builds on the etymological meaning of "photography" as drawing with light, but also on the work of Man Ray, the first known photographer to use this technique in his series called "Space Writing" of 1935. I describe Toma's work and our collaboration in my (illustrated) essay "A Philosopher in Darkness and in Light," in *Lucidité. Vues de l'intérieur / Lucidity. Inward Views: Le Mois de la Photo à Montréal 2011*, ed. Anne-Marie Ninacs (Montreal: Le Mois de la Photo à Montréal, 2011). Some photographs of our collaboration have been published as part of a French article and interview on my work in somaesthetics (see http://www.tales-magazine.fr/style-harmony-life-vision/richard_shusterman). For further discussion of this collaboration and its relationship to somaesthetics, see Richard Shusterman, *Thinking Through the Body: Essays in Somaesthetics* (Cambridge University Press, forthcoming).

8. In his historically rich and instructive book, Patrick Maynard also insists on distinguishing photography as something different from and more than the photograph. But he uses this distinction to argue his central thesis that "photography is a kind of technology" or, more precisely, "a branching family of technologies" or "set of technological procedures" rather than to argue, as I do here, for the aesthetic dimensions of the performative and experiential process of photographic art. See Patrick Maynard, *The Engine of Visualization: Thinking Through Photography* (Cornell University Press, 1997), pp. x, 3, 9.

9. Both continental and analytic theorists often insist on the photograph's direct and transparent presentation of the object it renders (rather than being a mediated representation of it) because it results from a mechanical, causal process. Barthes describes the photograph as "pure deictic language; . . . a photograph is always invisible: it is not it that we see," but "its referent," the object photographed (Barthes, *Camera Lucida*, pp. 5, 6). Sontag speaks of such transparency in terms of the photograph's "identity of image and object," its presenting "a piece of the world" through "mechanical genesis"; hence in appreciating photography, the object or "what the photographic is *of* is always of primary importance" (Sontag, *On Photography*, pp. 98, 158). Roger Scruton, from the perspective of analytic aesthetics, claims, "the photograph is transparent to its subject, and if it holds our interest, it does so because it acts as a surrogate for the thing which it shows." This is because the

relationship of the photograph to its generating process is "causal not intentional"; hence "photography is not a representational art." See his "Photography and Representation," in *The Aesthetic Understanding* (London: Methuen, 1983), pp. 103, 114. Kendall Walton also speaks of the photograph's transparency in "Transparent Pictures: On the Nature of Photographic Realism," *Noûs* 18 (1984): 67–72. For a useful analytic reconstruction and response to Scruton's argument, see Dominic McIver Lopes, "The Aesthetics of Photographic Transparency," *Mind* 36 (2003): 335–348.

10. The photographer and the subject photographed can, in principle, be the same person, though performing the different functions.

11. Digital photography, which immediately provides a photographic image, does not require the process of developing and fixing the image but does allow further creative processes such as enlarging and cropping the photographic image.

12. Sontag, *On Photography*, p. 38.

13. For more on somatic style and its relation to qualities of character, including ethical qualities, see Richard Shusterman, "Somatic Style," *The Journal of Aesthetics and Art Criticism* 69 (2011): 143–155.

14. This quote from Avedon is taken from Sontag, *On Photography*, p. 187.

15. See Sontag, *On Photography*, pp. 36–37, for these points. Important ethical issues can also arise when subjects know they are posing for the camera. For example, the photographer may abuse the confidence and trust that the posing subject grants him and exploit the subject's openness and cooperation by creating a photograph that presents the subject in a way she does not want to be presented, in a permanent, infinitely reproducible and displayable image that violates the subject's own self-image. Arthur Danto notes how Richard Avedon cruelly violates the trust of a transvestite subject—the psychologically delicate and physically "willowy" Candy Darling—by photographing "her" "in makeup and garter belt, and with her long hair" but in frontal nudity with the penis displayed, making her look not like the delicate feminine personality she identified herself with but rather as "a sexual freak." Danto rightly describes this as an "exceedingly cruel image" that is ethically suspect, and he goes on to argue more generally (using the further example of Avedon's portrait of Isaiah Berlin) that Avedon "has no interest in the sitter's wishes" but selfishly "asserts his autonomy over the subject." See Arthur Danto, "The Naked Truth," in *Aesthetics and Ethics: Essays at the Intersection*, ed. Jerrold Levinson (Cambridge University Press, 2001), pp. 257–282, at pp. 270, 274–275. Danto's analysis suggests that the intense engagement and intimacy Avedon describes as having with his subjects is essentially exploitative or even feigned rather than ethically honest. This predatory, manipulative falseness may well explain Avedon's feeling of "embarrassment" once "the sitting is over" and he has the photograph that he (rather than the sitter) wanted.

16. Barthes, *Camera Lucida*, p. 10.

17. Barthes, *Camera Lucida*, p. 11.

18. Barthes, *Camera Lucida*, p. 11.

19. Barthes, *Camera Lucida*, p. 12.

20. Barthes, *Camera Lucida*, p. 13.

21. Barthes, *Camera Lucida*, p. 14.

22. Barthes, *Camera Lucida*, pp. 66–67.

23. See Richard Shusterman, "Art as Dramatization." In his influential work on photography, Laszlo Moholy-Nagy (of the Bauhaus) speaks of how this art can produce a "heightened reality of an everyday object." See his *Painting, Photography, Film*, trans. Janet Seligman (1925; repr. MIT Press, 1987), p. 62.

24. Sontag writes, "The sales pitch for the first Kodak, in 1888, was: 'You press the button, we do the rest.' The purchaser was guaranteed that the picture would be 'without error'" (Sontag, *On Photography*, p. 53).

25. Sontag, *On Photography*, p. 164.

26. It is interesting that in contrast to the art of painting, whose noun has a gerund form suggesting action over time, photography does not. Though we do use the verb "to photograph," we more often speak of "taking/making a photograph" or "taking a picture."

27. One structural issue of demarcation is when the performative process begins. Clearly, the photographer can plan the setting, the camera settings, the desired poses, or outfit of the subject well before he meets with the subject at the chosen photographic setting. This perhaps means that the performative process can begin without the photographic target or subject, even though some such subject will always be implied.

28. Sontag, *On Photography*, p. 21.

29. Sontag, *On Photography*, p. 15.

30. Barthes, *Camera Lucida*, p. 92.

31. See Charles Baudelaire, "The Salon of 1859," in *Art in Paris, 1845–1862*, trans. Jonathan Mayne (London: Phaidon, 1965), pp. 153–154. Delacroix offered early praise of photography for its benefits to painting in providing a far clearer vision of real objects than drawing could, while Weston in the following century argued that photography was a great gift to painting by relieving it of "public demands" for "representation," by making "realistic painting superfluous," so painting could focus on other goals than exact representation. See Edward Weston, "Photography—Not Pictorial," *Camera Craft* 37 (1930): 313–320.

32. Barthes links photography to theater, though not in terms of aesthetics of experiential process; he does so instead through "the singular intermediary . . . of Death." Just as "the first actors separated themselves from the community by playing the role of the Dead" (a theme he sees continued in the makeup and masks of traditional theater), so "the Photograph . . . is . . . a figuration of the motionless and made-up face beneath which we see the dead" (Barthes, *Camera Lucida*, pp. 31–32). See Baudelaire, "The Salon of 1859," p. 154.

33. Sontag, *On Photography*, p. 76.

34. Benjamin, "The Work of Art," p. 225.

35. Benjamin, "The Work of Art," pp. 220, 221, 224, 225.

36. Benjamin's remarks on photography's reproductive powers are rich and polysemically suggestive. He does not merely assert that photography provides a revolutionary way of mechanically reproducing existing artworks that were already produced by other means (such as painting or lithography), but also suggests that it further provides a way to create (and reproduce) new artworks by mechanically reproducing and fixing visual images seen through the camera but not yet represented through other pictorial media: "photography freed the hand of the most important artistic functions which henceforth devolved only upon the eye looking into a lens," thus letting the camera create the

pictorial work by reproducing and fixing the pictorial image seen by the eye (Benjamin, "The Work of Art," p. 219).

37. Benjamin, "The Work of Art," p. 219.

38. See Walter Benjamin, "A Short History of Photography," trans. Stanley Mitchell, *Screen* 13 (1972), 5–26. My citations are from pages 7, 8, 17, 18, 19, and 24. I thank Diarmuid Costello for reminding me of this important article.

39. I thank the guest editors of this special issue for helpful comments in revising this article.

SHERRI IRVIN

Artwork and Document in the Photography
of Louise Lawler

Some things are artworks, and other things are not. The facts that determine whether something is an artwork, however, are not like the facts about whether something is an alligator or a crocodile; while the names 'alligator' and 'crocodile' are human contrivances, the categories to which they refer include organisms that really do differ in systematic ways that are independent of human beliefs and practices. What makes Duchamp's *In Advance of the Broken Arm* an artwork while other snow shovels manufactured in the same batch are not, on the other hand, is a set of social facts that cannot in any way be divorced from human beliefs and practices.

So, some snow shovels are artworks, and others—most others—are not. The same goes, I take it, for photographs: some of them are artworks, and (especially given the ubiquity of inexpensive photographic equipment these days) most are not. What are the facts that make it the case that a particular photograph, or a particular body of photographs, is art? I will consider this question in relation to the work of Louise Lawler, which walks a line that often separates artworks and mere photographs: namely, the line of documentation. A kind of photograph that is frequently taken and presented in artistic contexts (for example, in exhibition brochures and catalogues) is a photograph intended to document an artwork or exhibition. Typically, such photographs are not considered by anyone to be artworks, or even to be in candidacy for the status of artworks.

Louise Lawler's photographs, while they document artworks and the spaces in which they are displayed, are not mere documents: they are artworks in their own right. What makes this

the case? Is it something about the photographs themselves, about the way in which they are interpreted, about Lawler's intentions, about the discourse with which she frames them, about the contexts in which they are exhibited and collected? These are the questions that animate this discussion.

I defend a cluster account of art according to which, while there is no individually necessary condition for arthood, there are individual conditions that count toward arthood and clusters of conditions that are jointly sufficient for an object to be art.[1] That is to say, there is more than one way for an object to come to be art. In this article, I flesh out the content of my favored cluster account by discussing the contribution that particular conditions make to the arthood of specific works by Lawler and others.

The issue of when and under what conditions something is art arises in an especially pressing way for photography due to its many nonartistic applications. An account of what the arthood of artistic photographs consists in, I take it, is central to understanding photography as an art.

I. LAWLER'S WORK

Much of Lawler's oeuvre consists of photographs of artworks created by others. The artworks are photographed in a variety of settings: at auction (Figure 1), in the exhibition spaces and storage rooms of museums or galleries (Figure 2), and in corporate (Figure 3) or private (Figure 4) collections. Lawler sometimes follows the trajectory of a particular work as it moves from one setting to another: for instance, some works are

Figure 1. Louise Lawler, *Pink* (1994/1995). Laminated cibachrome on museum box, 47 7/8 × 59 1/2 in. Courtesy of the artist and Metro Pictures.

shown hanging both in a private home and at auction.

There is something destabilizing about Lawler's work at times, particularly when it is seen in representations. Looking at an image that is credited to Lawler, one wonders: is this a picture Lawler took of someone else's work, a picture someone else took of one of Lawler's works, or both? The cataloguing of her work sometimes reveals a similar confusion. Her work *Nude* (Figure 2) is a photograph of a painting by Gerhard Richter lying on its side in preparation for installation. But in the online ARTstor database, an installation view of the photograph is rotated ninety degrees so that Richter's painting, but not the Lawler work being catalogued, appears upright. The medium of the work is also listed as painting rather than photography, though Lawler (rather than Richter) is credited as the artist.[2]

Lawler has sometimes played on this destabilizing aspect of her work, though not excessively. Her 1995 work *They Have Always Wanted Me to Do This* depicts one of her own earlier photographs, *Auction II* (1989–1990). *Auction II* shows two works (by other artists) hanging at auction; *They Have Always Wanted Me to Do This* shows *Auction II* framed and hung on a background of worn floral wallpaper in a gallery.

Lawler also collaborated with Douglas Crimp on his book *On the Museum's Ruins*.[3] In that book, she made three different types of photographic contributions. Some of her artworks are *directly presented* in the book, without captions: there are series of pages where Lawler's photographs are juxtaposed with text, making up a body of text-image works. Some of her photographic works from earlier years are *represented* in the book to illustrate points made by Crimp, with captions attributing the works to Lawler and identifying their titles and years of production. Finally, Lawler took some of the installation photos of artworks produced by others that Crimp uses to illustrate his discussion. The installation photographs in this latter category do not appear to be artworks by Lawler; they are, instead, installation shots of the standard sort produced by professional photographers outside of any art-making practice.

A foil for my discussion of Lawler will be Larry Qualls. Qualls has taken over 100,000 photographs of works (including Lawler's) shown in contemporary art exhibitions since 1980.[4] Qualls's photographs are not regarded or treated as art. What makes for the difference between Lawler's project and Qualls's, such that Lawler's photographs of other people's works are artworks while Qualls's are not?

FIGURE 2. Louise Lawler, *Nude* (2002/2003). Laminated cibachrome on museum box, 60 × 40 × 2 in. Courtesy of the artist and Metro Pictures.

II. WHAT KIND OF QUESTION IS THIS?

As I have said, my aim is to establish what makes Lawler's photographic works—except for such photographs as the installation shots that she produced for Crimp—art when other photographs that resemble them to varying degrees are not. But before trying to answer the question of what makes Lawler's works art, we should consider just what kind of question it is. Is it a sociological question about which features of the work have, in actual fact, caused people (especially artworld authorities) to accept it as art? Or is it a normative question that may be answered from the philosophical armchair, perhaps with a great willingness to revise or reject artworld views?[5]

In reality, the question—and the answer I supply—have both sociological and normative elements. Art is essentially embedded in a set of social practices, and the nature of its products is determined in part by the nature of the social interactions and frameworks within and through which those products are made. To try to change those institutions and their practices would be, speaking loosely, a political project, which is not my aim. My aim is to try to understand them, which involves identifying the principles underlying them. This is a normative project, as opposed to merely a sociological or descriptive one, because social practices as complex and diffuse as those constituting the artworld are inevitably somewhat chaotic and not entirely rule-governed. To identify the principles

FIGURE 3. Louise Lawler, *Who Says Who Shows Who Counts* (1989). Cibachrome, 38 1/4 × 50 7/8 in. Courtesy of the artist and Metro Pictures.

underlying such practices is to identify the curves along which the relevant data points are roughly arrayed. These principles can then serve to justify future moves within the relevant practices.

My discussion will thus be significantly informed by the ways in which Lawler's works have actually been incorporated into social practices. But, as we will see, much of the treatment of Lawler's photographs presupposes, rather than determines, that the photographs are artworks. Part of my aim, then, is to disentangle the various ways in which Lawler's works are embedded in the practices of art and to ascertain which aspects of this embedding are responsible for their being artworks in the first place.

It is important for the success of my argument that the arthood of Lawler's works is not in question. My aim here is not to *argue* that Lawler is an artist; it is, rather, to use the uncontroversial fact that Lawler is an artist, and that many of her photographs clearly are artworks, as an occasion for understanding the conditions that determine the status of a body of photographs as art.

One might wonder whether and how this question, or its answer, really matters. Is it not a persnickety philosopher's question to ask whether or not something is art or to think that there are boundaries that separate art from other things and to try to figure out what they are? A compelling version of this worry can be seen as growing out of

Lawler's work itself, whose aim, as Andrea Fraser puts it, is to "disrupt the institutional boundaries which determine and separate the discrete identities of artist and art work from an apparatus which supposedly merely supplements them."[6] Is the identification of Lawler's photographs as artworks, in opposition to other, similar photographs that are not artworks, somehow revealed as or rendered inappropriate by Lawler's work itself?

To say that Lawler's work breaks down the boundary between artworks and non-artworks, though, would be to overstate its radicalness. Her work motivates us to consider *why* the photographs of Larry Qualls are not themselves art, but it does not motivate us to think that they are, in fact, artworks, or that there is no separation between artworks and other things. Her work might prompt us to rethink the nature and location of the art–nonart boundary; but if so, the investigation I am undertaking here seems to be entirely in the spirit of her project.

III. PHOTOGRAPHY AS AN ARTISTIC MEDIUM

A natural thing to say about oil paintings and bronze sculptures is that they are artworks by virtue of belonging to recognized artistic media. Photography is also (*pace* Scruton) a recognized artistic medium, and Lawler's works are

FIGURE 4. Louise Lawler, *Monogram* (1984/1999). Black and white photograph with printed mat, 3 1/2 × 5 1/4 in. (image), 14 × 11 in. (frame). Edition of 10, 2 AP. Courtesy of the Artist and Metro Pictures.

photographs. Can we use Lawler's engagement with the artistic medium of photography to explain why her works are art?

To answer the question, we must first observe that belonging to an artistic medium involves more than simply being made from a certain kind of stuff. Oil painting on canvas is a recognized artistic medium, and there is no widespread nonartistic application for the materials of oil painting. Thus, the fact that something is an oil painting on canvas virtually guarantees that it participates in the artistic medium. I say "virtually guarantees" because, presumably, someone could have a decid-

edly nonartistic reason to apply oil paint to canvas: perhaps painted canvases are effective at keeping raccoons out of the vegetable garden. Thus, the mere fact that an object is made from the materials associated with an artistic medium is not sufficient to establish that the object is, in fact, articulated in that medium.[7] However, it is, in the case of oil painting, a strong epistemic indicator that the object belongs to the medium.

The case of photography is different. While photography is an artistic medium, there are also widespread nonartistic applications of photography in family snapshots, scientific documentation,

and so forth. Indeed, at this point in history, the majority of extant photographs clearly are not artworks. The fact that an object is made of photographic stuff or using photographic methods, then, not only is not sufficient to position it in the artistic medium of photography; it is not even an epistemic indicator that it belongs to that medium (or, at most, it is a very weak epistemic indicator that functions in concert with other factors).

What, then, makes it the case that a photograph belongs to the artistic medium of photography? Consider David Davies's understanding of artistic medium:

A medium is a set of conventions (or shared understandings) whereby performing certain manipulations on a kind of physical stuff counts as specifying a certain set of aesthetic properties as a piece, and thus as articulating a particular artistic statement.[8]

To understand how medium functions in using shared understandings to allow for the articulation of an artistic statement, consider an example offered by John Dilworth:

[I]n many of his paintings Vincent van Gogh used a very free painterly style, which results in heavy brushstrokes being prominently visible in many of his works.... If the content of these works were interpreted literally or purely realistically ... one would have to conclude that these are pictures of hideously disfigured faces or horribly scarred landscapes.[9]

In fact, though, "the heavy brushstrokes express van Gogh's vigorous way of seeing the perfectly ordinary, unscarred people and landscapes."[10]

The medium of oil painting, then, is one in which, according to our shared understandings, only some of the features of the painted representation are to be understood as depicting features of the represented subject; others are to be understood, instead, as belonging to the painter's distinctive stylistic vision. Were there no such shared understandings, artists who mean to make available new ways of seeing ordinary objects would likely be understood, instead, as presenting a grotesque menagerie of fantastical objects.

Let us now see whether and to what extent this sort of story can be transferred to photography. Consider, for example, black-and-white photographs. Our shared understandings allow us to distinguish between a color image that depicts gray objects and a black-and-white image; we thus do not understand the objects in a black-and-white photograph as gray objects. In a color photograph, we may recognize that a filter has been used; we will then understand the photograph to contain not a representation of weirdly greenish objects, but a greenish representation of normally colored objects. Similarly, in both paintings and photographs, we typically understand that we are seeing a two-dimensional representation of a three-dimensional scene, not a representation of a bunch of flattened objects.

What allows us to draw these conclusions about which properties of the image belong to the represented subject and which do not? The following background knowledge and assumptions seem to be operative in our understanding of photographs: the widespread shared assumptions that were already established in relation to the pictorial medium of painting; our knowledge that a photograph is created by capturing light that has been produced by or reflected off of real objects; and our knowledge of the appearance of real objects and recognition of the similarities and differences between the image that we see and the way real objects of the sort represented would appear to us if we saw them directly. If this is correct, then the ability of a photographer to articulate a statement through photography may not depend heavily on the establishment of a *new* set of shared understandings that constitute the medium of photography. And this is why the content of photographs, at least at a pictorial level, is so easily "readable" even by naive viewers with no special grounding in art or artistic practices.

Everything I have said about reading a photographic image applies equally to artistic and nonartistic photographs. The background knowledge and assumptions that I have appealed to allow a photographer to create an image that is understood as depicting a particular content, regardless of whether the photographic project is an artistic one. But nonart photographs do not make artistic statements since they do not (at least in standard cases) ask us to consider the relation between the image that we are seeing and past artistic practices in photography and other media.

This observation should motivate a distinction between the medium of photography and the *artistic* medium of photography. All photographs that deploy the background knowledge and assumptions described above belong to the medium of

photography. But not all of them are thereby artworks, since many do not articulate artistic statements, to use Davies's terms. Berys Gaut puts forward such a distinction: "the medium is constituted by the set of practices that govern the use of the material," while "the art form is a particular *use* of the medium: a use that either aims to realise artistic values or that does realise those values."[11] To bring together Gaut's and Davies's insights, I treat Gaut's notion of realizing artistic values as roughly equivalent to Davies's notion of making an artistic statement and Gaut's notion of an art form as roughly equivalent to Davies's (and my) notion of artistic medium.

What, then, allows for a photograph to make an artistic statement, and thus belong to the artistic medium, or art form, of photography? The artistic statement that will be made through a particular photographic artwork depends on how that photograph is positioned in relation to past artworks and artistic practices, both photographic and otherwise; and there are many ways in which an artist may thus position her work. Some artists position their photographic work primarily in relation to the works of other photographers; some (for example, Hiroshi Sugimoto, some of whose photographs reconstruct images by Vermeer) make extensive reference to paintings; some (for example, Sherrie Levine, who photographed the works of Walker Evans and presented the resulting images as her own work) use photography to appropriate images made by others; some use photography to document doings or events that they wish to make available for the viewer's awareness. Now, one might wish to suggest that only some of these positionings are "truly photographic," while others are not. But I suspect that this will not be a very promising move. Artists can use a set of materials to a wide variety of ends and purposes, and I doubt that any desirable aim is served by saying, "Well, *this* is a work of painting, but *that* is just paint used for some non-painterly artistic purpose, and it does not really count as painting." The purposes to which a given set of materials may be put are subject to evolution and expansion, and to define a medium in relation to a limited collection of ends is, in the face of artistic innovation, likely to lead to an undesirable proliferation of media. Moreover, a choice to make a work using a given set of materials is, among other things, a choice to position that work in relation to past works using those materials: part of making sense of a conceptual painting is to see it specifically in relation to the history of painting.[12]

What, then, makes a photograph belong to the artistic medium, rather than just the medium, of photography? As I have said, the shared understandings that make it possible to grasp the artistic statement made by a photographic artwork depend on the way that it is positioned as art. For this reason, I submit that the criteria for belonging to the artistic medium of photography are simply (a) to have been made using photographic materials and methods (that is, in Gaut's terms, to have been made in accordance with "the set of practices that govern the use of [photographic] material") and (b) to be an artwork (of which more below), for the satisfaction of this latter criterion is what allows us to see the photograph as having a particular artistic positioning and thus as making an artistic statement. We cannot, then, use the claim that Lawler's photographs belong to the artistic medium of photography to establish their arthood, for the claim that they belong to the artistic medium of photography depends on a prior demonstration that they are artworks.

The specification of what should count as photographic materials and methods is largely a technical project for photography experts, not to be left to a philosopher. But I expect that the exposure of a light-sensitive material to light would come out as central; and if this is right, a digital image constructed without any technique that involves exposing a light-sensitive material to light would not count as a photograph, regardless of how photographic it appeared to the viewer. This means that there could be two digital images that look exactly alike, one of which is a photograph and the other of which is not. To my mind, this is a perfectly congenial result: how we should understand an artwork and what modes of analysis we should apply to it are matters not only of its appearance but also of its actual history of production. To understand a digital image that appears photographic without actually having been produced through photographic methods, one must inquire into the reason that an artist might have for engaging with the category of photography by producing an image that appears to be but is not in fact a photograph.

I make two further remarks about artistic media. First, not every artwork belongs to a recognized artistic medium. To come to be art, an object or event must have *some* kind of connection

to past artworks, but the connection need not be one of medium.[13] That is why it has been possible for new media, including photography and performance art, to emerge. Second, I do not know of any compelling reason to see media as mutually exclusive. The works of photographic appropriation artists like Sherrie Levine belong to the artistic medium of photography, on my account, but they may well also belong to the medium of conceptual art.

There is much more to be said about the artistic medium of photography that I have to leave aside. The upshot, for the present, is that we cannot conclude, from the mere fact that Lawler's photographs are photographs, that they are art; instead, we need to know whether they are art in order to know whether they belong to the artistic medium of photography.

IV. POSITIVE AESTHETIC VALUE

How, then, do some photographs come to be artworks while others are not? Could it be by virtue of some sort of positive aesthetic value: beauty, interesting formal features, or something like that?

Positive aesthetic value does sometimes play an important role in the determination that a particular body of photographs is art. Presumably, this is a crucial factor that led to photography's being accepted as an artistic medium in the first place. The photographs of Julia Margaret Cameron are often formally stunning, and this in itself creates a strong and, in my view, appropriate temptation to regard her works as artworks—although I deny that positive aesthetic value is *necessary*, in general, for photographs or other artworks to be art.

This is the wrong sort of story to tell about Louise Lawler's works, however, for two reasons. First, a number of Lawler's photographs do not even tempt us to think that they might be art by virtue of their formal or aesthetic features. Some of her photographs of artworks in corporate or auction settings are, in my judgment, aesthetically ordinary, even drab or depressing. An example is *Who Says Who Shows Who Counts* (1989), which shows Warhol's *Wicked Witch* on the wall of a boardroom (see Figure 3). This is not a criticism of Lawler's photographs as artworks: they are designed to make us attend to and reflect on the insti-

tutional framework within which artworks circulate, and sometimes that institutional framework is a very drab or ordinary one.

Second, even when her photographs clearly do traffic in positive aesthetic value, as many do, very often it is the kind of aesthetic value that creates an association with nonartistic forms of professional photography. Her photographs of works from private collections hanging in the owners' residences tend to evoke interior design photography (Figure 4). Lawler strengthens the allusion to illustrative photography that is aesthetically appealing, but still not art, by giving her works titles that evoke picture captions in the style section of a newspaper, like *Pollock and Tureen, Arranged by Mr. and Mrs. Burton Tremaine, Connecticut*.[14]

Another important point is this: with regard to objects created by our contemporaries, to bring something into the category of art by virtue of its formal or aesthetic features is a bit of a last resort. We may use aesthetic criteria to recognize objects as "outsider art," in the rare case in which nothing else about the situation connects the objects or their maker with art and its institutions. But when a set of objects was created by a person who is clearly aware of and engaged with the artworld, that engagement should be the focus of our inquiry. And it would be hard to find a purer case than Lawler of a maker who is aware of and engaged with the institutions of art.

V. APTNESS TO INTERPRETATION

I have suggested that, at least with regard to the works of our contemporaries, positive aesthetic value is not normally a key criterion in determining that they are art. But what about their tendency to be seen as making an artistic statement? Is this another species of value that can constitute the photographs as art, or count toward their status as art?

Lawler's photographs are widely and convincingly regarded as advancing some form of institutional critique. They reveal the treatment of artworks as commodities: financial commodities at auction, where they are unceremoniously reduced to their exchange value (Figure 1), or reputational commodities in private collections, where they are used to make statements about their owners (Figure 4). They reveal the circulation of power and privilege in the artworld, where wealthy

collectors can fetishize S&H Green Stamps, which would clearly be beneath them in real life, by virtue of the fact that they have been transfigured into art by Andy Warhol.[15]

It would be incorrect, though, to suggest that the aptness of Lawler's works to artistic interpretations is what makes them artworks. Normally, we undertake the project of interpretation when we already have independent reason to believe that something is an artwork: it is presented in a gallery, for instance. And even when we use a process of interpretation to come to the conclusion that something is art, this is typically a purely epistemic phenomenon. If I conclude, on seeing someone behaving strangely in a shopping mall, that I am seeing a work of performance art because the behavior is apt to the interpretation that it expresses a particular theme or meaning, it is not typically the case that this aptness to interpretation is what *makes* the behavior a work of performance art. Instead, I *explain* the occurrence of this oddly meaningful behavior in this context by attributing it to someone who sees herself as engaged in a certain kind of project, one that is responsive to the activities of contemporary art. It is not the fact that the behavior is apt to interpretation that *makes* it art; instead, the aptness to interpretation is a clue that informs me of its connection to art.

In a small number of cases, things might go differently. Just as things can be identified as "outsider art" by virtue of their aesthetic value, we might come to regard a group of objects as art because they are apt to interpretation, even though we have no reason to think that their maker had any explicit connection to art, either by way of his ideas or intentions or by way of an institutional framework. But, again, there is no reason to tell this sort of story about Lawler's work: Lawler is very far from being an outsider, and her photographs are not just things that we stumble upon in the world. We regard them as a body of work and interpret them because we already have reason to believe that they are art; aptness to interpretation is not what constitutes their arthood.

VI. ARTISTS, INTENTIONS, AND INSTITUTIONS

Artworks are not found objects; they are created and, usually, presented for sale or display by individuals who have intentions and beliefs regarding the objects themselves, the process by which they were made, their meanings, and their connection to other things in the world.

In some instances, a work of art (a poem, for instance) can be constituted as such by events in the mind of the artist. A work of photography, of course, cannot be composed *exclusively* in the artist's mind. But perhaps the photograph together with some event in the artist's mind is sufficient to constitute the artwork.

What sort of event in the artist's mind would be such as to constitute the photograph as a work of art? Must this mental event be outwardly expressed, or is its mere occurrence enough? Are there limits on the art-constituting power of such mental events, or can an individual confer art status on virtually anything?

Jerrold Levinson suggests that the mental event that constitutes an object as art is a certain kind of intention. "A work of art," he says, "is a thing intended for regard-as-a-work-of-art: regard in any of the ways works of art existing prior to it have been correctly regarded."[16] As he emphasizes, this does not mean that its maker must have any connection to the artworld or even possess the concept of art. Suppose that one of the ways in which past artworks have correctly been regarded is as objects of aesthetic delectation detached from the cares of the world. If a maker, however innocent of art and its history and institutions, creates an object that is intended for such aesthetic delectation, then in Levinson's view she has created an artwork.

This account has many virtues. It requires that the intention have a connection with existing art, but that connection need not be transparent to the maker. It allows for the wide variety of ways in which artworks have been correctly regarded, and it is open-ended, allowing for the likelihood that new modes of regard will emerge.

My view diverges from Levinson's in a number of respects (though the following remarks should not be taken as criticisms of his account). First, I think that something like the sort of intention Levinson describes is usually present and, where present, often plays a role in constituting an object as art. However, I also think that there are cases in which we do and should count something as art despite the absence of such an intention. As he advanced into dementia caused by Alzheimer's disease, the artist William Utermohlen executed a series of painted and drawn self-portraits that, while exhibiting the perceptual and cognitive

disturbances characteristic of the disease, also have remarkable stylistic features and reward serious efforts of appreciation and interpretation.[17] It may be that at some point during this progression, Utermohlen ceased to have the relevant sort of intention about the way his paintings should be regarded. However, we should continue to see them as art because of their formal and aesthetic features, their connection to his earlier paintings, their aptness to interpretation, the fact that they are articulated in paint, and so forth. These aspects of the work are, in my view, jointly sufficient to connect them in the right way with past art, even in the absence of an express intention about how they are to be regarded.

I also hold that there are limits on the ability of a maker to constitute his products as art by forming such an intention. Suppose that Larry Qualls (perhaps inspired by Louise Lawler, many of whose works he photographed) had formed a serious, settled intention that the 100,000 photographs that he took documenting artworks installed in museum and gallery settings themselves constitute a body of artworks, and should be seen as inviting reflection on the institutional framework in which artworks are circulated and displayed. In my view, this effort would be reasonably regarded as a failure: not just a failure to make a body of *good* artworks, but a failure to make a body of artworks at all. And it would be a failure even if he expressed the intention outwardly. The ad hoc tacking on of an art-related intention to an activity that would not otherwise be counted artistic is too thin to create the right sort of connection to art.

There are two further conditions such that the fulfillment of either of them might be sufficient to compel the conclusion that Larry Qualls's photographs are artworks. First, Qualls might couch his works, outwardly, in some sort of discourse that positions them as objects of interpretation. For instance, he might give a detailed and compelling explanation of how his works support an institutional critique. It would help if he gave some account of how the overwhelming and seemingly unedited bulk of the photographs, as well as their very straight, "styleless" appearance, in fact contributes to, rather than undermines, an effort to see them as making an artistic statement. The works would then be more compellingly seen as the product of a creative act that goes beyond an ad hoc pronouncement of arthood.

I should emphasize that I do not think that it is necessary in general that artists couch their work in a discursive framework for it to count as art. Discursive framing (or some related maneuver) becomes necessary when the works need to be dislodged from some salient nonart category into which their manifest features invite us to place them.

The second condition whose fulfillment might constitute the arthood of a body of photographs like Qualls's is some form of uptake by the institutions of art. If a critic or curator, seeing a group of Qualls's photographs and, perhaps, being aware of his intention that they be regarded as expressing some form of institutional critique (but without any further elaboration), found such a reading compelling and chose to interpret or display them in an artistic context, this would, in combination with Qualls's intention, be sufficient to constitute the works as art. It could then be left to others, rather than to Qualls himself, to do the interpretative work that I described above.

Thus, in my view, both the artist's intentions and the institutions of art have their roles to play in constituting objects as artworks. Moreover, for the artist's intention to do the job successfully, there has to be some sort of fit between the nature of the product and what the existing institutions of art are prepared to accommodate.[18] Duchamp could not have constituted his first readymade as art *just* by forming an intention that it be regarded in some way in which past artworks had been correctly regarded, or even by forming that intention and expressing it outwardly. He had to either combine that intention with some further discursive maneuver to make the connection to art compelling or secure uptake by the institutions of art. Ultimately, of course, he did both of these things.

My account implies that institutional uptake functions in different ways with regard to different sorts of artworks. Most of the time, institutional uptake simply indicates recognition that some product is art; but at times, institutional uptake plays a role in constituting the product as art.

With regard to Lawler's photographic works, we do not need to invoke institutional uptake to explain their arthood. Her works did not strain the boundaries of art at the time of their creation. Thus, the power to confer arthood on them rested with Lawler herself. The remaining question is, would it have been sufficient for

her to form a settled intention that the photographs be regarded as art, or was it necessary that this intention be expressed outwardly, and perhaps also that she supply some sort of discursive framework?

If all of her works had appeared to be interior design photography or exhibition documentation, some outward expression or discursive framing would have been required. But many of her works operate outside established modes of professional nonartistic photography, and their content and formal features do not invite the supposition that they are mere snapshots. *Pink* (Figure 1) is an example: the nonstandard cropping of the depicted artworks makes the image unsuitable for documentary purposes, and the attention to compositional detail and color reveals that it is not a mere snapshot. Given that such works do not naturally fall into a competing category like "snapshots" or "interior design photographs," Lawler's settled intention that they be regarded as art would be enough to establish their arthood, even prior to any outward expression of that intention on her part.

Moreover, even the works that do look more like straight installation or interior design photographs (Figure 4) can be incorporated into the category of art in the same way, by virtue of Lawler's settled intention that they belong to the same body of work or constitute a further development of the same or a related artistic project. The photographs that would be left out, on such an account, are those installation shots of others' artworks that she took simply to illustrate the arguments of Crimp's book. In the absence of a specific art-constituting intention, these photographs are not art. It is, of course, possible that Lawler did have such an intention, and thus that, unbeknownst to us, the works are art. However, the fact that the intention is nowhere signaled in the manner in which the photographs are presented—that, for instance, Lawler is credited as photographer rather than as artist—strongly suggests that no such intention is present.[19]

VII. CONCLUSION

I have suggested that there are a number of different ways in which objects can come to be artworks. That is to say, there are different kinds of art-constituting properties and relations. Forms of positive value, such as aesthetic value or aptness to interpretation, can play a role, but when an object's creator is aware of art and its institutions, it is more appropriate to see some relation to the artworld as constituting the arthood of her products. Often, the creator's settled intention that her products be regarded as art (in something like the sense suggested by Levinson) is decisive. But in some circumstances, it is not: if the products seem to fall into some existing nonartistic category, the creator will need to do something outwardly to dislodge them from or problematize their relation to that category. Offering a discursive framework is one way to do this. Another special case is when the products strain the existing boundaries of the category "art": in such a case, discursive framing of the products or institutional uptake may be required to constitute their arthood. Excluding these special cases, though, institutional uptake is not required: works that exist outside the institutional framework are not thereby stripped of their arthood.

My account implies that something may be art without our knowing that it is, for instance, if the artist dies without having an opportunity to express her intention. It also implies that the very same photograph could be art in some circumstances but not in others—and, indeed, that it could start out as a mere document and come to be an artwork later, once the artist has revised her settled intention about it.

The story I have told is complicated, but not more complicated than the realities it aims to capture. We apply the concept "art" to different objects for different reasons. To be an artwork is to have a connection of the right sort to art and its institutions, but there is more than one right sort of connection, and, indeed, the possibility that institutional uptake can confer, as opposed to merely recognize, an object's art status allows for the emergence of new sorts of connection that count as right.

The account also implies that an object can have a variety of connections to art and its institutions without thereby counting as an artwork. Not every connection is of the right sort. And that is why we can say, to my mind quite appropriately, that bodies of photographs taken and presented in art settings are not always art and that photographic artists can and do undertake photographic projects that are not themselves artistic. Larry Qualls's photographs, however valuable for our

understanding of the art of the late twentieth and early twenty-first centuries, are not art, and while Louise Lawler has created an important body of photographic artworks, it remains in her power to engage in professional photographic projects that are not art.[20]

SHERRI IRVIN
Department of Philosophy
University of Oklahoma
Norman, Oklahoma 73019

INTERNET: sirvin@ou.edu

1. The notion of a cluster account is introduced in Berys Gaut, "'Art' as a Cluster Concept," in *Theories of Art Today*, ed. Noël Carroll (University of Wisconsin Press, 2000), pp. 25–44; and "The Cluster Account of Art Defended," *The British Journal of Aesthetics* 45 (2005): 273–288. My preferred cluster account differs from Gaut's.

2. The Lawler work catalogued in ARTstor is *Four Nudes*, a gallery installation of four copies of *Nude*.

3. Douglas Crimp, *On the Museum's Ruins* (MIT Press, 1993).

4. Many of Qualls's photographs can be seen in the ARTstor database found at http://www.artstor.org/.

5. Philosophers have sometimes been happy to indulge in such revisionist thinking. Roger Scruton, for instance, famously argues that photography cannot be art, since it merely presents rather than representing its subject matter. See Roger Scruton, "Photography and Representation," *Critical Inquiry* 7 (1981): 577–603.

6. Andrea Fraser, "In and Out of Place," *Art in America* 73 (1985): 122–129.

7. Berys Gaut makes related comments in chap. 7 of *A Philosophy of Cinematic Art* (Cambridge University Press, 2010), pp. 282–307, especially pp. 288–289.

8. David Davies, *Art as Performance* (Malden, MA: Blackwell, 2004), p. 58.

9. John Dilworth, "The Abstractness of Artworks and Its Implications for Aesthetics," *The Journal of Aesthetics and Art Criticism* 66 (2008): 341–353, at p. 351.

10. Dilworth, "Abstractness," p. 351.

11. Gaut, *A Philosophy of Cinematic Art*, pp. 288, 289.

12. Some theorists have wished to offer a thicker account of artistic medium than I endorse here. For discussion, see David Davies, "Medium in Art," in *The Oxford Handbook of Aesthetics*, ed. Jerrold Levinson (Oxford University Press, 2003), pp. 181–191.

13. Jerrold Levinson has argued extensively for such a view in a series of papers: "Defining Art Historically," *The British Journal of Aesthetics* 19 (1979): 232–250; "Refining Art Historically," *The Journal of Aesthetics and Art Criticism* 47 (1989): 21–33; "Extending Art Historically," *The Journal of Aesthetics and Art Criticism* 51 (1993): 411–423; and "The Irreducible Historicality of the Concept of Art," *The British Journal of Aesthetics* 42 (2002): 367–379. While, as discussed below, I do not agree with every particular of his account, I am highly sympathetic to the general approach of specifying the conditions for arthood in terms of relations to past artworks.

14. *Monogram*, pictured in Figure 4, has been presented at auction with the title *Monogram—Arranged by Mr. and Mrs. Burton Tremaine, New York City*.

15. S&H Green Stamps were handed out with supermarket purchases at many stores in the United States; the recipient would paste them into collectors' books which, when filled, could be exchanged for products ordered from a catalog. Their popularity declined after the 1970s. Lawler's 1990 work *Who Are You Close To?* shows a *Green Stamps* painting by Warhol hanging on a red wall and flanked by two celadon horses. Like *Monogram* (Figure 4) and *Pollock and Tureen*, this work belongs to a series of photographs Lawler took of the private collection of the Tremaines.

16. Levinson, "Defining Art Historically," p. 234.

17. Many of the works are presented at http://www.williamutermohlen.org.

18. This claim is related to Arthur Danto's insight, first introduced in "The Artworld," *Journal of Philosophy* 61 (1964): 571–584, that what can be art at a given time is determined (at least in part) by an atmosphere of art theory.

19. I resist the requirement that the intention be outwardly expressed because I hold that an act of art making can sometimes be complete even before the resulting work or any ideas about it have been presented or conveyed to anyone.

20. This article was first presented at the 2010 conference "Agency and Automatism: Photography as Art since the 1960s," held at the Tate Modern. I am grateful to the organizers, Diarmuid Costello and Margaret Iversen, for inviting me to the conference and providing helpful comments on the article. Diarmuid Costello and Dominic McIver Lopes provided further, very useful comments on the penultimate draft. Thanks are due to Louise Lawler and Metro Pictures for permission to reproduce her work. James Woodward of Metro Pictures was particularly helpful throughout the process.

BENCE NANAY

The Macro and the Micro: Andreas Gursky's Aesthetics

Andreas Gursky is the darling of philosophers and art theorists of all kinds of traditions and denominations. He has been used as a prime example of the return of the sublime in contemporary art, as a trailblazer in the use of the digital manipulation of images in order to represent something abstract, and even as a philosopher of perception who makes some subtle point about the nature of visual experience. All of these arguments are based on some or another technological innovation Gursky uses: the size of his photos, their postproduction (often digital) manipulation, and their unusually high resolution.

The aim of this article is to shift the emphasis from these arguments on the significance of the new technology in Gursky's oeuvre to a much more important role technology plays in his works, namely, in their aesthetics. I begin by saying a bit more about the philosophical analyses of Gursky's photographs and the role new technology plays in them and then elaborate on the proposal that the aesthetics of Gursky's photographs heavily rely on these technological innovations—more precisely, high-resolution, postproduction manipulation, and sheer size—in three different ways.

I

One important and influential argument about Gursky's photographs (and one that taught many analytic philosophers Gursky's name) is that his pictures make a subtle point about the nature of our visual experiences. Here is Alva Noë's summary:

Part of the effect of Gursky's piece [*99 Cent*] is that it presents a "view" of the shop that is utterly contrived.

We never *experience* so much detail, not all at once like that.[1]

Noë takes Gursky to make the same point as the one he himself argues for: that our visual experience is not like a snapshot. Snapshots can have full resolution in every square inch of the picture, whereas our visual experience only has high resolution where we are focusing our attention. It does appear to us (under normal circumstances) that our visual experience is like a snapshot, but in fact it is not: change blindness and inattentional blindness experiments clearly show that we fail to notice very significant changes in our visual field if we are not attending to them. Noë replaces the snapshot conception with a more dynamic one, whereby our eyes are zipping around our visual field, giving us the illusion that we see everything clearly. In fact, there is very little that we do see clearly.[2]

What is important for our purposes is not whether Noë is right, but that he recruits Gursky as his ally in the fight against the snapshot conception of experience. In a later paper, Noë goes further and even says that the snapshot conception is "caricatured" by Gursky.[3] And he does so with the help of the use of new technology: of unusually high photographic resolution.

One thing to note, again, without taking sides in the debate about the nature of visual experience and the grand illusion, is that one can make pictures with very high contrasts and resolution without explicitly caricaturing the snapshot conception of visual experience. One example that springs to mind is Bronzino. Here is Heinrich Wölfflin on Bronzino's paintings, surprisingly similar to the first quotation by Noë above:

No human eye can see things in this way—I mean with this even firmness of the line. Not for a moment does the artist depart from the absolute distinctness of the object. It is as if, in the representation of a bookcase, an artist were to attempt to paint book by book, each equally clearly outlined, while an eye attuned to appearance only grasps the shimmer playing over the whole.[4]

Wölfflin contrasts Bronzino's "metallic distinctness of lines and surfaces" with Velasquez's paintings, but he also emphasizes that many of Bronzino's contemporaries used effects similar to Bronzino's (in fact, the distinctness of lines and surfaces is one of the many characteristics of the 'linear style' for Wölfflin).[5] So it may not be justified to take Gursky to do anything particularly original or philosophical here.

Many of Gursky's photographs are digitally manipulated: the films are pieced together digitally and then often manipulated even further. The colors are also often adjusted digitally, most often by increasing their saturation. This is another important technical aspect of Gursky's photos, but some art critics and theorists have argued that this digital manipulation serves a more theoretical purpose. More specifically, as Katy Siegel argues, it allows Gursky to create representations that are in some sense of, or depict, an abstract idea.[6]

Here is an example. Gursky's *Untitled V* (1997) is a photo of a display of athletic shoes on six extremely long shelves. Apparently, the photographer had encountered a similar display in real life, but thought that it "would not have sufficed for a convincing photograph. The real shoe display was pictorially ineffective and harmlessly presented," as he said in an interview.[7] Instead, he had a short shelf fixed, filled it with various models of shoes, photographed it from six different angles, and then digitally pieced the films together. This is the technique. The interpretation is that thereby Gursky created a representation of something that could be described as an abstract idea.[8]

Whether this claim is correct, of course, depends heavily on the concept of representation (or depiction) one uses. In the analytic tradition of philosophy of art (not Siegel's own), there has been a lively debate about what properties are represented in a picture, what are depicted, and what are neither represented nor depicted.[9] Consumerism could only be a candidate for something that is represented in the picture (not depicted),

but even this seems controversial. But the most important aspect of this argument about Gursky's photographs is not whether it is sound, but that it, again, aims to trace the consequences of a new technology Gursky uses, namely, digital manipulation.

The third argument I want to mention concerns the "sublime" in Gursky's photographs. The argument is that Gursky brings the Kantian and Burkean concepts of the sublime back into debates about contemporary art, and he achieves this mainly by the sheer size of his photographs (mainly but not exclusively: his choice of themes is also supposed to contribute). Gursky's sublime is supposed to be different from Kant's and Burke's, though, inasmuch as he depicts the human-made world, and not nature, which was the prime example in the eighteenth century.[10]

These are, of course, not the only philosophical and theoretical discussions of Gursky's oeuvre; in fact, most discussions on Gursky focus on the content of his photographs, for example, trying to decide whether he critiques or endorses globalization.[11] But what is important for my purposes, and the reason why I picked out the three philosophical interpretations, is that they all focus on three technical aspects of Gursky's work: the size of his photographs, their high resolution, and their postproduction (often digital) manipulation. According to these philosophical interpretations, these three technical aspects all help Gursky make some abstract philosophical point. I am not sure this is correct, but my main argument is that these three technical aspects play a much more important role in Gursky's work: they determine and make possible the aesthetics of these pictures. This is the claim I argue for in the remainder of the article.

II

The starting point of my argument is that Gursky's pictures operate on two levels. They need to be seen from two different perspectives, both close up and from far away. If we take only one of these perspectives into consideration, we are missing out on something.

Gursky himself often explicated the same point. As he says in an interview, "I see both microscopically and macroscopically."[12] In terms of the aesthetics of his pictures, this comment can be reformulated: his pictures should be seen "both

microscopically and macroscopically." As he says in another interview:

You never notice arbitrary details in my work. On a formal level, countless interrelated micro and macrostructures are woven together, determined by an overall organizational principle.[13]

In short, in order to properly appreciate a Gursky piece, we need to appreciate three aspects of the photograph:

(a) the microstructure,
(b) the macrostructure, and
(c) the relation between the two.

To put it simply, if we are looking at a large (say, twelve- by six-foot) Gursky print from a couple of centimeters, we will see details we could not see from farther away, but we will be missing out on a lot that matters for the aesthetics of the picture. If we are looking at the same print from the other end of the exhibition hall (say, from five meters away), we will see compositional elements that we could not see close up, but we will be missing out on a lot of details. So what we need to do is to go back and forth. And if one observes the spectators at a Gursky exhibition, this is exactly what they in fact do: walk away from the print to take in the entire composition and then walk closer to check some details and then walk back again, and so on. Gursky's photos must be among the pictoral works of art that require the most legwork.

If you look at Gursky's *Cable-car, Dolomites* (1987) from far away, you notice no cable car on the photo: all you see is an approximately symmetrical mountain landscape, a rocky slope in the lower half of the picture, and clouds in the upper half. There is also what looks like a tiny speck of dirt just left of the center of the picture. If you walk closer to the print, you see that what looked like a speck of dirt is in fact the cable car the title is referring to. But when you are close enough to the print so that you can make out the details of the cable car, you can no longer see the overall composition of the photograph (Gursky's *Madrid* [1988] is built on the very same compositional principles).

Another example: looking at Gursky's *Pyonyang III* (2007) from a distance, we have no idea what it is supposed to depict. All we see is a symmetrical composition of a long rectangle at the middle of the picture, and some yellow and light blue dots in front of it, that are organized geometrically (one line yellow, one line blue). Going closer, we see that the yellow and blue dots are in fact performers, and what seems like a rectangle in the middle of the picture is the audience of North Koreans enjoying the performance. The close-up view and the view from a distance give us two completely different experiences, and they are equally important for the appreciation of Gursky's photograph. In addition, the relation between these two experiences is as important as the experiences themselves.

The duality of the macro- and the microlevel of appreciating Gursky's photographs may remind one of one of the most important concepts in contemporary analytic aesthetics: the concept of twofoldness and of the general debate about the aesthetic appreciation of pictures.

What happens when we appreciate pictures aesthetically? Note that this question is different from asking what happens when we see something in a picture. We can see something in a picture even when we do not appreciate it aesthetically, for example, when we are watching a baseball game on TV.[14]

There are two very influential philosophical accounts of what happens when we appreciate pictures aesthetically. According to the first one, our attention alternates between the depicted object and the canvas.[15] According to the second, the experience we are supposed to go through when looking at pictures is a twofold one: we are simultaneously aware of the picture surface and the represented object.[16] We have a twofold experience in this sense.[17] As Richard Wollheim puts it, "The spectator is, and remains, visually aware not only of what is represented but also of the surface qualities of the representation."[18]

Which account is the correct one? It has been argued that we may not need to choose between the two. Maybe some pictures are to be appreciated, as Gombrich suggests, by alternating our attention between the two-dimensional surface and the three-dimensional depicted object, but some other pictures are to be appreciated in a Wollheimian twofold manner.[19] I argue at the end of this article that the appreciation of Gursky's photographs shows an interesting combination of Wollheim's and Gombrich's perspectives, and it also demonstrates how varied and complex twofold pictorial experiences can be. But before that, I argue that what underlies the

three crucial compositional attributes of Gursky's photographs are the technological innovations I mentioned in the previous section: postproduction manipulation, extremely high resolution, and extremely large prints.[20] I analyze these three aspects in turn before returning to the question of twofoldness and the aesthetic appreciation of pictures.

III

I start with the "macroscopic" aspect of Gursky's photographs: the experience we have if we are looking at his pictures from a distance. It has been often noticed that many of Gursky's photographs, if seen from a distance, look like abstract paintings. Take his *Rhine II* (1999). What one sees from a distance is a thick, gray, horizontal stripe across the picture at the middle, a thinner green one just above it, and two thicker green ones just below it, divided by another thin light green stripe. The comparison with some of Rothko's or, even more appropriately, Barnett Newman's paintings (rotated by ninety degrees) is very tempting. But Gursky's picture is, of course, a photograph of a river (the gray horizontal stripe) and its banks (the green stripes). The point is not limited to one or two of his photographs: most of them are carefully and consciously composed to be seen from a distance as an abstract picture (another clear example is his *Schwimbad Ratingen* [1987], with its striking similarity to the composition of Motherwell's paintings).

What it is important to take from this comparison is that Gursky devotes a lot of attention to the way his photographs look from a distance, that is, to the overall composition of his pictures. This composition is almost always symmetrical (or almost symmetrical), and it is very often organized around a rectangle in the middle of the picture.[21] A few examples are *Untitled V*, *Prada I* (1996), and *Prada II* (1997), where the rectangle is a row of shelves, *Paris Montparnasse* (1993) or *Avenue of Americas* (2001), where it is a large apartment building, *Untitled VI* (1997), where it is a Jackson Pollock painting, and *Toys "R" Us* (1999), where it is composed of two large buildings next to one another. This rectangle is often tilted, as in *Ruhrtal* (1989), where it is the area between the overpass and pillars holding it, or in *Schiphol* (1994), where it is the floor-to-ceiling window. And it also often has bent contours, as in *Bibliotek* (1999),

Stateville, Illinois (2002), or *Shanghai* (2000). Although these photographs are almost symmetrical, this symmetry is never exact. There is always imbalance and counterbalance, but this is most often provided by the "microscopic" aspect of the photos, so I postpone its discussion until the next section.

Another salient aspect of Gursky's composition is repetition; most of his photographs are structured around repeated motifs: windows in *Paris Montparnasse* and *Avenue of Americas*, balconies in his *San Francisco* (1998) and *Shanghai*, prison cells in *Stateville, Illinois*, cows in *Greeley* (2002), cars in *Salerno* (1990), the lights of Los Angeles in *Los Angeles* (1999), parasols in *Rimini* (2003), roads in *Bahrain I* (2005), and people in the majority of his pieces, but the most strikingly in the Pyongyang series.

Interestingly, and conveniently for our analysis, Gursky's early photographs use exactly these compositional principles. A good example is his little-known series of security guards (*Pförtner*, 1982–1985). In each of these small-scale color photos, there are two security guards standing side by side and always behind a rectangle-shaped occluder (desk, counter, and so on).

An even more striking early Gursky piece is *Gran Canaria* (1979), a small-scale black-and-white photograph, where we can find all the important features of the large-scale compositional elements of Gursky's later work. The comparison between this small black-and-white photo and the gigantic color photographs that Gursky is famous for can help us to understand both the macroscopic and the microscopic aspects of his pictures.

Gran Canaria is a picture of a bus in front of a wall. Behind the wall, we see a row of apartment buildings (or maybe hotels). The rectangle of the bus is situated at the middle of the composition in the same way that the rectangles are situated in the middle of later Gursky compositions, and the repetition of the buildings in the background also anticipates the importance of repeated compositional elements in his later works. Finally, the picture is delicately balanced. Although its main features are symmetrical (the bus and the wall), in the background, we get the delicate imbalance and counterbalance that Gursky likes in his later compositions: the row of buildings is off-center to the left, and on the right we get the counterweight of a lamppost. Not only are all the

compositional principles present, but they are also combined in the way they will be in Gursky's later photographs. There is an almost perfect similarity between this composition and his *His Sha Tin* (1994).

The surprising similarity between the compositional principles of this small black-and-white photo and Gursky's later pictures is important for two reasons, one biographical, the other technical. First, the standard account of the influences on Gursky's art is that he comes from the objectivist and documentarist Becher school. And it is indeed true that he studied under Bernd and Hilla Becher at the Kunstakademie in Dusseldorf (together with Josef Beuys and Gerhard Richter). But that was in the early 1980s, and it seems that Gursky had already figured out how he would compose his photographs when he made *Gran Canaria*, that is, in 1979. Gursky's biographers often ignore (or fail to emphasize) those two years that Gursky spent at the Volkwangschule in Essen in the late 1970s. The Volkwangschule was led by Otto Steinert, and some have pointed out the influence Steinert's more subjectivist approach made on Gursky (bringing about creative tension with the objectivism of the Becher school), but given that Steinert died the year Gursky started his studies at the Volkwangschule, this influence may be somewhat overstated.[22] But the influence of one of Gursky's young teachers, Michael Schmidt, has not been sufficiently acknowledged. Schmidt's compositions at that time, for example, his *Berlin-Wedding* (1976), have structural features very similar to those in *Gran Canaria*. But as Schmidt's oeuvre is very clearly a continuation of the modernist black-and-white photography of the 1920s and 1930s, in the tradition of Andre Kertesz and Henri Cartier-Bresson, this places the early Gursky compositions squarely in this modernist tradition. And, as his macroscopic compositional principles do not seem to have changed since then, at least one aspect of his photographs is to be appreciated in the same way as these modernist photographs—quite ironic for a photographer who is most often referred to as "postmodern."

But what is more important from our point of view about *Gran Canaria* is not only what it shares with later Gursky photographs, but also how it differs from them. It differs from them in many ways: it is a black-and-white small photograph, taken with a Leica camera. The photos Gursky is famous for are huge and have very vivid color

schemes. Nonetheless, they seem to have the same macroscopic compositional features.

And it is at this point where the new technology Gursky uses becomes not just relevant, but crucial for understanding the macroscopic composition of Gursky's photographs. It is easy to create modernist compositions with geometrical order of large expanses of homogenous areas in a small black-and-white photograph. It is not so easy in a huge, high-resolution color photograph. Take the compositional element of the monochrome light gray stripe of the top end of the wall, a horizontal thick gray line cutting across the middle of the composition in *Gran Canaria*, and compare it with the third aisle in Gursky's *99 Cent* (1999), which has the same role in the composition (a horizontal stripe at the middle of the composition cutting the picture in half). How can you use an area of high-resolution motley details as a building block for a modernist composition? This is the main challenge for Gursky's macroscopic compositions.

And Gursky's answer is postproduction manipulation. In *99 Cent*, he digitally manipulates the saturation of the colors to such a degree that the highly saturated orange and yellow colors are unreal enough to form a compositional feature that could be compared to a monochromic stripe in a black-and-white photograph in terms of its salience in an abstract composition. A piece that illustrates the importance of digital manipulation of colors (and maybe even explicitly reflects on it) is *Cans—Seurat* (2007), a photo of various soda cans stacked into a wall, as pixels of a photograph (or as the brushstrokes of Seurat's pointillist paintings). If we look at this photo from a distance, we can see an abstract composition, but what is important for our purposes is that the large-scale composition works only because the colors of the "pixels," that is, of the soda cans, are digitally manipulated: the red of the Coke and the blue of the Pepsi are much more saturated than the original color. This gives us only a small number of highly saturated colors, which then combine into a very salient abstract composition.

A more radical way in which Gursky manipulates the colors of his photographs digitally is the following. In some of his photos, he gets rid of all the hues except for one (or two). This serves the same purpose as the high saturation, namely, to allow him to compose macroscopically. Take *Shanghai* and *Kamiokande* (2007), where

the color scheme is digitally manipulated to such an extent that only one hue remains. As a result, Gursky can build up his composition as if it were a black-and-white modernist piece, as there are only the shades of this one hue that he varies.

An even more radical way of using digital manipulation for the same purpose is by piecing together the films of different pictures digitally. This is what happens in *Times Square* (1997) and *Rhine II*. In both cases, Gursky's aim was to get rid of unnecessary details so that nothing distracts from the macroscopic composition of the picture. The bottom line is that it would be very difficult to preserve Gursky's macroscopic compositional principles without the use of postproduction technology—there would be too many distracting details and colors to appreciate the modernist composition of these pictures. In this sense, postproduction manipulation is a necessary feature of the macroscopic aspect of Gursky's photographs.

IV

Gran Canaria shares the most important macroscopic features with Gursky's later photographs. But it lacks all the microscopic features that made Gursky so famous. *Gran Canaria* has no microscopic layer—no details to look at, nothing to verify or explore from close up; after all, it is a small black-and-white photo. So while the similarities with *Gran Canaria* helped us to analyze the macroscopic aspect of Gursky's later oeuvre, the differences from *Gran Canaria* help us to analyze the microscopic aspects.

There is, of course, a huge amount of detail in Gursky's photographs, and these details are not just there to distract us from the appreciation of the modernist composition from a distance. Importantly, besides being fascinating in their own right, these details often contribute to the appreciation of the macroscopic composition in important ways.

More specifically, the microscopic details are important for breaking the symmetry of the large-scale composition. As we have seen, Gursky's compositions are very often almost, but not completely, symmetrical. And the asymmetrical elements get all the more emphasis because of the overall symmetrical structure. Take some of his most symmetrical compositions, his hotel atrium photographs. In *Times Square*, *Shanghai*, and *Atlanta* (1996), the composition is almost perfectly

symmetrical, just as the atriums of hotels usually are. But as a result, we pay more attention within this strictly symmetrical structure to those details that are not symmetrical. In the case of *Atlanta*, they are the janitor trolleys, which are carefully (and, as it turns out, digitally) placed at various parts of this symmetrical grid to break its monotony. In *Shanghai*, they are a woman in a wheelchair and a dog, counterbalanced by a man admiring the view.

It is clear that the only way this effect can be achieved is by increasing the resolution of the photograph. And this is the point at which the microscopic structure of Gursky's photos also relies on the use of new technology: of extreme resolution. Without that, it would not be possible to have a cable car in the middle of the picture that looks like a speck of dirt from a distance but when we get closer, we see its tiniest details. Likewise, what appears to be geometrically organized colorful dots from a distance in the *Pyongyang* series have high enough resolution so that when we get closer, they turn out to be North Korean performers, and we can even make out the smile on their faces.

But there is also another way in which the microscopic structure of Gursky's photos relies on the use of new technology. Gursky proudly exclaims in an interview that "you never notice any arbitrary details in my work," and he is right: the details of the microstructure of his pieces are never superfluous.[23] But the only way of achieving this is by using postproduction (often digital) manipulation for getting rid of the superfluous details.

For example, in *Paris, Montparnasse*, we see a large apartment building with several hundred windows. If we look at the photo from afar, we see the windows arranged, like pixels, in an interesting, abstract geometrical pattern. But if we walk close to the print, what we see in these windows is carefully arranged with the help of digital manipulation: we often see the same pieces of furniture or the same curtain in different windows, for example.[24]

An even more subtle example is Gursky's *Prada I* (1996), where we see two very long shelves with shoes on them. (*Prada III* [1998] works on the same principle.) The overall composition is very similar to *Untitled V*, where we see six long shelves of athletic shoes, but in the case of *Prada I*, there is a twist. If we look closely, we can see that the shoes

are both from the Fall and the Spring collections; therefore, they would never be displayed together. The microstructure of Gursky's photographs has all kinds of surprises in store for those who are willing to explore the details (as soccer fans could confirm in the case of *EM Arena I* [2000] and *EM Arena II* [2000]). And this is achieved by the digital manipulation of these details.[25]

v

We have seen how important both the macroscopic and the microscopic aspects of Gursky's photographs are, and we have also seen that they are both intimately connected with the new technology Gursky uses: postproduction (often digital) manipulation and high resolution. The question I now turn to is how these two aspects of Gursky's pictures combine.

Gursky himself says that in his photographs, "interrelated micro and macrostructures are woven together, determined by an overall organizational principle."[26] This is true in some sense but very misleading in another. It is true that the microscopic and the macroscopic compositions are carefully crafted to work together. But this slogan is also misleading inasmuch as we can never see the microstructures and the macrostructures at the same time. In fact, it is an important feature of Gursky's work that our experience of the microstructures and that of the macrostructures is supposed to alternate.

When we are looking at a Gursky print from a distance, this view is rarely satisfying: we feel the urge to get closer to the print.[27] This may happen for a variety of reasons. Most often, we have no idea what we are looking at. We see a geometric composition of pretty colors, vaguely along the lines of the compositional principles of modernist photographs, but we have little or no idea what this is a photograph of. So we walk closer to the print and check. In some other instances, the reason why we may feel the urge to walk closer is because although we do recognize what the detail is, we want to see it more clearly: we see that there are soccer players in *EM Arena I* and *EM Arena II*, but we may want to know which teams are playing or who the players are. So we walk all the way to the print to check these details. Then we walk back to take in the full composition, having figured out the details. Then we notice a further detail, walk closer again, and so on.

This aspect of the appreciation of Gursky's work is clearly only possible because of the large scale of the prints. If the prints were smaller, we could take in both the microstructure and the macrostructure from the same vantage point. The size of the prints makes us realize, because of all the walking back and forth, the difference between the vantage point that is appropriate for appreciating the microstructure and the one that is appropriate for appreciating the macrostructure.

To sum up, Gursky's photographs rely on the new technology in three ways: the appreciation of the macrostructure relies on postproduction manipulation, the appreciation of the microstructure on both high resolution and digital manipulation, and the appreciation of the relation between the two on the extreme size of the prints.

A last important aspect of the appreciation of the relation between the microstructure and the macrostructure of Gursky's photographs needs to be mentioned. We have seen that we can never see the microstructures and the macrostructures at the same time. In fact, it is an important feature of Gursky's work that our experience of the microstructures and that of the macrostructures is supposed to alternate. This aspect of Gursky's photographs is especially important in the light of the current debate in contemporary analytic aesthetics about the appreciation of pictures, a debate to which I now turn.

vi

We have seen above that a seemingly obvious concept that we could use for describing the duality of the macro- and the microlevel in Gursky's work is the concept of twofoldness. I want to argue now that things are much more complicated. In fact, Gursky's photographs help us to understand how complex and varied twofold pictorial experiences can be.

In order to show this, I want to connect the contemporary discussion about the appreciation of pictures with a much older one that comes from Heinrich Wölfflin. Wölfflin argued that one important shift from the linear style of the sixteenth century to the painterly style of the seventeenth century is that the appropriate way of looking at the picture has changed: while the linear style presupposed that the viewer alternated her viewpoint, the painterly style of the following

century was working with one unified viewpoint only. As Wölfflin summarizes:

The distance required for distinct seeing is relative: different things demand different vicinities of the eye. In one and the same form-complex, totally different problems may be presented to the eye. For instance, we see the forms of a head quite distinctly, but the pattern of the lace collar beneath it requires closer approach, or at least, a special adjustment of the eye if its forms are to become distinct.... The demand for unified visual perception is radically non-existent for this type of [linear] art.[28]

Wölfflin uses Holbein's paintings as examples for this nonunified way of seeing and contrasts them with the portraits of Frans Hals, who, rather than painting the most exquisite details of objects in the background, uses just one carefully executed brushstroke that nonetheless looks appropriate from where the portraits are to be looked at.

It is crucial to note that the distinction Wölfflin talks about and the one about twofoldness are not the same. The debate about twofoldness is about whether we are simultaneously aware of both the depicted object and the design features of the picture surface: the brushstrokes, for example. Wölfflin's distinction has nothing to do with the design features of the picture surface. It is about our awareness of different depicted objects in the picture—and whether we can be aware of their details simultaneously.

It must be clear that Gursky's photos provide an extreme example for what Wölfflin means by the perceptual engagement required by the linear style: the appreciation of different features of these works require different vantage points, just as the appreciation of Holbein's paintings (that Wölfflin uses as the example for the linear style in this context) requires different vantage points. Gursky is very much a "linear" photographer.

The question is how these two different ways of appreciating Gursky's photos relate to one another. And here we need to go back to the twofoldness debate. When we look at these photos from afar, the microstructure is part of the design features of the surface, which makes it possible for us to see the macrostructure in the picture. But if we look at the picture close up, the very same details are what are depicted in the photograph. They serve both as the design features and as depicted objects. And this amounts to an unusual form of twofold experience.

Remember, according to the original concept of twofoldness, we are simultaneously aware of both the depicted object and the design features of the surface that make it possible for us to see the depicted object. This is the simultaneous awareness of two different entities: depicted object and design. In the case of Gursky's photographs, in contrast, we simultaneously see the very same pictorial elements, the microstructure, as both design features (as seen from afar) and depicted objects (as seen close up).

Gursky is, of course, not the first person in art history who utilized this special case of twofold experience in appreciating pictures. Another obvious example would be Giuseppe Arcimboldo, whose portraits work in a similar way: we see the fruit both as the depicted object and as the design feature that make it possible for us to see the portrait. Although Arcimboldo is the best-known representative of this way of composing pictures, the so-called "anthropomorphic landscapes" were very widespread from the second half of the sixteenth century, especially in the Low Countries.[29] In these paintings, we see the objects in the picture in two ways: both as various elements of the landscape—cows, walls, shrubbery—and as parts of a human face—eyes, nose, beard. In other words, we see them both as depicted objects (in the landscape) and as design features that make it possible for us to see a human face in the picture.

Gursky, somewhat surprisingly, falls into this tradition, as far as the use of twofoldness is concerned. But what is unique about Gursky's use of this form of twofoldness is that because of the large size of the photographs, it relies on the alternation of one's attention (and as a result, of one's vantage point) to bring about this twofold experience. If we are looking at an Arcimboldo painting, we can switch back and forth between seeing a fruit basket and seeing a face merely by shifting our attention. In the case of Gursky's photographs, this requires moving closer to and away from the print.

In this respect, Gursky's photographs are somewhat similar to Anselm Kiefer's paintings. Some of Kiefer's large-format pieces work on the very same principle as Gursky's large-format photographs. You have to go to the other end of the hall in order to have a chance to take in the

overall composition, whereas the details, which, in the case of Kiefer, often mean various objects stuck in the paint, are only visible if one walks back to the painting to have a closer look. We see these objects both as parts of the microstructure of Kiefer's pieces and as the design features that make it possible for us to see the macrostructure. (It would be very interesting to have a thorough comparative analysis of Gursky's and Kiefer's compositional methods, especially in the light of the fact that they were both students at the Dusseldorf Kunstakademie.)

In short, Gursky's photos provide an elegant demonstration of instances where both Gombrich and Wollheim are partially right about the appreciation of pictures. Wollheim is right because this experience is a twofold one: we are simultaneously aware of both the macrofeatures and the microfeatures. But, and here is the twist, this twofold experience is not the awareness of two different entities: the depicted object and the design features that make it possible for us to see this depicted object in the picture. It is the awareness of the very same pictorial elements, namely, the microstructure, as both depicted objects and as design features that make the perception of the macrofeatures possible. Importantly, we would be missing out on a crucial feature of these photos if we were not aware of the microfeatures when appreciating the macrofeatures and vice versa.

At the same time, just as Gombrich says, we cannot be fully aware of both simultaneously because we cannot be both ten yards away from the print and a couple of feet away from it at the same time. Our attention and, because of the large size of the prints, our spatial position need to alternate. Gursky's photographs show how unusual and varied the uses of twofold pictorial experiences can be.

BENCE NANAY
Department of Philosophy
University of Antwerp
2000 Antwerp, Belgium

and

Department of Philosophy
Peterhouse, University of Cambridge
Cambridge, CB2 1RD, UK

INTERNET: bence.nanay@ua.ac.be

1. Alva Noë, *Action in Perception* (MIT Press, 2004), p. 71.

2. Noë, *Action in Perception*, "Pictures and Mind," chap. 2, pp. 35–74; see also the papers in the "grand illusion" special issue of *Journal of Consciousness Studies* 9 (2002), issue 5–6.

3. Alva Noë, "Experience without the Head," in *Perceptual Experience*, ed. Tamar Szabó Gendler and John Hawthorne (Oxford University Press, 2006), pp. 411–434, at p. 419.

4. Heinrich Wölfflin, *Principles of Art History* (New York: Dover, 1915), p. 46.

5. Wölfflin, *Principles of Art History*, p. 45.

6. Katy Siegel, "Consuming Vision," *ArtForum* 39 (2001): 104–108. A similar, but more nuanced version of this claim is also made in Gregg Horowitz, "Photoshop, or, Unhandling Art," in *Action, Art, History: Engagements with Arthur C. Danto*, ed. Daniel Herwitz and Michael Kelly (Columbia University Press, 2007), pp. 82–102.

7. Michael Krajewski, "Kollektive Sehnsuchtsbilder: Andreas Gursky im Gespräch mit Michael Krajewski," *Das Bulletin* 5 (1999): 8–15, at p. 14.

8. Supposedly, the idea of consumerism; see Siegel, "Consuming Vision," p. 105.

9. Richard Wollheim, *Painting as an Art* (Princeton University Press, 1987); Richard Wollheim, "On Pictorial Representation," *The Journal of Aesthetics and Art Criticism* 56 (1998): 217–226; John Armstrong, "Non-depicted Content and Pictorial Ambition," *The British Journal of Aesthetics* 37 (1997): 336–348; Bence Nanay, "Narrative Pictures," *The Journal of Aesthetics and Art Criticism* 67 (2009): 119–129.

10. See Alix Ohlin, "Andreas Gursky and the Contemporary Sublime," *Art Journal* 61 (2002): 22–35, for a version of this argument; for some objections, see Jacinto Lageira, "Andreas Gursky: A Hellish World," *Parachute: Contemporary Art Magazine* 110 (2003): 56–75, and Siegel, "Consuming Vision."

11. One representative example is Alex Alberro, "Blind Ambition," *ArtForum* 39 (2001): 109–114, who argues that while Gursky in his early work was fighting globalization, he later betrayed this cause and just wanted to make pretty pictures.

12. Krajewski, "Kollektive Sehnsuchtsbilder," p. 15.

13. Veit Görner, ". . .I Generally Let Things Develop Slowly," in his *Andreas Gursky: Fotografien 1984–1998* (Wolfsburg: Kunstmuseum, 1998), pp. vii–x, at p. viii.

14. On this distinction, see Jerrold Levinson, "Wollheim on Pictorial Representation," *The Journal of Aesthetics and Art Criticism* 56 (1998): 227–233; Bence Nanay, "Is Twofoldness Necessary for Representational Seeing?" *The British Journal of Aesthetics* 45 (2005): 263–272; and Bence Nanay, "Inflected and Uninflected Experience of Pictures," in *Philosophical Perspectives on Depiction*, ed. Catharine Abell and Katarina Bantinaki (Oxford University Press, 2010), pp. 181–207.

15. Ernst Gombrich, *Art and Illusion*, 2nd ed. (Princeton University Press, 1961).

16. Richard Wollheim, "Seeing-as, Seeing-in, and Pictorial Representation," in his *Art and Its Object*, 2nd ed. (Cambridge University Press, 1980), pp. 205–226; Wollheim, *Painting as an Art;* Wollheim, "On Pictorial Representation"; Bence Nanay, "Taking Twofoldness Seriously: Walton on

Imagination and Depiction," *The Journal of Aesthetics and Art Criticism* 62 (2004): 285–289; Nanay, "Is Twofoldness Necessary for Representational Seeing?"; and Bence Nanay, "Picture Perception," *Phenomenology and the Cognitive Sciences* 10 (2011): 461–480. See also Dominic McIver Lopes, *Understanding Pictures* (Oxford University Press, 1996); and Dominic McIver Lopes, *Sight and Sensibility* (Oxford University Press, 2005).

17. A recently popular way of putting this is to say that our experience of the picture is inflected. See Michael Podro, "Depiction and the Golden Calf," in *Visual Theory: Painting and Interpretation*, ed. Norman Bryson, Michael Ann Holly, and Keith Moxey (New York: HarperCollins, 1991), pp. 163–189; Michael Podro, *Depiction* (Harvard University Press, 1998); Lopes, *Sight and Sensibility*; Robert Hopkins, "Inflected Pictorial Experience: Its Treatment and Significance," in *Philosophical Perspectives on Depiction*, pp. 151–180; and Nanay, "Inflected and Uninflected Experience of Pictures."

18. Wollheim, "Seeing-as, Seeing-in, and Pictorial Representation," pp. 214–215.

19. Lopes, *Sight and Sensibility*, "The Puzzle of Mimesis," pp. 20–48.

20. It is worth noting that these "innovations" are not particularly original or radical, especially if we compare them with some more recent attempts to use technological innovations in photography, such as Olivier Buchet's mold-eaten diapositives.

21. Interestingly, these compositional principles are very similar to those of a contemporary of Gursky's, Thomas Struth, who also studied under Bernd and Hilla Becher in Düsseldorf (but a bit earlier than Gursky). In the case of Struth's photographs, the central rectangle is very often a painting in a museum, surrounded by visitors. It is surprising that no systematic comparison has been made between Gursky's and Struth's compositions—especially given the importance of high-resolution large prints in both cases.

22. Notably, Peter Galassi, *Gursky's World* (New York: MoMA, 2001) pp. 6–9, at p. 6.

23. Görner, "I Generally Let Things Develop Slowly," p. viii.

24. See Siegel's "Consuming Vision" for an analysis of the relevance of this.

25. An interesting comparison here is Alexander Apóstol, who also often digitally manipulates his photographs and who also seems to be aiming at the re-creation of a version of modernist aesthetics. But while Gursky manipulates the details, Apóstol removes them: in his most famous series, he digitally erases all the windows and doors of 1950s modernist buildings of Caracas.

26. Görner, "I Generally Let Things Develop Slowly," p. viii.

27. Siegel, "Consuming Vision," makes a similar point.

28. Wölfflin, *Principles of Art History*, p. 22.

29. See *The Archimboldo Effect: Transformations of the Face from the 16th to the 20th Century*, ed. Pontus Hultén (Milan: Bompiani, 1987), for a good summary of the development of this subgenre.

DIARMUID COSTELLO

The Question Concerning Photography

What do Martin Heidegger's writings on art and technology and recent debates in analytic philosophy of photography have in common? Prima facie, very little. Even the weaker suggestion that there might be some common ground against which to assess their competing claims about some shared object of inquiry seems implausible. Nonetheless, in this article, I bring Heidegger's claims about art and technology into dialogue with Kendall Walton's work on photography. The impetus for doing so comes from noticing, their differences notwithstanding, some points of contact that may have gone unremarked for no better reason than that few philosophers are given to reading both. More specifically, I address the following three issues:

1. The extent to which the "mind-independence" thesis underwriting analytic philosophy of photography since Walton partakes of the antisubjectivism of Heidegger's philosophy of art more generally
2. Whether photography, as understood by analytic philosophers of art, is capable of meeting Heidegger's key criterion of authentic art, namely, that it provides a "decisive confrontation" with technology
3. Whether Heidegger and Walton's theories of art and photography are not equally contentious, insofar as they do agree, with regard to the role that artist and photographer play in their respective accounts

Given Heidegger's conception of technology, on the one hand, as the "supreme danger," because it reduces the significance of all beings to their utility (flexibility, availability, and so on) as a resource, and photography's tendency to reduce the world to an aesthetic resource, on the other, it seems unlikely that photography could embody the "saving power" of art. It seems much more likely that photography embodies precisely the problem that great art is supposed to contest on the Heideggerian story. But whether photography does, or at least could, fulfill such a role depends largely on what is involved in understanding photography *as an art*—as opposed to, say, a collection of prosthetic aids to vision. In Heideggerian terms, this is to ask: how might art resist technology when the art in question is photography? From a Heideggerian perspective, this would be *the* question concerning photography.

From the perspective of analytic philosophy of photography, by contrast, *the* question concerning photography would be whether the role of mind in the formation of photographic pictures is sufficiently distinctive to distinguish photographs in kind from other forms of depiction. Whatever resistance Walton's claim that photographs are "transparent" may have elicited, his more fundamental claim that photographic depiction is mind-independent in a way that distinguishes it from all nonmechanical forms of depiction has been widely accepted.[1] My goal is to show that these two questions, the Heideggerian one about how photography as an art might resist technology and the Waltonian one about the role of mind in photographic depiction, are mutually implicating.

One might have various worries about this project. I will mention only the three that strike me most forcefully. There are doubtless others.

The first worry is, when trying to bring such different bodies of thought together, how different their underlying assumptions are. Analytic

philosophy of art tends to be descriptive rather than normative: insofar as it takes existing practices of art as data for theory building, its claims need to be consistent with everything that informed critical practice takes to be in the relevant domain. Call this the "critical practice" constraint. As a result, analytic philosophy of art is not typically in the business of asking whether everything in the domain *should* be in the domain, or whether the artworld is justified in its practices: such practices are a presupposition of philosophical inquiry getting off the ground. As such, analytic philosophy of art tends to be resolutely nonnormative. To put it in a slogan: counterexamples matter.

Heidegger's theory of art, by contrast, is normative all the way down. Where one counterexample would worry an analytic philosopher of art, Heidegger's theory of art, if correct, is more at risk of *exemplification* than counter-exemplification. On Heidegger's account, almost everything called 'art' today is wrongly so called; if he is right, one would expect his theory to be largely inapplicable to art in its recent forms. The worry for Heideggerians is thus the inverse of analytic philosophers' fear of counter-exemplification. As a consequence, to most analytic philosophers of art, Heidegger's claims about great art occasioning a "strife between world and earth" are likely to appear uninformative at best and grandiose at worst. Conversely, from a continental perspective, the significance Heidegger attributes to great art as a cultural and historical horizon is likely to make the definitional and taxonomic projects of analytic philosophy of art appear rather meager by comparison.[2]

The second worry about trying to bring Heidegger and analytic philosophy of photography into dialogue is largely a function of the first, namely, how different the literatures surrounding the later Heidegger and Walton are as a result. The former typically confines itself to explicating the internal structure of Heidegger's thought; it seldom critically examines the justification for his claims in ways that would give skeptics reason to think they ought to engage seriously with it. One worry non-Heideggerians might have is how Heidegger could be in a position to *know* what he claims to know about various dispensations or "sendings" of Being, including the "supreme danger" represented by our own. Heideggerians, if they want to be taken seriously by non-Heideggerians on this score, cannot reply in a way that presup-

poses the truth of Heidegger's premises, for it is precisely the truth of those premises that is in question.[3]

The literature on Walton could not be more different in tone, consisting of an almost scholastic exchange of arguments and counterarguments as to whether his claims about photographic depiction cohere with our intuitions. In one recent sequence of exchanges, the persuasiveness of Walton's argument (that if we *are* willing to accept that we see objects with the mediation of mirrors, we have no reason *not* to accept that we see objects through photographs) was deemed to hang on the number and orientation of the mirrors involved. Beyond the point at which they cease to preserve information about the spatiotemporal location of the objects seen relative to their perceivers, it no longer cohered with his critics' intuitions to say that we *see* those objects.[4]

For Heideggerians, such debates only serve to beg the important question: appealing to our *intuitions* about what we feel inclined to say about particular cases can hardly serve as the final arbiter if those intuitions are themselves a product of (to put it in Heideggerian terms) an impoverished conception of Being. That is, the reflection of a limited, historically and culturally circumscribed conception of what it is to relate to entities in general. If that is correct, appeals to our intuition are likely to entrench rather than resolve the problem. Analytic philosophers of art, if they want to be taken seriously by those who do not share their methodological assumptions on this score, cannot presuppose the force of appeals to intuition when it is precisely the force of such appeals that is in question.

The third, and potentially most damaging, worry for my project of trying to think the two together is also largely a function of the first: even if it could be shown that something fundamental about both accounts may be captured in similar formulations, given how different their respective starting points are, one may doubt that this sheds much light on their underlying commitments. Given how different their starting points are, similar-sounding claims may have altogether different connotations.

But I am going set all such worries to one side here, if only to find out, in the spirit of approaching two philosophers outside the well-defined tracks of the standard debates on either, whether the project of bringing them into dialogue has wings.

To assess this claim, it is necessary to know what Heidegger thinks art (*techne*) and technology (*Technik*) have in common, and within that commonality, what sets them apart. What they have in common, for Heidegger, is that both art and technology are "modes of disclosure" (*aletheuein*), ways in which beings in general are brought to light, together with the underlying assumptions as to what beings are, that such modes of disclosure reveal. What sets them apart, accordingly, is what differentiates them *as* modes of disclosure. On Heidegger's account, this is the difference between "bringing forth" (*hervorbringen*) and "challenging forth" (*herausfordern*).

Both *techne* and *phusis* (nature) are forms of *poiesis*, or "bringing forth." *Phusis* is the highest form of *poiesis* because it is the bringing forth of that which discloses itself from out of itself or, more simply, of what has its power of disclosure within itself. Think of a bud bursting into bloom.[6] *Techne*, by contrast, is the bringing forth of that which has its power of disclosure in another; it is

an *assisted* form of disclosure. Think, for example, of a sculptor releasing the figure "slumbering" within the block, as Michelangelo is reputed to have claimed about his unfinished slaves. So understood, *techne* retains its connection to *phusis*: it enables what is coming into appearance to appear. Michelangelo does not simply impose his will on the block; he "releases," to put it in Heideggerian terms, what is already "coming to presence" within it. By remaining responsive to the possibilities inherent within the stone, Michelangelo "completes" nature's work. *Techne* remains handmaiden to *phusis*: it is nature's self-emergence that comes to fruition in the artist's work.[7]

Where *techne* respects nature's reticence, with which it works in concert, *Technik* severs this relation to nature's capacity for self-disclosure: it constitutes a "regulatory attack" forcing nature to surrender its latent power. Heidegger's example of such "challenging revealing" is atomic power: in comparison to wind power—which harnesses the power of the wind, but only when it blows—atomic power forcibly extracts the atom's latent power. In so doing, it maximizes nature's yield, albeit at the cost of transforming nature itself from the highest form of "bringing forth" to a mere quantum of resource. Heidegger's term is *Bestand* (standing reserve), indicating something made to stand by, on call for use or further transformation. His example is the hydroelectric plant that transforms the nature of a river into an energy source that henceforth derives its Being, determining the ways in which it is able to show up for us, from the power plant it now serves.[8] Treating nature as a resource in this way refuses to allow nature's "self-refusal," its recalcitrant materiality, to show up *as* self-refusal. Heidegger's way of expressing this is fittingly opaque: technology is, in its essence, a mode of unconcealing that covers over its own concealing of all other possible modes of unconcealing. It refuses to allow anything to show up *as* concealed, as unintelligible, as resistant to human ends. In the terms of "The Origin of the Work of Art," *Technik*—unlike *techne*—refuses "to let the earth be an earth."[9]

It is crucial to grasp that, on Heidegger's account of technology, man is not in any straightforward sense the agent of such disclosure, though he retains a privileged relation to it as that being within whose nature it resides to disclose a world.[10] Even so, like everything else that shows up for man, man appears to himself in a certain

light, depending on what "destining of Being" holds sway: technological man, qua utility-maximizer, understands his relation to everything that exists in ways that are incommensurable to those in which medieval man understands his relation to everything that exists, qua *ens creatum*. This is why Heidegger holds that human beings are themselves challenged by technology, rather than simply wielding it. What distinguishes the technological understanding of Being is that man appears to himself primarily as a resource for the first time: that is, man finds himself installed within an all-encompassing framework (*Gestell*) that he does not control, and in which human beings show up, like beings in general, first and foremost as resource.[11] What alarms Heidegger about such a relation to beings, what he calls the "supreme danger," is that it will become so pervasive as to eclipse all other possible modes of disclosure, including all forms of *poiesis*. Should technology become absolute in this sense, it would threaten to cover over all trace of itself as *a* destining of Being, that is, *one* possible way of relating to beings in general, such that man henceforth would take the way in which entities show up under its sway for the final truth about beings, including himself. At that point, man would risk becoming *nothing but* a resource in his own eyes, all other ways of understanding and interacting with beings being foreclosed.

It is because Heidegger understands art as a rival mode of disclosure, capable of confronting technology on the ground of what they have in common, that it holds such significance for him. Against the "supreme danger" presaged by the final triumph of a technological understanding of Being, art holds out a "saving power": the promise of a different, nondomineering relation to beings. As with technology, however, so too with art as a mode of disclosure: man is not in any straightforward sense its agent, even if the artist is, like the craftsman, "co-responsible" for what he "brings forth." Indeed, in the very first paragraph of "The Origin of the Work of Art," Heidegger rules out appeal to the artist as an explanation of how works of art come into being:

On the usual view, the work arises out of and by means of the activity of the artist. But by what and whence is the artist what he is? By the work; for to say that the work does credit to the master means that it is the work that first lets the artist emerge as master of his art. The

artist is the origin of the work. The work is the origin of the artist. Neither is without the other. Nevertheless, neither is the sole support of the other. In themselves and in their interrelations artist and work *are* each of them by virtue of a third thing which is prior to both, namely that which also gives artist and work of art their names—art.[12]

Given that Heidegger rejects a modern view of art at the outset, he cannot go on to infer the nature of art from its commonly accepted instances without presupposing the very conception he wants to contest. The problem he faces is thus a classically hermeneutic one of how to begin: his solution is to appeal instead to what he calls the "work-being of the work" (*Werksein des Werkes*). On Heidegger's account, the "work-being" of the work resides in the "strife" (*Streit*) it initiates between its "world," or what I shall gloss as the background horizon of intelligibility that it sets up (*aufstellend*), and its "earth," or what I shall gloss as whatever resists illumination from within that horizon of intelligibility, but is set forth (*herstellend*) as unilluminated within it. Accordingly, what makes something a work of art is that it enables whatever it illuminates to show up in the light of some underlying conception of Being, while disclosing that not everything can be understood in terms of that conception, by setting it forward as unmastered (and hence obscure) within it. That art retains this capacity "to let the earth be an earth" is ultimately what distinguishes *techne* from *Technik*.[13]

Truly epochal or ground-laying works of art make manifest the implicit understanding of Being of a particular historical culture and, in so doing, reflect it back to that culture as its understanding of Being for the first time. On Heidegger's account, the Greek temple does this; by gathering and focusing those practices that are decisive for its culture, it articulates that culture's implicit self-understanding. In Heidegger's words: "The temple ... first gives to things their look and to men their outlook on themselves."[14]

Given Heidegger's opening move, such disclosure cannot be a product of artistic agency in any straightforward sense; artists are not granted any privileged insight into the nature of their age. Rather, it is a product of "truth setting itself to work" in and through the work of art. This is an aspect of Heidegger's thought that I cannot hope to do justice to here. But in brief, the conception of truth Heidegger has in mind is not that of

correspondence between a proposition and a state of affairs in the world (and hence not one that could reduce works of art to utterances with propositional contents that correctly or incorrectly represent how things stand in the world) but what Heidegger takes to be the more primordial sense of truth as *aletheia*. So understood, truth draws attention to the "unconcealment" presupposed before any proposition can pick out, or fail to pick out, some state of affairs in the world. Entities must already be disclosed—and not neutrally, but in the light of some unthematized understanding of Being—before statements can correspond or fail to correspond to how things are.

I do not intend this thumbnail sketch to satisfy Heideggerians, much less to persuade non-Heideggerians, but to show how marginally, by modern standards, the artist figures in Heidegger's understanding of both how works of art come about and what they disclose. That said, Heidegger acknowledges that the "work-being" of the work cannot be grasped in isolation from the fact of its having been created. But he is at pains to distinguish *being created*, which is to be understood in terms of the "work-being" of the work (and not, say, the artist's intentions), from *being made*. So understood, "createdness" is not the work's generative *ground*, but a *product* of truth setting itself to work: it "fixes" truth (the strife between world and earth, intelligibility and opacity) in place as some particular configuration, that is, as a particular work of art.

III. WALTON ON TRANSPARENCY AND MIND-INDEPENDENCE

Clearly, a good deal more would be required to justify Heidegger's claims, but it is not my goal to provide a justification here. Instead I want to use Heidegger's claims regarding art and technology to motivate a question that could not arise from within Heidegger studies itself: could photography, as understood by analytic philosophers of art, hold out the prospect for a "decisive confrontation" with technology of the kind that Heidegger sought from authentic art? This would imply that analytic philosophy of photography partakes of something like the antisubjectivism of Heidegger's philosophy of art more generally. This is the counterintuitive proposition I now want to explore.

For this purpose, I will rely on Walton's account of photographic depiction in "Transparent Pictures" (1984), despite the fact that several aspects of his article have proved highly controversial.[15] This is because, for all the controversy that Walton's claim that photographs are "transparent" has generated, the more foundational claim (concerning the mind-independent nature of the photographic process) with which he underwrites it has been widely accepted, at least by other analytic philosophers of photography. According to Walton, it is a necessary condition of seeing that one's perceptual experience depend causally and counterfactually on what is seen: we "see through" photographs because had, contrary to fact, what was before the camera at the moment of exposure been different, what one sees in the resulting photograph would have differed accordingly. Given, however, that analogous claims can be made about many realist paintings, Walton needs to rule out such cases. To wit: only photographs are *naturally* counterfactually dependent on what they depict; had, contrary to fact, what was before the camera at the moment of exposure been different, its photograph would have differed accordingly, *irrespective* of whether the photographer had noticed the difference and intended to record it. A painting, by contrast, would only have differed if the painter noticed the difference and intended to depict it. This is because painting is, and photography is not, dependent on the mental states of the artist. Setting aside the further claim that, other conditions being met, this warrants claiming that we "see through" photographs, the underlying mind-independence thesis is widely accepted.

The question I want to pose is this: is the mind-independence thesis as plausible as it is generally taken to be and, if not, what makes it seem so plausible nonetheless? According to the mind-independence thesis, the way in which our visual experience of flower paintings, say, is dependent on the flowers depicted is different in kind from the way in which our visual experience of flower photographs is dependent on the flowers photographed. Only the latter is naturally counterfactually dependent upon what it is of. In effect, the flower paintings are a form of visual testimony and are correspondingly defeasible: they tell us what the painter believed was there. This is not to say that the painter *cannot* be correct in his beliefs, of course, but rather, the argument runs, that the photographer *need not* be. Whatever controversy

Walton's claim that photographs are transparent may have elicited, this claim is generally taken to be persuasive. By contrast, Heidegger's claim that the artist is not the "origin" of the work of art would, I take it, generally be thought counterintuitive, at least by non-Heideggerians. But is this difference in intuitions well founded?

It is notable that the mind-independence thesis strikes philosophers as much more intuitive than it does photographers, photo-theorists, and critics. Is this because the latter do not appreciate the philosophical point at issue, or because philosophers are insufficiently informed about how photography works, or both? Here I think it is worth insisting on the importance of something that should be better marked: namely, that what one takes as one's paradigm case of photography will have enormous, if often unwitting, repercussions for the philosophical theory one goes on to elaborate on its basis. Walton acknowledges that the paradigm case for his own account is the snapshot rather than the work of art; I believe that a more apposite paradigm case for his account would in fact be some kind of automatic recording mechanism. Think of time-lapse nature photography or speed cameras, of which it is literally true that the mechanism fires off automatically, irrespective of what anyone believes to be in front of the camera at the moment of exposure. Were one to begin from the kind of authorial control exercised by photographic artists, one would expect the account that emerges to be correspondingly different.

But am I simply begging the question by insisting on artistic agency in this context? The fact that photographers have it in their gift to set all manner of variables, as critics of mechanical conceptions of photography maintain, is typically taken to fall foul of Walton's point in just this way. To take only the pre-digital case: photographers, such critics maintain, make innumerable decisions about camera hardware and camera settings, film and paper stock, darkroom variables and techniques, and the like.[16] All this may be granted, the default philosophical response runs, and it still hold that from the moment of exposure to resulting print, at least in a fully automated process, the information channel from input to output is impermeable to the photographer's mental states.[17] Granted, such "encapsulation" can be weakened in various ways when the full range of darkroom techniques is employed, but, at least in theory, what was in front of the lens at the moment of exposure, as opposed to what the photographer *believed* was in front on the lens at the moment of exposure, should be retrievable from the resulting photograph, assuming one knows enough about how the variables relevant to processing the latent image were set. I am skeptical, but before I say why, I want to consider the relation between Walton's conception of photography and Heidegger's conception of art more closely.

IV. THE ART IN PHOTOGRAPHY

Recall Heidegger's distinction between bringing forth and challenging forth. The former, Heidegger claims, is the hallmark of authentic art, that is, art that does not seek to impose the subjective will of the artist on the material from which it is made, but works in concert with nature's own capacity for self-disclosure. In such art *techne* remains handmaiden to *phusis*: it is nature's self-emergence that comes to fruition in, and is completed by, the artist's work. There are notable parallels with the most basic theme in theoretical reflection on photography here. But to grasp their significance, it is necessary to realize that Walton's mind-independence thesis is only the most recent manifestation of a broader tradition of thought that can be traced all the way back to the way in which photography was presented by its original inventors and pioneers, notably Joseph Nicéphore Niépce, Louis-Jacques-Mandé Daguerre, and Henry Fox Talbot. Niépce, credited with fixing the photographic image for the first time in 1826, called his process heliography (or "sun writing") and described it as "spontaneous reproduction by the action of light." Daguerre characterized his own process as "not an instrument that serves to draw nature, but a chemical and physical process which gives her the power to reproduce herself." When the two joined forces, they contracted to "fix the images which nature offers, without the assistance of a draughtsman." Fox Talbot, meanwhile, described his rival calotype process, forerunner to modern negative–positive processes, as a "photogenic drawing" that depicts "by optical and chemical means alone" an image "impressed by nature's hand."[18]

What all these formulations share is the conceit that photography is at root a natural process through which nature "reproduces herself" (or rather her appearance) by means of light alone.

FIGURE 1. Lee Friedlander, *Stems* (1999). © Lee Friedlander, courtesy Fraenkel Gallery, San Francisco, USA.

So construed, photography—literally, writing with light—though dependent on the natural processes of optics and chemistry, remains free of *human* mediation in the respect that counts: the generation of the image itself. This constellation of ideas, departing from various metaphors concerning the "agency of light," has permeated theoretical reflection on photography ever since; the mind-independence thesis is just one of its more formally refined recent variations.[19] What the underlying notion has in common with Heidegger's theory of art is twofold, pertaining both to *how* works of art and photographs come into being and *what* they show as a result of how they come into being.

On both fronts, both accounts diminish the significance of their object's ostensible creator. Like authentic art on Heidegger's account, photography is here conceived as an *assisted self-disclosure of nature*: "not an instrument that serves to draw nature," as Daguerre puts it, "but a chemical and physical process which gives her the power to reproduce herself."[20] As a corollary of this stress on self-generation, both accounts are required to downplay their object's prima facie creator with respect to what appears. On neither account can what the work or photograph shows be reduced to a function of its creator's will. On Heidegger's account, authentic works of art are those that facilitate the appearing of what is already coming into appearance, rather than those that express an individual artist's vision. On Walton's account, what appears in any photograph can only be what was in front of the lens at the moment of exposure, irrespective of what the photographer believed to be there or intended to depict.

How what appears appears, by contrast, is a result of the way in which a given artist or photographer harnesses, to put it in Heideggerian terms, nature's interplay of self-disclosure and self-concealment. Even Walton, whose account is designed to hold for photography in general, is willing to grant talk of (some) photographs showing us the world "through the photographer's eyes."[21] But if Walton is right about the underlying mind-independence of the photographic

FIGURE 2. Édouard Manet, *Moss Roses in a Vase* (1882). Oil on canvas, 22 × 13 5/8 in. Sterling and Francine Clark Art Institute, Williamstown, Massachusetts, USA. Image © Sterling and Francine Clark Art Institute (photo by Michael Agee).

process, this ability of some photographs to show us the world from a particular point of view notwithstanding, there will be an important difference of scope to their respective accounts and hence of any affinities between them. Where Heidegger's conception of *techne* as handmaiden to *phusis* pertains exclusively to great art, Walton's conception of mind-independence pertains to the products of the photographic process in general. But is Walton right?

I have already suggested that Walton's account (and as a consequence much subsequent theorizing in the philosophy of photography) implicitly takes the snapshot or some more or less automatic recording mechanism as its paradigm case and that one would expect standard philosophical

<small>FIGURE 3. Lee Friedlander, *Stems* (1999). © Lee Friedlander, courtesy Fraenkel Gallery, San Francisco, USA.</small>

accounts to come out differently were this not so. So how do such theories fare in the face of serious photographic art?

I shall take Lee Friedlander's series of late flower photographs, made between 1994 and 1999, as a test case (Figure 1). *What* they show, the standard argument runs, can only be what was there to be seen. But what about *how* they show it? Here one finds a narrow set of parameters consistently mined for their aesthetic potential. The works are all black and white, of a domestic scale, photographed on 35 mm or square medium format film, often close up. Each image depicts the stems of cut flowers stood in clear glass vases of various shapes filled with water (see Figure 1). There is little background detail, and the subject is framed in such a way that either the top or the bottom of the vase, and sometimes both, is cropped out. In none are all the heads of the flowers visible, though occasionally one or two tulip heads curve back into the shot. At first glance, the subject appears to be the stems themselves, but on closer inspection it is as much if not more the effects that glass and water have on refracting and focusing light as the stems themselves that are foregrounded. It may even be that photography itself is being playfully allegorized here.

This is not some (bare) recording of flowers in water, then, but a making present, through the medium of photography, of a persistently mined and limited set of features. Some of these, such as the play of light and shadow, or the tiny oxygen bubbles that cling to the stems in several of the images, would not even be visible to everyday human attention, or at least not salient, absent the photographs that make them present. The photographs clearly depend on *what* was there, but *how* what was there becomes salient equally clearly depends on the photographer's exploitation of precision optics and the capacities of various films, papers, filters, and developing agents to enhance tonal contrasts and the like. In Heideggerian terms, the finished prints "allow what is coming into appearance to appear"; they make it salient, make it show up as worthy of attention for the first time. Contra Heidegger,

however, they do so in a highly *individual* manner. One need only compare Friedlander's *Stems* to the taxonomic and naturalist ambition of Karl Blossfeldt's plant and flower photographs or the erotic, fetishistic quality of Robert Mapplethorpe's images of orchids and calla lilies to be struck by the fact that this is anything but an impersonal disclosure of being.

So what? Walton goes out of his way to acknowledge that some photographs show us the world from a particular point of view, without this denting the fact that they show us the world itself from that point of view and not merely its depiction. Suppose, then, that Walton were to grant all this, while insisting on the distinction between natural and intentional counterfactual dependence nonetheless.

Take Édouard Manet's series of late flower paintings, made between 1881 and 1883, as a comparison class. Are there differences of kind of the sort that Walton's account requires? Consider the counterfactuals. Suppose that, contrary to fact, Manet breaks for lunch while painting *Roses Mousseuses dans un Vase* (Figure 2) and, unknown to him, several small but visible petals toward the rear of his still life fall off. Further suppose that Manet's housekeeper disposes of them before he resumes. Should Manet fail to attend to that aspect of the scene again, this change will pass unmarked in the finished painting. Walton's account goes through: what we see in the finished painting is *intentionally* dependent on the mental states of the artist; whatever the painter fails to notice—or notices, but decides not to depict—does not make the finished work. Are there the right kind of differences between this case and Friedlander?

Again, consider the counterfactuals. Suppose that, contrary to fact, having set up this still life (Figure 3), placed the camera on a tripod, and opened up the diaphragm of his lens to its maximum in order to reduce depth of field to a minimum, Friedlander leaves the room to take a call. Returning to his camera, and careful not to jolt the tripod, Friedlander takes one last look through the viewfinder and, finding everything to his satisfaction, trips the shutter, having failed to notice that an in-shot, non-occluded, but out-of-focus stem toward the rear of his still life has been removed by an irresponsible houseguest with a weakness for romantic gestures. Does Walton's account go through? Contrary to philosophical ex-

pectations, the answer is "no." Unless the photographer notices the difference and intends to record it, by adjusting his camera settings accordingly, it will not show up in the final image. What one sees in the final image will be the same—half a dozen or so stems pressed up against the near side of the vase in sharp relief against a murky, out-of-focus background—irrespective of whether that particular stem is present or not. In technical terms, this is a product of how camera optics (specifically, the inverse relation between aperture and depth of field) function, but in this context it is more pertinently a product of Friedlander's intentions, as embodied by the way he deploys such camera capabilities in the service of his creative ends.

These photographs, in other words, are *relevantly* mind-dependent: they are governed by Friedlander's use of his medium to realize his intentions. Because the missing stem made no difference to Friedlander's achieving the result he wanted, it did not figure in the decisions determining the final image. As a result, Friedlander's camera, functioning normally and free from outside interference, fails to record a perceptible difference in the world—the removal of an in-shot, non-occluded stem—that it needs to record for the standard counterfactual story to go through. Friedlander's results fail to track this perceptible change because the photographer failed to notice it, and he failed to notice it because it made no difference to realizing his intentions. So *what* appears in the photograph generated from the perceptual manifold recorded by Friedlander's camera, and not just *how* what appears appears, turns out to be intentionally dependent on the mental states (beliefs, intentions, and so on) of its maker after all, and the same is no doubt true of many other photographic works of art.[22] Where is the difference in kind to Manet?

What Walton and, I shall argue, Heidegger both miss, albeit for quite different reasons, is the artist's presence in her work. They miss the *depth of decision* that pervades every aspect of a convincing work of art, photographic or otherwise. Walton's account may work for snapshots, but it does not adequately capture large swathes of photography beyond this. Like analytic theories of photography more generally, Walton's account remains too close to folk psychological conceptions of the medium, themselves premised on "point and shoot" technology. Perhaps as a result, his account is insufficiently sensitive to the

ways in which photographs *can* be relevantly dependent on the mental states of the photographer in such a way as to undermine any hard-and-fast difference between photographs and other forms of depictive art.[23]

V. MIND-DEPENDENCE AND ARTISTIC CHARACTER

But what of Heidegger's account? Setting to one side the example of the Greek temple, is it a plausible account of *individually authored* works of art?[24] Heidegger's account of Vincent van Gogh's painting of a pair of peasant shoes is the obvious test case here. Van Gogh's painting is the pretext for a rather florid paean to the world and earth of the female peasant that Heidegger claims the painting discloses. The account is well known, and I do not intend to go over it here.[25] Instead I want to focus on the debate with the art historian Meyer Schapiro that it occasioned.[26] Schapiro has two broad objections to Heidegger's interpretation. The first, which he secures through empirical research, is that Heidegger is wrong at the level of the work's iconography: these are van Gogh's (not a female peasant's) shoes and van Gogh was a town dweller at the time these works were painted. Schapiro is much more likely to be right about this than Heidegger. But right or wrong, it is beside the point: Heidegger is only concerned with what the shoes as painted *disclose* of the peasant world, not with what is *represented* by the painting, and nothing in principle precludes disclosing *x* by representing *y*.[27]

Schapiro's second criticism is connected in his own mind to the first. It is that, as a result of getting the painting's iconography wrong, Heidegger fails to recognize "the artist's presence in the work."[28] In effect, the shoes are a kind of self-portrait: it is van Gogh who looks back at us from these shoes' worn physiognomy. I believe that Schapiro is essentially right about this, if not for quite the reasons that he gives. The painting is not a self-portrait because these are van Gogh's *shoes*, but because this is van Gogh's *painting*. It is a self-portrait in this sense simply by virtue of its being a painting by van Gogh. If this is right, Schapiro's second criticism stands independently of the irrelevance of his first.

Philosophers sympathetic to Heidegger routinely fail to grasp the depth of this point as a point about painting. Van Gogh's oeuvre, like

that of any other artist, is marked by a distinctive artistic vision: it embodies a *particular* set of convictions and conceptions of salience and value in the world. This is sometimes called "artistic style," though "artistic character" would come closer to what I have in mind, unless, that is, artistic style is understood as something that only fully manifests itself across an artist's oeuvre (or some significant stretch thereof) in ways analogous to those in which character only manifests itself across an individual's commitments taken over the long haul, rather than the intentions animating particular acts.[29] Artistic character, so construed, is what artists *cannot not* express; it permeates their oeuvre in ways analogous to those in which character in the everyday sense manifests itself over the course of a life lived. It would be hard to fully understand why we return to the works of some artists repeatedly and those of others not at all if they did not exude something like artistic character in this sense. What we are responding to in doing so is that particular conception of salience and value, call it a world, that an individual artist's work, and only her work, in all its peculiarities affords.

This is what sets individually authored modern works of art apart from both collectively produced works (such as the Greek temple) and individually produced images not made under modern conditions for autonomous art (medieval crucifixions or Orthodox icons, for example). But it is something that Heidegger's middle period view of art as an *impersonal* form of ontological disclosure indexed to a particular historical culture, taken together with his antipathy for the subjectivism of aesthetics, leaves no room to acknowledge, despite the fact that he is arguably trading on it himself when he appropriates van Gogh's romantic peasant pathos for his own ends. If this is right, Heidegger, not unlike Walton, if for rather different reasons, does not so much miss the artist's presence in his work as disavow his own reliance on it.

But what is the broader upshot of this? I said at the outset that my project was to take photography as theorized by analytic philosophers as a test case for Heidegger's claims about the relation between art and technology. On the account that has emerged, art stages a "decisive confrontation with technology" not *solely* by virtue of remaining responsive to nature's interplay of self-disclosure and self-concealment, but also, contra Heidegger,

insofar as it preserves a space for what I have called "artistic character." Preserving such a space is how art internally resists the reduction of human being to a faceless, interchangeable quantum of resource: we value the work of particular artists, analogously to the ways in which we value other persons, in large part for what cannot be found elsewhere.

This is no less true of photography than it is of any other work of art, which is why Heidegger and Walton's respective ways of formulating what I have called "the question concerning photography" are mutually implicating. From a Heideggerian perspective, the question would be how art could resist technology when the art is photography. From Walton's perspective, the question is whether the nature of the photographic process suffices to distinguish photographic pictures from all others. My response to Heidegger has been that works of art, photography included, resist a technological understanding of the Being of beings in part for reasons that Heidegger gives and in part by preserving a space for artistic character that his middle period view of art as impersonal form of ontological disclosure leaves insufficient room to acknowledge. My response to Walton has been that, to the extent that photographs succeed in preserving such a space, to the extent, that is, that they are marked by the depth of decision that is its corollary and in so doing qualify as art, they cannot be robustly mind-independent in the sense that Walton's account requires. These two responses are mutually implicating: photographic art resists technology to the extent that it is mind-dependent.[30]

DIARMUID COSTELLO
Department of Philosophy
University of Warwick
Coventry CV4 7AL, United Kingdom

INTERNET: D.Costello@Warwick.ac.uk

1. The locus classicus is Kendall L. Walton, "Transparent Pictures: On the Nature of Photographic Realism," *Critical Inquiry* 11 (1984): 246–276. But see also Walton, "Looking Again through Photographs: A Response to Edwin Martin," *Critical Inquiry* 12 (1986): 801–808; Walton, "On Pictures and Photographs: Objections Answered," in *Film Theory and Philosophy*, eds. Richard Allen and Murray Smith (Oxford: Clarendon, 1997), pp. 60–75; and Walton, "Postscripts

to 'Transparent Pictures,' Clarifications and To Do's," in Walton, *Marvelous Images: On Values and the Arts* (Oxford: Oxford University Press, 2008), pp. 117–132.

2. Martin Heidegger, "The Origin of the Work of Art," in *Poetry, Language, Thought*, trans. Albert Hofstadter (New York: Harper and Row, 1971), pp. 17–87.

3. See also Dana S. Belu and Andrew Feenberg, "Heidegger's Aporetic Ontology of Technology," *Inquiry* 53 (2010): 1–19. On Belu and Feenberg's account, if Heidegger's claims about the totalizing nature of "Enframing" are correct, he could not occupy the position he needs to occupy in order to make them; conversely, if he is in a position to make them, his claims cannot be correct.

4. See Nigel Warburton, "Seeing Through 'Seeing Through Photographs'" *Ratio* 1 (1988): 62–74; Gregory Currie, "Photography, Painting and Perception," *The Journal of Aesthetics and Art Criticism* 49 (1991): 23–29; and Noël Carroll, *Theorizing the Moving Image* (Oxford University Press, 1996), among others..

5. Martin Heidegger, "The Question Concerning Technology," in *The Question Concerning Technology and Other Essays*, trans. William Lovitt (New York: Harper and Row, 1977), p. 35.

6. See Heidegger, "The Question Concerning Technology," pp. 10–11; and Martin Heidegger, *Nietzsche* (New York: Harper Collins, 1979), vol. 1, pp. 80–83. On the relation between *techne* and *phusis*, see Bruce Foltz, *Inhabiting the Earth: Heidegger, Environmental Ethics and the Metaphysics of Nature* (Amherst, NY: Humanity Books, 1995), chap. 1; and Julian Young, *Heidegger's Later Philosophy* (Cambridge University Press, 2002), chap. 3.

7. Compare Heidegger's description of the cabinet-maker in Martin Heidegger, *What Is Called Thinking?* (New York: Harper and Row, 1968), pp. 14–15.

8. All these examples are taken from Heidegger, "The Question Concerning Technology."

9. Martin Heidegger, "The Origin of the Work of Art," in *Poetry, Language, Thought*, trans. Albert Hofstadter (New York: Harper and Row, 1971), p. 46.

10. In fact, this relation is more complex than I can do justice to here. See, in this regard, Heidegger's critique of instrumental conceptions of technology in his "The Question Concerning Technology," pp. 5–11. Against such conceptions, Heidegger appeals to Aristotle's conception of fourfold causality for a richer, noninstrumental conception of causality in terms of mutually implicating modes of being responsible, as in the silversmith's "co-responsibility" for the chalice he brings forth.

11. On *Gestell*, see Miguel de Beistegui, *The New Heidegger* (London: Continuum, 2005), chaps. 4 and 5; and Julian Young, "The Essence of Modern Technology," in *Heidegger's Later Philosophy*, pp. 37–63.

12. Heidegger, "The Origin of the Work of Art," p. 17.

13. There are at least three senses of "earth" at play in the essay that Heidegger does not clearly distinguish: earth as native soil (with reference to the world of the peasant disclosed by van Gogh's painting); earth as the materiality of material (with reference to the "stoniness of stone" as foregrounded in the Greek temple); and earth as what is rendered opaque by a given mode of disclosure (with reference to the epochal history of Being).

14. Heidegger, "The Origin of the Work of Art," p. 43. See Hubert Dreyfus, "Heidegger's Ontology of Art" on

works of art as "manifesting," "articulating," or "reconfiguring" what is decisive for a historical culture, in *A Companion to Heidegger*, eds. Hubert Dreyfus and Mark Wrathall (Oxford: Blackwell, 2005), pp. 407–419.

15. Walton, "Transparent Pictures: On the Nature of Photographic Realism," pp. 246–276. For an overview of these controversies, see Diarmuid Costello and Dawn M. Phillips, "Automatism, Causality and Realism: Foundational Problems in the Philosophy of Photography," *Philosophy Compass* 4 (2009): 1–21.

16. See, for example, Neil Walsh Allen and Joel Snyder, "Photography, Vision and Representation," *Critical Inquiry* 2 (1975): 143–169; and Joel Snyder, "Picturing Vision," *Critical Inquiry* 6 (1980): 499–526. For an exception, see Dominic McIver Lopes, "Jetz Sind Wir Alle Künstler," in *Kunst: Philosophie*, ed. Julian Nida-Rümelin and Jacob Steinbrenner (Ostfildern: Hatje Cantz Verlag, 2012), pp. 103–121.

17. This case is typically made by appeal to Fred Dretske, *Knowledge and the Flow of Information* (MIT Press, 1981). See Jonathan Cohen and Aaron Meskin, "On the Epistemic Value of Photographs," *The Journal of Aesthetics and Art Criticism* 62 (2004): 197–210, at pp. 200ff.; and Scott Walden, "Objectivity in Photography," *The British Journal of Aesthetics* 45 (2005): 258–272, at p. 263ff.

18. All these citations from Niépce, Daguerre, and Talbot are taken from Mary Warner Marien, *Photography: A Cultural History* (London: Lawrence King, 2002), p. 23.

19. The view persists in the most nuanced recent accounts of photography as a multistage process originating in a light exposure. See Dawn M. Phillips, "Photography and Causation: Responding to Scruton's Skepticism," *The British Journal of Aesthetics* 49 (2004): 327–340. Such accounts can be used to define photography independently of claims about mind-independence. See Lopes, "Nun Sind Wir Alle Künstler."

20. Marien, *Photography: A Cultural History*, p. 23.

21. Walton, "Transparent Pictures: On the Nature of Photographic Realism," pp. 261–262.

22. This is not an anomalous case. Imagine taking a long exposure of a yacht marina on a dead calm night using a slow film and the camera's smallest aperture for maximum detail. Half a dozen boats come and go, but none of this makes the final print, a richly detailed image of a marina populated by only those boats that remained at mooring throughout. Similarly, imagine images of dance performances that show no dancers or marching armies that show no soldiers. The number of qualifications and caveats to the standard account required to rule out such cases only serves to undermine the hard-and-fast distinction between painting and photography that it was supposed to capture.

23. Tracings, rubbings, and other more or less automatic transcription processes provide interesting test cases for this claim from the opposite direction.

24. Heidegger's account of the Greek temple is much more plausible for his purposes, arguably because it cannot be understood as a work of art in the modern sense of that term. See Diarmuid Costello, "Das Kunstwerk im Zeitalter seiner technischen Ausstellbarkeit," in *Die Ausstellung: Politik Eines Rituals*, ed. Dorothea von Hantelmann and Carolin Meister (Berlin: Diaphanes, 2010), pp. 161–189.

25. Heidegger, "The Origin of the Work of Art," pp. 33–34.

26. Meyer Schapiro, "The Still Life as Personal Object— A Note on Heidegger and van Gogh," and "Further Notes on Heidegger and van Gogh," both in *Theory and Philosophy of Art: Style, Artist and Society* (New York: George Brazillier, 1994), pp. 135–142, 143–151.

27. On this point, and the debate between Heidegger and Schapiro more generally, see Jacques Derrida, "Restitutions," in *The Truth in Painting*, trans. Geoff Bennington and Ian McLeod (University of Chicago Press, 1987), pp. 255–382.

28. Schapiro, "The Still Life as Personal Object," p. 139.

29. For a "deep" conception of artistic style, see Maurice Merleau-Ponty, "Cézanne's Doubt," in *The Merleau-Ponty Aesthetics Reader: Philosophy and Painting*, ed. Galen Johnson (Northwestern University Press, 1993), pp. 59–75, at p. 67. For a more analytic take on these issues, see Jenefer Robinson, "Style and Personality in the Literary Work," *Philosophical Review* 94 (1985): 227–247.

30. I would like to thank Miguel de Beistegui, Eileen John, Wayne Martin, Dawn Phillips, and especially Dom Lopes for their feedback on this article in draft.

RICHARD BEAUDOIN AND ANDREW KANIA

A Musical Photograph?

This article compares two objects: a photographic negative made by William Henry Fox Talbot in 1835 and the score of a solo piano work composed by Richard Beaudoin in 2009. Talbot's negative has come to be known as *Latticed Window (with the Camera Obscura), August 1835*, and Beaudoin's musical composition is called *Étude d'un prélude VII—Latticed Window*. As suggested by their titles, the composition owes a debt to the negative and thereby joins a long list of musical compositions indebted to particular visual images.[1] However, the relationship is deeper, and by explicating their respective ontologies, we hope to show that these two objects are strikingly analogous to each other across their respective media, so much so that we suggest the score of Beaudoin's *Étude d'un prélude VII—Latticed Window* should be considered a sort of musical photograph—a photograph of a musical performance.[2]

We begin by describing the origins and characteristics of both Talbot's photographic negative and Beaudoin's score and offering our basic argument that the latter is a musical photograph (Sections I and II). In Section III, we compare Beaudoin's score to other things one might consider contenders for the title of "musical photograph"—musical recordings, sonic spectrographs, ordinary musical transcriptions, and typical musical scores—and argue that it has at least as good a claim to the title as any of these and a better claim than most. In the final section, we consider an argument based on the transparency of photographs, which allows us to recapitulate our main claims.

I. WILLIAM HENRY FOX TALBOT'S *LATTICED WINDOW (WITH THE CAMERA OBSCURA), AUGUST 1835*

In 1835, Talbot made numerous images of his home in Wiltshire, England, including a series depicting the central window in its South Gallery, using a technique that he called "photogenic drawing." The process involved building a camera obscura out of a large box, fixing a glass at one end, and using that glass to project an image onto the opposite end. Sensitive paper mounted at the point of the projected image would, given time, capture the light allowed it. Talbot gives a detailed account of his materials and methods in his privately published 1839 paper, "Some Account of the Art of Photogenic Drawing, or, The Process by Which Natural Objects May Be Made to Delineate Themselves Without Aid of the Artist's Pencil," which was presented at the Royal Society of Great Britain on January 31, 1839.[3] In his account, Talbot also reflects on the implications of his discovery for such areas as portraiture, microscopy, and the rendering of sculpture. The essay includes remarkably poetic descriptions of the act of photography, as when Talbot describes images of the exterior of his house: "And this building I believe to be the first that was ever yet known *to have drawn its own picture.*"[4]

As seen in Figure 1, *Latticed Window* is accompanied by a text in Talbot's own hand, likely produced to accompany the image when it was exhibited by Michael Faraday at the Royal Institution on January 25, 1839. Beside the image, which is roughly one inch square, Talbot wrote: "Latticed Window (with the Camera Obscura), August

Latticed Window
(with the Camera Obscura)
August 1835

When first made, the squares
of glass about 200 in number
could be counted, with help
of a lens.

FIGURE 1. William Henry Fox Talbot, *Latticed Window (with the Camera Obscura) August 1835*, (1835). Courtesy of the National Media Museum/SSPL.

1835—When first made, the squares of glass about 200 in number could be counted, with the help of a lens." Two significant facts emerge from Talbot's concise inscription: (1) Talbot encourages viewers to marvel at the precision of the image by inspecting it with a magnifying glass and (2) by the phrase "when first made," Talbot acknowledges that his technique of fixing the light patterns to paper was unable, over time, to preserve every detail of the actual image.[5] Of course, even when first made, the image did not capture every detail of the scene photographed, a feature of photography that persists, if on a different scale, even in our digital age.

II. RICHARD BEAUDOIN'S *ÉTUDE D'UN PRÉLUDE VII—LATTICED WINDOW*

While only 1'51" in duration, Beaudoin's *Étude d'un prélude VII—Latticed Window* is the result of months of labor, not only by the composer but also by a small team of acoustic researchers. The piece originated from data collected using LARA (The Luzern Audio Recording Analyser), developed by Dr. Olivier Senn and his colleagues at the Hochschule Lucerne in Switzerland. In 2008, Dr. Senn's team spent months measuring the exact moments of pitch onset in Martha Argerich's celebrated recording of Chopin's Prelude in E minor, op. 28/4 (Deutsche Grammophon 415 836–2, recorded in Munich, October 22–25, 1975).[6] These onsets (the exact moments in time when each note comes into being) were charted at the level of the millisecond. The coordinates of each onset were recorded relative to all others, allowing for an extremely detailed picture of Argerich's

rhythmic interpretation of Chopin's score. Senn also measured the sound energy (or volume) of each onset, to the level of the decibel.

Collaborating with Senn in April 2009, Beaudoin devised a method of taking LARA's numerical output (the onset times in milliseconds and the sound energy in decibels) and transcribing it back into standard musical notation. This discovery became the framework for a series of compositions based on the Chopin–Argerich material, called *Études d'un Prélude*, twelve of which were completed in 2009–2010. Most of the works in the series altered the original Chopin material, applying techniques of elongation or distortion, or applying techniques borrowed from photography.[7]

Étude d'un prélude VII—Latticed Window is unlike any other work in the series, in that its length in performance is the same as the length of Argerich's recording (1'51"). There is a sense in which a good performance of Beaudoin's *Latticed Window* is a kind of altered re-performance of Argerich's Chopin interpretation (though the alterations are not insignificant). In this way, Beaudoin's score reveals itself as a graphic representation, or visualization, in standard musical notation, not just of another score, but of a specific performance of another score. (Figure 2 shows Chopin's original Prelude, while Figure 3 shows Beaudoin's score.) In this regard, it is, to our knowledge, unique within the field of music composition. In order to understand the way in which Chopin's Prelude (and Argerich's performance of it) have been transformed by Beaudoin into his *Latticed Window* and how that transformation is informed by Talbot's image, consider the following four networks of similarity and difference.

FIGURE 2. Chopin, Prelude in E minor, op. 28/4. Public domain, accessed at http://imslp.org/wiki/Preludes,_Op.28_(Chopin,_Fr%C3%A9d%C3%A9ric).

First, Chopin's left and right hands have been switched in Beaudoin's work, meaning that the melody is now below the accompaniment. This is inspired by the fact that Talbot's *Latticed Window* is a photographic negative. Whereas light and dark are reversed in Talbot's image, in Beaudoin's work the left and right hands, melody and accompaniment, figure and ground, as it were, have been reversed.

Second, Chopin's music, which was written in the middle register of the piano, has been moved to the instrument's extreme high and low registers

FIGURE 3. Richard Beaudoin, Score of *Étude d'un prélude VII—Latticed Window*. Copyright 2009 by the composer; all rights reserved.

Figure 3. Continued.

by Beaudoin. The shift of register is a response to Talbot's negative being in black and white and follows the analogy between color and music articulated by the French composer Olivier Messiaen: "When I move the same chord from midrange up one octave, the same color is reproduced shaded toward white—which is to say, lighter. When I move the same chord from midrange down an octave, the same chord is reproduced, toned down by black—which is to say, darker."[8] By recasting Chopin's music into the piano's extreme high and low registers, *Latticed Window* uses only the "lightest" and "darkest" sonorities available on the instrument.[9]

Third, the key has been changed from Chopin's original E minor into E-flat minor in Beaudoin's composition. This change was made simply because E-flat minor is a historically (and some would argue, aurally) darker key than E minor, just as Talbot's image is darker than the sunlit window it depicts.

There exists one further cluster of relationships between these objects, which is alluded to in the texts that Beaudoin and Talbot supply to accompany their respective objects. In the text accompanying *Latticed Window*, Talbot admits that the image fails to capture all of the details of the scene he photographed. Beaudoin's score is headed by the words 'Latticed Window (with LARA)—August 2009. When first measured the total events, initially about 225 in number, were filtered to include those >0.748 seconds (r.h.) and >0.540 seconds (l.h.).' This highlights a fourth difference between Argerich's performance of the Chopin and Beaudoin's work: any event in Argerich's performance whose duration was below a certain time threshold (separately chosen for each hand) was simply left out of the transcription. Just as Talbot's negative loses the details of the light that the negative was not sensitive enough to retain, so Beaudoin's score loses the details of Argerich's interpretation of the Chopin that fell below his chosen durational threshold. This purposeful "imperfection" in the preservation process from Chopin to Beaudoin via Argerich is the very thing that allows the score to be readable and performable by a musician, as we discuss further below.

The primary result of Beaudoin's labors is a musical work that is intended to be performed, which in this respect is no different from a typical piece of Western classical music (such as Chopin's orig-

inal Prelude). As with most such pieces, the work is physically embodied in a score—a set of instructions to the performer about what to do in order to produce a performance of this work. But because of its unique origins, we argue that the score is unique in that it is a *musical photograph* of Argerich's performance of Chopin's Prelude.[10] Just as Talbot (with the aid of the camera obscura) used the light present during a span of time in 1835 to fix a two-dimensional image, mechanically counterfactually dependent on and visually similar to the scene that can be recognized in it, Beaudoin (with the aid of LARA) used the sounds produced during Argerich's 1975 performance to fix a two-dimensional image, mechanically counterfactually dependent on those sounds and in which can be recognized a performance of Chopin's prelude.[11] We thus focus on two features usually taken to be essential to a representational photograph: (1) it must be *mechanically counterfactually dependent* on its target, and (2) this dependence is reflected in *visual similarity* between the image and its target.

Is Beaudoin's score *really* a musical photograph? Of course, to some extent, this is "just semantics"; the relationship between Beaudoin's score and Argerich's performance is like that between a photograph and the object or scene it represents in certain ways and unlike it in other ways. Whether or not we ultimately decide to call the score a musical photograph is not as important as the ways in which thinking about these relationships illuminates the media of both photography and music and the aesthetic implications of those media. Nonetheless, we do believe that the similarities are significant enough to defend the claim that Beaudoin's score is a musical photograph as more than just a thought-provoking metaphor.

III. COMPARISONS WITH OTHER MEDIA

i. Recordings. When one thinks of musical media analogous to photography, one might first think of sound recordings. For instance, one might say that if anything is the musical equivalent of a photograph of Argerich's performance, it is the original recording with which Senn and Beaudoin began. But there are a number of disanalogies here. Perhaps most striking is the fact that a musical recording, appropriately experienced, has a perceptible

and meaningful temporal length. That is, it takes time to unfold, its musical events occurring in a predetermined order.[12] In this respect, a recording is more like a moving image, such as a film, than a photograph, which represents (usually) a short temporal slice of some scene in an atemporal way (in the sense that there is no predetermined order in which one must experience the different elements of a photograph, nor any specific length of time an appropriate experience of the photograph should take). On the other hand, while a score is a visual representation, it is at least linear, in that it is appropriately read in a particular order. And it might be argued that it is temporal insofar as it is appropriately "viewed" or read at the same tempo as a performance of it. (Of course one *could* look at different parts of the score in any order one liked, but one could similarly listen to bits of a recording in different orders. The point here is about the *appropriate* mode of experience of these things.)

A second disanalogy between the musical recording and a photograph (closely related to the first) is that the recording is not a visual but a sonic representation. That is, the sounds of a recording (played in an appropriate way), including many musically important audible features, such as timbre, pitch, and rhythm, are mechanically counterfactually dependent on the sounds of the recorded performance. Moreover, the sound of the recording being played is *aurally*, not visually, similar to the sound of the original performance: we can *hear* Argerich's performance *in* the played recording; we do not *see* it there.

What is the relevance of these disanalogies, though? Recordings are to be heard rather than to be seen and are thus different from photographs. But this is because recordings aim to represent musical events, which are audible rather than visible. Thus, it might be argued that at a deeper, structural level, a recording is more like a musical photograph than Beaudoin's score because sound recording bears the same relations to musical events that photography bears to visible objects. We have no objection to the idea that musical recordings could be considered musical photographs for the above reasons. What is interesting about Beaudoin's score is that it shows that there are other possible kinds of representations of musical events that could equally well be called musical photographs—kinds that have heretofore gone undiscussed. Beaudoin's score is

less like a musical photograph than a recording in that it is "cross-modal"—it represents sounds visually, while a recording represents them sonically. But it is more like a musical photograph in that it is a visual representation. It is no surprise that musical events can be represented sonically, in a mechanically counterfactually dependent way. It is perhaps surprising that musical events can be represented visually in a mechanically counterfactually dependent way and that they can be represented using artistic techniques, such as filtering, that have analogues in photography.

ii. Spectrographs. However, there are other ways of visually representing musical performances in two dimensions than with a musical score. One is by means of a spectrograph. Consider the data delivered by LARA in analyzing Argerich's performance. Such data can be (and initially are) represented numerically or linguistically; that is, it is an array of numbers representing the time, frequency, energy, and so on, of every sound event included on the recording. But these data can be displayed visually. Figure 4 shows a spectrograph taken by LARA of the first 21 seconds of the performance, the x-axis representing time (in seconds) and the y-axis showing frequency (in hertz). Could we thus consider a spectrograph a musical photograph of Argerich's performance as captured on the recording?

Such a spectrograph may be considered a photograph of a musical performance in some sense: it is a visual representation of a musical performance that is mechanically counterfactually dependent on it. Even if such a spectrograph may be considered a *sonic* photograph, however, it should not be considered a *musical* one. A spectrograph represents *sounds*, or vibrations in the air, but not *music*, which requires perception of a uniquely human sort. The distinction between sounds and music is difficult to limn precisely, but there is general agreement that human beings (unlike dogs, say) *hear* music *in* certain sounds, just as we see three-dimensional objects *in* certain two-dimensional arrangements of pigment.[13] Illustrative differences between sounds and music (at least Western tonal music) include the following: (1) When we hear sounds as music, we hear the sonic spectrum as divided into octaves—notes that *repeat* at different "heights." This phenomenon is not an intrinsic feature of the sonic spectrum. We hear octaves in sounds with frequencies separated

FIGURE 4. Spectrograph of Chopin's op. 28/4 in Martha Argerich's 1975 interpretation (seconds 0–21), created with the Lucerne Audio Recording Analyzer (LARA).

by a factor of two, but pairs of sounds whose frequencies are related by other factors (three, five, and so on) are just as objectively present in the sound spectrum. The repetition of notes at the octave is a response-dependent feature of sounds and seems to be culturally universal.[14] (2) When we hear sounds as music, our perception is "categorical," as it is when we hear sounds as language. Just as we hear any of a wide range of sounds as a certain phoneme (for example, /pa/) when we hear it as language, but past a certain threshold we hear intrinsically very similar sounds as a different phoneme (for example, /ba/), we hear all sounds within a certain range as a certain note (for example, C#) when we hear it as music, but past a certain threshold we hear intrinsically very similar sounds as a different note (for example, D).[15] This general phenomenon also seems to be culturally universal, though of course not all cultures divide the octave into the same pitch classes. (We also do not mean to imply that all musical sounds are actually, or perceived as, pitched.) Though these two features relate to pitch, similar points could be made about rhythm and other musical features of sound.[16]

A spectrograph of Argerich's performance, then, is not a *musical* photograph of it because the musical features of the performance cannot

be *seen* or *recognized* in the spectrograph; only the sonic features can. In some sense, of course, the spectrograph contains musical information. Thus, if we understand "visual representation," in a thin sense, to mean something like "carrying information in a visual form," then the spectrograph could be said to represent Argerich's performance. But when we talk of photographs and other pictures being representational, we typically mean something more than this: we mean that features of what is represented can be "seen in" the visual array. (Compare a JPEG file on your hard drive. There's visual information there, but it cannot be *seen* until interpreted by a piece of software that projects or prints an *image*.)

There is an interesting distinction to be made here between the score and an ordinary photograph, however. Musical notation is largely conventional in a way that ordinary depictions (such as typical photographs) are not. (For example, untutored children can understand the content of many photographs, but not of any scores.) This might lead us to say that the disanalogy between the spectrograph and a photograph is located more in our perceptual systems than in the representations.[17] Whatever its source, however, the disanalogy is there, supporting our argument in this section that Beaudoin's score is a better

candidate than a spectrograph for being a musical photograph of Argerich's performance. On the other hand, to the extent that musical notation is *linguistic*, it detracts from our claim that the score is a musical photograph. There is something to the notion that we *see* the music *in* the notation, as we *see* an object *in* an image. Musical notation is not wholly linguistic; it is partly iconic. Nonetheless, the analogy is imperfect. Part of the problem is the cross-modal nature of the representation of music in notation, a point we return to below.

Is Beaudoin's score mechanically counterfactually dependent on Argerich's performance, as the spectrograph is? As discussed above, Beaudoin made many decisions in the production of his score that had implications for how Argerich's recording was represented in it, such as, for example, the decision to represent the sounds Argerich produced with her right hand, higher in the musical register, with notes lower in the musical register, which the performer of Beaudoin's work would play with his left hand. It would be a mistake to think that this detracts from the mechanical counterfactual dependence of the score on its target, though, just as it would be a mistake to think that a photographer's choice of lens or printing technique detracts from the mechanical counterfactual dependence of her photograph on its target. Such decisions result in less visual similarity between the resulting object and its representational target, but visual similarity is distinct from counterfactual dependence.

However, there is an intentional connection in the chain of counterfactual dependence linking Beaudoin's score with Argerich's performance: Beaudoin transferred "by hand" the information from LARA into his score. He did so "mechanically" in a loose sense, that is, in strict accordance with predefined, unambiguous rules; but this part of the process was mediated by beliefs, and thus was not mechanical in the sense required for a strict analogy with photography. We will ignore this break in the chain, however. Because both the LARA data and the resulting score are made up of discrete, discontinuous bits of information, it is easy to imagine a mechanical process that does what Beaudoin in fact did intentionally. For the purposes of this article, then, we consider a close counterpart of Beaudoin's actual score—one in which the chain of counterfactual dependence between Argerich's performance and Beaudoin's score is continuously mechanical.

iii. Ordinary transcriptions. Beaudoin's *Latticed Window*, by contrast with a spectrograph, employs musical notation and thus visually represents the musical features of the performance, albeit in a distorted way. It is thereby, in part, a musical transcription of Argerich's performance. Considering the reasons for the distortions can help us develop the analogy with photography in more detail. Given the technology available to Beaudoin, one might ask why he did not produce a more accurate, less distorted transcription of Argerich's performance. Part of the answer, obviously, is that he was engaged in an artistic, not a reportorial project. But another part of the answer is that there is no way to represent the musical details of such a performance in a way that would be useful for Beaudoin's purposes. Western musical notation has been developed to represent something like musical works for performance, works that require performative interpretation.[18] It has also been put to other uses, such as transcribing improvised performances, but because of the purposes for which it was designed, no doubt in combination with basic perceptual and cognitive limitations, such transcriptions tend to represent something like the work of which the improvisation would have been a performance, were it a performance of a work.[19]

Given the remarkable precision of LARA's rhythmic measurements (pinpointing the onset of each note at the level of the millisecond), transcribing Argerich's performance into standard notation involves a complicated balance between the richness of the data and the limits of human perception. It is possible, say, to create a mapping such that each millisecond in Argerich's recording is represented by one 512th note in the transcription. (A 512th note is one with seven flags attached to its stem.) Such a transcription could be helpful for those engaged in performance studies, since it would represent musical details in a form any trained musician could understand, allowing for the comparison, for instance, of the rubato applied in different measures. However, although one could study such a score, one could not "take it in" in the ordinary way, due to its overwhelming detail.

For the same reason, such a transcription could not be performed. At the tempo of Argerich's performance of the Chopin, this transcription would confound almost any human pianist; even if a pianist could handle such a notation cognitively, it would be nearly impossible to obtain the motor control to execute it. This presents a problem for a composer wanting to use such data to produce a new piece that is realistically performable. Beaudoin's solution, in *Latticed Window*, is to use a remarkably fast (but humanly possible) tempo alongside an unusually large time signature. This, together with the filtering out of the smallest events of the recording, represents a compromise between LARA's spectrographic richness and our cognitive and motor limitations.

By analogy, suppose it were possible to take an incredibly detailed photograph of the Mona Lisa, such that its molecular structure were somehow captured visually. In order for us to see these details, perhaps the photograph would have to be the size of a planet. Such a photograph would be useless to us as a photograph of the painting, because we could not see the painting in it, for reasons analogous to why we cannot see the molecular structure of the painting when standing in the Louvre. A representation in musical notation of Argerich's performance, of the sort described above, even if possible, would be useless to us as a musical photograph of that performance in a similar way. There are two basic ways to produce a more useful (that is, comprehensible) musical photograph of a performance using microtiming data, both of which have been employed by Beaudoin. One is to stretch the data out across time, to produce a kind of slow-motion transcription of the performance. Beaudoin did this in many of the pieces in the *Étude d'un prélude* series, including the first piece in the series, *Chopin desséché*, which expands the time axis from 1'51'' to 7'25''. The other is to put the data through a coarse filter, retaining only durations that are discriminable by the human eye and ear. This is one of the transformational techniques Beaudoin uses in *Latticed Window*, as described in Section II. We have already mentioned how this technique reflects the limitations of Talbot's photographic technology, but, of course, photographers from the very birth of the technology have used such limitations, whether dictated by the contemporary state of the technology or freely chosen, for artistic ends. One might consider the history of artistic photography a history of the invention and use of such limitations.

iv. Musical scores. Since we have argued that Beaudoin's score for *Latticed Window* could be considered a musical photograph, it is worth asking whether traditional musical scores could be too. For instance, why not say that Chopin's score for his Prelude in E minor, op. 28/4, is a musical photograph of Argerich's performance? There are two main reasons why we should not say this. The first, of course, is that Chopin's score is not counterfactually dependent on Argerich's performance, since the score predates the performance by over a century. Just as any object within the frame of a photograph will be captured by the camera whether the photographer wills it or no, every event in Argerich's performance is captured by LARA's processes, whether or not Beaudoin (or anyone else) wills it. Unlike LARA's output, Chopin's score is impervious to Argerich's performance. She, and any other number of performers, could have interpolated as many extra notes as they wished; this would not affect the number of notes in Chopin's Prelude.

This leads us to the (related) second main difference between Chopin's and Beaudoin's scores. Chopin's score is not a transcription of a performance; it prescribes how certain performances—those of this prelude—should be, rather than describing any particular performance. In this respect, it is more like the circuit diagram an engineer produces for a new electrical component than a photograph of such a component. It tells others what they ought to do in a generic fashion, rather than showing them what some particular thing is like. Of course, Beaudoin's score is prescriptive, too, but before it was prescriptive it was descriptive.[20] Beaudoin took a transcription (or, more accurately, helped produce a transcription with certain features) of a certain performance (Argerich's) of a given work (Chopin's) and transformed it into the prescription for producing performances (anyone's) of a different work (Beaudoin's). Such a process is as unusual in the visual arts as in music, but we can easily imagine analogues (and works of this sort probably exist). Suppose an artist takes a photograph of a lithographic print that was designed by a second artist and executed by yet a third. Then suppose the first artist "publishes" the photograph, clearly

indicating, LeWitt-like, that the photograph itself is not her artwork, but that other artists should execute instances of her work by painting images of the print captured in the photograph. The fact that the artist uses the photograph to prescribe what others should do in producing instances of her artwork does nothing to take away from the fact that it is a photograph. Beaudoin's score prescribes what a performer should play in order to perform *Latticed Window*, just as our imagined artist prescribes what others should do in order to produce instances of her work. Thus, we argue, the fact that Beaudoin's score is prescriptive does nothing to detract from the reasons for thinking that it is a musical photograph.

IV. TRANSPARENCY

Throughout this article, we have made reference to two features of representational photographs widely discussed in the literature: mechanical counterfactual dependence and visual similarity. These features have been most widely discussed in the context of the transparency of photographs, that is, the question of whether, in looking at a photograph of some object you thereby see (indirectly) the object itself, *through* the photograph.[21] Now consider the following argument. Typical photographs are transparent. Thus, if Beaudoin's score for *Latticed Window* is a (musical) photograph, by looking at it one thereby sees Argerich's performance (or the recording of that performance) *through* the score. But we do not see Argerich's performance (or the recording of it) through the score. Therefore, it is not a photograph.

One might reject this argument by rejecting the supposition that photographs are transparent, but this does not seem very promising. The point of the argument is to show an important dissimilarity between the score and photographs; that dissimilarity remains even if photographs are not transparent. What is the dissimilarity? It is not a lack of counterfactual dependence, the most widely discussed feature of transparency. Beaudoin's score is counterfactually dependent on the recording of Argerich's performance and thereby on the performance itself, since the recording is counterfactually dependent on the performance. What the score lacks that a photograph possesses is *visual similarity* with what it represents.[22] Consider, as

others have done, a machine that mechanically produces a linguistic description of the visual appearance of a scene.[23] No one argues that such descriptions enable us to see the scene represented, precisely because the scene is not *depicted*. Musical notation, as a quasi-linguistic form of representation, is similarly not a form of depiction, which is one reason we cannot see a musical performance through Beaudoin's score. Another, perhaps more obvious, reason is that a musical performance is not a visual entity. It is something appropriately heard, rather than seen.[24] Thus, no visual representation of a musical performance can be a depiction of a musical performance, nor a fortiori a musical photograph.

We have said three things relevant to this objection already. First, we do not claim that the score of *Étude d'un prélude VII—Latticed Window* is *simply* a photograph, in exactly the same sense as a photograph by Cartier-Bresson or this month's cover of *Vanity Fair*. Our argument is not that Beaudoin's *Latticed Window* has relinquished its status as a piece of music, nor that its score should be hung alongside Mapplethorpe prints. Rather, having outlined their respective ontologies, we argue that the similarities between Beaudoin's score and Talbot's *Latticed Windows* make it more than metaphorical to call this score a musical photograph.

Second, given that this is an extended use of the term 'photograph,' it does not follow from the fact that Beaudoin's score lacks some feature ordinary photographs possess that the score is not a photograph in an extended sense. Musical recordings are sometimes referred to as musical photographs, though there are obvious, clear differences between the media of sound recording and photography. What we hope to have shown here is that there is another, at least equally good candidate for the title "musical photograph" that has thus far been overlooked.

Third, though it is true that Beaudoin's score is not, and could not be, visually similar to Argerich's performance in the way an image is visually similar to a visual object, it is still true that one can *see* that performance *in* the score, just as we might say we *hear* an emotion *in* a musical passage, even though emotions have no sonic features. The visual similarity of photographs (and other depictions) to the things they represent is surely important in large part because it grounds our seeing those things in the images. Thus, the fact that

we can see Argerich's performance in Beaudoin's score lends plausibility to the claim that it is relevantly like a photograph.

The score of Richard Beaudoin's *Latticed Window* is mechanically counterfactually dependent on a particular musical performance of another musical work, a performance one can see in the score.[25] These features lead us to describe Beaudoin's score as a musical photograph of that performance—an extended use of the term 'photograph,' to be sure, but not a capricious one. On the other hand, the score is not visually similar to the performance in the way ordinary photographs are visually similar to the objects one can see in them. This makes the analogy imperfect. But the best alternative candidate for a musical photograph of a particular performance, a sound recording, is also imperfectly analogous to ordinary photographs. Though recordings are mechanically counterfactually dependent on their sources, they are not visual entities; one does not see anything in them, nor are they visually similar to their sources. Of course, they are sonically similar to their sources, and we can thus *hear* those sources in recordings.[26] To claim that either a recording or a score like Beaudoin's is a musical photograph is to use the term 'photograph' in an extended sense. What we hope to have shown here is that Beaudoin's compositional process generates a new kind of musical object, one that warrants this extension of the term into the domain of notated music.[27]

RICHARD BEAUDOIN
Department of Music
Harvard University
Cambridge, Massachusetts 02138

INTERNET: beaudoin@fas.harvard.edu

ANDREW KANIA
Department of Philosophy
Trinity University
San Antonio, Texas 78212

INTERNET: akania@trinity.edu

1. Other such works include Modest Mussorgsky's *Pictures at an Exhibition* (1874), Franz Liszt's *Von der Wiege bis zum Grabe* (1881), Sergei Rachmaninov's *The Isle of the Dead* (1907), Paul Dessau's *Guernica* (1937), Gunther Schuller's *Seven Studies on Themes of Paul Klee* (1959), and Henri Dutilleux's *Timbres, espaces, mouvements* (1978).

2. This claim has, in fact, already been made, but not extensively argued for, in Richard Beaudoin, Stephen Davies, and Jonathan McKeown-Green, "Micro-measured Interpretations as Material for Composition" (unpublished manuscript).

3. Reprinted in : William Henry Fox Talbot, "Some Account of the Art of Photogenic Drawing, or, The Process by Which Natural Objects May Be Made to Delineate Themselves Without Aid of the Artist's Pencil," *Photography: Essays and Images: Illustrated Readings in the History of Photography*, ed. Beaumont Newhall (New York: The Museum of Modern Art, 1980), pp. 23–31.

4. Talbot, "Some Account," p. 28.

5. Geoffrey Batchen points out that there are at least twice as many squares of glass in the window as suggested by Talbot, in "A Latticed Window," in *Singular Images: Essays on Remarkable Photographs*, ed. Sophie Howarth (London: Tate Modern, 2005), pp. 15–21.

6. The methodology for these measurements can be found in Olivier Senn, Lorenz Kilchenmann, and Marc-Antoine Camp, "Expressive Timing: Martha Argerich plays Chopin's Prelude op. 28/4 in E minor," in *Proceedings of the International Symposium on Performance Science 2009*, ed. A. Williamon, S. Pretty, and R. Buck (Utrecht: European Association of Conservatories, 2009), pp. 107–112.

7. For instance, *Étude d'un Prélude VI—The Real Thing* (string quartet, ca. 5'30", August 25, 2009) was composed in response to a 2000 painting of the same name by the UK artist Glenn Brown, who uses photography and Photoshop to produce, in oil on board, versions of iconic paintings; while *Étude d'un Prélude VIII—Kertész Distortion* (string quartet, ca. 7'30", August 25, 2009) was inspired by André Kertész's 1933 photograph, "Distortion No. 172." For a summary of the compositional process and descriptions of several of the works, see Davies, Beaudoin, and McKeown-Green, "Micro-measured Interpretations," and Richard Beaudoin, "The Principles of Microtiming and Musical Photorealism" (unpublished manuscript), available at http://nrs.harvard.edu/urn-3:HUL.InstRepos:3415685.

8. Olivier Messiaen, *Music and Color: Conversations with Claude Samuel*, trans. E. Thomas Glasow (Portland, OR: Amadeus, 1994), p. 64.

9. For a philosophical introduction to musico-visual synesthesia, see Kathleen Higgins, "Visual Music and Synesthesia," in *The Routledge Companion to Philosophy and Music*, ed. Theodore Gracyk and Andrew Kania (New York: Routledge, 2011), pp. 480–491.

10. Beaudoin's score is unique in this respect as far as we know. But the uniqueness claim is a contingent one; there is no reason why Beaudoin or future composers could not produce further such musical photographs.

11. It is possible to make a musical score in standard notation that preserves every rhythmic and dynamic aspect of a performer's interpretation (a sort of *Latticed Window* without any alterations to key, handedness, or detail); such experiments were in fact part of the process of making *Latticed Window*. While such a work might be a simpler example of a musical photograph of the sort we are discussing, such true imitations of performances were not Beaudoin's aim; moreover, the alterations made in *Latticed Window* strengthen the analogy with Talbot's image. We return to these points below.

12. For more on the temporality of artworks, see Jerrold Levinson and Philip Alperson, "What Is a Temporal Art?" *Midwest Studies in Philosophy* 16 (1991): 439–450.

13. Andrew Kania, "Definition," in *The Routledge Companion to Philosophy and Music*, pp. 3–13.

14. Thomas Stainsby and Ian Cross, "The Perception of Pitch," in *The Oxford Handbook of Music Psychology*, ed. Susan Hallam, Ian Cross, and Michael Thaut (Oxford University Press, 2009), pp. 47–58.

15. Christopher Mole, "The Motor Theory of Speech Perception," in *Sounds and Perception: New Philosophical Essays*, ed. Matthew Nudds and Casey O'Callaghan (Oxford University Press, 2009), pp. 211–233. Of course (in the musical case, at least), we hear the different sounds as different (for example, we hear the C#s as progressively sharper), but we still hear them as falling into the pitch-class C#.

16. For an introduction to such matters, see Roger Scruton, "Rhythm, Melody, and Harmony," in *The Routledge Companion to Philosophy and Music*, pp. 24–37.

17. Thanks to Joseph Moore for bringing this point to our attention.

18. Stephen Davies, "Notations," in *The Routledge Companion to Philosophy and Music*, pp. 70–79.

19. For some examples of transcriptions that capture more detail than most, yet still clearly illustrate the gap between musical event and transcription, see Paul F. Berliner, *Thinking in Jazz: The Infinite Art of Improvisation* (University of Chicago Press, 1994), pp. 505–757.

20. One might think that Chopin's score is still descriptive, not of a performance of his prelude, but of the various playings he engaged in while composing the work (whether actual, or "in his head"), or of some preexisting, eternal sound structure. (Similarly, one might think a diagram of a novel circuit is descriptive of a preexisting, eternal circuit structure.) We think this is a rather odd way of conceiving of composition, but even if it is correct, Chopin's score is still not a musical photograph in the sense we have been defending, because (i) it does not transcribe a single performance (let alone a performance of a preexisting work) and (ii) his "description" of these musical items is intentionally mediated in a way that disqualifies it from being mechanically counterfactually dependent. Thanks to the editors for raising this issue.

21. For an introduction to this literature, see Nigel Warburton, "Photography," in *The Oxford Handbook of Aesthetics*, ed. Jerrold Levinson (Oxford University Press, 2003), pp. 614–626.

22. It lacks aural similarity, too, since the score makes no sound.

23. Kendall L. Walton, "Transparent Pictures," reprinted in *Marvelous Images: On Values and the Arts* (Oxford University Press, 2008), pp. 105–109.

24. At least, the aspects able to be captured in musical notation are appropriately heard rather than seen. Jerrold Levinson, for instance, argues that we must understand the gestures that occur in musical performances in order properly to appreciate those performances (for example, the caressing nature of the cellist's bowing) ("Authentic Performance and Performance Means," in *Music, Art, and Metaphysics* [Cornell University Press, 1990], pp. 393–408). And seeing musicians perform is the most obvious way of gaining such understanding. However, even if this is true, it does not affect the argument, since musical scores do not look like, say, performing cellists.

25. Or, strictly speaking, the score of the close counterpart we have been considering has these features.

26. Perhaps we do not just hear these sources in recordings, but literally hear the sources; that is, perhaps musical recordings are transparent. This would be a further argument for considering recordings to be musical photographs. On the transparency of musical recordings, see Andrew Kania, "Musical Recordings," *Philosophy Compass* 4 (2009): 22–38.

27. For helpful discussion, we thank Stephen Davies, Joseph Moore, Olivier Senn, Michael Schreyach, and the editors of this issue.

Drawings of Photographs in Comics

I. INTRODUCTION

In this article, I examine the following under-appreciated phenomenon: within comics, photographs are commonly rendered in a drawing style that is strikingly more realistic than the style adopted for the remainder of the surrounding comic. In addition, I take it as a datum—demonstrated by direct examination—that the practice of rendering depictions of photographs more realistically is not merely a stylistic quirk, but is, instead, intended to serve some substantial aesthetic end (and, further, that in many cases, such as those considered below, the technique in question succeeds in successfully serving that end). Put simply, these depictions of photographs would not be as striking, and as a result, the narratives in which they are embedded would be noticeably impoverished, if these photographs were rendered in the same less realistic, "painterly" style as the remainder of the comic. As a result, we are faced with an explanatory puzzle: what role does this more realistic rendering of photographs play?

The following idea suggests itself: the more realistic style of depiction is somehow linked to the objective purport of photographs—that is, to the idea that photographs are somehow more objective, accurate, or authoritative than other modes of visual presentation. On this way of understanding the phenomenon in question, the more realistic rendering style would serve to increase the objective purport of the (fictional) photographs depicted in the comic by rendering them in a manner that suggests a higher level of objectivity, accuracy, or authority as records of the fictional objects and events they depict.

It turns out that this strategy for explaining the more realistic rendering of photographs in comics fails, at least as applied to fictional comics. I develop this argument as follows: first, in Section II, I briefly review the idea that photographs have objective purport, concentrating on those details relevant to the arguments to follow. Next, I describe three typical examples of the phenomenon in question in Section III. In Section IV, I examine a similar phenomenon in a nonfictional comic, arguing that although this usage of a more realistic rendering style can be explained in terms of objective purport, the explanation cannot be generalized to the fictional comics presented in Section III. I then argue directly in Section V that no account in terms of objective purport can adequately explain the phenomenon in question. The arguments in Section V will depend on a principle, which I call the *panel transparency principle*, that deserves further scrutiny and which receives such scrutiny in Section VI. I conclude with a tentative sketch of the direction a more successful positive account might take.

II. PHOTOGRAPHS AND OBJECTIVE PURPORT

It is widely accepted that photographs have objective purport—that is, that photographs present a veneer of objectivity lacked by paintings or, in the case that will be of present interest, drawings, no matter how accurate and informative that drawing or painting might be. In addition, it is widely accepted that viewers cannot help but attribute a higher level of objectivity to photographs than they attribute to corresponding paintings or drawings.

The idea that photographs have objective purport (although not the nomenclature) traces back to André Bazin, who writes that

the photographic image is the object itself, the object free from the conditionals of time and space that govern it. No matter how fuzzy, distorted, or discolored... it shares, by virtue of the very process of its becoming the being of the model of which it is the reproduction; it is the model.[1]

For our purposes here, we need not accede to Bazin's somewhat metaphysically suspect identification of photograph and photographed in order to acknowledge the more fundamental truth: photographs do, in fact, seem to present their subject matter in a more objective manner than other modes of representation.

While there is widespread agreement that the phenomenon Bazin identifies is genuine and that photographs either are, or at the very least are treated as being, more objective than nonmechanical representations of the same subject matter, there is much less agreement regarding what, exactly, the objective purport of photographs amounts to—that is, what aspects of photography underlie its objectivity. Proposals for explaining objective purport of photographs include, but are not limited to, reference to their representing their subjects (André Bazin), their being "traces" of their subjects (Gregory Currie), their perceived objectivity (Barbara Savedoff), and their transparency (Kendall Walton).[2] For present purposes, I need not settle this debate here. Instead, I merely need to assume the rather plausible and widely accepted thesis that photographs do (at least in many cases) have objective purport of some sort or another.

There are, broadly speaking, three ways that we can understand the objective purport of photographs, further widening, and hence increasing the plausibility of, the assumption that photographs have objective purport:

OP1: Photographs, in general, *have* a greater claim to objectivity, authenticity, or authority than do corresponding drawings, paintings, and the like.

OP2: Viewers of photographs, in general, *cannot help but treat photographs as having* a greater claim to objectivity, authenticity, or authority than do corresponding drawings, paintings, and the like.

OP3: Viewers of photographs, in general, *ought to treat photographs as having* a greater claim to objectivity, authenticity, or authority than do corresponding drawings, paintings, and the like.

I do not try to sort out which of these distinct theses are true, nor shall I attempt to tease out the relationships between them (although I will note that OP1 plausibly entails OP3). Instead, I shall leave things rather vague, assuming merely that at least one of OP1, OP2, and OP3 is true, filling in further details as needed.

There is one particular detail that needs to be sorted out immediately, however: is there any reason for thinking that nonphotographic representations of photographs have, or can have, objective purport (in any of the three senses outlined above) at all or that, in particular, drawings of photographs have objective purport? After all, objective purport is a characteristic that distinguishes photographs from other modes of representation, including drawings. Thus, one should no more assume that drawings of photographs have objective purport merely because photographs do than we should assume that drawings of horses have hooves merely because horses do.

While this is right, to an extent, and there seems to be no reason to think that drawings of photographs, in general, have objective purport, careful attention should be paid to the entire title of the article. Our concern at present is not just any old drawing of a photograph, but is instead drawings of photographs *in comics*. (It is worth emphasizing at this point that the phrase 'drawing of a photograph,' as I use it here and below, is meant to be understood as denoting an *actual* drawing depicting either an actual or a fictional photograph.) There is some reason for thinking that drawings of photographs in comics do have objective purport, even if drawings of photographs more generally need not. To see this, we need to attend to three facts:

1. Comics are (typically) fictional narrative artworks.
2. With respect to narrative artworks, the audience of the work is not the only "agent" toward which the drawing of a photograph might be "purporting its objectivity."
3. With respect to narrative artworks, the actual world is not the only "world" that the drawing of a photograph might be "objectively purporting."

Typically, when we are presented with a drawing of a photograph in a comic, the drawing is meant to represent a photograph that exists within the

relevant fictional world, although it will typically fail to exist in the actual world. Since actual photographs have actual objective purport relative to actual viewers, however, and since fictions typically obey most or all of the "natural laws" governing the actual world, fictional photographs typically have fictional objective purport relative to fictional viewers: in typical cases, a drawing of a photograph within a comic objectively, accurately, and authoritatively represents individuals and actions within the fictional world to the same extent that actual photographs accurately depict individuals and actions in the actual world. Furthermore, drawings of photographs in comics have a sort of indirect objective purport relative to readers insofar as they objectively record events within that fictional world.[3]

The point made in the previous paragraph is not mere nitpicking—on the contrary, this fact regarding representations of photographs has been used to great effect in novels, films, and, of course, comics.[4] Thus, we have identified two senses in which drawings of photographs within comic might, and often do, have objective purport.

Where *w* is a work of fiction (such as a comic):

A drawing of a photograph within *w* has *diegetic objective purport* if and only if the photograph depicted in *w* has objective purport relative to fictional agents within the fiction.

A drawing of a photograph within *w* has *nondiegetic objective purport* if *w* has objective purport relative to readers of that fiction.

Thus, a drawing of a photograph has diegetic objective purport if and only if the (fictional) photograph depicted in the drawing has a special claim to objectivity, authenticity, or authority relative to providing (fictional) agents with information regarding the fictional world that they inhabit, and a drawing of a photograph has nondiegetic objective purport if and only if the drawing of the photograph has a special claim to objectivity, authenticity, or authority relative to providing the reader of the fiction with information regarding the fictional world about which they are reading. With this distinction in place, the next task is to look at some examples of the problematic phenomenon at issue: realistic drawings of photographs in otherwise less realistically rendered comics.

III. COMICS, PHOTOGRAPHS, AND RENDERING STYLE

Perhaps the most familiar examples of this phenomenon occur in the supplementary "documentary" material included at the end of each issue of *Watchmen*.[5] For example, consider the mug shot of Rorschach (Walter Kovaks) provided in his arrest report at the end of Chapter 6 (p. 29) as compared to a panel depicting the character in a similar pose taken from the main body of this issue (p. 16). While the depictions are similar, and there is no doubt that it is the same character being depicted in the two drawings, the rendering style in the mug shot is noticeably more realistic than the depiction of Rorschach in the panel, including more (and more realistic) detailing and subtler shading. A similar phenomenon occurs in the supplementary material at the end of Chapters 8 and 9 (to mention merely the most striking examples).

These examples are enough to show that the phenomenon in question is real. Nevertheless, given that the technique of including such supplementary "documentation" at the end of each issue of a comic has become, one suspects, an almost uncontrollable aesthetic "tic" on Alan Moore's part (see, for example, *The League of Extraordinary Gentlemen*), it is worthwhile to look at additional examples.[6] This will also serve to convince the reader that the phenomenon is not confined to nonstandard pseudo-documentary appendices, but also commonly occurs within the body of comics.

Our second example comes from Neil Gaiman's "When Is a Door?", which originally appeared in *Secret Origins Special* #1 and is reprinted in *Batman: Whatever Happened to the Caped Crusader*.[7] This comic contains a particularly striking example where a drawing of a photograph of the Riddler with his henchmen is juxtaposed with the Riddler himself (p. 4 in the original comic).[8] Again, we see that the drawing of the photograph of the Riddler is rendered much more realistically than the drawing of the Riddler himself—in particular, the Riddler's facial anatomy is much less exaggerated in the photograph (and, unlike the renderings of the Riddler situated properly within panel borders, the drawing of the photograph at least loosely conforms with actual human facial anatomy). Again, we have a case where a drawing of a photograph in a comic is rendered in a more realistic style than the artwork found in the remainder of the comic.

In order to be as broad as possible, we shall take our third example from a nonmainstream, nonsuperhero comic: Will Eisner's "The Name of the Game," later collected in his anthology *Life, in Pictures*.[9] This comic, which is a fictional story loosely based on Eisner's wife's family history, contains a drawing of a photograph in a newspaper article (p. 480) that, like the examples from *Watchmen* and "When Is a Door?", is rendered in a much more realistic style than the surrounding panels.

A number of things are worth emphasizing: first, as already noted, all three of these comics involve drawings of photographs where the rendering style is noticeably more realistic than the style adopted for the main body of the comic. Second, the first two are clearly fiction, while the third is a fictionalized account of Eisner's wife's family. Third, all three are, without doubt, exceptional works of comic art.[10] Fourth, the creators in question (Moore, Gaiman, and Eisner) are notable for being among those creators most concerned with the formal aspects of their chosen medium.

As a result, the fact that these drawings of photographs are rendered more realistically than the surrounding images is likely no accident. We cannot help but ask what aesthetic function Moore, Gaiman, and Eisner take the more realistic depiction of photographs to be serving, and further, whether this stylistic choice is an appropriate or promising means for achieving these aesthetic ends. As already suggested, one tempting answer to this question is as follows: the more realistic rendering style is used to depict the (fictional) photographs because such a rendering style emphasizes or increases their objective purport. There are problems with such an account, however, but before examining these problems in detail I shall first look at and ultimately reject an alternative conception of what Moore, Gaiman, and Eisner might have been up to—a conception that does link realistic drawing style to objective purport.

IV. WHAT IS NOT GOING ON, PART I

One type of drawing of photographs within comics has received scholarly attention—their metatextual use in probing and subverting the objective purport of photographs when used within autobiographical or biographical works. The example that has received the most attention along these lines is Allison Bechdel's *Fun Home*, in particular, the splash panel occupying pages 100–101 of the comic.[11] This panel depicts Bechdel holding a photograph of a barely dressed young man—a photograph that was taken by her father and kept in a hidden "stash" only discovered by Bechdel after his death. What is distinctive about the drawing (apart from its striking subject matter) is that Bechdel's hand is drawn in a less realistic, "cartoony" style, while the photograph itself is rendered in a much more detailed, laboriously cross-hatched manner. A number of interpreters have argued that Bechdel's stylistic approach here serves her larger goal of challenging the authority of photographs as objective and unequivocal documents of the past. Thus, Julie Watson writes that

Bechdel . . . probes the interplay between personal memory, a kind of subjectivity imaged in cartoons, and photography, an indexical form of documentary evidence (that is, referring to objects of sight, however misleadingly). And in her readings of photos—through both words and drawings—she undermines the claim of photographs to one kind of tacit authority, and opens them to interpretation that grants them a different kind of encoded subjectivity, a legacy of family history.[12]

I do not attempt here to provide a detailed evaluation of Watson's analysis of *Fun Home*, but instead I merely note that at least part of this analysis can be summarized rather neatly in terms already familiar from the discussion above: according to Watson, the function of the much more realistic style used to depict photographs within *Fun Home* is to emphasize their status as photographs and thus to emphasize their claims to accuracy, authenticity, and authority—that is, their objective purport—in order to more powerfully frame Bechdel's challenge to this supposed objectivity. In other words, Bechdel uses the realistic drawing style to emphasize the very aspect of photography that she intends to contest. As a result, we can explain the aesthetic function of the realistic rendering style adopted in this particular case in terms of the objective purport of photographs more generally.

There is no doubt that this analysis of Bechdel's text is interesting and fruitful. What is equally clear, however, is that it will not generalize to the cases discussed in the previous section. The reason is simple: Bechdel is challenging the role

of photographs as objective, unequivocal records of the actual past. The fact that her drawings are drawings of real photographs, situated in a nonfictional comic, is critical. We cannot coherently interpret the drawings of photographs within *Watchmen*, "When Is a Door?", or "The Name of the Game" as similarly challenging the objective purport of (actual) photographs, however, since there is no coherent way to interpret these drawings as drawings of real photographs whose genuine, real-world authenticity or authority can be in question. As readers of these comics, we know that the individuals and events depicted are fictional, and thus these depictions have no claim to any objective representation of the actual world (or, no such claim beyond that implied by the controversial thesis that fictional worlds might be parts, in some sense, of the actual world, a thesis not assumed here). As a result, we cannot generalize Watson's strategy in order to explain the more realistic rendering style found in drawings of photographs in *Watchmen*, "When Is a Door?", or "The Name of the Game."

Of course, one could use drawings of fictional photographs to challenge the *fictional* authenticity or authority of photographs within the depicted fictional world in much the same manner that Bechdel's comic challenges the authority and authenticity of actual photographs. Furthermore, given that we often draw conclusions about the actual world based on our observations regarding fictions based on it, this would allow us to challenge the objective purport of actual photographs via drawings of fictional photographs in an indirect sense.[13] This is clearly not the manner in which the drawings of photographs in *Watchmen*, "When Is a Door?", and "The Name of the Game" function, however. On the contrary, the reader is clearly meant to understand these fictional photographs as legitimate records—in some substantial sense of 'legitimate'—of objects and events within the fiction.

Thus, there remains some intuitive pull to the idea that the more realistic rendering style used in drawings of photographs in *Watchmen*, "When Is a Door?", or "The Name of the Game" is meant to emphasize or augment their objective purport, even if this emphasis or augmentation does not serve a Bechdelian metafictional strategy. Unfortunately, as we shall see in the next section, this intuition is mistaken.

V. WHAT IS NOT GOING ON, PART II

I now examine directly whether we can understand the more realistic style used to render drawings of photographs in *Watchmen*, "When Is a Door?", and "The Name of the Game" as attempts to emphasize or augment either the diegetic objective purport or the nondiegetic objective purport of these fictional photographs. For the sake of concreteness, I examine Gaiman's "When Is a Door?", although similar comments apply to the other two cases discussed above (and the wealth of undiscussed comics like them in relevant respects).

Of course, a literal answer to this question, which is formulated in terms of what the creators were attempting, is dependent on the attitudes and intentions of the creators. Thus, we could, sticking to such a literal-minded approach, just ask them.[14] But the answer would be of somewhat limited interest. The more interesting question is whether rendering photographs in a more realistic style actually succeeds, or could succeed, in emphasizing or augmenting the objective purport of the fictional photograph in either of the two senses discussed above, and, if so, why this might be aesthetically effective. It is easy to see, however, that the more realistic rendering style neither emphasizes nor augments the objective purport of photographs in either of the two senses identified above.

First off, we can ask whether the more realistic style used in depicting the photograph of the Riddler might increase the diegetic objective purport of the photograph. In other words, does the more realistic style of art either increase the objectivity, authority, or authenticity of the photograph itself (viewed from the perspective of the Riddler himself or other characters within the comic) or increase the objectivity that the Riddler (or other fictional characters) would or should attribute to the photograph?

Not only is the answer "no," but it is not even clear that the suggestion is metaphysically coherent. No doubt, when presented with a (genuine albeit fictional) photograph of himself, the Riddler will ascribe a certain amount of objectivity, authenticity, or authority to the photograph as a record of past events. It is not clear that it makes sense, however—even when discussing fictions—to ask what reaction the Riddler might

have when confronted with a photograph of himself that is *more realistic than he is*. Thus, we can reject the idea that the more realistic style of art emphasizes or augments the diegetic objective purport of the photograph.

There is a substantial and somewhat controversial principle at work in the argument just formulated, which can be summed up as follows:

The panel transparency principle: Characters, events, and locations within a fictional world described by a comic appear, within the fictional world, as they are depicted in typical panels within that comic.

In other words, the panel transparency principle states that the Riddler really does have an impossibly long jaw (impossible relative to facts about human anatomy operative in the actual world), just as he is depicted in the standard (non-photographic) panels contained in "When Is a Door?" As a result, the drawing of a photograph that depicts him as having more reasonable facial anatomy misrepresents his appearance and, as a result, does not represent a more accurate or more authoritative representation of how he appears.

Actually, we do not need the full force of the panel transparency principle. Instead, we merely need the substantially weaker claim that the more realistically rendered drawings of photographs are not *better* representations of the Riddler's appearance than are the less realistic renderings occurring in the standard panels (where 'better' is understood as more accurate—see the discussion of caricature in the next section). This weaker claim is entailed by the panel transparency principle. Nevertheless, the panel transparency principle is of independent interest and hence deserves more scrutiny, which it receives in the next section—for now I merely highlight its role in the arguments presented here and below.

The second question we need to ask is whether the more realistic style used in depicting the photograph of the Riddler might increase the nondiegetic objective purport of the photograph. In other words, does the more realistic style of art either increase the objectivity, authority, or authenticity of (the drawing of) the photograph itself (viewed from our own perspective) or increase the objectivity that we attribute, or should attribute, to the photograph? Recall that we are not asking whether the realistic rendering style increases the accuracy, authority, authenticity, or our attri-

butions of such to the photograph as a record of individuals and events in the actual world. Rather, the question is whether the more realistic rendering increases the objective purport of the drawing of the photograph as a record of events and individuals in the fictional world of the comic.

The answer, again, is clearly "no." After all, presumably the drawings of the Riddler found in the other panels contained in the comic present accurate representations of the appearance of the Riddler within the fictional world (again, we are here assuming the panel transparency principle)—hence, the Riddler does have an abnormally long jaw. The drawing of the photograph of the Riddler, however, has a much more "reasonable" jawline. If anything, the mismatch between artistic style in the drawing of the photograph and the artwork depicted in the other panels brings about a decrease in objective purport: the Riddler just does not look like the person depicted in the photograph, and thus the photograph is *not* an accurate record of the fictional events depicted in the photograph—at least, not as they would have appeared to the other fictional characters within the comic.

This leaves us at a bit of an impasse, however. The realistic drawing style does seem to play an aesthetically important role, yet there does not seem to be any way to understand what role the switch in artistic style is playing in terms of the objective purport of photographs (and, indirectly, in terms of the objective purport of drawings of photographs within comics). On the contrary, if anything, the mismatch between the way the Riddler appears within the fictional world and his appearance in the drawing of the photograph contravenes any claim to objective purport. Thus, how do we explain the role that such "realistic" depictions of photographs play within comics? Before looking at the shape an answer to this question might take, however, we need to take a closer look at the panel transparency principle.

VI. THE PANEL TRANSPARENCY PRINCIPLE

The panel transparency principle asserts that characters (and other elements) within the fictional world described by a comic such as Gaiman's "When Is a Door?" appear, within the fictional world described by that comic, as they are depicted in typical panels within that comic. The use of the term 'typical' here is important, since the account

sketched above depends on our distinguishing between typical panels, where the Riddler is drawn as he appears in the fictional world, and atypical panels, such as the drawings of photographs under discussion.

There are further complications. Clearly, stylistic choices are made within comics (and any other artistic medium, for that matter) based on a number of criteria, only one of which is accurate representation. Thus, certain kinds of caricature can result in drawings that are inaccurate representations of the appearance of the subject but that emphasize nonvisual characteristics, such as personality or moral character.[15] A proper formulation of the panel transparency principle will need to distinguish between stylistic elements that function in this symbolic or metaphorical way and those stylistic elements that are nevertheless part of the genuinely representational content of the drawing. Having noted this issue, however, we will set it aside for another time and focus instead on two rather counterintuitive consequences that follow from the panel transparency principle.

First is the fact that the principle saddles certain characters with rather strange and otherworldly physical characteristics. For example, if the panel transparency principle is true, then the Joker, during the events depicted in *The Long Halloween*, has six-inch-long teeth.[16] Even more worrisome, an unsubtle adoption of the panel transparency principle entails that Bill Clinton looks like a waffle in the fictional world described by Gary Trudeau's *Doonesbury*.[17]

We can at least partially address this first worry. There is a difference between the representation of the Joker as having extremely long teeth and the representation of Bill Clinton as a waffle. The latter is clearly functioning on a symbolic or metaphorical level—suggesting a tendency toward vacillation on the part of Clinton. As a result, the reader is not invited to imagine that Clinton *visually* resembles a waffle in the fictional world described by Trudeau. Stylistic devices that function in a similarly metaphorical or symbolic manner are not part of the representation content of the panel, much as standard conventional devices such as speech balloons do not function as straightforward visual representations. The Joker's teeth, on the other hand, do not function in such a symbolic manner, and as a result we *do* seem invited to treat his six-inch-long teeth as how he appears within the fictional world described in *The Long Halloween*.

Second, as is evidenced by our rather careful relativization of the Joker's dental situation to "events depicted in *The Long Halloween*," there is another, rather more troubling consequence of the panel transparency principle: if the principle is true, then characters change their appearance dramatically from one point in time to another (equivalently, from one artist to the next).[18] Thus, at other points in the timeline of the fictional world described by DC Comics continuity, the Joker has much more human-like dentition (for example, in Alan Moore and Brian Bolland's *The Killing Joke*).[19]

While these consequences are no doubt strange, there are a number of reasons for thinking that the panel transparency principle is, nevertheless, true.

First, there is the fact that characters in comics sometimes comment on the strange appearances of other characters. If the characters in question do not actually appear as they are depicted in the panels, then this phenomenon would be hard to explain.

Second, if the characters in a comic do not appear as they are depicted in typical panels, then what do they look like? Comics are a visual narrative medium, and presumably the primary purpose of a visual medium is to provide visual information regarding what is happening, where it is happening, and to whom. Denying the panel transparency principle would require us to develop a sophisticated account that distinguished those aspects of panels that do depict literal characteristics of the fictional world in question from those aspects that are primarily stylistic. It is one thing to say that metaphorical stylistic devices such as the Clinton waffle are not straightforwardly representative of appearances. It is quite another thing to claim that nonmetaphorical content must be subdivided into the representative and the nonrepresentative.

When confronted with a Tim Sale panel where the Batman punches a six-inch-toothed Joker, we might affirm that the Batman struck the Joker and deny that the Joker has six-inch teeth, but we would also need to determine whether the (abnormally long) shattered tooth fragments flying from the Joker's mouth represent a breaking of teeth, or whether this also is merely stylistic. It is not clear how such distinctions are to be made. The point is not merely an epistemological worry

regarding the difficulty of formulating such a distinction. Instead, the problem is a metaphysical one. If the characteristics of the fictional world described by a comic are determined by (among other things) the pictorial content of the panels, then it is difficult to see what criteria can be used to determine which aspects of the panels (other than purely metaphorical or conventional aspects) are representative in the relevant sense without succumbing to a vicious regress. Further, our actual understanding of the content of such a panel does not seem to involve such complex distinctions between literal and stylistic content. Instead, we seem to understand that the Batman has, in fact, shattered many of the Joker's (six-inch-long) teeth, implicitly assuming that the Joker (and his teeth) appears much as he is depicted in the panel, even if he appears differently elsewhere.

Third, and perhaps most compelling, there is the fact that, when characters are depicted in the actual world, such as when we construct costumes based on these characters, we depict the characters as they appear in the panels. Thus, when depicting Uncle Scrooge McDuck, the costume designers at Disney World do not attempt to teach an actual duck to be miserly, but instead place an actor within an elaborate costume that closely resembles the way Uncle Scrooge appears in the classic Carl Barks comics. This suggests that Uncle Scrooge does not resemble an actual duck, but instead appears, within the fictional world described by *Four Color Comics*, much as he appears in the panels that constitute those comics.[20]

None of these considerations are completely decisive, but jointly they constitute sufficient reason for taking the panel transparency principle seriously. If the panel transparency principle is true, then, as we saw in the previous section, the more realistic style used in the depictions of photographs in *Watchmen*, "When Is a Door?", and "The Name of the Game" does not increase the objective purport of the fictional photographs depicted. Thus, assuming that this realistic rendering style is serving some genuine aesthetic end, the question that remains is this: what role does such realistic rendering play?

VII. CONCLUSION: GESTURES TOWARD A SOLUTION

One thing to notice about all three examples discussed in Section III above is that the drawings of photographs do not appear *within* the panels of their respective comics. In the case of *Watchmen*, the more realistic drawings of photographs appear only in the supplemental, pseudodocumentary appendices. Even more tellingly, the photographs in "When Is a Door?" clearly float "above" the relevant panels—their corners stretch beyond the panel borders. This suggests that these photographs need not be understood as depictions of objects as they appear within the fictional world, but that they are instead playing a different role.

What I would like to suggest is that there are two "modes of presentation" within comics. The first, which typically occurs within panel borders (either explicit or implicit), depicts the fictional world as it appears to the fictional characters that inhabit it. The second mode—the mode in which the more realistically depicted photographs are presented—typically occurs outside or "above" panel borders. I call such images *extra-panel content*. Extra-panel content need not be interpreted as depicting (fictional) items or events as they would appear within the fictional world, or even as depicting items or events that inhabit the fictional world at all. Instead, such elements can play a number of meta-literary roles. Metaphorically speaking, panel borders provide windows through which we can observe objects and events within the fictional world directly (windows that "obey" the panel transparency principle), while objects that appear "between" us and these windows—extra-panel content—live in a sort of narrative purgatory, depicting neither proper parts of the fictional world nor proper parts of ours.

Drawings of photographs are not the only possible type of extra-panel content. Other objects can be depicted outside or above panel borders in order to metatextually comment on the literal, panel-bound content. One example is the depiction of the Mighty Moose Whisky bottle on pages 22–23 of Alan Moore's *Swamp Thing*.[21] The bottle does not occur within a panel, but instead is lying on its side, at the top of the page, dripping whisky down and around the panels below it. The panels themselves do not depict anyone drinking, but instead show Matthew Cable discussing one of his past benders (and its supernatural effects) with his wife, Abigail. Thus, the bottle cannot be understood as depicting anything actually occurring or present in the events depicted in the panels

below it, but instead plays the role of extra-panel content, metaphorically commenting on the manner in which Matt's alcohol abuse has "saturated" both characters' lives.

Clearly, extra-panel content can play a number of roles, with the two types discussed above being only a small sampling. Nevertheless, we can say a bit more about what is typically going on when drawings of photographs are rendered more realistically and occur as extra-panel content. One plausible thought is this: the drawing of a photograph of the Riddler depicts the Riddler as he would have looked were he to inhabit the actual world. While I do not have space here for a detailed defense of such a reading, I will note that it is upheld by the fact that photographs, when they are depicted firmly within the borders of a particular panel and must therefore be interpreted as part of a depiction of events within the fictional world, are usually drawn in the same style as the surrounding artwork. For example, compare the drawing of the photograph of the Riddler that we have been discussing to the less realistic style used for the same photo when it is in the Riddler's hand within the panel on the same page.

If this brief suggestion is right, and extra-panel drawings of photos represent, not how fictional objects appear within the fiction, but how they would appear were they actual, then these drawings of photographs fail to have objective purport. Instead, the particular aesthetic force of such drawings of photographs lies not in their objectively or authentically or authoritatively representing anything, but rather in their constituting a sort of bridge principle between the fictional world that we enjoy through a comic and the actual world that we inhabit while so enjoying the comic.

Of course, if this is right, then the natural next question to ask is: what function does such "bridging," extra-panel content play? One suggestive thought is that, in bridging the metaphysical gap between actual and fictional worlds and, in particular, the difference between appearances of the same, this device assists in our "identification" or "empathy" or "sympathy" with—that is, our involvement with and investment in—the agents and actions depicted within the fiction. Space concerns, however, preclude me from doing anything more than suggest such ideas and recommend further thought on the topic.[22]

ROY T. COOK
Department of Philosophy
University of Minnesota
Minneapolis, Minnesota 55455

INTERNET: cookx432@umn.edu

1. André Bazin, "The Ontology of the Photographic Image," in André Bazin, *What Is Cinema?* trans. Hugh Gray (University of California Press, 1967), pp. 9–17, at p. 14. I have appropriated the term 'objective purport' from Aaron Smuts, "'Pickman's Model': Horror and the Objective Purport of Photographs," *Revue Internationale de Philosophie* 4 (2010): 487–509, to which this article, and especially the present section and Section IV and Section V, owe a great debt.

2. Bazin, "The Ontology of the Photographic Image"; Gregory Currie, "Visible Traces: Documentary and the Contents of Photographs," *The Journal of Aesthetics and Art Criticism* 57 (1999): 285–297; Barbara Savedoff, *Transforming Images: How Photography Complicates the Picture* (Cornell University Press, 2000); Kendall Walton, "Transparent Pictures: On the Nature of Photographic Realism," *Critical Inquiry* 11 (1984): 246–277.

3. It is worth noting that because many explanations of the objective purport of photographs depend on the particular causal relations that hold between photograph and photographed, the role played by photographs might be substantially more complicated in science fiction stories where the laws of nature are altered.

4. See Smuts, "'Pickman's Model,'" for extensive discussion of this phenomenon.

5. Alan Moore, Dave Gibbons, and John Higgins, *Watchmen* (New York: DC Comics, 1986). Page numbers are reproduced in this volume as in the original floppies—hence each chapter begins with page 1.

6. Alan Moore et al., *The League of Extraordinary Gentlemen Vols. I* and *II* (New York: Wildstorm and DC Comics, 2001–2003).

7. Neil Gaiman et al., *Batman*: *Whatever Happened to the Caped Crusader*: *Deluxe Edition* (New York: DC Comics, 2009).

8. The trade paperback does not have page numbers.

9. Will Eisner, *Life, in Pictures* (New York: Norton, 2007).

10. I do not use the term 'exceptional' here as a synonym for 'masterpiece.' Although, in fact, I firmly believe that *Watchmen*, at least, is a masterpiece on a par with acknowledged masterpieces in other art forms, I do not wish to mislead readers into thinking that the arguments set out here depend, in any way, on assuming that comics can reach such aesthetic heights. Thus, by 'exceptional,' I merely intend to indicate that these works are of the highest rank, aesthetically, when compared to other comics.

11. Allison Bechdel, *Fun Home*: *A Family Tragicomic* (New York: Houghton Mifflin Harcourt, 2006).

12. Julie Watson, "Autographic Disclosures and Geneologies of Desire in Alison Bechdel's *Fun Home*," *Biography* 31 (2008): 27–58, at p. 52. See also Jennifer Lemberg, "Closing the Gap in Allison Bechdel's *Fun Home*," *Women's Studies Quarterly* 36 (2008): 129–140.

13. Thanks are owed to an anonymous referee for pressing this point.

14. It is worth noting, however, that in electronic correspondence with Marcus Rossberg (who commented on an early version of this article at the 2010 American Society of Aesthetics Eastern Division meeting), Neil Gaiman stated that the more realistic photographs in "When Is a Door?" were not intended to indicate greater authenticity, but are instead "an entirely metafictional construct," an intention completely in line with the account developed here (Neil Gaiman, Twitter post, retrieved April 14, 2010).

15. Thanks are owed to an anonymous referee for pressing this point.

16. Jeff Loeb and Tim Sale, *The Long Halloween* (New York: DC Comics, 1999).

17. Gary Trudeau, *40: A Doonesbury Retrospective* (New York: Andrews McMeel, 2010).

18. Another possible interpretative option, suggested to me by Christy Mag Uidhir, is that acceptance of the panel transparency principle entails an implausible proliferation of fictional 'Batman' worlds—one for each artist, or at least artistic style, in which the character is rendered. In other words, we accept the panel transparency principle, but also accept that fictional agents (like actual agents) do not dramatically change appearance over time. As a result, different artists must be depicting different characters. This option contradicts the obvious fact that the Joker, as depicted by one artist, remembers and is motivated by past events that occurred when that character was depicted by other artists, however.

19. Alan Moore and Brian Bolland, *The Killing Joke* (New York: DC Comics, 1995).

20. Uncle Scrooge McDuck first appeared in Carl Barks, "Christmas on Bear Mountain," *Four Color Comics* #178 (New York: Dell Comics, 1947). We might be tempted (as an anonymous referee was tempted) to think that the Scrooge McDuck at Disneyland is not a representation of a fictional character, but is instead part of a three-dimensional extension of the fiction. Even so, the fact that Scrooge is depicted unrealistically in this alternative medium provides some support for the claim that his appearance within the fictional world is similar.

21. Alan Moore et al., S*aga of the Swamp Thing: Book 1* (New York: Vertigo and DC Comics, 2009).

22. I thank Christy Mag Uidhir, Aaron Meskin, Henry Pratt, and Marcus Rossberg for helpful comments and criticisms. Early versions of this article were given at the April 2010 American Society of Aesthetic Eastern Division meeting in Philadelphia, Pennsylvania, and at a work-in-progress seminar at the University of Minnesota, and it has benefited greatly from helpful feedback from both audiences.

Photography and Knowledge

Photography has been associated with the acquisition of knowledge since its inception. Elizabeth Eastlake and Charles Baudelaire, two of the earliest commentators on the medium, saw it as the business of photography "to give evidence of facts" and allowed that the new technology should be "the secretary and clerk of whoever needs an absolute factual exactitude in his profession." Later, modernist thinkers such as Rudolf Arnheim and Siegfried Kracauer talked of the "authenticity" of the medium and praised it for being "uniquely equipped to record and reveal physical reality." Contemporary thinkers such as Patrick Maynard and Barbara Savedoff devote crucial chapters of their respective books to discussions of the "detective function" or the "documentary authority" of the medium.[1]

I am highly sympathetic with the idea that photographs typically offer an epistemic advantage relative to other kinds of representations. But I admit to being uneasy with the metaphors that these thinkers offer. Photographs are not, literally, secretaries or clerks, nor do they have authority over us. Yes, photographs are often authentic in some sense, and they can certainly record or reveal or detect physical reality, but the same can often be said for other kinds of representations, such as words or nonphotographic pictures. It would be good to know in nonmetaphorical terms wherein the epistemic advantage of the medium lies.

Surprisingly, this is a difficult task. Perhaps even more surprisingly, it is one that has received careful attention only very recently, and it is far from being completed. Here I critically examine two important papers and a follow-up commentary coauthored by Jonathan Cohen and Aaron Meskin, explaining in what respects I think their analysis succeeds and in what respects it fails.[2] I then offer my own analysis, showing how it avoids the problems that render Cohen and Meskin's analysis inadequate.

I. PHOTOGRAPHS AS SPATIALLY AGNOSTIC INFORMANTS

Cohen and Meskin's analysis relies on a notion of information according to which "information is carried when there is an objective, probabilistic, counterfactual-supporting link between two independent events."[3] An event e_1 carries information about another event e_2 if and only if

(I) the probability that e_2 has property Q is much higher given that e_1 has property P than it would be if e_1 had had property R

and

(II) if e_2 had not been Q, then (all things being equal) e_1 would not have been P.

For example, the retinas of my eyes carry information about the greenness of the leaves on the tree in front of me because (i) the probability of those leaves being green conditional on the relevant patches of my retinas being irradiated by green light is much higher than the probability of the leaves being green conditional on the relevant patches being irradiated by nongreen light, and (ii) if the color of the leaves had been different (if, for example, I was looking at the tree in the autumn), then the relevant patches on my retinas would have been irradiated by nongreen light.

When information construed in this way pertains to the visible properties of objects, Cohen

and Meskin call it "v-information," and in the manner just sketched, our visual system is designed to utilize v-information to help determine the character of the world around us. But in the course of its normal operation, our visual system also utilizes what Cohen and Meskin call "e-information," which is information regarding the spatial location of objects relative to our bodies.[4] If I am looking at a tree, my visual system not only processes v-information in ways that ultimately enable me to form beliefs about the color of its leaves, but as well it processes e-information in ways that ultimately enable me to form beliefs about whether the tree is in front of me, above me, below me, and so on. In this way, ordinary vision exploits both v-information and e-information to help guide us through the world.

However, creating an informational system that provides e-information is frequently quite difficult, as the arrangements required to maintain the truth of the relevant probabilities and counterfactuals often require physical proximity, and such proximity can be difficult or costly to maintain. E-informational systems are, to use Cohen and Meskin's term, *demanding* sources of information.[5] Furthermore, often we want to learn about visible properties of objects, but we do not care about where those objects are positioned in relation to our bodies. The upshot of these nor-

mative pressures is that we frequently seek informational systems that furnish v-information without at the same time attempting to furnish costly e-information. We seek what Cohen and Meskin refer to as *spatially agnostic informants*.[6]

As it turns out, spatially agnostic informants are not hard to come by, for *pictures* can, and sometimes do, satisfy the two conditions for information transfer with respect to the visible properties of objects they depict, but not with respect to the location of those objects in relation to the viewer.

Consider the class of pictures Cohen and Meskin refer to as "veridical landscape paintings," an example of which is Rackstraw Downes's *110th and Broadway*, 1978–1980 (see Figure 1).[7]

To keep matters simple, focus on a detail such as the color of the lettering on the Sloan's sign across the intersection (in the original, which is in color, the lettering on the Sloan's sign is red). Given Downes's realist aims and *plein air* techniques, it is very likely true that (i) the probability of those letters being red conditional on the relevant patches of the picture being red is much higher than the probability of the letters being red conditional on the relevant patches not being red, and (ii) if the color of the letters had been different, then the relevant patches on the picture would have been some color other than red. The canvas thus carries v-information about the color

FIGURE 1. Rackstraw Downes, *110th and Broadway* (1978–1980). 23 × 39 in. Oil on canvas. Original in color. © Rackstraw Downes, Courtesy Betty Cuningham Gallery, New York.

of the lettering on the sign and, in all likelihood, carries v-information about many other features of the intersection at the time that the painting was made. And yet there is no similar correlation between features of the canvas and its location in relation to the objects depicted. If the painting is moved farther from or closer to the Sloan's store, the color patches and shapes on the canvas will remain the same. Thus, the canvas does not offer e-information to its viewers even though it does offer v-information; it is a spatially agnostic informant.

Photographic pictures are likewise often spatially agnostic informants. A Polaroid snapshot taken from the same vantage point as the one occupied by Downes as he created his canvas would exhibit color patches and shapes that satisfy (I) and (II) with regard to visible properties of the scene, but not with regard to spatial-relational properties holding between the snapshot and the objects depicted in it. One could carry the snapshot to the other side of the planet and not alter the shapes and colors on its surface in any way.

It is thus not their status as spatially agnostic informants that epistemically sets photographic pictures apart from veridical landscape paintings. Instead, according to Cohen and Meskin, it is the *cognitive status* of typical viewers of the two kinds of images that does so. More specifically, it is certain beliefs that viewers bring with them to the act of viewing:

By and large, viewers believe that the type of photographs is one whose members carry v-information. And by and large, viewers believe that the categories to which they assign veridical paintings are ones whose members may fail to carry v-information.

Furthermore,

subjects who come into visual contact with a photograph (under ordinary viewing conditions) typically categorize that object as a photograph; in contrast, subjects who come into visual contact with veridical . . . paintings do not typically categorize them as veridical . . . paintings, but rather as paintings.[8]

Here Cohen and Meskin distinguish between three types of pictures. The first, *photographs*, typically supply v-information and are believed typically to supply v-information. The second, *veridical paintings* (such as the Downes canvas), likewise typically supply v-information and are believed typically to supply v-information. The third, *paintings* (such as Poussin's depictions of an imagined Arcadia), frequently fail to supply v-information and are believed frequently to fail to supply v-information.

At the level of types, Cohen and Meskin's analysis thus does not epistemically distinguish between photographs and veridical paintings. But at the level of tokens it does. Because token veridical paintings exhibit the same kinds of physical characteristics as token paintings, viewers frequently form false beliefs about them, categorizing them as paintings when they are in fact veridical paintings. Viewers therefore often fail to recognize the v-informational richness of token veridical paintings and are thus unable to exploit it. Their situation is analogous to that of Othello who, when confronted with a rich source of (propositional) information in Desdemona, fails to recognize her as belonging to the informationally rich type to which she in fact belongs, and so is unable to exploit the epistemic virtue that she offers.

With photographs, however, matters are different. The physical characteristics of token photographs (small size, glossy surface, and so on) render them easily recognizable as tokens of the type to which they belong, and so viewers believe token photographs to be v-informationally rich, and are thus able to exploit this richness. Photographs are akin to the legendary Delphic oracle in that both are rich sources of information *and* easily recognizable as such. According to Cohen and Meskin, it is this that accounts for the epistemic advantage that photographs have over veridical nonphotographic pictures. As they put it in a later discussion, "[y]ou will only take as evidence [regarding facts in which you have an interest] a [picture] that *does* carry information if it is recognizable to you as an instance of a type whose instances you believe carry information."[9]

My first concern with Cohen and Meskin's analysis centers on its psychological plausibility. To see the problem, note first of all that Cohen and Meskin emphasize that the notion of information they invoke "is utterly non-doxastic. That is, we do not understand the provision of information in terms of a capacity to provide true beliefs nor, in fact, do we construe information in any cognitive terms at all."[10] It may be that the correlations characterized by (I) and (II) function in the earliest stages of visual processing in ways that ultimately lead to the formation of perceptual beliefs,

but such correlations are nonetheless far removed from any of the familiar doxastic occurrences studied at the level of psychology. Information, in the sense invoked by Cohen and Meskin, is utterly nonpropositional and, hence, is not the sort of thing that can be true or false. It is, and is only, a pattern of correlations exhibited by some states and events and not others, a pattern characterized by highly technical propositions expressed by (I) and (II).

Although I have no objection to such a construal of information, I worry that it mixes poorly with the belief ascriptions that are essential to Cohen and Meskin's analysis. The viewers of pictures that Cohen and Meskin have in mind are ordinary people looking at snapshots in photo albums or paintings on gallery walls, people who lack the highly technical concepts involved in Cohen and Meskin's notion of information. Given that it is a plausible constraint on correct propositional attitude attribution that the individuals to whom those attitudes are ascribed possess the concepts involved in the embedded contents, it is unlikely that "viewers believe that the type of photographs is one whose members carry v-information" or that they "believe that the categories to which they assign veridical paintings are ones whose members may fail to carry v-information."

In order to understand my second concern with Cohen and Meskin's analysis, a preliminary distinction is required between two aspects of investigation into why we value objects or processes in general. The first, *ontic*, aspect involves developing an understanding of the objects or processes that persons value, but doing so apart from a consideration of the cognitive status of those persons. The second, *cognitive*, aspect involves developing an understanding of the beliefs that those persons develop about the ontic matters, and how those beliefs interact with desires to yield the value assigned to the objects and processes.

To take a simple example, it is a fact about most people that they value gold more than they do iron. Part of the story about why this is so has to do with facts about gold and iron themselves, facts that we can study in isolation from a consideration of anyone's cognitive status. Gold, we learn in developing our chemistry, has an atomic structure that renders it chemically very stable, that renders it physically malleable, and that gives it a certain bright and reflective color. Iron, we learn, has an atomic structure that renders it highly reactive, brittle, and that gives it a dark and unreflective color. But an understanding of these ontic matters alone does not yield an understanding of why it is that gold is valued over iron. We must extend our investigation into the cognitive domain, examining the beliefs that people have about gold and iron and the various desires that they have that interact with these beliefs. People, we learn in developing our folk psychology, believe that gold is noncorrosive, that it can be worked, and that it is a pleasing color. Furthermore, people believe that iron rusts, that it will crack if formed in intricate ways, and that it is dull in appearance. And we note as well that people desire metals that do not corrode, that can be worked, and that are pleasing to the eye. These cognitive facts, in conjunction with the ontic facts, begin to yield a complete understanding of why it is that people value gold more than they do iron.

One might reasonably expect that the same considerations apply to our understanding of why people typically assign greater epistemic value to photographs than they do to other types of pictures. If so, on the ontic side, we have to investigate typical photographic technologies and the various high-level generalizations about photographs in relation to the objects they depict that are subtended by the proper functioning of these technologies. And we have to investigate how these technologies and supported high-level generalizations differ from those associated with other types of pictures. On the cognitive side, we have to investigate the beliefs that people typically have about, if not the technologies and formative processes associated with the various kinds of pictures (since people often lack these), then at least the high-level generalizations associated with each kind of picture. And, finally, we have to understand how these beliefs interact with commonly held desires.

Returning to the Cohen and Meskin proposal, we have seen that they contribute substantially to the cognitive aspect of this investigation. They ascribe to viewers (although implausibly in my view; see above) beliefs concerning the v-informational carrying capacity of types of pictures and beliefs regarding to which of these types token pictures belong. But when it comes to the required ontic side, their analysis is inadequate.

To see why, consider once again the gold-iron example, and note that characteristically there is a connection between the beliefs ascribed on

the cognitive side of such an analysis and the occurrences described on the ontic side. More specifically, people are frequently caused to have the beliefs that they have because the world is as those beliefs represent it to be. In the example, people are caused to have the belief that gold is malleable by the fact that gold is malleable. Such causation in turn subtends explanation insofar as we can explain the fact that people believe that gold is malleable by pointing to the fact that gold is malleable. Extending this, we can begin to explain the fact that people value gold more than they value iron by pointing to this ontic-grounded belief, the ontic-grounded belief that iron is not malleable, and the widely held desire for malleable metals. Call cases involving this pattern of explanation *standard* cases.

There is, of course, a large class of cases that deviate from the standard cases insofar as there is no ontic basis for the beliefs in the ascribed cognitive structures. Consider, for example, forked sticks that are used as divining rods. Some people value forked sticks more than they do sticks shaped in other ways because those people desire to locate underground water and possess the belief that forked sticks indicate the presence of underground water along with the belief that sticks shaped in other ways do not. Here there is no ontic basis for the former beliefs for the simple reason that forked sticks are as inefficacious at indicating the presence of underground water as are sticks shaped in other ways. The former beliefs are false. Call such cases *error-theoretic*, as they involve widespread and systematic error on the part of a significant group of people.

Returning to the Cohen and Meskin proposal, their text suggests that it does not belong to the error-theoretic type. With regard to the v-informational richness (or lack thereof) of the types *photograph*, *veridical painting*, and *painting*, they allow that "some of the relevant background beliefs are false in some cases" but add that "the relevant background beliefs are true in many cases."[11] Assuming that explanations of why people value items are either standard or error-theoretic, we can thus conclude that the Cohen and Meskin proposal is standard. There must, therefore, be a discoverable and explicable ontic base grounding and explaining the beliefs that viewers have regarding the v-informational content of the types *photograph*, *veridical painting*, and *painting*. And it is precisely in this respect

that the Cohen and Meskin proposal is inadequate. For they offer no account of why tokens of the type *painting* are v-informationally impoverished relative to tokens of the types *photograph* and *veridical painting*. The beliefs that viewers are alleged to have about such matters are therefore left unsupported.[12] In the gold-iron example, the malleable character of gold and the brittle character of iron cause the widespread beliefs that gold is malleable and iron brittle, and such causation can thus subtend the corresponding explanations of the presence of those beliefs. But there is no analogous explanation available in the Cohen and Meskin proposal.

Such an omission is surprising, and I find I can account for it only by speculating that Cohen and Meskin believe that they *do* have an ontic basis to offer, and that it can be found in the spatially agnostic character of photographs. As noted above, Cohen and Meskin point out that such character renders photographs undemanding sources of v-information and that this makes photographs epistemically valuable because (i) frequently, we are not interested in obtaining e-information, but we are interested in obtaining v-information, and (ii) information systems that fail to carry e-information are often thereby able to carry v-information about a wider range of subjects about which we desire v-information. If this is correct, it is an ontic characteristic of photographs and thus one that can cause, and therefore explain, widespread beliefs about an epistemic feature of photographs. The problem is, however, that this is not the ontic base that Cohen and Meskin require to complete their analysis. What Cohen and Meskin in fact require is an ontic difference between the type *photograph* and the type *painting* that renders the former type typically v-informationally rich relative to the latter type. Spatial agnosticism does not do this, however, for the simple reason that, except in very unusual circumstances, *all* types of pictures, if they v-inform, do so in spatially agnostic ways. Spatial agnosticism factors out of the current analysis, an ontic common denominator among the three types of representation under consideration and, I suspect, a mere vestige of Cohen and Meskin's earlier disagreement with Kendall Walton regarding the transparency of photographs.[13]

If I am correct that Cohen and Meskin's analysis suffers from this ontic omission, then perhaps they can easily patch things by offering the required

ontic component in a future discussion. How-ever—and perhaps even more worrisomely than the apparent ontic omission itself—I find in their texts an explicit rejection of what I take to be the most promising characterization of the required ontic base. I have in mind a character-ization that has appeared in the literature on pho-tography almost since the invention of the tech-nology. It has to do with pictorial etiology. Many have pointed out that photographic pictures, as opposed to handmade pictures such as veridical paintings and paintings, have a *mechanistic* eti-ology, one that importantly excludes the menta-tion of the photographer from the formative pro-cess.[14] Very roughly, and subject to qualifications that will be discussed below, when a photogra-pher presses the shutter, the process that maps features of the scene onto features of the resul-tant picture bypasses her mentation so that fea-tures of the scene are rendered in the picture re-gardless of whether or not she noticed them. In contrast, when a painter creates an image, fea-tures of the scene must register in his cognition to at least some extent in order for them to be ren-dered on the canvas.[15] Likewise, it can be argued that the mechanistic character of the photographic process places any desires the photographer might have about what will be depicted in the picture outside of the formative process, thereby limiting her control in this regard. But this is not so in the case of the painter, who can add features at will. In information-theoretic terms, handmade images such as paintings are much more susceptible to *equivocation* and *noise* than are photographs and thus as a type are more v-informationally im-poverished than photographs as a type.[16] Cohen and Meskin could use this alleged ontic feature in their analysis. However, they explicitly reject this mechanistic-etiological approach, citing with approval the currently popular view that the men-tation of the picture maker is as much involved in the formation of a photograph as it is in the for-mation of a veridical painting or a painting.[17] I am thus at a loss to see how they might proceed.

II. THE OBJECTIVITY-BASED EPISTEMIC ADVANTAGE

i. *Ontic Component.* My own ontic story takes as its foundation the mechanistic character of the photographic process just discussed. It is no secret that this position has received substantial criticism

over the past few decades.[18] Indeed, with a few exceptions, most today accept as orthodoxy that "the production of photographs is shot through with intentional conditions on the selection of lenses, the development process, and so forth," and that therefore no purchase can be gained along these lines on an ontic distinction between photographic and handmade images.[19]

However, I have argued elsewhere that al-though critics of the traditional mechanistic view correctly note that the mentation of the photogra-pher typically has a substantial effect on the char-acter of the photographs produced, they nonethe-less fail to distinguish between two importantly distinct *ways* in which mentation can be involved in the formation of pictures. Mentation is *primar-ily* involved in the formation of a picture when it is a component of the sequence of events that subtends the mapping of features of the depicted scene onto features of the picture, whereas menta-tion is *secondarily* involved when it has a bearing on the character of the resultant picture, but is not directly involved in the subtending process.[20]

To take a simple example, the photographer de-cides in which direction to point her Land camera, and her decision in this regard will have a sub-stantial effect on the character of the photograph produced. But once she has made this decision and pressed the shutter button, her mentation is excluded from the optical-chemical process that subtends the mapping of features of the scene onto features of the resultant picture. Her deci-sion is secondarily involved in the formation of the picture, but not primarily involved. Contrast this with the case of the painter, whose mentation is involved secondarily in the decision about which scene to paint, and then again primarily insofar as features of that scene must register in his mind in order for them to be depicted in the resultant picture.

Because the term 'objectivity' is generally as-sociated with processes that importantly exclude mentation (a process that objectively measures student performance, for example, is one that by-passes the teacher's thoughts on the matter), we may refer to picture-forming processes that lack primary mental state involvement as objective. It is in this sense that there is merit to the traditional view that photography is an especially objective medium.

There are, of course, many objections that can be raised at this point, several of which merit

serious consideration: the use of Land cameras is the exception and not the norm; the primary-secondary distinction is ad hoc; the use of digital imaging techniques enables photographers easily to involve their mentation primarily in the formation of their pictures, and so on. As I have offered replies to such objections elsewhere, I do not do so here.[21] Instead, I simply assume that the traditional photographic process is objective in this way, and I explain how such objectivity lays down the ontic base that is tracked by beliefs of viewers of pictures.

Two further elements are required in order adequately to characterize this ontic base. The first is what I refer to as a *proto-belief*.[22] Proto-beliefs are perceptually or cognitively induced intentional states that are candidates for becoming full-fledged beliefs but that differ from full-fledged beliefs insofar as they lack the functional roles that the latter exhibit. They are states with contents that can be true or false, but that we do not act upon in the course of attempting to fulfill our desires. They are what in folk psychology we call appearances.[23] In perception, the vast majority of proto-beliefs quickly become perceptual beliefs, as matters are generally as they appear to be. But there are occasions on which the contents of proto-beliefs are so much in conflict with the contents of background beliefs that the former are rejected. Familiar examples include the situation in which a stick half immersed in water appears bent, or the roadway ahead on a sunny day appears to be covered in pools of water.

The second required element is that of a *high-level regularity*, an idea that emerges from reflection on our interactions with technologies whose mechanisms we do not understand. Imagine Fred, who knows nothing about how automobiles work in terms of the detailed operation of the engine, transmission, and so on, but who does know how to operate an automobile in the rough-and-ready sense of being able to press it into service in the course of his daily life. The contents of Fred's beliefs pertain not to the detailed mechanisms, but rather to high-level regularities that are subtended by these mechanisms. Fred carries with him background beliefs with contents such as "turning the key starts the car" and "placing the shifter in the *D* position enables the car to move forward." Fred is no isolated exception. Even those who are relatively sophisticated in terms of their understanding of technologies that subtend high-level regularities in one domain must rely on knowledge

of those high-level regularities in other domains. People who understand automotive technology might be ignorant of the details of lithographic, audio, or aeronautical technology, for example, and so must lapse into an understanding based on the regularities subtended by those technologies in order to function in relation to them.

Bringing proto-beliefs and high-level regularities together with objectivity, my central ontic assertions are that

O1: proto-beliefs induced in the minds of viewers of objectively formed pictures are frequently true

and

O2: proto-beliefs induced in the minds of viewers of nonobjectively formed pictures are frequently false.

Furthermore, because photographic pictures are typically formed objectively and handmade pictures are not, it follows from the correctness of O1 and O2 that proto-beliefs induced by looking at photographs are much more frequently true than proto-beliefs induced by looking at handmade pictures.

What reasons does the skeptical reader have for accepting O1 and O2? There are several, some obvious, others less so. Here are two: (a) Painters or sketchers can easily fail to notice visible features in the scene that they are depicting and, because their mentation is primarily involved in the formation of their pictures, such failures will result in the omission of features in the pictures that otherwise would have induced true proto-beliefs in the minds of viewers. Similar failures to notice details on the part of photographers will not likewise result in the omission of features on the photographs, precisely because their mentation is not primarily involved in the formation of the photographs. Thus, viewers of the photographs will not likewise fail to have true proto-beliefs induced in their minds.

(b) Painters or sketchers, their mentation primarily involved in the formative process, can easily add features to their pictures that have no analogues in the depicted scene and that thus typically induce false proto-beliefs. Photographers may wish to do the same, but have a much harder time doing so, as their mentation is only secondarily involved in the formative process. And thus the pictures they produce rarely induce such false proto-beliefs.

What about veridical paintings, such as the Downes canvas discussed above? It might be objected that their existence falsifies O2, as such pictures by definition are ones that frequently induce true proto-beliefs.[24] However, while it is true that a prevalence of veridical handmades would falsify O2, it is also true that such pictures are rarely encountered. Photorealist canvases are not only very difficult to create, they are as well not the sort of picture that most painters and sketchers want to create, even if they could. As the truth of O2 can survive exceptions, such rarely encountered examples are not a threat.

It might also be objected that O1 and O2 are not fully ontic assertions, since the high-level regularities they express hold between picture-types characterized in etiological terms on the one hand and the truth values of contents of certain kinds of mental states on the other. O1 and O2 thus straddle the mental–extra-mental divide and so arguably mix poorly with my earlier characterization of the ontic side of the analysis, which might be construed as pertaining exclusively to extra-mental occurrences. But the essence of the ontic side of the analysis is *not* its extra-mental character, although typically it does deal with extra-mental occurrences. Instead, the essence of the ontic component is that it investigates those occurrences that are represented by beliefs embedded in the cognitive component. And, as is well known, human beings have the capacity for beliefs about their beliefs and, specifically, the capacity to evaluate their beliefs for truth or falsity. As I hope to show below, typical viewers of pictures have beliefs that represent the regularities expressed by O1 and O2, thus rendering them bona fide aspects of the ontic component, their partial mental character notwithstanding.

ii. Cognitive Component. With the ontic base laid down, the cognitive component can easily be stated. My central cognitive assertions are that

C1: viewers believe that proto-beliefs induced in their minds by looking at objectively formed pictures are frequently true

and

C2: viewers believe that proto-beliefs induced in their minds by looking at nonobjectively formed pictures are frequently false.

It will immediately be objected that C1 and C2 ascribe to viewers contents involving technical concepts such as that of a proto-belief and an objectively formed picture, and that they are therefore no more psychologically plausible than Cohen and Meskin's ascriptions involving concepts such as v-information. However, the difference between the ascriptions is that the concepts involved in C1 and C2 can easily be replaced by (less precise) folk psychological analogues. Couched in the language of folk psychology, C1 and C2 can be restated as

C1FP: people believe that the appearances that result from looking at photographs are frequently true

and

C2FP: people believe that the appearances that result from looking at handmade pictures are frequently false,

both of which are plausible ascriptions. Starting at a very young age, people encounter myriad photographs and handmade pictures *and* the things depicted in those pictures. Young Johnny sees snapshots of his mother in the family photo album alongside his art-class efforts to depict her, and compares the appearances each of these engenders in his mind with the appearances engendered when he looks at his mother directly. He quickly realizes that there is no contest between the two—the appearances engendered by his art-class efforts are disappointingly false. Such experiences continue through life, as he repeatedly encounters instances of both types of picture and learns on the basis of this that the appearances engendered by looking at photographs are much more often true than those engendered by looking at handmade pictures. He comes, in other words, to have the beliefs ascribed by C1FP and C2FP.[25]

It might nonetheless be objected that even this involves attributing too sophisticated a psychology to viewers of pictures. Do ordinary folk really think about the truth values of their thoughts, looking for correlations between those truth values and the etiologies of those thoughts? The case can be made that the answer to such a rhetorically asked question is yes. Placing pictures to one side, it is a truism that in our daily lives we encounter both people who frequently utter true sentences and those who (whether through deliberate attempts to deceive or through careless assertions regarding matters about which they are ignorant)

frequently utter false ones. In the face of this, we make it a practice to search for correlations between the (eventually revealed) truth values of beliefs that we have formed on the basis of such utterances on the one hand and the identities of individuals who made the utterances on the other. If certain individuals are thereby revealed to be unreliable, we discount their assertions in the future. I conjecture that our practice with regard to photographic and handmade pictures piggybacks on this perhaps innately endowed capacity, and that it should be no more surprising that we engage in such complex inferences in the case of pictures than it is in the case of learning about the world via assertions made by other persons.

Returning to the more precise formulations, and assuming C1 and C2 are correct ascriptions, it remains to be determined how they interact with other intentional states so as to generate the epistemic value typically associated with photographs but not handmade pictures. I suggest that when a viewer encounters a photograph, she quickly and on the basis of the characteristic features of photographs discussed above forms the belief that

F: this picture is objectively formed,

and that F, in conjunction with C1, leads her to infer (typically unconsciously) that the proto-beliefs engendered by looking at the picture are likely true, whereupon she elevates them to the status of full-fledged beliefs. And when a viewer encounters a handmade picture, he forms the belief that

NF: this picture is nonobjectively formed,

and NF, in conjunction with C2, blocks the proto-belief from being elevated to the status of a belief.

Note that this inferential pattern in the case of an encounter with a photograph constitutes *warrant* for the beliefs formed about visible features of the scene depicted in the photograph. The fact that O1 obtains means that viewers have strong inductive support for C1. And, because objectively formed pictures are typically identifiable as such, viewers also have confidence in the truth of F.[26] Given that the inference on the basis of C1 and F is demonstrative, viewers are not only compelled to form true beliefs about visible features of the scene depicted, but they are compelled as well to believe that those beliefs are true. They have warranted, true beliefs; they have knowledge.

And, finally, as has been recognized at least since Plato, we have desires, not only for true beliefs, but as well for reasons to believe that our true beliefs are true. These desires, working in conjunction with the meta-beliefs regarding the truth of the first-order perceptual beliefs, yield at least some of the epistemic value we associate with photographs.

III. PHOTOGRAPHIC EPISTEMIC ADVANTAGE AND THE LARGER PICTURE

Barbara Savedoff argues convincingly that Margaret Bourke-White's famous *Bread Line During the Louisville Flood, Kentucky* (1937) succeeds as a photograph in part because of the "irony of circumstance" that it conveys, an irony involving the juxtaposition of rural black poverty and suburban white affluence.[27] Savedoff points out that establishing this irony depends on the "documentary authority" of the photographic medium insofar as it establishes that the breadline was indeed in proximity of the billboard. Had the image had some other sort of etiology—had it been a digital construction, a pencil-on-paper sketch, or some similar type of image that lacked such authority—it would run the risk of generating merely an "irony of idea," a less-stinging irony arising from the imagination of the image maker, rather than from the actual circumstances of 1937. But what exactly is documentary authority? We now have an answer. Bourke-White's image is an arrangement of lines and tones on a surface that induces in the minds of typical viewers a proto-belief with the content that there was a breadline in proximity of a billboard. But similar arrangements of lines and tones with different etiologies would likewise induce a proto-belief with this content: a digital construction or a pencil-on-paper sketch would do so as well. In the case of the photograph-induced proto-belief, however, viewers who believe that they are looking at a photograph have reason to believe that this proto-belief is true. This reason comes in the form of an inference, with C1FP in the role of the major premise and the belief that a photograph is being viewed in the role of the minor. And to say that they have reason to believe that their proto-belief is true is to say that it is likely that the billboard was in fact in proximity of the breadline, an arrangement that subtends the irony of *circumstance*. By way of contrast, the proto-belief induced by a sketch

is typically accompanied by the belief that the image is a sketch, with the result that C2FP is taken as the major premise and the inference drawn is that the proto-belief is likely false, an arrangement that subtends merely an irony of *idea*. In this way, we have a fuller understanding of why this photograph—and, I suspect, many other photographs from the modernist canon—succeed *as photographs*.

But much remains to be investigated. If digital imaging techniques make it easy to undermine the objectivity-based epistemic advantage, will the difference between photographic and handmade images dissipate, or will institutional factors limit the extent to which this takes place? If photographs have an advantage in terms of yielding knowledge of visible features, does this advantage extend to knowledge of nonvisible features such as the "ethical knowledge" investigated by Susan Sontag?[28] If the epistemic advantage can help us better to understand the success of photographs from the modernist canon, will it likewise enable us better to understand the success of photographs from the postmodernist canon? Investigations along these lines, and others, are reserved for another occasion.[29]

SCOTT WALDEN
Department of Philosophy
Nassau Community College
Garden City, New York 11530

INTERNET: scott.walden@ncc.edu

1. Elizabeth Eastlake, "Photography," in *The London Quarterly Review*, April 1857, reprinted in Vicki Goldberg, *Photography in Print* (University of New Mexico Press, 1988), pp. 88–99, at p. 97; Charles Baudelaire, "Salon of 1859," trans. Jonathan Mayne, reprinted in *Photography in Print*, pp. 123–126, at p. 125; Rudolf Arnheim, "The Two Authenticities of the Photographic Media," *The Journal of Aesthetics and Art Criticism* 51 (1993): 537–540; Siegfried Kracauer, *Theory of Film* (Princeton University Press, 1997), p. 28; Patrick Maynard, *The Engine of Visualization* (Cornell University Press, 1997), chap. 5, "Seeing Machines," pp. 117–148; Barbara Savedoff, *Transforming Images: How Photography Complicates the Picture* (Cornell University Press, 2000), chap. 5, "Transforming Media: Painting, Photography, and Digital Imagery," pp. 185–210.

2. Jonathan Cohen and Aaron Meskin, "On the Epistemic Value of Photographs," *The Journal of Aesthetics and Art Criticism* 62 (2004): 197–210; "Photographs as Evidence," in Scott Walden, ed., *Photography and Philosophy: Essays on the Pencil of Nature* (Oxford: Wiley-Blackwell,

2008), pp. 70–90; and "Photography and Its Epistemic Values: Reply to Cavedon-Taylor," *The Journal of Aesthetics and Art Criticism* 67 (2009): 235–237.

3. "Photographs as Evidence," p. 72.

4. The terms are introduced in "Photographs as Evidence," p. 74.

5. The distinction between demanding and undemanding sources of information is first made in "On the Epistemic Value of Photographs," p. 204.

6. "On the Epistemic Value of Photographs," p. 204.

7. Veridical paintings are first mentioned in "On the Epistemic Value of Photographs," p. 205. Veridical *landscape* paintings are first mentioned in "Photographs as Evidence," p. 76.

8. "Photographs as Evidence," p. 76.

9. "Photography and Its Epistemic Values: Reply to Cavedon-Taylor," p. 236.

10. "Photographs as Evidence," p. 82.

11. "Photographs as Evidence," p. 77.

12. Dan Cavedon-Taylor senses this omission in his important critique of the Cohen and Meskin proposal. He notes that "[t]he existence of objective, viewer-independent differences [that is, what I am calling 'ontic differences'] between the two media [that is, photographs and paintings] could arguably explain *why* viewers have the background beliefs about photographs that they do" ("The Epistemic Status of Photographs and Paintings: A Response to Cohen and Meskin," *The Journal of Aesthetics and Art Criticism* 67 [2009]: 230–235 at p. 234). Absent such "objective, viewer-independent differences," we are left with no explanation of why viewers have the beliefs that Cohen and Meskin ascribe.

13. Cohen and Meskin's criticism of Kendall Walton's claim that we see through photographs can be found in "On the Epistemic Value of Photographs," especially Sections I and II. Walton's original statement of his position occurs in his "Transparent Pictures: On the Nature of Photographic Realism," reprinted in *Photography and Philosophy: Essays on the Pencil of Nature*, pp. 14–49.

14. Eastlake refers to the camera as an "unreasoning machine" ("Photography," p. 97). Stanley Cavell describes the "automatism" of photography as "removing the human agent from the task of reproduction" (*The World Viewed* [Harvard University Press, 1971], p. 23). The clearest description of the mechanical character of photography is found in Walton's "Transparent Pictures: On the Nature of Photographic Realism," Section 5.

15. Dominic Lopes has argued that painters and sketchers need not, and typically do not, form *beliefs* about visible features of the scene before them in the course of creating their pictures. But he does allow that the scene must register in their minds to some degree. See his *Understanding Pictures* (Oxford University Press, 1996), especially pp. 183–184.

16. For a discussion of the relevant construals of equivocation and noise, see Fred I. Dretske, *Knowledge and the Flow of Information* (MIT Press, 1981), chap. 1.

17. Cohen and Meskin reject the mechanistic (or "automatic") view in "On the Epistemic Value of Photographs," p. 209, and again more recently in "Photography and Its Epistemic Values: Reply to Cavedon-Taylor," p. 237.

18. See especially the highly influential criticism of the "mechanical model" of photography offered by Joel Snyder

and Neil Walsh Allen in their "Photography, Vision, and Representation," *Critical Inquiry* 2 (1975): 143–169.

19. Cohen and Meskin, "Photography and Its Epistemic Values: Reply to Cavedon-Taylor," p. 237. The most notable example of an exception is Walton. See "Transparent Pictures: On the Nature of Photographic Realism," Section 5.

20. See Section IV of my "Objectivity in Photography," *The British Journal of Aesthetics* 45 (2005): 258–272.

21. See Walden, "Objectivity in Photography," especially Section IV, and my "Truth in Photography," *Photography and Philosophy: Essays on the Pencil of Nature*, pp. 108–110.

22. Walden, "Truth in Photography," pp. 96–97. Proto-beliefs are perhaps equivalent to the outputs of informationally encapsulated modules as discussed by Jerry Fodor, *The Modularity of Mind* (MIT Press, 1983). An intriguing line of investigation would explore the intersection between these and the class of propositional attitudes that Kendall Walton and Patrick Maynard refer to as "states of imagining." See Kendall Walton, *Mimesis as Make-Believe: On the Foundations of the Representational Arts* (Harvard University Press, 1993) and Maynard's *The Engine of Visualization*. Tamar Gendler's notion of alief is also relevant, although proto-beliefs have more conventional, propositional contents. See her "Alief and Belief," *The Journal of Philosophy*, 105 (2008): 634–663, especially p. 635 n4.

23. While in perception there is almost always a phenomenology accompanying proto-beliefs, it is the underlying propositional core of the proto-beliefs to which this analysis appeals, a core that will typically be much less introspectively salient to the person who has the proto-belief than is its phenomenal character. My claim is thus *not* that phenomenological appearances somehow "match" the observed reality, whatever this might mean. Thus, the criticisms of the "visual model" offered Snyder and Allen in "Photography, Vision, and Representation," pp. 143–169, would not apply.

24. Perhaps here I should register my discomfort with the term 'veridical painting.' Veridicality is associated with truth and truth with propositions—propositions that some might assume are expressed by the pictures themselves, in the same way that propositions are expressed by declarative sentences. But I have no better term to offer and, as long as veridical paintings (or, better, 'veridical handmades') are understood to be by definition nonphotographic images that tend to induce true proto-beliefs, no confusion should result.

25. This characterization of the cognitive side of the analysis replaces my earlier attempt to do so in terms analogous to Grice's characterization of the cognition associated with implicature (see Paul Grice, "Logic and Conversation," reprinted in his *Studies in the Ways of Words* [Harvard University Press, 1989], pp. 22–40, and my "Objectivity in Photography," pp. 271–272). In that earlier work, I assumed that viewers have beliefs with contents pertaining directly to the objectivity of the photographic process. I papered over the psychological implausibility of this by suggesting that viewers did indeed have such beliefs but that they did not realize that they had such beliefs in the same way that according to Grice typical speakers have beliefs pertaining to conversational maxims but do not realize that they do. I was never entirely satisfied with this approach, however, as the concepts involved in beliefs about conversational maxims are much less complex than concepts having to do with objectivity. It was Jody Azzouni who in conversation pointed out to me that the contents of the ascribed beliefs could pertain, not to the objective character of the process that subtends high-level regularities (or, as he calls them, 'gross regularities'; see his *Knowledge and Reference in Empirical Science* [London: Routledge, 2000]), but rather to the high-level regularities themselves.

26. Although the advent of digital imaging techniques places this in jeopardy. For more on this concern, see my "Truth in Photography," pp. 108–110.

27. Barbara Savedoff, *Transforming Images*, pp. 202–209.

28. Susan Sontag, "In Plato's Cave," in her *On Photography* (New York: Picador, 1973), pp. 3–24.

29. I am indebted to Jody Azzouni for his extremely helpful suggestions and to an anonymous referee for this journal.

LAURA PERINI

Depiction, Detection, and the Epistemic Value of Photography

In *The Engine of Visualization*, Patrick Maynard calls for thinking about photography first of all as a technology that uses light to mark surfaces in order to produce images, and secondly, to investigate what the more specific versions of this general technique are used to accomplish.[1] This approach facilitates an expansive view of photography that is not limited to the production of images that are used as depictions. Indeed, one of the main themes of the book is the distinction between using photographic images as depictions and using them to make detections. Maynard argues that although these functions are independent, it is often the case that the depictive function of photos aids detection. In this article, I evaluate this view. On the one hand, Maynard seems to oversell his claim with respect to photographs, as I show by working through his primary example. In another respect, however, Maynard undersells his view. Maynard is fully aware that not all images function as depictions, but the aesthetics literature has been dominated by discussion of depiction. Discussion of the epistemic value of photographs has thus centered on comparison to hand-rendered depictions, such as whether they are more objective or embody information. The issue of how information is extracted from photographs drops away in these comparisons, and the significance of depiction as an aid to extraction is obscured. Science involves many kinds of images that are not depictions or have severe limitations in the extent to which they can be comprehended as depictions. Familiarity with these cases in which depiction cannot aid in making detections and the difficulty in making detections that can ensue highlights the importance of Maynard's result about the positive role that depiction can play in making detections from photographs.

I. MAYNARD: DEPICTION AS AN AID TO DETECTION

One important function of photography is detection. It is possible to make many kinds of detections with photographs through visual perception because the states of the marked surface include traces of other things.[2] For Maynard, a key aspect of detection is the transmission of information. Following Dretske, Maynard distinguishes between the information source (such as an object photographed), the channel (such as the photoreceptive surface, camera mechanism, and so on), and the receiver of the information.[3] This is an objective account of information: information transfer depends on relations between states of the subject and those of the marked surface. Maynard claims that there are certain "functional relationships between some states of a subject and the states of the photographic image. These relationships are durable and repeatable under wide variations in other conditions."[4] We "all assume" these relationships "whenever we take or look at photographs."[5] These assumptions are important, because the detective function of photography is not accomplished simply by storing information in marked surfaces. Making detections involves extracting that information; as a result, the receiver knows something about the detected item. Detectable information in photographic images can include states of the source and states of the channel, such as the shutter speed. Photography can be, and often is, used to *make* detections—but only

because the information is stored in a visible form and only to the extent that we are able to extract information from that visual form.

The problem Maynard recognizes is that the capacity to store information is not sufficient for the image to have epistemic value. Viewers must register the information as detected. Because detection is connected to an objective account of information, Maynard claims that "we can only detect what is so."[6] However, it is possible to be mistaken about what is detected by a photograph because a variety of assumptions about the functional relations between image state and the things photographed, as well as other cognitive and perceptual resources, are deployed in registering putative information as detected.[7] Making detections with photographs involves some risk.

Photographs are also often used as depictions. Maynard draws on Walton's account of depiction, according to which pictorial comprehension is a matter of using the picture to imagine seeing what it depicts and to imagine, of your visual activity, that you actually are seeing what is depicted.[8] So, "as we look at our marked display surface depictively, our visual activities are guided by the imagining activities that it automatically incites in us."[9] Pure depiction occurs when what is depicted is not detected, such as when a man in a red suit is photographically depicted as Santa Claus. Pure detection occurs when the image supports detection, but not depiction: given the conditions in which the image is used, it does not prescribe imagined seeing. However, in many cases, a photo will support both functions. Maynard presents *Backyard* (1932) by Walker Evans as an example. This photo depicts a child as having freckles and also allows for detection of her freckles. The physical state of the marked surface carries information, and in this case, that information is made accessible through treating the image as a depiction; for Maynard, this involves imagined seeing of the child. The kind of imagining prescribed by a picture will involve deploying a great deal of knowledge about visible things, prior visual experience, and visual skills in the visual activity of engaging with the photo. For this reason, Maynard's claims about the relation between depiction and detection are not so tightly tied to the Waltonian framework as they might seem at first blush. The broad net of perceptual and cognitive resources that are deployed in comprehending depictions (on a

Waltonian view) that then are involved in making detections would also be involved in pictorial comprehension according to some alternative accounts of depiction.[10]

The question at hand is the extent to which the fact that the depictive use of photographs can aid their use for making detections accounts for the epistemic value of photographs. It is no surprise that to a certain extent, the epistemic value of photographs depends on their capacity to convey information about the visible features of their subjects. After all, information about visible features is very valuable: given our knowledge of visible objects, events, and states of affairs, we can detect far more than visible features on the basis of the right kind of information about visible features. The advance here is the stress on the role of depiction in aiding detection—or, as Costello and Phillips characterize it in their endorsement of Maynard—in the *extraction* of information from photographic images.[11]

Maynard presents one example that I discuss in detail, because although Maynard presents it as support for his claim that depiction aids detection, it will help clarify the limitations of the extent to which depiction aids detection through photography.

Maynard presents a detailed discussion of a photo finish image from a horse race to support his view that depiction facilitates detection. The photo finish image contains information about the conditions at a single narrow location over several moments. Comprehending the image as a depiction of a single moment in time allows for extraction of a specific, important bit of information: which horse crossed the finish line first. This information could be easily extracted by taking the image for what it is, a visual representation of a sequence of events at the finish line. So is the ability to use the image as a depiction to make the same detection really an epistemic advantage? This is unclear, because treating the image as a depiction is misleading in many ways.

The photo finish picture is produced by exposing a moving film to a slit, and thus it embodies information about the state of a particular narrow area (the finish line) over time. Naive viewers will comprehend this photo as a depiction, because it looks like a typical snapshot—that is, one in which all of the film is exposed to a whole scene at one moment. Viewed as a depiction, it represents the locations of various horses and riders at

a single moment over a relatively broad spatial area. Treated as a depiction, it is largely inaccurate: there was no moment in time in which the horses were in those relative spatial positions and configurations. For example, at the moment when the first horse's nose crossed the finish line, the third horse's hooves were not in the position as depicted. The third horse's hooves were in that position later, when *it* crossed the finish line. Nevertheless, taken as a depiction, the photograph facilitates accurate detection of the winner of the race. But it also facilitates many mistakes—extraction of content from the photo-as-depiction that was not detected by the imaging process and furthermore is not accurate. In certain tightly controlled situations, like the use of photo finish photography, there is no harm in treating the image as a depiction. That is because it will support the correct detection of the order of horses crossing the finish line, and that is the only informational use to which the image is put. However, that is just one of all the putative detections that a viewer could make by taking this image as a depiction. So this example provides little support for the claim that depiction aids detection in general, that is, even when depiction is inaccurate.

Mistakes in extraction are possible even with everyday photographs, as Maynard establishes with a hypothetical example "of the snapshot in which someone blinks, where what is *recorded* on the surface (a blink) may be different from what the picture would have us *imagine* we are seeing (a person of reduced capacities)."[12] Maynard does not discuss the example further, but he seems to have in mind a case where there is no visual cue in the photograph that would guide imagining seeing a man during a blink, like blurring around the eyelid. Such a photograph must be made with a very fast shutter speed, at one of the rare moments when an eye is half open. Recall Maynard's assertion that whenever we look at pictures—which includes looking at them as depictions—we assume certain functional relations between the subject and image. In treating the image as a depiction, the viewer generally looks at a photograph in light of a range of channel conditions, rather than the highly specific conditions of very fast shutter speed and timing needed to produce a sharp image of a half-closed eye from a normal subject. In this case, the viewer would be guided to imagine seeing an incapacitated man. The issue is not whether or not the viewer is correct in taking the photo to depict

an incapacitated man. Maynard is concerned with how the photograph is used, and his point is that if it is used as a depiction, a viewer aiming to make a detection through treating the photograph as a depiction would be misled about what she has detected with the photograph. Using photographs as depictions is often a threat to detection because it fosters a way of working with the image that need have no connection to the kind of information it actually presents.

II. SCIENTIFIC IMAGES AND THE EXTRACTION PROBLEM

The discussion above shows that the depictive use of photographs poses a significant risk to their use for detection, but at this point we have little sense of the value of depiction as an aid to detection. Making detections with photographs requires not just that photographs embody some information, but that this information can be extracted or "registered as detected," as Maynard puts it. If interpreting photographs as depictions leads to mistakes about what has been detected, then the depictive use of photographs seems to threaten their epistemic value rather than enhance it.

Maynard is exceptional in stressing the epistemic significance of the connection between depiction and detection in photography. The literature on the epistemic value of photography tends to obscure the degree to which the epistemic value of photographs depends on the depictive use of photographs to facilitate detection. The concerns addressed in that literature frequently involve comparisons to hand-rendered depictions, such as the capacity of photos to embody information, and the relative objectivity of photographs.[13] These concerns reflect the importance of depiction in the aesthetics literature: as the subject of sustained inquiry, it provides solid conceptual ground from which to approach photography. For a different perspective on Maynard's view, we need some exposure to images that do not function as depictions. Science offers a wealth of examples.

Scientific imaging techniques are not confined to the production of images that function as depictions. The tactic here is not mere contrast with a different sort of image altogether (that is, contrasting depictive images with nondepictive images); rather, it is to investigate images

FIGURE 1. Electron micrograph. Reproduced with kind permission from the American Society for Microbiology. Source: Antoinette Ryter and Otto Landman, "Electron Microscope Study of the Relationship Between Mesosome Loss and the Stable L State (or Protoplast State) in *Bacillus subtilis,*" *Journal of Bacteriology* 88.2 (1964): 457–467, Figure 5.

very closely related to photos. Marking surfaces with visible light is, after all, only one way of producing images. Contemporary scientists often use technologies that are closely related to photography *as Maynard defines it*—using light to mark surfaces for display. Scientists produce images by marking surfaces using electrons, sound waves, X-rays, and the like. Analysis of these technologies, which, on Maynard's terms, are so similar to photography, will provide a perspective that reinforces Maynard's view that the epistemic value of photographs often depends on the fruitful interaction of depictive and detective use of photographs.

Scientists produce a diverse array of images with striking differences both in their visible features and what they represent. The images relevant to our purposes are those made by automated processes that produce a marked surface as the fairly direct output of interaction with a specimen.[14] The technologies involved in making such images include various photographic techniques, combinations of light microscopy with photography, transmission electron microscopy, and different kinds of X-ray imaging. Such images play crucial roles in contemporary science. They are often presented in research papers and talks—the primary ways in which scientists publicly present and defend new ideas. In these venues, photographs and images from related technologies are presented as evidence: they are supposed to support the conclusion the author defends.

The evidential function of the products of imaging techniques in scientific reasoning depends on the capacity of these images to support detection. That depends on their capacity to bear information, but an account of information embod-

ied in the image is not sufficient to account for its role as evidence. As we saw with photographs, their epistemic value does not amount to anything unless it is possible to extract information from them. Scientific images often are highly limited in the extent to which they can be treated as depictions. Thus, that route to extracting information is not available. In the next section, I present three examples of scientific images in order to clarify the limitations involved regarding the extent to which using images as depictions aids detection in science and to sketch the kinds of alternative tactics used in extracting information from such images.

III. SCIENTIFIC IMAGES: CASE STUDIES

Figure 1 is an electron micrograph, an image produced by aiming a beam of electrons at a very thin sample of biological material. Electrons that go through the sample react with a film; others are blocked by the biological material in the sample. The developed film is light where electrons made contact with the film, so darker areas indicate regions of biological material. This is an image that can be comprehended as a depiction of biological structure. In this case, the authors make a supposed detection that is inaccurate: the image was thought to show the presence of a bacterial organelle, called a mesosome (the *m*'s superimposed on the image indicate mesosomes.) The upshot of research on these putative organelles is that they are now known to be mere artifacts of sample preparation methods. The *m* areas correspond to biological material that clumped up during sample processing, but do not correspond to structures in

living bacteria. Used as a depiction of bacterial cell structure, the image led to a mistake about what was detected. The image can also be taken as a depiction of the structure of the prepared sample that was subjected to electron microscopy. Using the image as a depiction in this way supports detections of small, dense regions within the prepared sample—those are real features of the treated specimen. Taking the images as depictions of cellular structure, including mesosomes, rather than as a depiction of the structure of the prepared sample prompts a mistake about what was detected with the image.

In scientific contexts, where knowledge about the source is limited, the kind of constraints that prevent mistakes as a result of using the image as a depiction to make detections will often be absent—in contrast to the way a photo finish image is used. Most people are unfamiliar with imaging under conditions where such constraints are absent, because their encounters with the imaging techniques used in science occur in medical contexts, rather than research contexts. Maynard notes that images like X-ray films of anatomy can be handled as depictions and so aid detection of medical conditions.[15] It is important to recognize that the context of medical diagnostics is significantly different from that of basic research. The imaging techniques involved in medical practice are the results of work on the part of practitioners to control the sources and channels of information flow and develop appropriate interpretive practices so that doctors can comprehend them as depictions as a reliable means to making detections.[16] The conditions that generate this kind of reliability often do not hold in the context of basic research.

Figure 2 is an autoradiograph: an image produced by exposing a film to radioactive material. It was first published in an ethnographic study of how scientists work with images in a molecular biology laboratory by Klaus Amann and Karin Knorr Cetina.[17] I first explain the technique used to produce this image and then draw on their results in order to clarify how scientists make detections with it. In this case, autoradiography is being used to visualize the results of an experimental technique called gel electrophoresis. This is a process used to separate macromolecules like nucleic acids (DNA and RNA) by size. The gel is a thin layer sandwiched between two glass plates. An aqueous solution bathes the top and bottom

ends of the gel. This makes it possible to pass an electric current from the top to the bottom of the gel, which is the key to separating the compounds of interest. First, samples are loaded into holes in the top of the gel, called "wells." The locations of the wells are visible in Figure 2: the straight line of dark bars near the top of the image. Then the electric current is turned on and it pushes the negatively charged compounds in each well straight down toward the bottom of the gel. Since the gel is semi-solid, small compounds move through it faster than larger ones. The effect of the current is that it pushes small compounds through the gel fairly quickly, but the larger ones are more hindered by the gel matrix and do not move as fast. This difference in speed is what ultimately separates a starting mixture of different compounds by size. In this experiment, the researchers loaded the wells with different samples of radioactively labeled nucleic acid fragments, which are negatively charged. They turned on the current long enough for short segments to move down near the bottom of the gel. The longer fragments are near the top. After electrophoresis, the gel is dried and exposed to a film sensitive to the energy released by the radioactive decay of the labeled nucleic acids, which are arrayed in the dried gel.

The researchers whom Amann and Knorr Cetina observed were studying the initiation of transcription, which is the first stage of gene expression, in which an RNA segment is made based on a template from a strand of DNA. They use gel electrophoresis to separate the nucleic acid fragments by length because the length of the fragments allows them to determine what happened in particular experimental reactions, such as whether and where transcription was initiated along a segment of DNA. Since the nucleic acid fragments that bear this information are far too small to see, the use of autoradiography to produce an image of their location in the gel is a key part of the experimental technique.

In their article, Amann and Knorr Cetina document the extensive work involved in making detections from autoradiographic images.[18] While the researchers know which sample mixtures were loaded into the different wells, they need to determine the size of the nucleic acid fragments that caused particular bands in individual columns in the image. This is the information they need in order to draw conclusions about the experiment on the basis of the image. It sounds simple enough,

FIGURE 2. Autoradiograph. Reprinted with permission from Springer Science+Business Media. Source: Klaus Amann and Karin Knorr Cetina, "The Fixation of (Visual) Evidence," *Human Studies* 11.2 (1988): 137, Exhibit 1.

but Amann and Knorr Cetina show how difficult it is for the researchers to come to conclusions about which band on the image relates to which length of fragment, and so they have a very difficult time extracting the information they need from the film. In various pairs and small groups, lab personnel will repeatedly gather to look at and discuss a film. Those conversations involve discussions of parts of the film and how one area relates to another as well as references to the experimental technique (how the samples were treated and how the gel was run) and to past experiments and their results. These activities make it clear that the information they need from the film is not accessible simply by comprehending the film as a depiction. In attempting to extract information from the image, they may be able to comprehend the image as a depiction of the location of nucleic acid throughout the gel. But what they need is a different kind of

information—the length of the fragments in individual bands. They can only extract this information by identifying bands in the marker column as representations of a specific length of fragment and then comparing the bands in the marker columns to those in experimental columns in order to determine the lengths of the fragments in those columns. For that purpose, treating the gel as a depiction of nucleic acid *location* is merely a starting point for extracting the desired information. But even if treating the film as a depiction of the various locations of nucleic acids in the dried gel aids detection of those locations, a more substantial interaction between depiction and detection is blocked: the visual information one gets from the gel is not conducive to imagining seeing the bands as differently sized (or recognizing that, or experiencing a sense of visual similarity between the experience of the image and nucleic acid size). In short, the visual input provided by the image is not conducive to comprehending the image as a depiction of nucleic acid sizes. The spots vary in thickness and darkness, neither of which varies with the properties that individuate nucleic acid sequences. Rather than interpreting the image as a depiction of nucleic acid size, making detections involves different kinds of visual activity on the part of the scientists.

The last example, Figure 3a, is an X-ray diffraction pattern of a protein complex called the F1 ATP synthase. The ATP synthase complex has an important biological function: it catalyzes the formation of ATP, the "energy currency" of the cell, from precursor compounds. The ATP synthase is large for a protein, but it is too small to resolve with a light microscope. Transmission electron microscopy can provide a very imprecise outline of the complex but no details. X-ray crystallography provides a way to determine the structure of molecules on this scale—for example, the model of the ATP synthase complex (Figure 3b) was made on the basis of such an image.[19]

In this technique, a beam of X-rays is aimed at a protein crystal—an ordered, repeating array of the protein complex. The crystal scatters the beam, generating a pattern of spots. Each spot on the diffraction pattern is a place where X-rays, scattered from all different parts of the protein molecules arrayed in the crystal, have reinforced each other. The light areas occur when any X-rays that scatter off the protein cancel each other out (the white horizontal bar is a blank area due to

the mechanics of the technique). In the diffraction pattern, the properties of each spot are determined by the properties of the whole protein crystal. This amounts to a very different format for embodying spatial information than is involved in imaging techniques like standard photography, in which properties of a small area of the image are largely determined by properties of a corresponding small area of the scene or object subjected to the imaging technique.

As a whole, the diffraction pattern embodies information about the structure of the protein, but this information cannot be extracted by treating it as a depiction of molecular shape. The array of spots in the diffraction pattern has completely different spatial characteristics compared to the three-dimensional protein structure (represented in 3b). Inability to comprehend the diffraction pattern as a depiction is not due to a lack of visual imagination, skill, or expertise on the part of the viewer. Because of the way spatial information is distributed throughout the diffraction pattern, it is not possible to imagine seeing the protein through seeing the image, except as part of an imaginative activity in which the content that you see—the structure of the protein—is merely assigned.[20] But that is not the imagined seeing that would be involved in comprehending the image as a depiction.

While James Watson famously detected a crucial piece of information about the structure of DNA with a single glance at a diffraction pattern produced by Rosalind Franklin, he did not do so by comprehending that image as a depiction of the structure of DNA. According to his autobiography, his collaborator Francis Crick used mathematical analysis to determine that a helical molecule would produce a diffraction pattern in which spots form a cross shape. When Watson saw Franklin's image, he noticed the prominent cross made by the dark areas in the diffraction pattern, and thus knew that the image was produced by a helical structure.[21] This incident is an example of a case in which the relationship between molecular structure and diffraction pattern has been worked out so that a researcher can extract structural information from a diffraction pattern by visually recognizing features of the image known to correlate with structural features. This kind of case is the exception rather than the rule. Extracting the kind of structural information depicted in Figure 3b from the diffraction pattern of a complex molecule

FIGURE 3. (a) Diffraction pattern. Reproduced with permission from IUCr. Source: Matthew Bowler et al., "Diffraction Cartography: Applying Microbeams to Macromolecular Crystallography Sample Evaluation and Data Collection," *Acta Crystallographica Section D*, 66 (2010): 855–864, Figure 4(d)1. (b) Ribbon diagram of F1 ATP synthase structure.

like a protein is a multistep, complicated analytical process. That process begins with collecting data about the image: numerical representations of spot locations and intensities. These data are then subjected to extensive mathematical analysis, the results of which are used to construct the model of the protein's structure.

Summing up, some kinds of scientific imaging technologies, like transmission electron microscopy, allow for comprehending the image as a depiction. However, in basic research contexts, these imaging techniques are often used under conditions where there is inadequate information about the source or channel to constrain *how* the image is construed as a depiction. As a result, comprehending the image as a depiction can lead to misrepresentation; detection is not enhanced. With other imaging technologies, the imaging channel does not provide the kind of information that supports depiction of the features of interest. We saw that the degree to which comprehending the autoradiograph as a depiction aided detection was limited; while the autoradiograph may be used as a depiction of the location of nucleic acids, it could not be understood as a depiction of nucleic acid size. In this case, at the most, depiction plays a supporting role in the extraction of information from the image. Making detections about fragment length, and thus about which RNA fragments were produced in the experiment, could not be accomplished by treating the film as a depiction of those features and required intensive additional work on the part of the researchers. Finally, the use of depiction as a

means for making detections was blocked entirely for the X-ray diffraction image due to the way spatial information is embodied in a diffraction pattern. Extracting that information requires using the image in a different way; for a complex molecule like a protein structure, that involves complex mathematical analysis of data collected from the image.

IV. CONCLUSION

Maynard stresses the point that the ability to "make detections by just looking at photographs . . . *always* depends upon background information regarding sources, as well as about our channels of perception."[22] The hard work needed to make photography valuable as a means to making detections, as Tucker's study of early photography shows, took place in developing photographic techniques that reliably captured information in the images; initial challenges ranged from inability to produce consistently photographic portraits that were recognizable likenesses to figuring out how to produce informative photographs of meteorological conditions, like different kinds of clouds.[23] With the channel under control, "photo images can be so managed as to make our *extraction* and *interpretation* of their information content relatively easy."[24] The fact that one can make detections with photographs through comprehending them as depictions makes it easy, even if there is always a risk of being mistaken about what has been detected as a result.

In contrast, for many scientific images, the resources the viewer deploys in taking the image as a *depiction* of the features of interest are either unavailable or so unconstrained that attempts to make detection through using the image as a depiction are unreliable. In science, detection often *cannot* depend on depiction. Researchers are put in the position of needing to extract information from images without treating them as depictions or with comprehension in terms of depiction playing only a partial role in information extraction. They deploy alternative tactics in the attempt to extract information, and those alternatives tend to be complicated and laborious in comparison to the ease with which we make detections by comprehending a photo as a depiction. And generally, only specialists with extensive background in the area of research will be able to make any significant detections from scientific images. Thus, the epistemic significance of the connection between depiction and detection with photographs is in part due to the fact that information is made so easily accessible to so many. Maynard claims that photography is *"the site of historically the most spectacular interaction of depictive and detective, functions."*[25] Examination of scientific images, which provides an appreciation of the extent to which images are used to serve detective, but not depictive, functions, supports his claim about photography and the degree to which the epistemic value of photography stems from this interaction.[26]

LAURA PERINI
Department of Philosophy
Pomona College
Claremont, California 91711

INTERNET: laura.perini@pomona.edu

1. Patrick Maynard, *The Engine of Visualization: Thinking through Photography* (Cornell University Press, 1997).

2. Maynard, *Engine of Visualization*, p. 122.

3. Fred Dretske, *Knowledge and the Flow of Information* (MIT Press, 1981).

4. Maynard, *Engine of Visualization*, p. 217; he argues for this point in chapter 6.

5. Maynard, *Engine of Visualization*, p. 217.

6. Maynard, *Engine of Visualization*, p. 130.

7. Maynard, *Engine of Visualization*, p. 128.

8. Kendall Walton, *Mimesis as Make-Believe: On the Foundations of the Representational Arts* (Harvard University Press, 1990), p. 293.

9. Maynard, *Engine of Visualization*, p. 104.

10. Accounts of depiction that appeal to relatively broad sets of cognitive and perceptual resources to explain pictorial comprehension include recognition-based and experienced resemblance views. Defending a recognition-based view of depiction, Lopes claims that the basic step for a viewer to understand a picture is "to entertain a thought which links the visual information presented by the picture with a body of stored information from its subject" (Dominic Lopes, *Understanding Pictures* [Oxford University Press, 1996], p. 158). Rollins argues for a recognition account in which knowledge is involved in pictorial interpretation in Mark Rollins, "The Mind in Pictures: Perceptual Strategies and the Interpretation of Visual Art," *The Monist* 86 (2003): 608–631. Robert Hopkins claims that, besides himself, those attempting to develop a theory of depiction starting from an account of pictorial experience have not addressed the issue of pictorial interpretation, because the connection seems obvious. See Robert Hopkins, "Pictures, Phenomenology and Cognitive Science," *The Monist* 86 (2003): 654–676, at p. 654. Hopkins argues for an experienced resemblance account of depiction, according to which "an awareness or conception of the things to which resemblance is experienced" is necessary, and that in some cases additional knowledge is also required for pictorial interpretation (Robert Hopkins, *Picture, Image, Experience: A Philosophical Inquiry* [Cambridge University Press, 1998], pp. 132, 137–138].

11. Diarmuid Costello and Dawn Phillips, "Automatism, Causality and Realism: Foundational Problems in the Philosophy of Photography," *Philosophy Compass* 4 (2009): 1–21.

12. Maynard, *Engine of Visualization*, p. 140.

13. Catharine Abell, "The Epistemic Value of Photographs," in *Philosophical Perspectives on Depiction*, ed. Catharine Abell and Katerina Bantinaki (Oxford University Press, 2010), pp. 81–103; Jonathan Cohen and Aaron Meskin, "On the Epistemic Value of Photographs," *The Journal of Aesthetics and Art Criticism* 62 (2004): 197–210; Scott Walden, "Objectivity in Photography," *The British Journal of Aesthetics* 45 (2005): 258–273. All these papers trace the problem of accounting for the epistemic value of photographs back to Kendall Walton, who aims to account for the difference in realism between photographs and non-photographic depictions, but he explicitly identifies their different ability to play epistemic roles (such as serving as evidence) as part of the project in his "Transparent Pictures," *Critical Inquiry* 11 (1984): 246–277.

14. Such techniques are most similar to photography, as Maynard defines it. Contemporary scientists also use mechanized techniques in which data are collected and subjected to extensive mathematical analysis prior to visualization, such as MRI. Because that additional step of analysis raises a distinct set of issues regarding what the images represent and what detections they support, I will not address them here. For a discussion of epistemic issues involved with "heavily mathematized" scientific imaging techniques, see Megan Delehanty, "Empricism and the Epistemic Status of Imaging Techniques," PhD dissertation,, University of Pittsburgh, 2005.

15. Maynard, *Engine of Visualization*, p. 140. For a more extended discussion of medical imaging and depiction, see Nola Semczyszyn, "Signal into Vision: Medical Imaging as

Instrumentally Aided Perception," PhD dissertation, University of British Columbia, 2010.

16. The kind of work involved is described in Bernike Pasveer, "Representing or Mediating: A History and Philosophy of X-ray Images in Medicine," in *Visual Cultures of Science: Rethinking Representational Practices in Knowledge Building and Science Communication*, ed. Luc Pauwels (Lebanon, NH: University Press of New England, 2006), pp. 41–62.

17. Klaus Amann and Karin Knorr Cetina, "The Fixation of (Visual) Evidence," *Human Studies* 11 (1988): 133–169.

18. Amann and Knorr Cetina, "(Visual) Evidence," pp. 138–158.

19. The structural diagram was generated using the coordinates for the F1 structure model published in J. P. Abrahams, A. G. Leslie, R. Lutter, and John Walker, "Structure at 2.8 A Resolution of F1-ATPase from Bovine Heart Mitochondria," *Nature* 370 (1994): 621–628. The authors did not include a diffraction pattern in that publication; the image in Figure 3a is a diffraction pattern of the same enzyme complex published in a different study.

20. Peter Kung, "Imagining as a Guide to Possibility," *Philosophy and Phenomenological Research* 81 (2010): 620–633.

21. James Watson, *The Double Helix: A Personal Account of the Discovery of the Structure of DNA*, ed. Gunther Stent (New York: W. W. Norton, 1980), p. 98.

22. Maynard, *Engine of Visualization*, p. 144.

23. Jenifer Tucker, *Nature Exposed: Photography as Eyewitness in Victorian Science* (Johns Hopkins University Press, 2006).

24. Maynard, *Engine of Visualization*, p. 218.

25. Maynard, *Engine of Visualization*, p. 120.

26. This article was written at the University of Pittsburgh Center for Philosophy of Science, supported by their Visiting Fellows program, and by a Steele Fellowship from Pomona College. I thank Pat Corvini for her help with this article.

Contributors

PETER ALWARD is Associate Professor of Philosophy at the University of Lethbridge. He received his M.A. from Dalhousie University and his Ph.D. from the University of North Carolina, Chapel Hill. He works primarily in the philosophy of language and the philosophy of art. He is currently peddling a book manuscript on the philosophy of fiction entitled *Empty Revelations: An Essay on Talk About and Attitudes Toward Fiction*.

PALOMA ATENCIA-LINARES is a doctoral student at University College London, where she is working on her dissertation, *Arts and Facts: Nonfiction and the Visual Arts*. She held a Fulbright Scholarship to pursue her M.A. in Philosophy at Temple University, and she currently holds the British Society of Aesthetics Studentship and an Arts and Humanities Research Council (AHRC) grant.

RICHARD BEAUDOIN's compositions have been performed at the Amsterdam Concertgebouw, Wiener Konzerthaus, and London's Royal Festival Hall and have been commissioned by the Staatstheater Kassel, Konzerthaus Dortmund, and Boston Lyric Opera. His writings have appeared in the *Journal of Music Theory*, *Perspectives of New Music*, and *The Journal of Aesthetics and Art Criticism*. Mr. Beaudoin holds the post of Lecturer on Music at Harvard University.

ROY T. COOK is Associate Professor of Philosophy at the University of Minnesota–Twin Cities. He has published numerous articles on philosophical logic, the philosophy of logic, the philosophy of mathematics, and more recently, the aesthetics of comics. He is the author of *The Dictionary of Philosophical Logic* (Edinburgh University Press, 2009), the editor of *The Arché Papers on the Mathematics of Abstraction* (Springer, 2007), and coeditor (with Aaron Meskin) of *The Art of Comics: A Philosophical Approach* (Wiley-Blackwell, 2012). He lives in a small house in Minneapolis with his wife, numerous cats, and approximately 1.7 million LEGO bricks.

DIARMUID COSTELLO is Associate Professor of Philosophy at the University of Warwick, Chair of the British Society of Aesthetics, and Co-Director of the (AHRC) research project "Aesthetics after Photography." He has coedited two other journal issues on photography: "Photography after Conceptual Art" (*Art History*, 32.5, 2009) and "Agency and Automatism" (*Critical Inquiry*, 38.4, 2012). His articles have appeared in *The Journal of Aesthetics and Art Criticism*, *The British Journal of Aesthetics*, and *Critical Inquiry*. He is working on two book projects: "On Photography" and "Aesthetics after Modernism."

SHERRI IRVIN is Associate Professor of Philosophy at the University of Oklahoma. She has published articles on everyday aesthetics and the philosophy of contemporary art in *The Journal of Aesthetics and Art Criticism*, *The British Journal of Aesthetics*, *Museum Management and Curatorship*, and *New Waves in Aesthetics*, among other venues. She edits the aesthetics and philosophy of art section of *Philosophy Compass*. She is currently working on a book, *Challenging Objects: A Philosophy of Contemporary Art*.

ANDREW KANIA is Associate Professor of Philosophy at Trinity University in San Antonio. His principal research is in the philosophy of music, literature, and film. He is the editor of *Memento* (2009), in Routledge's Philosophers on Film series, and coeditor, with Theodore Gracyk, of *The Routledge Companion to Philosophy and Music* (2011).

DOMINIC MCIVER LOPES is Distinguished University Scholar and Professor of Philosophy at the University of British Columbia. He is the author of *Understanding Pictures* (Oxford University Press, 1996), *Sight and Sensibility: Evaluating Pictures* (Oxford University Press, 2005), and *A Philosophy of Computer Art* (Routledge, 2009), in addition to papers on such topics as depiction, the ontology of art, theories of art, and aesthetic value. He is now at work on a book entitled *Beyond Art*.

CHRISTY MAG UIDHIR is Assistant Professor of Philosophy at the University of Houston. His work has appeared in a number of anthologies and journals, including *Philosophical Studies, Australasian Journal of Philosophy, American Philosophical Quarterly, The British Journal of Aesthetics*, and *The Journal of Aesthetics and Art Criticism*. He is currently editing an anthology for Oxford University Press entitled *Art and Abstract Objects* and writing a book on the consequences of taking intention-dependence seriously as a necessary condition for being art.

BENCE NANAY is Research Professor at the University of Antwerp and Senior Research Associate at Peterhouse, University of Cambridge. He edited *Perceiving the World* (Oxford University Press, 2010) and is the author of *Between Perception and Action* (Oxford University Press, forthcoming). He has published articles in *Journal of Philosophy, Philosophical Quarterly, Philosophical Studies, Analysis, Monist, Philosophy and Phenomenological Research*, and *Synthese*, among others. His areas of specialization are philosophy of mind, aesthetics, and philosophy of biology.

LAURA PERINI is Assistant Professor of Philosophy at Pomona College. Her research focuses on the diverse array of visual representations scientists use, both as part of the research process and in presenting and defending new ideas in publications. She aims to clarify what visual representations contribute to scientific reasoning and to explain how they do so. She has published several articles and book chapters examining the nature of scientific visual representations, how they function as evidence, and their capacity to convey explanatory content.

RICHARD SHUSTERMAN is Dorothy F. Schmidt Eminent Scholar in the Humanities at Florida Atlantic University (Boca Raton) and Director of its Center for Body, Mind, and Culture. Author of *Body Consciousness* (Cambridge University Press, 2008), he has also written *Surface and Depth* (Cornell University Press, 2002), *Performing Live* (Cornell University Press, 2000), *Practicing Philosophy* (Routledge, 1997), and *Pragmatist Aesthetics* (Oxford/Blackwell, 1992, Rowman & Littlefield 2000, and translated into fourteen languages). A graduate of Hebrew University of Jerusalem and Oxford University (D.Phil.), he has held academic appointments in France, Germany, Israel, Japan, and China and has been awarded research grants from the NEH, Fulbright, ACLS, Humboldt Foundation, and UNESCO.

SCOTT WALDEN holds a Ph.D. from the CUNY Graduate Center and is Assistant Professor of Philosophy at Nassau Community College. He is editor of *Photography and Philosophy: Essays on the Pencil of Nature* (Wiley-Blackwell, 2010). Walden's photographic work has received multiple awards from the Canada Council for the Arts, and he is the 2007 winner of the Duke and Duchess of York Prize in Photography.

DAWN M. WILSON (née Phillips) is a Lecturer in Philosophy at the University of Hull. She was a Postdoctoral Research Fellow in Philosophy at St. Anne's College, Oxford, in 2010–2011 and previously a Research Fellow at the University of Warwick for the AHRC project "Aesthetics

After Photography." In published articles she has critically examined the "mind-independence" of photographic images and defended the significance of the causal provenance of photographs by presenting a multistage account of the photographic production process. She is currently preparing a monograph, *Aesthetics and Photography*, along with articles on photography and time and photography and music.

JOHN ZEIMBEKIS received his B.A. from Trinity College Dublin and his Ph.D. from the École des Hautes Études en Sciences Sociales in Paris. He is Maître de Conférences at the University of Grenoble and Associate Researcher at the Centre National de la Recherche Scientifique. He is the author of *Qu'est-ce qu'un jugement esthétique?* (Vrin, 2006) and articles on fiction, depiction, the metaphysics of identity, and aesthetic value.